THE BEGINNING AND
THE END OF THE WORLD

cx

THE BEGINNING AND
THE END OF THE WORLD

ↄ

St Andrews, Scandal and the Birth of Photography

Robert Crawford

BIRLINN

First published in 2011 by
Birlinn Limited
West Newington House
10 Newington Road
Edinburgh
EH9 1QS

www.birlinn.co.uk

ISBN: 978 1 84158 980 0
ISBN: 978 0 85790 058 6

A catalogue record for this book is available from the British Library

Des... Newtonmore
...ed ...by M...G... Bodmin

to A.C. *from* R.C. *with love*

Contents

ↀↀ

Acknowledgements

○○

My greatest debt is to this book's dedicatee. Alice, who knew St Andrews long before I did, made it possible for us to come and live there. She now works as Senior Academic Liaison Librarian for Arts and Divinity at St Andrews University Library. Reader, I married her – the best decision of my life. Along with our children, Lewis and Blyth, Alice was very patient during the writing and rewriting of *The Beginning and the End of the World*. Probably my family will be relieved if they never hear the names of its protagonists again, but thanks to Alice for reading it in draft, for being stringent as well as sympathetic; and thank you, Blyth and Lewis, who have tramped with me up St Rule's Tower, to the Rock and Spindle, and endlessly around the streets of our home town.

Fortunate accidents are vital to writing. It was sheer good luck that I met my former St Andrews colleague, Martin Kemp, now Research Professor of the History of Art at Trinity College, Oxford, during an exhibition of Calum Colvin's photography in the Royal Scottish Academy, Edinburgh, and was able to outline this project to him, then to gain hugely from his generous advice and support. Thanks are due also to Calum Colvin himself, for his enthusiastic response; to Professor Larry J. Schaaf, whose writings on the history of photography have been splendidly helpful to me for years now, and whose tactful, insightful support and advice, whether in conversations in St Andrews, or via email from his Rock House in Baltimore, have been of great value. I am deeply grateful to Martin Kemp and Larry Schaaf for reading this book in an advanced draft. In St Andrews the historian of Scottish photography Dr Tom Normand was another of my readers,

friends and encouragers. Thanks are due to him not least for advice about photographic theory and specific guidance about my typescript, but also for looking over my selection of photographs by Robert Moyes Adam on whom, at one point, I had thought of writing a separate book. Margaret Street of Edinburgh generously shared with me her memories of meeting R. M. Adam. Professor Sondra Miley Cooney, who is writing a biography of Robert Chambers, was kind enough to read chapter five and to point out some mistakes in it. At an earlier, very different stage, *The Beginning and the End of the World* was saved by being critiqued by my School of English colleague, Dr Sara Lodge, whose astute and writerly advice led me to abandon the original design and to completely recast the text. Thank you, Sara, you were absolutely right – though I still want to write elsewhere about falling under a train.

Unless I had been a millionaire, or had had thousands of free air miles, this book could not have been researched without recourse to earlier work by photographic historians including Dr David Bruce (formerly of the National Galleries of Scotland); Dr Anne M. Lyden of the Getty Museum, Los Angeles; Dr Alison Morrison-Low of the National Museums of Scotland (yet another generous reader and commentator on my typescript); my insightful former St Andrews colleague Professor Graham Smith; Dr Sara Stevenson (formerly of the National Galleries of Scotland); and other scholars whose names appear in my text or footnotes but whom I have never met. I listened with interest to lectures given in the School of Art History at St Andrews by Dr Duncan Forbes of the National Galleries of Scotland and by Professor François Brunet of the University of Paris Diderot, and I asked each an almost identical question about Brewster, photography, and death. Thanks to both gentlemen for their courtesy and patience.

Digital resources allowed me to look through many hundreds of photographs, particularly those in the collections of the Departments of Special Collections at St Andrews University Library and at Glasgow University Library. Thanks are due to the curators, keepers, and staff at each institution, particularly to the Keeper of Photography at St Andrews, Marc Boulay (who advised me from the inception of this project, gave very generously of his time to read the typescript when it was being redrafted yet again, and worked with me in assembling the

plates in digital form), and to the Keeper of Special Collections at Glasgow University Library, Dr David Weston, who generously allowed items from his Hill and Adamson archive to be reproduced here. At St Andrews the Keeper of Special Collections, Dr Norman Reid, was yet another reader of this typescript – one of his many kindnesses. To Norman and colleagues, not least Jane Campbell, Rachel Hart, Elizabeth Henderson, and Moira Mackenzie, I extend warm thanks; and gratitude to the National Library of Scotland.

The Principal of the University of St Andrews, Professor Louise Richardson, has been a staunch supporter of this offbeat project. I hope she will see it as a niftily timed contribution to the 600th birthday celebrations of St Andrews University – one that may still be of interest when we are 602. I have tried to make good use of my time as a Senate Assessor on the University Court, which allowed me to meet researchers and teachers in other academic departments more than sometimes happens. So thanks for their patience to all the Court members and officers, and to Professors and Drs Jan Bebbington, John Burnside, R. M. M. Crawford, Tom Edwards, Dina Iordanova, Ulf Leonhardt, Anne Magurran, Don Paterson, Eric Priest, Rona Ramsay, Wilson Sibbett, Alyson Tobin, Pat Willmer, Derek Woollins, and many other St Andrews academics. All my colleagues in the School of English were exemplary and fun, as always. Professor Lorna Hutson, my Head of School, was tolerant, kind and shrewd. Jane Guttridge, Sam Dixon, Laura Macintosh, and Sandra McDevitt were models of tact and helpfulness. At the late stages of the book, Dr Helen Rawson of the University Collections was nimbly resourceful. Especially timely was Principal Richardson's willingness to ask the principal of my *alma mater*, the University of Glasgow, if he would permit the use of images from the Special Collections Department of Glasgow University Library. So thanks also to Principal Anton Muscatelli for generously agreeing that Scotland's second most ancient university should give a wee birthday present to Scotland's most ancient.

This book emanates from St Andrews University; but it is also about St Andrews. Gratitude is due to such local institutions as Madras College and its archives; the St Andrews Preservation Trust and its Museum; the staff of the St Andrews Museum in Kinburn Park and its

redoubtable café; the staff of MUSA (the Museum of the University of St Andrews); the staff of Historic Scotland at St Andrews Castle and at the cathedral. I feel that the number of times I have paid to take visitors up St Rule's Tower must be sufficient to have built on an additional ten feet or so of masonry. Or even a lift.

To Birlinn, publishers of this book and of my anthology *The Book of St Andrews*, renewed gratitude. Hugh Andrew was excellent to work with; Liz Short was a wizard with the pics; Andrew Simmons was a supportive editor; and as copy-editor Jonathan Meuli was constantly sharp-eyed. As always, David Godwin and Charlotte Knight at David Godwin Associates were smart agents. Thank you.

This book quotes from a number of copyright poems. I would like to thank John Burnside, Douglas Dunn, Kathleen Jamie and Don Paterson for permission to use extracts from their work. In addition, I would like to thank my editor at Cape, Robin Robertson, for allowing work by Cape poets to be quoted here. My appreciation of photography has been quickened by conversations about and collaboration on poetry-and-photography projects with the Edinburgh photographer Norman McBeath. I know I have learned from his joviality and from his perceptive, meticulous eye.

Lastly, though, I accept sole responsibility for any mistakes here. Sometimes it is hard to unpick just who took which photograph and where. The chapters that follow have been tinkered with rather a lot as they migrated between flashdrives, fell down the back of desks, and were shaken and rearranged; but I hope they have become reasonably readable and, as far as I can manage, error-free.

Robert Crawford,
Castle House / The Poetry House,
School of English,
University of St Andrews
January 2011

The Plates and Other Illustrations

❧

Professors, townsfolk, golfers and students took hundreds of photographs in St Andrews throughout the 1840s – the earliest at or just before the start of the decade. This book contains only a very small selection. By 1846, when Robert Adamson and David Octavius Hill published a few of their images as *A Series of Calotype Views of St Andrews*, most of the great early pictures had been taken. However, it is often very difficult to date exactly when individual photographs were produced, and it is hard to identify the photographers with certainty. Even with Adamson pictures, it is not always clear whether the photographer was Robert or his brother John. So precise dates and attributions remain in many cases unstable. A few pictures may have been taken or arranged by women, but all the names of the photographers we have belong to men.

It would be possible to publish a fascinating album of surviving early St Andrews pictures. Subjects would range from ruins to golf, servants to professors, children to cliffs, gardens to ships, grand university and school buildings to poor fishermen's houses. To assemble such an album would require substantial financial investment and would call on the resources of some of the world's major collections of early photography, including the Getty Museum, the Metropolitan Museum in New York, the National Galleries of Scotland, National Museums of Scotland, and National Library of Scotland, as well as the collections of the Department of Special Collections at the University of St Andrews, whose Photographic Archive, holding almost 750,000 images, is by far Scotland's largest, and a national treasure. One day I hope such an album may be published as the catalogue to a great exhibition. For the moment, this book offers a sprinkling of illustrations drawn almost entirely from the

impressive holdings of the collections belonging to the universities of St Andrews and Glasgow. Many can now be seen on databases accessible through those institutions' websites, but a good number of the images in this book have never before been published in any volume.

The endpapers of *The Beginning and the End of the World* come from Dr Grierson's *St Andrews As It Was and As It Is*, a guidebook published in Cupar in 1838 by G. and S. Tullis, printer to the University of St Andrews (St Andrews University Library St A DA890.S1 G8 E38A). Within the book are four gatherings of plates:

I between pp. 76 and 77

Plate 1 Sir David Brewster by Robert Adamson with David Octavius Hill, around 1843–5; print from calotype negative (University of St Andrews Library Photographic Archive, ALB24–71).

Plate 2 North Street, St Andrews, looking from the cathedral end towards the steeple of St Salvator's College, University of St Andrews, by Sir David Brewster or Major Hugh Lyon Playfair; print made in 1854 from a calotype negative of around 1842 (University of St Andrews Library Photographic Archive, ALB2–199).

Plate 3 St Salvator's College steeple in North Street under repair around 1845, by an unidentified photographer; print from calotype negative (University of St Andrews Library Photographic Archive, ALB6–51).

Plate 4 North Street and the cathedral ruins with the square St Rule's Tower viewed from the steeple of St Salvator's College on an early afternoon around 1850, by an unidentified photographer; print from calotype negative (University of St Andrew Photographic Archive, ALB10–116).

Plate 5 A shawled woman in front of the ruined Blackfriars Chapel and part of Madras College, St Andrews, around 1844, by Robert Adamson with David Octavius Hill; digital image from original calotype negative (Glasgow University Library Special Collections Department Hill and Adamson Collection, HA0832).

Plate 6 Mrs Lyon's Laundry Maid, around 1845, by an unidentified photographer; print from calotype negative (University of St Andrews Library Photographic Archive, ALB6–32–6).

Plate 7 Dr John Adamson, probably around 1849. In an 1851 article and in his 1852 *Treatise on the Stereoscope*, Brewster wrote that

'Dr Adamson of St Andrews, at my request, executed two binocular portraits of himself, which were generally circulated and greatly admired.' Print from stereographic calotype negative (University of St Andrews Library Photographic Archive, ALB8–88).

Plate 8 George H. Gordon, Madras College Writing Master, around 1844, by Robert Adamson with David Octavius Hill; print from calotype negative (Glasgow University Library Special Collections Department Hill and Adamson Collection, HA0104).

Plate 9 Major Playfair with Professor William Macdonald, Professor of Civil and Natural History, University of St Andrews, by an unidentified photographer, 1850s. This later picture of two men in costume gives a sense of the Major's taste for amateur theatricals, evidenced by the theatre in his 1840s garden. Print from glass negative (University of St Andrews Library Photographic Archive, ALB1–130).

Plate 10 Mr Rodger, around 1855, by an unidentified photographer. The photographer Thomas Rodger (1832–83) poses with his watch chain and monocle ribbon. Print from calotype negative (University of St Andrews Library Photographic Archive, ALB6–32–5).

Plate 11 Proposed Photographic Establishment St Andrews, The Property of Thomas Rodger, Esq., 1866. Architectural plan of Rodger's studio which still stands in Market Street and may be the world's oldest surviving purpose-built photographer's studio building. (St Andrews University Library Department of Special Collections MS 37778B_BN1060).

II between pp. 108 and 109

Plate 12 Robert Chambers around the time he authored *Vestiges of the Natural History of Creation* (1844), an engraving by T. Brown of a portrait by Sir J. Watson Gordon, reproduced in Lady Priestley's *The Story of a Lifetime* (1908).

Plate 13 Anne Chambers as a young mother, an illustration reproduced in her daughter Eliza's much later memoir. Lady Priestley, *The Story of a Lifetime* (1908) (St Andrews University Library sCT 3328.P8FO8). London: Kegan Paul, Trench, Trubner & Co.

Plate 14 From the Links of St Andrews Looking South Eastward. A lithograph by F. Schenck of Edinburgh used as the frontispiece to

Robert Chambers, *Ancient Sea-Margins* (Edinburgh: W. and R. Chambers, 1848). The author presented a copy of this book to St Andrews University Library where it is now in the Department of Special Collections (For GB454.M2C5).

Plate 15 A Laundry Maid, around 1845, by an unidentified photographer; print from calotype negative. This picture comes from the album of Alexander Govan, Druggist, South Street, St Andrews (University of St Andrews Library Photographic Archive, ALB6–54–3).

Plate 16 Professor Robert Haldane, Principal of St Mary's College, University of St Andrews, around 1845, by Robert Adamson with David Octavius Hill; print from calotype negative (University of St Andrews Library Photographic Archive, ALB6–37–2).

Plate 17 Major Playfair with a trophy, around 1850, by an unidentified photographer; print from calotype negative (University of St Andrews Library Photographic Archive, ALB6–21–2).

Plate 18 Houses being pulled down for 'improvement' in South Street, March 1844, by John Adamson; print from calotype negative. A man identified as Mr John Kennedy stands on the site of the Albert Buildings (University of St Andrews Library Photographic Archive, ALB6–156).

Plate 19 Fisherwomen baiting lines, North Street, around 1845, most probably by Robert Adamson with David Octavius Hill; print from calotype negative (University of St Andrews Library Photographic Archive, ALB6–91).

Plate 20 Scene at the same part of North Street (but now with a street-lamp), late 1840s, by Thomas Rodger; print from calotype negative (University of St Andrews Library Photographic Archive, ALB2–200)

Plate 21 A boy feeding a pet rabbit, around 1850, by an unidentified photographer; print from calotype negative (University of St Andrews Library Photographic Archive, ALB6–1).

Plate 22 The Adamson family around 1844, with John on the left and Robert on the right, by an unidentified photographer (but probably Robert Adamson with David Octavius Hill); print from calotype negative (Glasgow University Library Special Collections Department Hill and Adamson Collection, HA0336).

Plate 23 Specimen skeletons from the Museum of the St Andrews Literary and Philosophical Society, around 1865, by John Adamson; print from calotype negative (University of St Andrews Library Photographic Archive, ALB8–91–1).

Plate 24 Potato Head, around 1855, by John Adamson; print from paper negative. This oval mock-portrait has what seems to be a potato resting on a cloth draped like a jacket and collar (University of St Andrews Library Photographic Archive, ALB6–158).

III between pp. 140 and 141

Plate 25 St Andrews from the Kinkell Braes, around 1845, probably by Robert Adamson with David Octavius Hill; print from calotype negative (Glasgow University Library Special Collections Department Hill and Adamson Collection, HA0776).

Plate 26 St Andrews Castle from the Scores at low tide, around 1845, by Robert Adamson with David Octavius Hill; print from original calotype negative (Glasgow University Library Special Collections Department Hill and Adamson Collection, HA0779).

Plate 27 The Rock and Spindle at low tide with surrounding rocks, looking north in the direction of St Andrews, around 1845, by Robert Adamson with David Octavius Hill (possibly involving John Adamson); print from calotype negative (Glasgow University Library Special Collections Department Hill and Adamson Collection, HA0836).

Plate 28 The Rock and Spindle with surrounding rocks, a tidal pool, a boy on a horse and figures on the foreshore, again looking north in the direction of St Andrews, around 1845, by Robert Adamson with David Octavius Hill (possibly involving John Adamson); print from calotype negative (Glasgow University Library Special Collections Department Hill and Adamson Collection, HA0839).

Plate 29 The Rock and Spindle, looking north in the direction of St Andrews, around 1845, by Robert Adamson with David Octavius Hill (possibly involving John Adamson); print from calotype negative (Glasgow University Library Special Collections Department Hill and Adamson Collection, HA0843).

Plate 30 The Rock and Spindle with figures and an apparently incoming boat, looking north in the direction of St Andrews, around 1860, by Thomas Rodger; print from glass plate negative (University of St Andrews Library Photographic Archive, ALB10–50).

Plate 31 St Andrews Castle from the shore below the cliffs, around 1845, by Robert Adamson with David Octavius Hill; print from calotype negative (Glasgow University Library Special Collections Department Hill and Adamson Collection, HA0791).

Plate 32 The Sea Tower of St Andrews Castle on the cliff from the shore, around 1845, by Robert Adamson with David Octavius Hill; print from calotype negative (Glasgow University Library Special Collections Department Hill and Adamson Collection, HA0790).

IV between pp. 172 and 173

Plate 33 St Andrews Castle, looking along the rock strata of the cliff from the Scores, around 1845, by Robert Adamson with David Octavius Hill; print from calotype negative (Glasgow University Library Special Collections Department Hill and Adamson Collection, HA0786).

Plate 34 'C. W. [Charles Waterston] fowling on grassy slope above cliffs and gorge on the west side of Mingulay', 19 June 1905, by Robert Moyes Adam; image from quarter-plate glass negative (University of St Andrews Library Photographic Archive, RMA–S137A).

Plate 35 'Seas breaking at base of Red Boy Stack, Tom a Reithean headland, Mingulay', 28 July 1922, by Robert Moyes Adam; image from quarter-plate glass negative (University of St Andrews Library Photographic Archive, RMA–S760).

Plate 36 'Pole trap on hillside behind Forest Lodge, Loch Tulla', 1 January 1907, by Robert Moyes Adam; image from quarter-plate glass negative (University of St Andrews Library Photographic Archive, RMA–S299).

Plate 37 'Sandpiper's nest with four eggs, among dead leaves and branches in oak copse, near Duchray House, Aberfoyle', 12 June 1909, by Robert Moyes Adam; image from half-plate glass negative (University of St Andrews Library Photographic Archive, RMA–H49).

Plate 38 'Descending a chimney, Harold Raeburn on Salisbury Crags, Edinburgh', February 1920, by Robert Moyes Adam; image from 5 × 4 inch glass negative (University of St Andrews Library Photographic Archive, RMA–F96).

Plate 39 'Monadhliath Mountains, Abhainn Cro Chlach, six and a half miles from Dalbeg, Findhorn source', 4 May 1953, by Robert Moyes Adam; image from half-plate glass negative (University of St Andrews Library Photographic Archive, RMA–H10491(2)).

Plate 40 Sir David Brewster by Calum Colvin, one of the collaged and photographed images from Colvin's 2009 exhibition of stereoscopic portraits, *Natural Magic*. A print of the Brewster image is now owned by the University of St Andrews. The copyrighted image here is reproduced by kind permission of Calum Colvin.

Setting the Scene

છ

TODAY ALMOST everyone in the developed world owns a camera. Many people have several. Embedded in mobile phones or computers, hung over motorways or attached to buildings, even orbiting the planet on satellites, cameras photograph us day and night. Individuals, places, towns are recorded repeatedly. Over the last few years vans with cameras have been driving up and down our roads capturing images of all the houses for Google Street View, the close-up version of Google Earth.

We live in an era when the internet, television, cinema, and all sorts of camera images are part of our lives at work and play; so much so that most of us have almost no idea of just how and where all this extensive photographic documentation started. Paris, surely? Maybe London? New York? Where was the first sizeable community to be comprehensively caught on camera by photographers – fully daguerreotyped, recorded through the agency of photogenesis, or however people put it back then?

This book tells the story of how St Andrews came to be the first town in the world to be documented thoroughly through photography. It shows how Victorian photographic pioneers produced work that has had a global resonance. Among my sometimes apocalyptically minded protagonists are a very quarrelsome professor, a cello-playing ex-military golfer, a married couple coping with mental breakdown, and a physician obsessed with sewage. The chapters that follow chronicle lives that intersected for a time with kaleidoscopic serendipity. What emerges is how these people's lasting legacies still have a bearing not just on the unique coastal settlement where they met, but

also on today's much wider debates about environmental sustainability and the prospect of large-scale extinction.

For some years art experts and curators have been aware that around 1840 St Andrews, best known today as the world's capital of golf, hosted a striking concentration of groundbreaking photographers.[1] Historians of science, most notably Professor James Secord of Cambridge University, have pointed out too that during the early 1840s one of the most widely discussed works of evolutionary thought was authored in this royal burgh on the east coast of Scotland.[2] Drawing on substantial new research as well as on the work of earlier investigators, *The Beginning and the End of the World* connects these pioneering scientific and artistic activities. On occasion it even entwines them with golf.

Some of my material will be of interest to scholars of art and science, but I cannot claim to write as one of their number. My background is in poetry, biography, literary history and criticism; I am pursuing images that rhyme, and this book draws some conclusions that its early Victorian protagonists, setting up their cameras on street or shoreline, might have found strange. It signals how people can come to terms with widespread fears about mortality. Moreover, it shows how art and science combine when we try to interpret our environment, and to confront ideas which threaten accepted world views.

Still dominated by its magnificent ruins, and the site of several very public martyrdoms, over the centuries photogenic St Andrews has stimulated many thoughts about transience, belief and mortality. Nowadays so famous for attracting golfers and students from around the globe, the little harbour town is regarded by most tourists as charming and sleepy. Some distance from modern centres of power, it is literally ec-centric. Beautiful to look at in all weathers with its expansive beaches, long stone pier, cliff-top ruined castle and cathedral, it can seem a place where quiet self-consciousness shades into parochial smugness. Yet, improbably, St Andrews is also home to the English-speaking world's third oldest university, an institution now celebrating its six-hundredth birthday. A rum crew of writers from the medieval poets William Dunbar and Gavin Douglas through Robert Fergusson (Robert Burns's favourite Scottish poet) to the more recent novelists

Willa Muir and Fay Weldon have studied here; several St Andrews graduates signed the American Declaration of Independence, and scientific alumni range from John Napier, inventor of logarithms, to Edward Jenner (pioneer of smallpox vaccination) and the modern Nobel Prize-winning medic Sir James Black. Founded in 1413 – some say 1411 – this small, intellectually distinguished and resilient institution has a frequently photographed seaside location which makes it Europe's most delightfully situated seat of learning, though hardly its richest or grandest.

The present book is unusual in its intense focus on a scientific and artistic community operating outside major urban centres. Set in the county called the Kingdom of Fife, today's St Andrews is about an hour's drive north of Edinburgh. In the 1840s, long before the great rail and road bridges were built to span the Firth of Forth and connect Edinburgh with Fife, reaching the fishing port of St Andrews from the Scottish capital took the better part of a day. The early photographic documentation of this relatively remote town came about sometimes through awkward accidents and botched chemical experiments. It also happened through conscious artistic design. In presenting biographies of a place and some of its people this book juxtaposes minutiae that are, as Alastair Reid puts it in a poem set in St Andrews, 'peculiar to this piece of the planet'.[3] It is through acts of local fidelity that we find ways to speak for the planet as a whole.

St Andrews has spoken for the world before. In the early 1840s it produced one of the nineteenth century's most scandalous books. Robert Chambers's *Vestiges of the Natural History of Creation* did more than any other volume to upset ordinary Victorians' view of their place in the great scheme of things. Published in 1844, it circulated widely, catching the attention of readers as different as Queen Victoria and Abraham Lincoln. Audiences in Britain, America and beyond were horrified by its arguments about the beginnings of the world and of the cosmos. It even implied that humanity might die out and that human beings were not necessarily the end for which 'our' planet was made. Chambers's identity as its author was for decades a closely guarded secret. He discussed geology, science, photography and golf with local people, meeting them formally and informally in the streets of the

town, but they had no knowledge of the manuscript he was writing. Yet in their haunting way, some of the pictures taken by the pioneering St Andrews photographers also make visible fears about extinction, ruin, the vastness of time, and humanity's uncertain place in the world. Today, as we face up to our own fears about sustainability, our ideas need to be at once committedly local and immediate, as well as global in their implications. So my use of this small Scottish town as a lens through which to glimpse such big issues is not as quixotic as it might appear. Petering out into a breathtaking expanse of sand and eroding away at its North Sea cliffs, St Andrews is quite spectacularly on the edge. In the twenty-first century, as it was in the 1840s, it is an ideal place from which to consider how we stand.

The Beginning and the End of the World focuses initially on David Brewster, an eccentric and brilliant inventor distinguished for cussedness as well as brainpower. In St Andrews he was involved in unholy rows, though later, when she met him at the Great Exhibition in London's Crystal Palace, Charlotte Brontë saw him differently. With typical professorial bossiness Brewster had told the organisers that their centrepiece, the Koh-i-noor diamond, must be lit by 'fifteen or sixteen gas lights' to bring out its full radiance, but to Brontë (who had 'rather dreaded' meeting him) he was simply a man with a 'kindly Scotch accent' who had offered her a 'lucid explanation' of optical inventions such as the Brewster stereoscope, then an international attraction.[4] My account of Brewster sets him against a wider intellectual landscape, and gives a flavour of how he was instrumental in bringing to St Andrews the nascent techniques of photography. It stresses the way he associated the medium not just with an awareness of new possibilities, but also with a heightened sense of death.

The book's third chapter looks at a club Brewster helped found – the St Andrews Literary and Philosophical Society. This organisation brought together local academics and townsfolk as part of an ambitiously wide international network encompassing Charles Darwin, Charles Babbage, and many of the most famous scientific investigators of Victorian Britain. Among these people were pioneering photographers such as John Adamson whose younger brother Robert went on to form with David Octavius Hill the most famous artistic partnership in

the history of photography. In the Lit and Phil issues to do with extinction – raised alike by recently discovered fossils, mortality statistics, and by unstable, evanescent photographs – could be aired. This club fizzed with fresh speculations which might be discussed in small-town St Andrews, and gave at least some of its people contact with discoveries abroad.

Chapter four is about another of the local photographers, a spiky but popular character, the remarkable cello-playing gardener, golfer, agitator and town planner Major Hugh Lyon Playfair, who reshaped the St Andrews population and environment even as he photographed them. Like Brewster, Playfair realised that to be sustainable his community required not just to treasure its past but also to rebuild itself and engage with the most promising aspects of modernity. If Playfair's reforming zeal for doing away with old ways could sometimes present extinction as a good thing, then in his remarkable cosmological garden overshadowed by ancient ruins he sought (as in his photographs) to capture and pattern time itself. Chapter five is about Anne and Robert Chambers, the couple who produced in manuscript that astonishing book about time – the 'Victorian sensation', *Vestiges of the Natural History of Creation*.[5] I discuss how the circumstances of their residence in St Andrews, Anne's role as amanuensis and Robert's encounters with the members of the Lit and Phil, contributed to the making of the book, and why it so shocked the world of their day. The next chapter, 'Rock', begins with an account of the unusual Dr John Adamson, statistician of mortality and scrutineer of sewage, who with his brother Robert was instrumental in producing several of the most fascinating early St Andrews images. Yet at the heart of this penultimate chapter are less the Adamsons themselves than some of the spectacular rock formations with which they were closely familiar. Little known, the pictures of these taken in the 1840s are among the most striking images in early photography. Chapter six suggests how we may read in these images the same underlying but insistent preoccupation with time, geology and extinction which Chambers's writing was articulating simultaneously in *Vestiges*.

All these narratives are set in a place caught up in the events known in Scotland as 'the Disruption'. In 1843 the Disruption broke apart

Scottish religion when many Church of Scotland clergy staged a mass walkout, giving up their livelihoods to preserve their independence from rich and titled patrons in order to stay true to the congregations which had democratically elected them. In 1840s Scotland democratic energies were breaking apart an old world view and seeking to create a new one. Some of the best known works associated with the St Andrews photographers, especially the productions of Robert Adamson with D. O. Hill, record this, while other pictures – the several hundreds that simply show local scenes and people – appear unrelated. Yet when brought together these photographs, along with writings from mid-nineteenth-century St Andrews, indicate not only that the place was astonishingly innovative and engrossed in the great and sometimes frightening debates of modernity, but also that it was finding ways to confront them that involved new combinations of science and art in photography as well as in literature. By encouraging men and women to contemplate a frightening situation – by forcing them to look the possibility of ruin and extinction straight in the eye – such new partnerships helped people come to terms with it.

Considerations of the beginning and the end of the world were unlikely to be resolved in a small Scottish seaside town any more than in Paris or London. Yet it is striking how vividly and intelligently these explorations were conducted in the grey stone houses, university classrooms, and photographic darkrooms perched close to the brink of windswept North Sea cliffs. The concluding chapter of *The Beginning and the End of the World* suggests how the legacies of nineteenth-century St Andrews and its eccentric photographers connect with our own debates about sustainability. Today the Scottish burgh at the heart of this book exemplifies a world right on the edge. Here again combinations of art and science can help us think through contemporary dilemmas about a sense of looming environmental catastrophe which makes many feel disconcertingly imperilled – as if suddenly and unintentionally we had migrated to a vulnerable margin, as improbable and fragile as St Andrews or flood-prone Venice.

2

A Magician in the City of the Dead

ℰℐ

I N V E N I C E in autumn 1818 Lord Byron opened a package from his
publisher. Inside was something hard which looked like a small
telescope. There was a covering letter: 'I send you a very well-constructed
kaleidoscope, a newly-invented toy which, if not yet seen in Venice, will
I trust amuse some of your female friends.'[1] Seldom averse to amusing
female friends, Byron was delighted with the gift. Soon, in *Don Juan*, the
long poem he had just begun, he described a rainbow as 'Quite a celestial
kaleidoscope'.[2] Kaleidoscopes were new, but already becoming inter-
nationally fashionable. After crossing the Atlantic from Greenock to
New York that summer, Edinburgh musician James Flint noted in a
bookseller's window 'Lord Byron's latest productions', remarking that
'The Kaleidoscope of Dr. Brewster is here fabricated in a rude style, and
in quantities so great, that it is given as a plaything to children.' Young
and old alike were fascinated by this fusion of art and science. It was
compact enough to hold in your hands, yet its pieces seemed to produce
an infinite variety of patterns. Raised to the light, it was literally brilliant.
Everyone was eager for a kaleidoscope, wanted to be mesmerised by its
colours, to know how it worked, and to see if it could be bettered. In New
York Flint heard that a local artist's journeyman 'proposes to take a
patent for an improvement he had made on it'.[3]

The kaleidoscope was the first mass-produced scientific object to
become overnight an intercontinental craze. 'In the memory of man,'
wrote Dr Roget (future compiler of the *Thesaurus*) in 1818, 'no
invention . . . ever produced such an effect'; up to 'two hundred
thousand instruments have been sold in London and Paris during
three months'.[4] As popular optical entertainment, kaleidoscopes were

forerunners of the camera in the nineteenth century, television in the twentieth century and the games console in the twenty-first. The new 'toy' exemplified what its inventor, David Brewster, went on to call 'natural magic': it combined science, enchantment and art. Just a few years after Byron opened his package, another poet and peer, Lord Macaulay, used the ingenious invention as an image for the poet's consciousness: 'The mind of Petrarch was a kaleidoscope'.[5] Brewster's invention combined 'harmonic colours . . . [in] . . . the most chaste and delicate patterns'; it interested artists such as Turner and, later, Holman Hunt who made a watercolour entitled simply 'Kaleidoscope'.[6] To fledgling publishers Robert and William Chambers in Edinburgh it offered the ideal title for their first magazine. This small, affordable publication would combine short, captivating articles on all sorts of topics, constantly reconstellating snippets of knowledge. *The Kaleidoscope: or, Edinburgh Literary Amusement, A Periodical Miscellany, Chiefly Humorous* was launched in winter 1821. Only eight pages in extent, and published fortnightly, it did not last long. Yet, while it continued, Robert Chambers became himself a sort of human kaleidoscope, crafting its constantly shifting contents – from satire and poetry ('To the Evening Star') to scientific speculation about 'Theories of the Universe'. Signing off in the final issue, he celebrated how, writing anonymously, he had constantly metamorphosed his literary identity:

> I have . . . had no more regard to the decorums of sex than a hacknied actress, in breeches for the hundredth time; have been every thing, yet nothing; every sex and no sex; spoken from heaven in the character of an angel, and howled, with equal complacency, from hell, as Beelzebub:–and all to serve you, my dear public.[7]

Later used by Baudelaire as an image of modern art, the kaleidoscope was a gift to the protean consciousness; it made flux and fluidity elegant. No wonder writers toyed with its possibilities.

To its inventor, though, it was essentially 'a new Optical Instrument'.[8] That is the phrase Brewster used in 1817 when he took out British patent number 4136. He had gone to some trouble coming up with the name 'KALEIDOSCOPE' which 'is derived from the Greek words

kalos, beautiful; eidos, a form; and *skopeo, to see*'.[9] Putting this explanation into print in his *Treatise on the Kaleidoscope*, Brewster published the three Classical terms using the Greek alphabet, though he or his printer got the words a little wrong.[10] He was determined to be taken seriously. 'Capable of creating beautiful forms', his invention might be applied 'to the fine and useful arts'.[11] Practical applications might range from planning 'the formation of circular Gothic windows' for a cathedral to less exalted 'Designs for Carpets'.[12] A little over-earnestly, Brewster noted that, 'The property of the Kaleidoscope, which has excited more wonder, and therefore more controversy than any other, is the number of combinations or changes which it is capable of producing from a small number of objects'. It had been calculated that,

> 24 pieces of glass may be combined 139172428888725299942512-8493402200 times, an operation, the performance of which would take hundreds of thousands of millions of years, even if upon the supposition that 20 of them were performed every minute. This calculation, surprising as it appears, is quite false, not from being exaggerated, but from being far inferior to the reality.[13]

With his winningly eccentric scientist's intensity, Brewster was aware of his invention's attractiveness 'as an instrument of recreation'. He explained you could look through it at such opaque objects as 'coins . . . shells, flowers, leaves' or 'the seconds hand of a watch', though the instrument worked best when viewing tiny translucent fragments of coloured glass. These transformed it into 'an ocular harpsichord'.[14] Nevertheless, for Brewster his kaleidoscope was principally an offshoot of research into 'natural philosophy' – as physics was then called – not a foray into the toy trade. Sadly, he was commercially jinxed. Having taken out his expensive patent, he handed his prototype to a London instrument maker. This man let details leak out so that the new invention was immediately copied across Europe and America. Brewster realised he might have made as much as a hundred thousand pounds – many millions in today's money – 'had I managed my patent rightly'.[15]

Brilliant but unlucky, Brewster was one of the inventors most admired by his contemporaries. In Australia a plant (*Cassia Brewsteri*) was named after him; in Greenland there is a Cape Brewster. 'Brewster's Rule' was so called because of his researches into the polarisation of light. He even got his own mineral, Brewsterite. But repeatedly he was thought to mismanage things. He made many enemies, including, perhaps, posterity, which has largely forgotten him. *The Victorian Eye*, Chris Otter's 2008 specialist academic history of nineteenth-century 'light and vision in Britain', ignores Brewster's voluminous publications, mentioning – fleetingly – just one magazine article where he remarks on the benefits of wearing spectacles.[16]

Yet, in the first half of the nineteenth century, Brewster published work on his kaleidoscope, his lenticular stereoscope, and on Brewster's polyzonal lens, none of which now bears his name. It was a golden age of amateur scientists, for the excellent reason that professional scientists did not yet exist. Deriving from the Latin word *scientia* (knowledge), the term 'scientist' was coined in the early 1830s, by analogy with the word 'artist'. No one expected it to catch on. Initially, it was scorned by Britain's many researchers, but it certainly described the indefatigable Brewster. In England many of the most influential people who practised science were moneyed gentlemen. Neither English nor independently wealthy, Brewster, born in Jedburgh in 1781, came from the Scottish lower middle-class. He was the son of a schoolmaster. Aged ten, just after his mother died, he had constructed his first telescope, guided by a local Borders ploughwright whose hobby was astronomy. By his late thirties he had written over two hundred scientific papers and articles – from a 'Query respecting the phenomena of Loch Ness' to a study of 'Glass Drops' – with a further thousand still to come. He made his living editing magazines and encyclopedias. Still a teenager, he had published his first paper (on astronomical theory) in the *Edinburgh Magazine, or Literary Miscellany*. Three years later he was the magazine's editor.

By then Brewster had obtained an MA from Edinburgh University. In his early twenties he applied for its chair of mathematics. He was turned down. Next, in 1807, he was also rejected for the chair of mathematics at the older University of St Andrews. Frustrated in his

academic ambitions, he spent over a decade editing the *Edinburgh Encyclopaedia*, while also writing for its more celebrated Edinburgh rival, the *Encyclopaedia Britannica*. His interests ranged from poetry ('Winter: A Dirge' is deservedly forgotten) to freemasonry; from geology and fossils to intellectual property laws; but optics was his lifelong passion. His treatise on 'Optics' for the *Edinburgh Encyclopaedia* runs to over two hundred pages. A late son of the Scottish Enlightenment, Brewster was one of the leading encyclopedists of an encyclopedic age. His major works were published in the United States as well as the United Kingdom, and speedily translated into French and German.

In 1819 he met another determined Scottish polymath. Robert Jameson, son of a Shetlandic soap-maker, was at the heart of Edinburgh's most vehement intellectual wrangles. Wiry, wild-haired, he was already by the age of thirty Edinburgh University's Professor of Natural History. Where the late Edinburgh pioneer of geology, James Hutton, backed by his friend John Playfair, argued as 'Plutonians' that the internal heat of the planet had shaped earth's rocks and surface, Jameson, a 'Neptunist', vehemently contended that water – element of the sea-god Neptune – was predominantly responsible. In defending this position, Jameson allied himself with continental geologists like Freiberg's A. G. Werner, with whom he had studied, and with the Frenchman Georges Cuvier. Never bashful, Jameson co-translated and publicised Cuvier's highly influential *Essay on the Theory of the Earth*, already in its fifth, expanded edition by 1827. This imposing work suggested that before mankind arrived, whole species had been wiped out in mass extinctions.

In an age when advanced French speculations about the beginning of the world jostled uneasily with biblical narratives, the young Presbyterian Brewster was concerned about 'the Effects of the French Revolution upon Science and Philosophy'.[17] Yet he remained relatively open-minded, while Jameson, with some spin, presented Cuvier as allowing for a principled reinterpretation of the biblical chronology of Creation, rather than a materialist, post-French-Revolutionary attack on it. As well as being responsible for the intellectually innovative and much argued-over 'Jameson's Cuvier', Jameson was keeper of

Edinburgh University's natural history museum – a hoard of minerals, fossils, stuffed birds, shells, skeletons, and insects. By the 1820s local investigators complained that he excluded from the museum people he took a dislike to. He was said to exhibit only specimens which supported his Neptunist arguments. Rocks collected by the late James Hutton and sent to the museum years earlier were never unpacked from their boxes.[18] For all he was clever, Jameson, like Brewster, could be obstinate.

At first the two men seemed well matched. Jointly they founded and edited the *Edinburgh Philosophical Journal*, a magazine remarkably open to new scientific thinking. They even appear to have collaborated on a splendidly titled 'Account of Meteoric Stones, Masses of Iron, and Showers of Dust, Red Snow and other substances, which have fallen from the Heavens, from the earliest period down to 1819'.[19] Soon, though, the two editors' compatibility turned to prickly disagreement. Each was stubborn, outspoken, polemical by inclination. Brewster left the magazine to set up the rival *Edinburgh Journal of Science*. A pattern of enthusiastic intellectual collaboration which before long turned into quarrelling would dog him throughout his long life. He was a hard man to get on with.

This tendency in Brewster could so easily have scuppered what became his central scientific friendship. Yet, curiously, his most stimulating intellectual liaison of the 1830s and 1840s progressed without any acrimony. One reason was that for much of the time, like many relationships between nineteenth-century scientific investigators, it was largely epistolary. Perhaps, too, the pair of impatient correspondents were so obsessively interested in optics that each prized the other's ideas. This friendship and correspondence had begun when Brewster had been introduced by the astronomer and optical scientist Sir John Herschel (whose father had discovered Uranus) to a younger wealthy acquaintance. Well-off and Cambridge-educated, the English scholar and inventor William Henry Fox Talbot had been working on what became the new art of photography since at least 1832. Photographic historian Larry J. Schaaf points out that Brewster, Talbot, and Charles Babbage were all present at a scientific breakfast in 1831 where Herschel made 'simple images with light in a solution of platinum

salts'; soon this and related work were summarised in Brewster's magazine.[20] Firm friends by early 1839, Talbot and Brewster were corresponding about how much Talbot should reveal of his work. Bruised by his own experience with the kaleidoscope, Brewster advised his friend to keep details secret.[21]

Notwithstanding this advice on secrecy, it may well have been Brewster who alerted Robert Chambers to the importance of Talbot's work – Edinburgh was a small world. Having started in the Scottish capital as editor of the *Kaleidoscope*, now Chambers had moved on, still with his elder brother William, to produce *Chambers' Edinburgh Journal*. A March 1839 piece published there explains how Talbot prepares photographic paper using silver nitrate, then, after the picture has been taken, washes it with a weak solution of iodide of potassium to make it 'absolutely unalterable by sunshine'. Much of the article is given over to quoting Talbot on 'what he calls *The Art of Fixing a Shadow*':

The phenomenon which I have now briefly mentioned, appears to me to partake of the character of the *marvellous*, almost as much as any fact which physical investigation has yet brought to our knowledge. The most transitory of things, a shadow, the proverbial emblem of all that is fleeting and momentary, may be fettered by the spells of our 'natural magic', and may be fixed for ever in the position which it seemed only destined for a single instant to occupy. This remarkable phenomenon, of whatever value it may turn out in its application to the arts, will at least be accepted as a new proof of the value of the inductive methods of modern science, which, by noticing the occurrence of unusual circumstances (which accident perhaps first manifests in some small degree), and by following them up with experiments, and varying the conditions of these until the true law of nature which they express is apprehended, conducts us at length to consequences altogether unexpected, remote from usual experience, and contrary to almost universal belief. Such is the fact, that we may receive on paper the fleeting shadow, arrest it there, and in the space of a single minute fix it there so firmly as to be no more capable of change, even if thrown back into the sunbeam from which it derived its origin.[22]

In this lyrical prose Talbot is clearly excited about his new-found ability to use natural means to 'fetter' or 'fix for ever' what in nature is always evanescent. 'Modern science' is utterly *'marvellous'*. Strikingly, Talbot describes the new discovery using his friend Brewster's phrase 'natural magic'. Brewster's 1832 *Letters on Natural Magic Addressed to Sir Walter Scott, Bart.* was an imaginative response to Scott's 1831 *Letters on Demonology and Witchcraft.* Brewster was a populariser as well as a serious researcher. His 1831 *Life of Newton* and his 1832 *Letters on Natural Magic* both appeared in the publisher John Murray's 'Family Library' series. Giving a 'popular account of . . . prodigies of the material world which have received the appellation of *Natural Magic*', Brewster sets out some of the wonders of visual research, such as optical illusions, the Brocken spectre and the Fata Morgana.[23] Yet even as he explains his 'natural magic', he relishes its marvellousness. For Brewster, as for Talbot and so many other Victorian investigators, to practise science was in no way to renounce the sensations or language of amazement. Just as in an earlier century John Baptista Porta, 'A Neapolitane', had enthused over the marvels of 'Natural Magick', so Brewster, echoing Porta's title, sought to link science to a sense of wonder often associated with alchemy, poetry and art.[24] For the Victorians Brewster and Talbot, 'Natural philosophy' was bound up with 'natural magic'.

Clearly Brewster's writing influenced Talbot, who shared with Brewster and Chambers an admiration for the work of Walter Scott. Like Brewster, Talbot saw optical research in particular as combining the artistic and the scientific. If the phrase 'natural magic' sounds to us unscientific, to the early pioneers of research it was a powerful metaphor. Brewster, Talbot, and Chambers shared a love of words; like Brewster, Talbot was classically educated and fascinated by ancient biblical and other texts. Going to the Greek language, in 1839 he called his discovery a way of drawing that was 'Photogenic' – meaning that it came into being – had its genesis – through light. The investigation of light could be seen as linked to the biblical creation's 'Let there be light', and to Christ as 'the light of the world'. Nature and man might be co-creators, as a new, chemically assisted *fiat lux* brought about the making of pictures.

Not long afterwards Talbot discovered another process. He found that a mere thirty-second exposure in his camera would leave a latent image on specially prepared paper; though this latent image was invisible, it could be rendered beautifully visible if the paper were then processed in a darkroom.[25] Just as he had viewed his earlier 'photogenic drawings' in terms of Brewster's 'natural magic', so when he went to the Greek word *kalos* and coined the term 'calotypes' for another new way of making beautiful pictures which he had discovered, Talbot may well have had in mind Brewster's earlier coining of the word 'kaleidoscope'.

Brewster was closely interested in his good friend Talbot's photographic researches, but was also well aware of the invention which the Frenchman Louis Daguerre had introduced to the world in 1839. Each 'daguerreotype' was a unique, positive image, whereas calotypes involved creating a negative image on silver iodide-coated paper, from which in turn positive pictures could be printed. Experimenting with these techniques, Brewster developed his knowledge of chemistry as well as optics, but his interests took in not only science but also religion; licensed as a preacher in his youth, he had undertaken pastoral duties in the Edinburgh area. Something, though, had gone wrong: not, apparently, a crisis of faith, but certainly a loss of confidence in its public profession. His daughter knew her father had fainted while saying a Christian grace before a meal at an Edinburgh dinner party: 'Catch me, Brewster,' a friend quipped to him, 'if I'll ever dine with you again.'[26] The workaholic Robert Chambers was relieved to hear Brewster too had suffered mental problems exacerbated by overwork. Chambers explained to his brother William that

> Talking one day with Sir David Brewster about the effects of a literary course of life, I learned that he, when engaged in a great amount of hard work for his Encyclopedia, had experienced precisely the same morbid feelings which I had in similar circumstances. For one thing, he became unable to face people on the street . . . Even in learning that such feelings *are* disease, there is an alleviation of the evil, for it removes the deplorable fear that one is about to go altogether to wreck.[27]

The young Brewster had abandoned his ministry, not his faith. In later years he published *More Worlds than One: The Creed of the Philosopher and the Hope of the Christian*. He was a vehement believer, and middle age would see him embroiled in stormy ecclesiastical politics. Brewster thrived on heated argument. Indeed, he had married into it. Juliet Macpherson, who became his wife in 1810, was the daughter of James 'Ossian' Macpherson, translator (many said forger) of the famous Ossianic poems, works supposedly composed by a prehistoric Gaelic bard but rendered into decorous English prose by Macpherson in the 1760s. Macpherson had grown rich and famous on the back of Ossian's oeuvre, becoming a Member of the British Parliament in London as well as enjoying a profitable colonial association with the East India Company. A man with a fine, anxious conceit of himself, he was buried at his own request in Westminster Abbey. Still, the controversy over the Ossianic poems had led to many an attack on his veracity, most famously by the sometimes Scotophobic Samuel Johnson. Loyal to his wife's family, Brewster was convinced the Ossianic poems were genuine; unlike most people he 'never had a moment's doubt' on the issue.[28]

As his fame grew, so did Brewster's knack for encouraging controversy. In the mid 1830s, for all that he had become one of the first scientists since Isaac Newton to be knighted for his scientific research, he was involved in litigation which threatened to bankrupt him. What saved him was his appointment to the main college of St Andrews University in 1838 thanks to the influence of his patron and friend from student days, the optical experimenter turned politician, Lord Brougham. Having failed before to obtain university chairs, Brewster had written with characteristic conviction in 1830 that 'There is no profession so incompatible with original enquiry as a Scotch Professorship, where one's income depends on the number of pupils.'[29] He sometimes seemed to regard students with impatient aloofness. Depicted by fashionable Irish artist Daniel Maclise in the 1830s, he looks confidently suave. Seated in a carved wooden armchair, legs crossed in pale trousers, his expression shows purposeful intentness as he clasps his big hands and extends a long, pointed, leather-slippered foot.[30] The Principal of the United College of St Salvator and

St Leonard in St Andrews, ecclesiastical capital of the ancient east-coast Scottish Kingdom of Fife, would not have to expend energy on recruiting his own 'pupils'. Nineteenth-century St Andrews was a university used to operating with very small numbers of students. This post would allow time for scientific work.

St Andrews had once boasted an internationally celebrated professoriate, but the lustre of the university had dimmed.[31] One reason was that the place was hard to get to. For all that it had been a jewel of medieval Europe, its first regular modern coach service from Edinburgh had been introduced only in 1829 (a post coach arrived at 5 p.m., then left 'at half-past 8 o'clock on the following morning').[32] When they finally arrived, many travellers were impressed but disturbed by this remote and ancient city by the sea. Dr Samuel Johnson, who had visited in 1773, eulogised the place in sentences of measured eighteenth-century prose which made it sound, potentially at least, an academic arcadia:

> Saint Andrews seems to be a place eminently adapted to study and education, being situated in a populous, yet a cheap country, and exposing the minds and manners of young men neither to the levity and dissoluteness of a capital city, nor to the gross luxury of a town of commerce, places naturally unpropitious to learning; in one the desire of knowledge easily gives way to the love of pleasure, and in the other, is in danger of yielding to the love of money.

Johnson, though, was also one of many visitors over recent centuries to see St Andrews as an architectural *memento mori*. With its 'ruins of ancient magnificence' it was a place of 'mournful memorials' and 'gloomy depopulation'. It showed what happens when a society leaves 'universities to moulder into dust'. The immense cathedral, ravaged by centuries of weather which even in the Middle Ages had brought its roof crashing down, was also, Johnson noted, a victim of Scottish Reformation iconoclasts. Thanks to John Knox and his followers, it exemplified 'atrocious ravages' and 'extensive destruction'. With its cliff-top ruined castle and its ancient university 'pining in decay and struggling for life', the town had filled Johnson with 'mournful images'. For all it was 'almost completely surrounded by gardens'

and farms, St Andrews continued to impress nineteenth-century visitors as a picturesque city of death, a stunning place for brooding on mortality.[33]

Emblems of death here were unavoidable. In the early nineteenth century 'A gentleman still living in St Andrews, knew a person who saw the execution' of the last witch there, burned, it was said, about a hundred years before – 'an old woman of the name of Young, whose house is still pointed out in the west end of Market Street'.[34] The ageing Walter Scott, visiting in 1827, noted that the cathedral 'ruins have lately been cleared out'; he 'sate down on a gravestone' – one of many that thronged the cathedral precincts – to ponder his lost youth.[35] By the nineteenth century the once great pilgrimage site of St Andrews, to which St Rule was said to have brought relics of Scotland's patron saint, was moribund. Reduced to a golfing and fishing community, it had a population of around 4,300, plus maybe 100 students at the tiny university. *St Andrews as It Was and as It Is* is the telling title of an 1838 local guidebook. Acknowledging 'valuable assistance received from Principal Sir David Brewster', it invokes Walter Scott's *Old Mortality*, and relates St Andrews to Virgil's lines on the town of Ardea, 'a place renowned in days of yore, | But now her perished glory is no more'.[36]

However good for sea-bathing, the town could seem all the more spectral when fog-bound. Most springs, as one local put it in 1841, it was 'severely afflicted with a dense, chilly fog called "Easterly Haar"' which 'usually comes in suddenly from the sea, about the middle of the day or afternoon, and is peculiarly cold and disagreeable to the feelings'.[37] A sense of St Andrews as a spectral little city of the dead intensified in the Victorian period. The poet and man of letters Andrew Lang, who had studied there in the mid nineteenth century, recalled it as

> St Andrews by the Northern Sea,
> A haunted town it is to me!
> A little city, worn and grey,
> The grey North Ocean girds it round,
> And o'er the rocks, and up the bay,
> The long sea-rollers surge and sound.

And still the thin and biting spray
Drives down the melancholy street,
And still endure, and still decay,
Towers that the salt winds vainly beat.
Ghost-like and shadowy they stand
Dim-mirrored in the wet sea-sand.[38]

Moving to this foggily splendid place so manifestly ravaged by time, so often imaged in terms of decay and death, Principal Brewster had his work cut out. Wanting to revitalise its intellectual life, he soon realised, for instance, that 'the Chemistry class . . . has not been taught as it ought to have been', and had 'no chemical apparatus' despite the university's having purchased £233 worth of 'miserable trash' from an 'absolutely useless' old laboratory.[39] St Andrews might have seen both Catholic and Protestant martyrdoms, much celebrated in Scottish history: Brewster sounds as if he wanted to martyr some of the present-day professors. He was moving to a place of 'irretrievable decay'. Grass grew on some of the streets. As one visitor put it in the early 1840s,

There is no single spot in Scotland equally full of historical interest. A foreigner who reads the annals of Scotland, and sees, in every page, the important position which this place occupied in the literary, the political, and the ecclesiastical transactions of the country, would naturally imagine the modern St Andrews, though amerced perhaps of its ancient greatness, to be a large, splendid, and influential city. On approaching it, he sees across an almost treeless plain a few spires standing on a point of rock on the edge of the ocean; and on entering he finds himself in a dead village, without the slightest importance or attractions, except what it derives from the tales that these spires recall.[40]

A reasonable observer would have thought that for Brewster the investigator of 'natural magic' to leave Edinburgh for this depleted Fife ghost town was eccentric to the point of madness.

Science, however, like art, happens anywhere. Brewster's friend Herschel had emphasised that scientific breakthroughs were sometimes

found 'remote . . . from beaten tracks'. For him the pleasures of knowledge were 'altogether independent of external circumstances, and are to be enjoyed in every situation in which a man can be placed'.[41] For Brewster, seaside St Andrews perhaps held both romantic and historic allure. In Edinburgh he had got to know 'Dr J. C. Gregory . . . the descendant of the illustrious inventor of the reflecting telescope'. The illustrious inventor was Professor James Gregory of St Andrews, the pioneer of calculus and friend of Newton's. You can still see the north–south meridian line, along which Gregory was said to have aligned his telescope, marked on the floor of St Andrews University's oldest library. Newton was Brewster's great hero. And to move to the university of Newton's most distinguished Scottish scientific colleague may have appealed. Like Herschel, Brewster loved a famous story about Newton, and retold it more than once (it is still quoted from Brewster's *Newton*):

> . . . a short time before his death he uttered this memorable sentiment:– 'I do not know what I may appear to the world; but to myself I seem to have been only like a boy playing on the seashore, and diverting myself in now and then finding a smoother pebble or a prettier shell than ordinary, while the great ocean of truth lay all undiscovered before me.' What a lesson to the vanity and presumption of philosophers, – to those especially who have never found the smoother pebble or the prettier shell! What a preparation for the latest inquiries, and the last views of the decaying spirit, – for those inspired doctrines which alone can throw a light over the dark ocean of undiscovered truth![42]

In St Andrews, beside a real ocean, Brewster might have the opportunities he craved to contemplate 'the smoother pebble'.

Shortly before moving to Fife, though, he got a fright that reminded him of his own mortality. He was someone, his patient daughter Maria recalled, whose eyes were 'more tried than those of ten ordinary men, not only by constant reading and writing, but by gazing through mysterious "bits of glass" at noonday, and by microscopic and other experiments by gas-light'. One day Brewster collapsed.

An acute and agonising pain suddenly darted into his eye-balls, deluging them with water, and necessitating complete darkness and quietness till the paroxysm had passed, which was sometimes not for two or three days. This complaint recurred frequently, and yielded to no mode of treatment, till at last he heard accidentally of a cure said to be discovered by Sir Benjamin Brodie, which consisted in using three or four times a day in the ordinary way, common snuff mixed with powdered quinine in equal proportions. This had a most rapid and wonderful effect, and he never again appeared to have any weakness or suffering in his eyes, although to the last he never spared them; in some of his optical writings, however, he alludes to having had symptoms both of hemiopsy or half-vision, and also of incipient cataract. Some years after, on mentioning the good he had derived from this prescription to his friend Sir Benjamin Brodie, its supposed originator, he found that the latter had never heard of it, and was much surprised by the effects, although he admitted the possibility of the cure, supposing the disease to be neuralgia.[43]

Despite the interruptions of ill health, Brewster and his family lived in style. When they relocated to St Andrews they moved to a substantial house. St Leonards, part of the ancient St Leonard's College, stood and still stands close to the cathedral graveyard. Beside it is the medieval St Leonard's Chapel, the university's oldest building, with its ancient well. The Brewsters treasured the place's association with sixteenth-century poet, dramatist, historian and controversialist George Buchanan. Prickly, brilliant, and fascinated by astronomy, Buchanan epitomised the Renaissance man. He had studied and later taught at St Andrews, as well as in Paris, in Bordeaux (where he educated the French essayist Montaigne), and at the University of Coimbra in Portugal. In Coimbra he had been arrested for heresy and tormented by the Inquisition. Brewster's daughter recorded a still-prevalent sense of Buchanan as a stern presence, one of those Scottish Protestant Reformers, like John Knox, who had 'drunk of St Leonard's Well'. Describing St Leonards in 1838 as 'now the property and residence of Sir David Brewster', *St Andrews as It Was and as It Is* mentions – somewhat questionably – that 'the room is still shewn in

which George Buchanan studied'.[44] Perhaps oppressed by this legacy of long-dead St Andrews, Maria Brewster too believed the house had been Buchanan's old home. She found it 'gloomy looking', even if, soon after they moved, it assumed a more cheerful appearance 'with its tiny lawn and garden, and its creepers of ivy and jessamine, fuchsias and roses'.[45] On one side was the ivy-covered old chapel – 'unroofed and desolate . . . a large ash tree, growing within its precincts' – and on the other side the ruined spires, walls, cloisters and vast cathedral grave-yard.[46] Fortunately, David Brewster was pleased with the place. Its curious nature and situation were among the many things the newly appointed principal had in common with his English friend Talbot, who lived in a former abbey at Lacock in Wiltshire. Brewster, visiting in 1836, regarded Lacock as 'a paradise – a fine old abbey, with the square of cloisters entire, fitted up as a residence, and its walls covered with ivy, and ornamented with the finest evergreens'.[47]

At Lacock Talbot was seen as a recluse. For all his Harrow-and-Cambridge education, he could be socially awkward – 'rather unlicked' a contemporary once called him, noting his obsessive interest in science: 'He has an innate love of knowledge, and rushes at it as an otter does to a pond.'[48] This 'sometimes flawed but highly creative man' found a soul-mate in Brewster.[49] Talbot's wife, Constance, was surprised by how well the two got on. She had written to Talbot's mother in 1836,

> You are perfectly right in supposing Sir D.B. to pass his time pleasantly here. He wants nothing beyond the pleasure of conversing with Henry discussing their respective discoveries & various subjects connected with science. I am quite amazed to find that scarcely a momentary pause occurs in their discourse. Henry seems to possess new life – & I feel certain that were he to mix more frequently with his own friends we should never see him droop in the way which now so continually annoys us.[50]

As this friendship burgeoned, correspondence between St Andrews and Lacock became extensive. Towards Talbot, Brewster was benign. In other aspects of his career he continued to thrive on polemic. Not just light, lenses, and truth, but struggle, controversy, even heresy were for

him the stuff of science. In 1841 he published *The Martyrs of Science*, studies of the great astronomers Galileo, Tycho Brahe, and Kepler. Written at 'St Leonards, St Andrews', the book shows sympathy not just for 'the ardour of Galileo's mind' but also for the way 'his temper was easily ruffled'.[51] Following in the wake of Thomas Carlyle's May 1840 lectures 'On Heroes and Hero-Worship' which presented 'the hero' as 'prophet . . . as poet . . . as priest . . . as man of letters' and as king, Brewster displayed the hero as researcher into optical science. The Protestant principal's scientists are brilliant battlers. Soldiers of light, yet ready to use 'powerful weapons of ridicule and sarcasm', they are opposed alike by the Catholic Inquisition and by petty local prejudice.[52] It is hard not to think of them as heroically idealised Brewsters.

One of his earliest publications had been his revision of James Ferguson's *Astronomy, explained upon Sir Isaac Newton's Principles.* Its first chapter quotes the poet Edward Young – 'An undevout astronomer is mad' – and sees the stars, 'numberless suns and worlds', as evidence of a Creator who has probably made other 'inhabited planets' with 'myriads of intelligent beings'. The universe is 'an amazing conception, if human imagination can conceive it'.[53] Brewster held linked religious, scientific, and aesthetic beliefs. For him the eye was the 'sentinel which guards the pass between the worlds of matter and of spirit'.[54] With its very Protestant conception of martyrdom, *The Martyrs of Science* praises those who sacrificed their lives for scientific truth rather than for mystical faith. Brewster's book ends with a call to battle, exalting scientific knowledge and the power of imagination:

> . . . opinions which have in one century been objects of ridicule, have in the next been admitted among the elements of our knowledge. The physical world teems with wonders, and the various forms of matter exhibit to us properties and relations far more extraordinary than the wildest fancy could have conceived. Human reason stands appalled before this magnificent display of creative power, and they who have drunk deepest of its wisdom will be the least disposed to limit the excursions of physical speculation.
>
> The influence of the imagination as an instrument of research, has, we think, been much overlooked by those who have ventured to

give laws to philosophy. This faculty is of the greatest value in physical inquiries. If we use it as a guide, and confide in its indications, it will infallibly deceive us; but if we employ it as an auxiliary, it will afford us the most invaluable aid. Its operation is like that of the light troops which are sent out to ascertain the strength and position of an enemy. When the struggle commences, their services terminate; and it is by the solid phalanx of the judgment that the battle must be fought and won.[55]

Brewster's title page of *Martyrs of Science* makes plain the vigour with which he fought. It does not list his imaginative discoveries, but trumpets the distinctions they had won him:

SIR DAVID BREWSTER, K.H. D.C.L.,

PRINCIPAL OF THE UNITED COLLEGE OF ST SALVATOR AND ST LEONARD,

ST ANDREWS; FELLOW OF THE ROYAL SOCIETY OF LONDON; VICE-PRESIDENT

OF THE ROYAL SOCIETY OF EDINBURGH; CORRESPONDING MEMBER

OF THE INSTITUTE OF FRANCE; AND MEMBER OF THE

ACADEMIES OF ST PETERSBURG, STOCKHOLM,

BERLIN, COPENHAGEN, GOTTINGEN,

PHILADELPHIA, &C. &C.

If this listing sounds too anxiously effortful, it is nonetheless impressive. When Brewster, founder of the British Association for the Advancement of Science, attended that Association's twelfth meeting, at Manchester in the summer of 1842, leading scientists queued up to meet him. '"There he is – that's Brewster",' his daughter recalled people whispering excitedly. 'It was a well-filled hemisphere in which he moved as a star of the first magnitude.'[56] Among the other bright stars who conversed with him were Sir John Herschel, the mathematician and optical researcher Professor Maccullagh from Trinity College Dublin, geologists such as Sir Roderick Murchison, and Henry Fox Talbot himself. Brewster's friend had been experimenting further with photographic techniques, and discussed with him this 'source of life-long interest'. On the same visit the St Andrews professor also met once more with Charles Babbage, another polymathic investigator with an

interest in photography, and someone he had known for over two decades. Convinced science in England was in dire straits, Babbage, like the Brewster who engaged in debates over the 'Decline of Science in England and Patent Laws', was a spiky scientific combatant.[57]

Brewster's visits to England were usually for scientific meetings. In 1842, from Manchester he and his daughter went on to Cambridge, staying at Queen's College for a week. Near King's College Chapel they admired by moonlight the statue of Sir Isaac Newton. Brewster paid homage as Newton's 'biographer and loving disciple'.[58] The principal returned to St Andrews in the summer of 1842 secure in his position as a leading Victorian scientist. He passed on to local associates news of science internationally – not least astronomy, geology, and photography. Brewster loved fine scientific instruments. For all he experienced problems with his eyes, in 1840 he had the university purchase for his use at a cost of fifty-two pounds, eight shillings, and eightpence a beautifully made brass microscope. Its barrel 48 centimetres long, it bore the name of one of the leading microscope makers of the day, Andrew Ross of 33 Regent Street in London's Piccadilly. This new, improved design had just been introduced the previous year.[59]

At a charge to the university of a further eight pounds and ten shillings, Brewster was also having a daguerreotype camera made for him. The manufacturer was Thomas Davidson, but Talbot's remained the distinctive photographic *nous* to which Brewster was particularly attracted.[60] In late 1840 he announced in St Andrews he would give 'a public lecture in the College here on the Principles & Methods of Photogenic Drawing and the Daguerrotype'. He wished to exhibit one of Talbot's 'Portraits'.[61] Talbot sent two. The principal showcased them at his lecture, which, he reported proudly, was 'well received', though he and his friends encountered continuing problems developing photographs.[62] In spring 1841 Talbot gave Brewster a full account of his calotype process and techniques, mailing this in two separate parts for reasons of security. Promising to keep it 'secret till you shall give it to the World', Brewster did share it with friends in the St Andrews Literary and Philosophical Society which he had recently helped found. He seems to have had Talbot's blessing.

Brewster needed blessings, because he had other problems too, not

all photographic. He was, he made clear to Talbot, enmeshed in arguments within the Church of Scotland. As Brewster put it testily in May 1841, after he attended the Edinburgh meeting of its General Assembly, the Kirk was 'at present in a state of illegal persecution by the Civil Courts'.[63] Back at St Leonards, he went on struggling with the calotype process. 'I cannot understand', he complained, how 'a sheet of writing paper' might be so permeated by 'Solar Rays'.[64] In Brewster's mind, filled with his 1841 *Martyrs of Science*, photography, like the Kirk's struggles, involved modern kinds of martyrdom, fitting perhaps for a successor to George Buchanan. When the Royal Society rejected Talbot's paper on the calotype process as well as Brewster's essay on polarised light, the Scot complained to his English friend, 'I almost rejoice in your Martyrdom, for I am myself a Martyr in the very same cause, and thro' the agency of the same Inquisition.'[65] He thought their martyrdoms might be suitable for an extra volume of Charles Babbage's controversial book, *Reflections on the Decline of Science in England, and on some of its Causes* (1830), which Brewster had reviewed some years before, asking, 'why does England thus persecute the votaries of her science?'[66] His family were well aware of Brewster's sense of martyrdom. They liked to tease him. Maria, who shared her father's religious enthusiasm, recalled Brewster finding in a 'Christmas Box' a slip of paper that read, 'For binding four Martyrs, so many shillings.'[67] In the summer of 1841, Brewster told Talbot, probably only half-jokingly, he felt 'left at the stake'.[68]

Frustrations connected with his attempts at photography exacerbated this. 'I regret to say that I have entirely failed in your Calotype process', he wrote to Talbot in 1841, 'and so have two of my friends Major Playfair & Dr Adamson to whom I communicated it.' Brewster and his next-door neighbour Major Hugh Lyon Playfair had sought help from the under-paid St Andrews University professor of chemistry, Arthur Connell: 'we could get nothing like a good picture'. Playfair had tried 'repeatedly and patiently'. Another local associate, 'Dr [John] Adamson who is a good Chemist, & successful with the Daguerreotype has also failed'. Was there a problem with the paper (Playfair later sent Talbot samples to check)? Were the chemicals wrongly mixed (Adamson was uncertain about the strength of the acetic acid involved)?

Brewster, Playfair, Adamson, and Connell all needed help with their 'difficulties'.[69] Talbot, whose 1841 description of the ideal place for photography – 'some locality where picturesque objects are to be met with, such as a cathedral, or a seaport Town' – sounds very like St Andrews, sent advice and the Fife experimenters slogged on.[70] 'Dr Adamson has been working like a Horse with your Calotype Process,' Brewster wrote to Talbot in October; 'I have often gone over the process with him. He has done only a few good Photographs.' In Edinburgh some efforts to make calotypes had been abandoned, but not in St Andrews. There seemed to be problems with the watercolourists' paper, whose chemical makeup varied slightly from batch to batch. Brewster complained the pictures were 'often covered with large irregular white masses obviously arising from a defect in the Paper'.[71] He felt stymied.

Planning to visit Talbot in the summer of 1842, he made it clear he was still planning an 'Article on the Calotype and Daguerreotype' for the *Edinburgh Review*. He was eager for Talbot's advice and 'any historical or personal details which have not yet appeared respecting the Calotype'. He also updated Talbot on the German Ludwig Ferdinand Moser's theories about 'latent light' which Brewster soon discussed with fellow investigators in St Andrews.[72] Despite trouble with trains ('I cannot find . . . any acc[oun]t of the times or ways of traveling along the Birmingham and Gloucester Railway'), Brewster eventually reached Lacock Abbey and was able to obtain further guidance on photography for his doggedly persistent Fife friends.

Excited by the enthusiasm with which his work was being received, Talbot now planned to come to Scotland. Brewster was eager for the inventor of the calotype to visit him *in situ*: 'You must of course come to St Andrews the Headquarters of the Calotype; and I trust you will take up your quarters with us while you are here.' From the 'Ghostly ruins of St Leonards College' he wrote warmly to his friend at Lacock, singing the pleasures of the 'fresh air' of the Highlands, which Talbot was keen to encounter, and especially of Fife: 'here at St Andrews the Air is singularly fresh and salubrious in the months of July August & Sept[embe]r, when we have none of the East Winds which infest the East Coast at other seasons'.[73]

Photography was now a challenge the whole Brewster family shared. Alongside his son Henry, the local Adamson brothers, and his neighbour Major Playfair, Brewster was producing calotypes, while his wife was 'making up a book of Specimens' (now in the Getty collection) to include Talbot's work alongside their own. Apparently Juliet Brewster stuck the photographs into her old commonplace book, inscribed with quotations from favourite poets such as Burns, Byron, and Thomas Campbell. Covering up poetic inscriptions with photographs, she was assembling a new kind of visual poetry. Her husband, who would soon write of photography as one of the 'great arts', enthused over the aesthetic value of these pictures: 'Some of the positives are perfect Rembrandts. Major Playfair has taken some groups with many figures which are singularly fine.'[74] Much of its contents published by the photographic historian Graham Smith in his 1990 *Disciples of Light*, the Brewster Album contains work by a number of local photographers. It includes depictions of everything from the Brewsters' garden to St Andrews antiquities, musicians, golfers, and friends. The Chambers family was also involved in some of these pictures. In 1841 Anne and Robert Chambers had moved from Edinburgh to St Andrews with their eight children, partly so they could put some distance between Robert and the endless demands of his workplace. Robert's daughter, Jane, wrote excitedly about St Andrews to her aunt in November 1842, listing places she had enjoyed in that summer,

> . . . the Old Cathedral and the Square Tower. The view from the Tower amply repays the trouble of ascending the long flight of steps. It is indeed magnificent in a fine day. The burying-ground amongst the ruins is very neat and pretty, being remarkably well kept. Mamma says the ruins by moonlight are superb, seen from the Scores – a fine walk at the back of the town, near the beach. Dr Adamson has sent us some very beautiful Calotypes, which give a very correct view of several places I have mentioned. I send them to show to you and Grandmamma and Uncle William; but please return them in a few weeks. I also send you a view of myself, and my dear friend Mary Playfair, and her brother Fred, done by Major Playfair, our new provost.[75]

Jane enjoyed looking at these photographs and being in them. Like Brewster she found them 'beautiful'. Her letter shows how calotypes circulated among the Chambers family in St Andrews and Edinburgh. The science behind them fascinated Brewster most, not least the way it involved something as ephemeral as breath as well as fixed, solid surfaces:

> I have been lately making experiments on the transference of Images from Calotypes on to Glass. I have taken beautiful impressions on Glass. When from a Positive the Reflected Picture produced by breathing is positive and the transmitted one negative. My theory of this class of phenomena, and I would almost venture to say of those discovered by Moser is that vapour from the Picture is taken into the Pores of the Glass or Metallic surface. In my results I am confident of this fact; I have this moment been trying by the friction of Shamois leather to efface the Picture from the Glass; but it persists, and rubbing will reverse it by rubbing into the pores other matter, or dissolving the absorbed vapour.[76]

*

It was, as a leading article in *Chambers' Edinburgh Journal* put it in 1842, 'a great misfortune to be an enemy-maker'. This article praises one of Robert Chambers's heroes, Walter Scott, for his even temper and the way he managed to write in a style 'void of offence'.[77] In St Andrews, though, Brewster became the great local example of an enemy-maker. Eventually he fell out with Chambers.[78] This was particularly unfortunate, since the two often circulated in the same company, not least at the British Association for the Advancement of Science whose meetings Chambers sometimes attended and one of whose most zealous supporters was Brewster.

And it was in the academic session 1842–3 that he was propelled into his most public controversy, leading him towards bitter censure, and confirming him as a modern martyr. Yet for the principal, as for so many in his age and nation, rows were unavoidable. Nineteenth-century Scotland was a country of Catholics as well as Protestants, secularists as well as believers, but nothing was more central to its

identity than the Presbyterian Kirk. Over the preceding decade tensions within that kirk had been fuelled by much older arguments about its democratic workings. Fifty years earlier the national bard Robert Burns had celebrated traditions of egalitarian worship. His greatly admired poem 'The Cotter's Saturday Night' distrusted the 'pomp' and 'display' of elaborate religious ritual. Suspicious of the aristocracy and the 'sacerdotal stole', it exalts the plain worship of ordinary cottagers,

> Princes and lords are but the breath of kings,
> 'An honest man's the noble work of GOD:'[79]

A tendency among Scots Presbyterians to insist absolutely on kinds of egalitarianism had long preceded Burns's eighteenth-century articulation of it. Centuries earlier, the Renaissance Scottish King James VI (founder of the library later named after him at St Andrews) had complained bitterly about the Kirk's 'fyrie ministers' who 'fantasie to thame selfis a democratike forme of gouuernement'.[80] Now in the 1840s such ancient democratic aspirations were again convulsing national life. Early that decade a long-running dispute over how to choose church ministers came to a climax. While Kirk moderates were happy that in accordance with the law a local patron, often an aristocrat, might nominate a parish minister, more democratically minded believers maintained that ordinary parishioners should be able to veto any patron's nomination, and elect the minister themselves. Such arguments within the established Church of Scotland, the nation's official Christian domination, boiled over at the Kirk's annual gathering of ministers and elders, its General Assembly, in Edinburgh in May 1843. Implacably committed to democratic elections, its elected leader or moderator headed a spectacular walkout. Following his lead, about four hundred ministers (among them David Brewster's solemn, bespectacled brother James) resigned their livings, refusing to accept lairdly patronage. Brewster's daughter Maria was among the many who regarded such a refusal as a form of national heroic martyrdom. Her poem 'To the Leaders of the Church of Scotland' exclaims,

Hail, champions of Zion! Advance to the field,
Guard the fanes of our Scotland with sword and with shield;
Let your war-cry re-echo o'er hill and o'er heath,
For the Headship of Jesus – for freedom or death!
What though ye be torn from your homes, from your hearth,
Though ye pillow your heads on the cold lap of earth, –
Though your altars be raised on the hill's misty height,
And your orisons rise mid the silence of night, –
'RETRACT! NOT A HAIR'S BREADTH!' to you it is given
For Zion to strive as your fathers have striven;
Houseless, and homeless, they wandered of old, –
Their home was the corrie – their temple the wold.[81]

May 1843 saw just such scenes of impassioned sacrifice as the ministers renounced their patrons and gave up their former, Church-owned, dwellings. Known as the Disruption, this democratically minded revolt was both shocking and courageous: it marked the start of a new 'Free Kirk'. The ministers who walked out willingly sacrificed their homes and land (their 'manses' and 'glebes') as well as their incomes in order to stay true to their principles. Many thousands of parishioners backed them.

Soon photographed at the centre of a group at the Free Church Assembly in Glasgow, David Brewster was at the heart of the Disruption.[82] A leading supporter of the Free Kirk, he was associated in the public mind with scientific controversies as well as with governmental arguments that shook the Kirk and universities. The writer, geologist and journalist Hugh Miller edited and wrote for a newspaper, *The Witness*, which also supported the emergent Free Kirk. Eventually, in Miller's sometimes depressive mind, overwork and perhaps conflicts associated with his geological and religious passions – which he sometimes found hard to reconcile – would lead to suicide. Writing about the 'intense anxiety' obvious on the day of the Disruption, Thursday 18 May 1843, Miller described the jam-packed St Andrew's Church, George Street, Edinburgh, where the General Assembly listened to their moderator and each person present eyed the surrounding crowd.

Science, like religion, had its representatives on the Moderator's right and left. On the one side we saw *Moderate* science personified in Dr Anderson of Newburgh, – a dabbler in geology, who found a fish in the Old Red Sandstone, and described it as a beetle; we saw science *not Moderate*, on the other side, represented by Sir David Brewster.[83]

Proud of the new Free Kirk, whose moderator was the St Andrews graduate, pioneering social reformer and champion of scientific geology, Thomas Chalmers, Brewster wanted the fledgling church commemorated. This was to be done through an immense group portrait by the artist David Octavius Hill, illustrator of *The Land of Burns*. Hill's painting's verisimilitude would be enhanced and complemented through the use of the new scientific art of photography. Brewster's St Andrews acquaintance, the young aspiring engineer Robert Adamson, brother of Dr John Adamson, was just the man to cope with the delicate chemistry involved in taking pictures of the Free Kirk's founders. As Brewster wrote to Fox Talbot in early July 1843,

> You may probably have heard, tho' only as a dying Echo, of the great moral event in Scotland, of 500 Ministers quitting their manses & Glebes & Stipends for Conscience sake, and forming a Free Church, unshackled by secular interferences. A grand historical picture is undertaken by a first rate Artist, to represent the first General Assembly of the Free Church. I got hold of the Artist – showed him the Calotype, & the eminent advantage he might derive from it in getting likenesses of all the principal characters before they dispersed to their respective homes. He was at first incredulous, but went to Mr Adamson, and arranged with him the preliminaries for getting all the necessary Portraits.
>
> They have succeeded beyond their most sanguine expectations. – They have taken, on a small scale, Groups of 25 persons in the same picture all placed in attitudes which the Painter desired, and very large Pictures besides have been taken of each individual to assist the Painter in the completion of his Picture.

Mr D.O. Hill the Painter is in the act of entering into Partnership with Mr Adamson, and proposes to apply the Calotype to many other general purposes of a very popular kind, & especially to the execution of large pictures representing diff[eren]t bodies & classes of individuals.

I think you will find that we have, in Scotland, found out the value of your invention not before yourself, but before those to whom you have given the privilege of using it. I have seen one of the groups of 25 persons with our distinguished Moderator Dr Chalmers sitting at the heart of them, and I have never seen any thing finer.[84]

Commemorated in calotypes, the Disruption might mark the start of a new church, but it was also the divisive end of a theological world Brewster had known since his earliest years. The Disruption convulsed Scotland, and made an impact on artists as on everyone else. 'There has not been such a subject since the days of Knox – and not then!', Lord Cockburn was quoted as exclaiming.[85] D. O. Hill's friend the Edinburgh painter Thomas Duncan joined the Free Kirk, painted an 1843 portrait of Thomas Chalmers, then the following year went on to portray the seventeenth-century 'Martyrdom of John Brown of Priesthill'. The Free Kirk associated itself with earlier Scottish Protestant martyrs for what they saw as the cause of religious freedom, not least in St Andrews. Another of Duncan's projects during this period was for a major history painting of John Knox's sixteenth-century hero George Wishart dispensing the sacrament in the prison of St Andrews Castle on the morning of his execution.[86] D. O. Hill's brother purchased this painting, which was soon photographed by Hill and Adamson.[87] Published in 1842, Maria Brewster's poetry collection *The Covenant: or, The Conflict of the Church* juxtaposes poems connected with the earlier Reformation and Covenanting 'Ecclesiastical History of Scotland' with treatments of 'the Church of Scotland in its Present Struggles'. One of her poems, 'On George Wishart's Martyrdom, Near the Castle of St Andrews', fuses the violent death of the protestant preacher Wishart with the stormy seascape beneath the castle that was just a few minutes' walk from her home.

> Behold yon ruined pile, which rears its head
> Like some grim spectre of the mighty dead;
> White girt by boundless Ocean's bulwark strong,
> With Time's relentless hand it struggles long;
> Wild sea-mews 'thwart the troubled billows sail,
> And through the din resounds their mournful wail;
> While stately ships are gulfed in that dark main,
> Against whose might the pilot's skill is vain,
> And crested waves besiege yon rocky step,
> Which guards the shell-paved caverns of the deep:
> Cast in the sternest mould of Nature's hand,
> Behold a scene magnificently grand![88]

'Rousing the brave for Truth and Liberty', Maria sought to put heart into the radical, battling Protestants of 1840s Scotland, among whom was her father.[89]

'We are now fighting a great battle of civil & religious liberty', Brewster wrote to Talbot in November 1843, explaining that 'a part & parcel of it' was

> 'University Reform . . . We are building 800 Chambers and 500 Schools, and as I feel a deep interest in all these matters, I, of course, take an active part, and have thus been withdrawn, to a certain extent, from my usual and more peaceful occupations.'[90]

The author of *The Martyrs of Science* was also fighting locally for the 'martyrs' of his nascent church.

As the Free Kirk sought to set up its own national network of churches and its own educational establishments, some in St Andrews were appalled by Brewster's stance. Efforts were made to unseat him as Principal of the United College. There were vitriolic debates in the University Senate. George Cook, Professor of Moral Philosophy and (like Brewster) a vice president of the St Andrews Literary and Philosophical Society, was the leading Church of Scotland opponent of the Free Kirk.[91] Wishing to establish a chair of Natural History in St Andrews, Brewster had been arguing for years with Cook, who

staunchly opposed Brewster's wishes. Their tussles soon shaded into ecclesiastical wrangling, and the Disruption intensified this. Mathematician and theologian Robert Haldane, Principal of St Mary's College, St Andrews, was, like most of the St Andrews professors, an entrenched supporter of the established Church of Scotland. He disputed long and hard with Principal Brewster.[92] All this confirmed Brewster's sense of martyrdom.

1842 had seen the setting up in St Andrews of a substantial obelisk, the Martyrs Monument. Commemorating George Wishart and four other Reformation victims of religious intolerance, it was designed, as Maria Brewster put it, 'to perpetuate the memory of the Martyrs who there suffered by fire'. With her customary exclamatory rhetoric, she celebrated the campaign for the monument,

> The hour is come, oh patriots, to arise, –
> Recall the days of yore with tear-dimmed eyes,
> And let the Obelisk its crest upraise,
> For Scotland's martyrs of the olden days![93]

In the period just before and after the Disruption this upraised 'Obelisk' was also a visual reminder of earlier generations of St Andrews martyrs prepared to stick to their principles through fire and persecution. One of the earliest panoramic landscape photographs of St Andrews ascribed to Hill and Adamson has the Martyrs Monument at its centre.[94] Taken from the West Sands beach, the picture shows the newly erected obelisk on the skyline counterbalancing the ancient spire of St Salvator's, the university church. The 1840s town architecture was at times a physical manifestation of bitter struggle. In November 1843, the month when he wrote to Talbot about 'fighting a great battle', Brewster was to the fore in founding and opening a new local church born out of the Disruption and linked to the Free Kirk movement.[95] This provided an oppositional alternative to the ancient University Chapel, joined to the great fifteenth-century tower of St Salvator's College. Provocatively, Brewster's new building, soon photographed as the 'Free Ch[.]', was situated right across the street and named Martyrs Church.[96] Its deliberate construction on this site was part of the principal's 'great

battle'. He urged on his new, spiritedly democratic church just as he encouraged the complex new art and science of photography – with hectic, combative vigour.

Excitingly, uneasily, God, science, and democracy were meeting as allies of the Free Kirk. Writing, planning, experimenting, arguing, praying and holding forth from his 'Ghostly ruins of St Leonard's College', Brewster fought on in ways that could make him seem extreme and temperamental – and which ultimately would alienate him.[97] One educated visitor in 1844 exclaimed simply,

> Sir David Brewster! He lives in St. Andrews and presides over its principal college, yet no one speaks to him! With a beautiful taste for science, he has a stronger taste for making enemies of friends. Amiable and agreeable in society, try him with a piece of business, or with opposition, and he is instantly, and obstinately, fractious to the point of something like insanity. With all arms extended to receive a man of whom they were proud a few years ago, there is scarcely a hand that he can now shake.[98]

In 1845, when the government-appointed St Andrews University Commissioners published a report into the workings of the institution, this bitter in-fighting became public knowledge. Some reacted with horror, others with amusement to what looked like an inept parochial apocalypse. For Brewster his struggles, his risking of martyrdom, and his scientific work were all part of intellectual advancement.

* *

At first sight the photographs taken by the St Andrews photographers from 1839 into the 1840s seem far distant from these convulsive battles. They also appear remote from the Robert Chambers who, while living in St Andrews, drew on Jameson's Cuvier, Brewster's researches, and other work as he attempted to set out in a remarkable manuscript the whole history of creation. Yet, curiously, as described by Brewster, photographs sound both suited to the recording of momentous events in society, and, at the same time, rather like sections of Chambers's

manuscript – a production Brewster thoroughly detested, and which will be discussed in detail in chapter five of the present book. In his impressive survey of early photography published in the January 1843 *Edinburgh Review* Brewster contends that 'every picture becomes an authentic chapter in the history of the world'. Chaptering history, photographs chronicled time, just as Chambers in the eighteen chapters of his manuscript chronicled the remote history not just of the world but also of the universe, hinting at its beginning and its end. In outlining the development of photography, Brewster (like Chambers in his different context) invoked 'the law of progressive development'. For Brewster, engaged in the intellectual controversies which resulted in the Disruption and the formation of the new Free Kirk, such a law of development was paralleled by a moral evolution: 'Under the influence of a similar law, our moral and religious condition is gradually ascending to its climax; and when these grand purposes have been fulfilled – when the high commission of the Saint and the Sage has been executed – man, thus elevated to the perfection of his nature, will enter upon a new scene of activity and enjoyment.'[99]

Others, including Chambers, were less celestially rhapsodic about photography. Brewster recognised that the coming of the new medium might itself be disruptive. Still, 'when great inventions and discoveries in the arts and sciences either abridge or supersede labour – when they create new products, or interfere with old ones – they are not on those accounts to be abandoned'.[100] The new 'art of Photography' which 'has called to its aid the highest resources of chemistry and physics' was, Brewster emphasised, 'as great a step in the fine arts, as the steam-engine was in the mechanical arts'. He saw it as the beginning of a new world, ready to 'take the highest rank among the inventions of the present age'.[101] Characteristically polemical, he took a swipe at the Royal Society for its 'refusal to publish the photographic discoveries of Mr Talbot!', but went on to praise a number of photographers. Bolstering his position through using the editorial 'we', he mentioned evangelically that

We have now before us a collection of admirable photographs executed at St Andrew's, by Dr and Mr Robert Adamson, Major

Playfair, and [Brewster's soldier son] Captain Brewster. Several of these have all the force and beauty of the sketches of Rembrandt, and some of them have been pronounced by Mr Talbot himself to be among the best he has seen.

Brewster adds in a note that

All these calotypes were taken by means of excellent camera-obscuras constructed by Mr Thomas Davidson, optician, Edinburgh.

Mr Robert Adamson, whose skill and experience in photography is very great, is about to practise the art professionally in our northern metropolis.[102]

This is just what happened in 1843 when, introduced by Brewster to D. O. Hill, Robert Adamson entered into the most remarkable artistic partnership of the nineteenth century. Together Hill and Adamson produced their series of calotypes now regarded as masterworks of photography. Brewster at the height of the Disruption saw photography's global potential. He realised it might not only record the world's antiquities and beauties, but might even strengthen religious faith. Written among the grey ruined stones of St Andrews by the Presbyterian evangelical principal (a man normally suspicious of undue ornamentation), his *Edinburgh Review* article contains the greatest paean in the history of early photography.

How limited is our present knowledge of the architectural orna-ments of other nations – of the ruined grandeur of former ages – of the gigantic ranges of the Himalaya and the Andes – and of the enchanting scenery of lakes, and rivers, and valleys, and cataracts, and volcanoes, which occur throughout the world! Excepting by the labours of some traveling artists, we know them only through the sketches of hurried visitors, tricked up with false and ridiculous illustrations, which are equal mockeries of nature and of art. But when the photographer has prepared his truthful tablet, and 'held his mirror up to nature', she is taken captive in all her sublimity and beauty; and faithful images of her grandest, her loveliest, and her

minutest features, are transferred to her most distant worshippers, and become the objects of a new and pleasing idolatry. The hallowed remains which faith has consecrated in the land of Palestine, the scene of our Saviour's pilgrimage and miracles – the endeared spots where he drew his first and latest breath – the hills and temples of the Holy City – the giant flanks of Horeb, and the awe-inspiring summits of Mount Sinai, will be displayed to the Christian's eye in the deep lines of truth, and appeal to his heart with all the powerful associations of an immortal interest. With feelings more subdued, will the antiquary and the architect study the fragments of Egyptian, Grecian, and Roman grandeur – the pyramids, the temples, the obelisks of other ages. Every inscription, every stone, will exhibit to them its outline; the gray moss will lift its hoary frond, and the fading inscription unveil its mysterious hieroglyphics. The fields of ancient and modern warfare will unfold themselves to the soldier's eye in faithful perspective and unerring outline; and reanimated squadrons will again form on the plains of Marathon, and occupy the gorge of Thermopylae.

But it is not only the rigid forms of art and of external nature – the mere outlines and subdivisions of space – that are thus fixed and recorded. The self-delineated landscape is seized at one epoch of time, and is embalmed amid all the co-existing events of the social and physical world. If the sun shines, his rays throw their gilding upon the picture. If rain falls, the earth and the trees glisten with its reflections. If the wind blows, we see in the partially obliterated foliage the extent of its agitation. The objects of still life, too, give animation to the scene. The streets display their stationary chariots, the esplanade its military array, and the market-place its colloquial groups; – while the fields are studded with the various forms and attitudes of animal life. Thus are the incidents of time, and the forms of space simultaneously recorded; and every picture becomes an authentic chapter in the history of the world.

In considering the relations of Photography to the art of portrait painting, we are disposed to give it a still higher rank. Could we now see in photogenic light and shadow Demosthenes launching his thunder against Macedon – or Brutus at Pompey's statue bending

over the bleeding Caesar – or Paul preaching at Athens – or Him whom we must not name, in godlike attitude and celestial beauty, proclaiming good-will to man, with what rapture would we gaze upon impersonations so exciting and divine! The heroes and sages of ancient times, mortal though they be, would thus have been embalmed with more than Egyptian skill; and the forms of life and beauty, and the lineaments of noble affections and intellectual power, the real incarnations of living man, would have replaced the hideous fragments of princely mortality scarcely saved from corruption.

But even in the narrower, though not less hallowed, sphere of the affections, where the magic names of kindred and home are inscribed, what a deep interest do the realities of photography excite! In the transition forms of his offspring, which link his infancy with manhood, the parent will discover the traces of his own mortality; and in the successive phases which mark the sunset of life, the child, in its turn, will read the lesson that his pilgrimage too has a period which must close.

Nor are these delineations interesting only for their minute accuracy as works of art, or for their moral influence as incentive to virtue. They are instinct with associations equally vivid and endearing. The picture is connected with its prototype by sensibilities peculiarly touching. It was the very light which radiated from his brow – the identical gleam which lighted up his eye – the pallid hue which hung upon his cheek – that penciled the cherished image, and fixed themselves for ever there.[103]

Even if he was no great photographer himself, Brewster had had longer than almost anyone else in the English-speaking world to ponder on the new medium's significance, and he understood its workings from the inside. It is true that in 1842 another (probably Scottish) commentator had pointed out that photographic portraits from life could have 'a dull, leaden hue', so that 'the countenance has a deathlike unpleasant appearance', but much more profoundly, like noted later theorists of photography such as Susan Sontag, Roland Barthes, and Philippe Dubois in the twentieth century, Brewster saw the medium as

bound up both with preservation and with mortality.[104] In so doing, he may have been influenced by his own place of residence, that city of martyrs which prompted so many of its antiquarians and other visitors to contemplate mortality and the erosions of time. Yet while some of what Brewster wrote about the 'ruined grandeur of former ages' may relate to pictures taken by his friends of ecclesiastical and other ruins close to home, his insight goes far beyond. Writing in a way that brings together religious language ('worshipper . . . hallowed remains . . . pilgrimage and miracles') with the more scientific interests of 'the antiquary and the architect', he sees photography as bound up with the passing of time and involving the apparently 'reanimated'. It promises a fresh start, the beginning of a new visual world, bringing to life moments in elemental nature ('sun . . . rain . . . wind') as well as in human society ('esplanade . . . marketplace . . . colloquial groups'). Yet this new beginning carries too a sense of ending and mortality. The excitement of starting anew is paradoxically fused with a consciousness of termination. 'Sages' may be 'embalmed with more than Egyptian skill' by the fledgling medium; 'fragments' of 'mortality', for all they may be displaced by photography's 'real incarnations of living man', are nonetheless insistently perceived. The most intimately familial photographs convey 'traces of . . . mortality'. Family photographs teach the viewer 'that his pilgrimage too has a period which must close'.

Even though a few years later in 1847 he was convinced he was living in 'a new era' when photography held 'all the promise of an auroral dawn', in his ringing 1843 *Edinburgh Review* account of the fledgling medium, Brewster presents this new art-science as a kind of *memento mori* as well as a spur to Christian virtue.[105] He then shifts to the past tense, suggesting how a photograph of a person invokes their absence, their loss. The implication is that the sitter, so present in the photograph, is now actually dead.

It was the very light which radiated from his brow – the identical gleam which lighted up his eye – the pallid hue which hung upon his cheek – that penciled the cherished image, and fixed themselves for ever there.

By 1843, as far as I know, none of the people photographed by Brewster and his St Andrews circle had yet died, but some, such as the university's Professor Thomas Gillespie, pictured holding his walking stick (probably to stop his hands shaking), were elderly and venerable; Gillespie died the following September. Brewster, who had a particular photographic interest in what he called 'the delicate lines and shades of the human countenance', was described in 1844 as silver-haired, with 'a pallid but reflective countenance': he may have had his own mortality in mind.[106] Certainly he is considering not only imaginary photographs taken long ago, he is also writing about his *now*, the 1840s. He is very conscious that the photograph, in holding a moment, seems to have arrested time and so reminds the viewer intensely just how much onlooker and subject alike are themselves time-bound organisms. Only death truly stops time for us. In seeming to do so, photography becomes death's effigy. It carries a note of *ubi sunt* – where are they now? – an unavoidable, acute pang of loss. 'Photography is an elegiac art', writes Susan Sontag, 'All photographs are *memento mori*.'[107] In this perception she was anticipated by Brewster, who wrote in an age when, some modern commentators have argued, daguerreotypes could be associated with dying.[108] Brewster was the first to present with eloquence the linkage between photography and death, and arguably his eloquence never has been bettered. He is the greatest early English-language theorist of photography.

Brewster's contemplation of mortality also impressed Hugh Miller, whom we have already encountered writing for his paper *The Witness* about the Free Kirk Disruption. Miller's June 1843 essay on Hill and Adamson's work begins with discussion of 'another age' with its 'Assembly of the dead'. It then goes on to discuss 'old age' as depicted in the Disruption photographs taken 'through the medium of . . . the Calotype, – an art introduced into Edinburgh, during the last fortnight, for the first time, by Mr Adamson of St Andrews'. Miller urges Edinburgh people to make a 'visit to the study of Mr Adamson', and refers them to the 'admirable article in the *Edinburgh Review* of January last', before concluding by quoting its 'truly eloquent passage', the paean to photography by 'a gentleman confessedly at the head of science in Scotland . . . Sir David Brewster'. The paragraphs which so

impressed Miller and other early readers are the four paragraphs linking photography to 'animation' and 'mortality'. He concludes with mention of 'the identical gleam which lighted up his eye' and 'the pallid hue which hung upon his cheek'.[109] Again for Miller, it is the perception of a link between photography and death which is most telling.

This is the insight so memorably articulated by Sontag and by Barthes almost one and a half centuries later. In his book *Camera Lucida* Barthes writes of photography's 'funereal immobility'. He understands that this was necessarily part of early photography's procedures which – around 1840 – involved long periods of staying as still as a 'statue'. But, like Brewster before him, Barthes knows photography has the power to 'embalm' (Brewster and Barthes use the same verb). For Barthes the photograph is 'a micro-version of death'. If early photographs called for an unnatural stillness, that made them, as Miller knew, similar to a kind of *tableau vivant*: living bodies participated in a drama where standing absolutely still and silent demanded the suppression of life-signs. While acknowledging photographs can be banal, Barthes writes shrewdly about the poetic quality they can possess, presenting an elemental image, like a haiku. For Barthes photographs offer a temporary sense of 'resurrection' (Brewster's term had been 'reincarnations'), but the photograph's essence is that it articulates a 'That-has-been'. It carries a 'melancholy', as if one listened to the recorded voices of dead singers.

Where Brewster, having struggled arduously with chemical processes, maintained that the photograph shows 'the very light which radiated from his [the sitter's] brow', Barthes in *Camera Lucida* emphasises that not painters but chemists invented photography. They made it possible to represent directly the luminosity given off by a variously lit object. Barthes refers to Susan Sontag's sense in the photograph of a missing being touching the viewer like the long-delayed radiance from a star. Photographs do not necessarily say *what is no longer*, but only and for certain *what has been*. Many critics and historians see concerns about geology, evolution and the enormously far-off beginnings of the earth as at the core of the unsettling of established belief systems in the nineteenth century. For Barthes it is the arrival of photography which 'divides the history of the world'.

Photographers are, willy-nilly, 'agents of Death' even as they present images of preserved life. For when we look at any photograph, but most obviously when we view early photographs, we realise that true life cannot be stilled without becoming dead. Barthes argues that the nineteenth-century inauguration of photography provided a new focus for contemplating mortality. 'Photography may correspond to the intrusion, in our modern society, of an asymbolic Death, outside of religion, outside of ritual, a kind of abrupt dive into literal Death.'[110] Brewster, writing – in his 'dead village' – of photography as an embalming medium, and one which presented a lost 'gleam which lighted up his eye', did not wish to relinquish religious belief. Quite the contrary. He was no Roland Barthes. Yet he clearly sensed in 1843 how the new invention with all its 'natural magic' brought with it a quickened intimation of mortality, an insistence on the significance of time, a disturbingly individual and local apprehension of the meaning of the end of the world.

Like Robert Chambers's work on what we now call evolutionary theory, Brewster's paean to photography is a product of his specific living environment – the people, streets, institutions and landscape around him. For by 1843 Brewster was already aware in very practical terms of what photography could do. Thanks to his presence, St Andrews in the 1840s became the first town in the world to have its people, monuments, and locale thoroughly documented by the camera. Rich in medieval and Reformation ruins, its identity as an architectural *memento mori*, a tiny, ravaged city of death, was intensified, but also given curious vitality through the work of its scientific and artistic investigators. To some extent the photographing of St Andrews was a deliberate project; the professors, historic buildings, and other local scenes were consciously and systematically captured. But the process was also accidental: produced out of experiment as well as design, the pictures, often gathered in family albums and dispersed as gifts, accrued in a haphazard fashion. Some are lost forever. Brewster's own picture hoard, which must have been 'one of the most interesting photographic collections ever assembled',[111] was destroyed in a fire in 1903; only the photographs he gave away to friends remain. Though they have tended to be written about separately, the group of surviving

albums of photographs from St Andrews along with individual extant negatives and prints give for the first time a picture of a town community and environment in the round.

The early St Andrews pictures cover mainly leisured middle-class life, but also include some images of working-class men and women – fisher folk, farm-workers, domestic servants. The St Andrews photographers set their cameras on top of walls, on the cobbles of the street, in gardens, on the edges of cliffs. They documented many aspects of local life – from the musical and the literary to the community's antiquarian, scientific, geological, golfing, fishing, and farming pursuits. At the heart of their recording were the great ruined monuments of St Andrews itself; in photographing these, they made intimate portraits of time. In the very year when Brewster articulated his sense of photography's acutely insistent *ubi sunt*, the new practice was at its most nimble locally. 1843 saw William Furlong, one of the youngest and most athletic of the St Andrews photographers, carry his bulky camera up the stone spiral staircase right to the top of the square, thousand-year-old St Rule's or St Regulus's Tower. There, high above the cathedral grounds, he had taken a panoramic shot of the town. Brewster soon sent a copy to Talbot.

> I enclose what I hope you will admire, a picture taken from the top of St Regulus's Tower here, 130 feet high. The steeple is that of St Salvator's College in North Street. The building in the centre is our New College. Over it is St Andrews Bay, and over that the mouth of the Eden. The negative was taken by Mr Furlong and the positive by me. It is too dark, but I have no better copy.[112]

The image looks along North Street in the direction of the long, pale line of the West Sands and the golf links. Towards the estuary of the River Eden, it fades off into infinity. By the time Furlong descended the tower, photographic images of St Andrews were already travelling round the world. An album of calotypes of St Andrews was exhibited in Tasmania as early as 1843.[113] Local people feature repeatedly in the pictures, particularly the Brewster and Playfair families; but many of the photographs are also conditioned, sometimes whimsically, by the

interests and affiliations of other members of the St Andrews Literary and Philosophical Society founded by Brewster. A photograph in the Brewster Album, now in the Getty Museum, Los Angeles, shows 'Mr Furlong' with Robert Adamson on the 'Bridge on the Kenly', a river near the Adamson family farm at Burnside, outside St Andrews.[114] Robert went on to photograph the Lit and Phil's burgeoning collection of taxidermied local wildlife, curated by his brother and photographic mentor, John.[115]

The St Andrews photographers made images of what they loved: their families, the ancient, heritage of their community, the geologically dramatic coastline. To picture these was to treasure them, and to relish not just a sense of sublime, sometimes oppressive, grandeur, but also an awareness of domestic intimacy and of inevitably passing time. As theorised by Brewster, photography suited this place so conscious of mortality among its haunting ruins and antiquities. If each photograph, like St Andrews, might be seen to speak of death, nonetheless, each was too – as Robert Frost would later say of poetry – a momentary stay against confusion. Brewster, like us, treasured also the access to familial moments that photography afforded. He was a battling public figure, a would-be martyr of science, fighting among the ruins and ravages of time; but his onslaught was supported by his faith and his family circle, most obviously by his daughter Maria with her sense of inspired spiritual conflicts 'mid St Andrews' fanes' beside a 'sea-girt . . . rough and rocky shore'.[116] However in the photographs of his circle we also perceive what his daughter signalled in the title of her book: *The Home Life of Sir David Brewster*. Principal Brewster may be solemnly patriarchal, and his sitters almost all reservedly bourgeois, but there is a winning intimacy about the minute care with which their lives are caught in long-gone St Andrews daylight: the texture of a dress, the polish on a chair which has been carried out into the garden of St Leonards, the lush climbing plants on a trellis.

3

Lit and Phil

ℭℨ

PHOTOGRAPHED, fêted, and fought against, Brewster was the commanding intellect who transformed Victorian St Andrews, but he did not do so alone. His intellectual gifts ran deep, especially in the area of optical science, yet they were also impressively wide-ranging. From poetry to history, religion to photography, editing to administration, Brewster epitomised the sort of figure mischievously dreamed up in the 1830s by his fellow Scottish polymath Thomas Carlyle: the 'Professor of Things in General'.[1] Still today in science as in the arts specialist skills and knowledge matter, but often so does a ready instinct for creative trespass. In the twenty-first century we might call this 'interdisciplinarity': but without needing to use this term, Brewster's St Andrews had its own very efficient ways of bringing together – formally and informally – people with varied intellectual interests. Sometimes these preoccupations were odd and the folk who held them were obscure; but often, thanks especially to Brewster's clever orchestration, these now-forgotten enthusiasts came to be connected with some of the greatest minds of the age.

On 7 January 1839, just days before Louis Daguerre's Parisian breakthroughs in photography were first reported in Britain, the 29-year-old Charles Darwin joined the St Andrews Literary and Philosophical Society. Still relatively little known, Darwin was about to publish his *Journal of Researches into the Geology and Natural History of the various countries visited by HMS Beagle* – the book that would make his name. In St Andrews it was soon read by several members of the Lit and Phil, and its first chapter refers to recent work by Sir David Brewster on a singular 'artificial substance resembling shell.'[2] Brewster

had founded the St Andrews Lit and Phil nine months earlier. He aimed to galvanise his community by assembling local people with an interest in science, and putting them in touch with internationally important scientific work, not least his own. St Andrews was late in the game in getting such an organisation. In the north of England the Newcastle Literary and Philosophical Society traced its origins to the 1790s, while the early nineteenth century saw the establishment of the Leeds Philosophical and Literary Society in 1818, closely followed by Lit and Phils in Hull (1822), Whitby (1822), York (1822), Bradford (1822), and Scarborough (1827).[3] These were part of a wave of such associations which had sprung up across Britain, attracting mainly local gentry and middle-class men with interests in learned pursuits.[4] The Edinburgh Philosophical Society had long since morphed into the Royal Society of Edinburgh, while the equally grandly named Royal Philosophical Society of Glasgow had been founded in a Glasgow pub in 1802. St Andrews must have seemed rather an intellectual backwater in not having its own Lit and Phil: Brewster remedied that with aplomb.

The St Andrews Lit and Phil was founded at a meeting in the old University Library (today called the King James Library) on 16 April 1838. The particular aim was to establish a museum at the university – exactly the sort of natural history collection that Brewster's former associate Robert Jameson had long presided over at the University of Edinburgh. The St Andrews gentlemen also had in mind 'the general object of promoting Literary and Philosophical research'. Several of them, including Principal Brewster, hoped the museum would lead to a St Andrews professorship in Natural History, a subject for which Jameson (soon one of their Corresponding Members) served as examiner at Edinburgh.[5] As one Lit and Phil member put it, Natural History was then understood to comprise several 'great divisions', namely 'Mineralogy and Geology, Botany, Zoology, and Comparative Anatomy'.[6] Darwin may have been recruited by Brewster as a natural historian, but possibly he joined as an 'Honorary and Corresponding' member simply because Charles Lyell, distinguished author of the multi-volume *Principles of Geology* (1830–33) and President of the Geological Society in London, joined at the same time. The

roll-keeper of the St Andrews Lit and Phil recorded Lyell's name as that of the Geological Society's 'President', followed by Darwin's as its 'Secretary'.[7]

Unlike the St Andrews society's founders – local academics, church ministers, doctors, lawyers, schoolteachers and other gentlemen – the future author of *On the Origin of Species* had only a passing acquaintance with the town's seaside streets. He had visited once in his teens. As a young man Darwin had studied at Edinburgh University for two sessions, where he 'listened in silent astonishment' to Robert Grant expounding 'his views on evolution'. Later, Grant became another honorary member of the St Andrews Lit and Phil. For all that he found Robert Jameson's 'lectures on Geology and Zoology . . . incredibly dull', Darwin had significant experiences in Edinburgh. With Grant he collected 'animals in the tidal pools' of the Firth of Forth. The young Darwin went trawling for oysters with some of the Newhaven fishermen whom he had befriended. In later years he also recalled how he had taken lessons in taxidermy in Edinburgh from 'a negro . . . who . . . gained his livelihood by stuffing birds . . . a very pleasant and intelligent man'.[8] Yet, though Scotland was important to his intellectual formation, the future Secretary of the Geological Society knew relatively little of the Kingdom of Fife, whose rural hills can be seen by anyone looking northwards across the shining Firth of Forth from the battlements of Edinburgh Castle. No correspondence from Darwin survives in the St Andrews Lit and Phil's scanty archives. The presence of his name among those of Brewster and the other members might seem an accident of history, so obscure it has gone unrecorded by the great Victorian scientist's biographers.

However, its inscription, along with the names of several others among the age's greatest minds, is emblematic. Here in the Lit and Phil's roll following a list of local clergy and their friends, was a litany of the scientific great and good. As well as now-forgotten scientists from Jamaica to Paris and from Berlin and St Petersburg to Stockholm and Ceylon there appear such luminaries as Sir John Herschel, who joined Talbot in pioneering photography; Brewster's old crony Charles Babbage, designer of 'difference engines' and nowadays regarded as the grandfather of computing; the great geologist Lyell; and, not least, the

man who became in 1840 the inventor of 'calotype' photography, Brewster's good friend William Henry Fox Talbot. Other names are recognizable for different reasons. Dr Robert Knox, listed as a Fellow of the Royal Society of Edinburgh, would soon be disgraced for his close association with the murderers Burke and Hare. But side by side with the notorious and the distinguished – the publisher Robert Chambers, 'His Highness The Rajah of Travancore', and a brace of Fellows of the Royal Society – are long-forgotten men such as the Reverend Brodie of Monimail, Secretary to the Literary and Philosophical Society in the nearby Fife market town of Cupar, or Mr John Bain of the local Bank of Scotland, university factor and 'most intelligent and accurate man of business'.[9]

The members of the St Andrews Literary and Philosophical Society were all male – gentlemen of some standing in the community; not until 1862 did the first woman matriculate as a St Andrews student. Yet, for the time, their Society was surprisingly democratic. New discoveries were being discussed across the land – by men, and, even if they were excluded from most learned societies, by women too. In the mid 1830s Lydia Fraser, having attended a public lecture in the north east of Scotland discussing 'carboretted hydrogen', went on to participate in a demonstration of electrical energy. She wrote to her fiancé, Hugh Miller, of how she was subjected to a shock from a 'voltaic pile', and then, alarmingly, felt as if her world was about to end. She experienced

a violent trembling from head to foot. The crowd faded from my sight and I became insensible to everything. Dr Macdonald called the affliction hysteria, and I suppose the effect was hysterical. Although not subject to hysterics, I know by experience what they are. But the sensation was altogether peculiar and unnatural. Oh, the horrible unnaturalness of it. I am yet far from perfectly restored. To procure sleep, I have been obliged to have resort for the first time in my life to laudanum . . . I was almost fixed in the belief that I was suffering under a temporary derangement.[10]

Lydia Fraser's intellectual curiosity and physical bravery were probably not unusual among nineteenth-century women, but few in Scotland

had the chance to develop scientific gifts. The Enlightenment had encouraged the founding of many societies, some learned, others resolutely drunken and bawdy. Almost all were exclusively for men. In St Andrews there was a Ladies' Society and a Female Society, but these were middle-class charitable associations linked to local churches, not intellectual clubs.[11] Male intellectual societies, however, encouraged some interaction between various professions and, to a limited extent, different classes. The St Andrews Lit and Phil's membership included local retired soldiers and farmers as well as university professors. Around the time of the Disruption it was also a place where ecclesiastical opponents might meet calmly to discuss matters other than doctrine. The terms 'literary and philosophical' covered a wide range of fields, illustrated by gifts to the developing museum, which ranged from geological specimens to musical instruments and artefacts from exotic places.

The natural history museum's curator, local physician John Adamson, had studied at St Andrews, Edinburgh and Paris before voyaging to China. He had returned to St Andrews at the age of twenty-six in 1835, the year the town's principal streets were first lit by gas in winter. Ranging widely in age and with several members having seen service in India, travelled in Europe, or toured the Far East, the Lit and Phil had a broad spectrum of cosmopolitan experience to match its eclectic interests. Its members rode or strode determinedly to meetings through winter winds that made the climate 'too sharp and penetrating for rheumatic constitutions', then through the 'regular monsoon' of spring that brought the haar which 'obscures the light of the sun, checks vegetation, and has a most unpleasant effect on the human feelings'.[12] Waiting eagerly for summer sunshine, they were a dedicated, educated fellowship, about a hundred in total; roughly a quarter of their number attended an average meeting. The Lit and Phil also had an engaged local focus on its ancient native place. Though officially their president was the Right Honourable Lord William Douglas, a distinguished scientist and Fellow of the Royal Society, usually Vice President Brewster led the proceedings. His vision was thoroughly international, his local commitment unwavering. At the second meeting of the new association he stated that a focus of the group would be the study and

preservation of the antiquities of St Andrews itself. At the meeting of 7 August 1838 the updated guidebook, *St Andrews as It Was and as It Is*, in whose compilation Brewster and several other Lit and Phil members had assisted, was 'laid upon the table' during the society's Antiquarian Committee's report delivered by Dr Thomas Gillespie.[13]

St Andrews needed preservation as well as renovation: for all its venerable antiquities, it stank. Rotting fish, seaweed, and bad sewage made several of its streets insalubrious. Perhaps it was no worse than other early Victorian fishing communities, but St Andrews differed from most in that very close to its fishermen lived neighbours – professors, teachers, doctors and the like – who might have relished the Romantic situation and the historic monuments but who also worried about the filthy state of parts of their town. The place risked becoming unsustainable, a fading burgh of rot. It was the home of the third oldest university in the English-speaking world, but St Andrews in the 1840s looked miniscule. An 1838 map shows just three principal streets, somewhat unimaginatively called North Street, South Street, and Market Street. Almost parallel, they gradually converge (as they have done since at least the twelfth century and still do) in the direction of the ruined cathedral, North Street to the north, South Street to the south, Market Street right in the middle. Linking these thoroughfares or running off them at various points was a series of lanes or wynds: Baker Wynd, College Wynd, Heuksters Wynd and others. St Andrews was a place of ruins, bad smells, fish guts, golf, seagulls and education. Castle Wynd led to the derelict medieval seafront castle where Knox and his Protestant forces had been besieged in the mid sixteenth century by Catholic rivals who had hauled great ordnance up the cathedral towers and the spire of St Salvator's chapel, in order to bombard their enemies. With three annual fairs, its weekly Monday market for corn and its Wednesday and Saturday markets 'for butter, eggs, poultry, &c.', the town might now seem peaceful, but its vehement preachers had long orated about the beginning and the end of the world, and its citizens, not least David and Maria Brewster, rather relished this blood-soaked municipal past.[14] One of its early Reformation martyrs had been Patrick Hamilton, set alight in North Street in the 1520s on a pyre in front of St Salvator's College. Knox recorded

how a brass ball had been placed in the mouth of another, the fifteenth-century Bohemian Pavel Kraver (called in Scots 'Paul Craw'), to stop him crying out heresies as he endured his burning in Market Street.

In Brewster's day the Scores Walk, named after the 'scaurs' or cliffs near the castle, led along picturesque coastal fields towards the Butts. On these seafront hillocks Renaissance students had set up 'butts' or targets for archery contests, their prize a silver arrow. Like many of the place names, the famous buildings of St Andrews spoke of the past – of grey friars and black friars, old mills, burial grounds, and abbey walls. Some houses on College Wynd had been inhabited since the 1530s. Still in use today, the North Street lodgings of sixteenth-century Scoto-Latin student-poet James 'the admirable' Crichton (famed for his wide-ranging intellect, but killed in a sword-fight in Mantua while still in his mid twenties) were lived in by St Andrews undergraduates. Witch Lake, a sea-cove near the Butts, was a reminder that Fife had once been notorious for witch trials.

By the time the Lit and Phil was founded, though, the witches were long gone. Near the Butts, thirsty Victorian students tried to sneak into a low, cottage-like pub, one of the few buildings along the Scores. Beyond lay Pilmour Place and the grassy 'links', today best known as the 'Old Course', the celebrated 'home of golf'. To walk from Brewster's house at St Leonards beside the cathedral to the links at the opposite end of town took fifteen minutes. To stroll down the tree-lined drive from Robert and Anne Chambers's family home at Abbey Park, past the fields of the Glebe and down East Burn Wynd to the Brewster family home on the right, or to the centre of town, the medieval Town Church or the Townhouse in the middle of Market Street, took about five minutes. Then as now it was impossible for residents to walk through St Andrews without encountering familiar faces. Often Brewster and Chambers must have met each other by chance, and nodded to other members of the Lit and Phil like John Adamson, who lived in a fine house in Market Street; or the banker Bain, from whom the Lit and Phil borrowed £30 in 1842 to help it on its way; or several of the teachers from Madras College, the academy set behind ruined Black-friars Chapel in South Street, and which had been completed in 1834 thanks to the welcome philanthropy of Andrew Bell. A St Andrews

citizen, Bell had prospered in India where he had pioneered the 'Madras system' of education which encouraged older pupils to help teach younger ones.

Proud, unsanitary and ancient, the town was also tinged with modernity. Of an 1840s local educational improver it was said, in memorably inept verse, 'He made the Madras flare up like gas'.[15] Not far from the cathedral, near the mill by the road to the busy fishing harbour, was a 'Gas Work'. Another, more attractive recent building, Abbey Park itself, signalled the start of a Victorian construction programme. Encouraged by Provost Hugh Lyon Playfair, this would transform the town into a leading seaside resort. At the start of the 1840s, however, there were persistent worries about smells: not just seaside niffs, strong when winds blew them in and thick haar clung to the buildings, but other stinks too. A brewery stood just off South Street, near the West Port, the ancient entrance to the town. Up until the 1830s the street now called Union Street had been 'The Foul Waste', a hint, if any were needed, that local drains were dire. Odours, especially when associated with the lower classes, continued to disturb some of the town's better-off citizens, not least members of its Lit and Phil. Dr Adamson published two reports on the town's sanitation, hoping it might soon be improved. For the moment, though, a site of fine ruins and compromised grandeur, St Andrews was losing some of its charm. Especially in malodorous hot weather.

Some people did their best with the pongy marine environment. The fishermen, a law unto themselves, doggedly and dangerously put out to sea. On land other working-class men manufactured golf-balls and golf-clubs or harvested mussels; fishwives carried marine produce and sometimes kindling in great wicker creels bound to their backs, often bent double battling against North Sea winds. In Anstruther, a fishing community south of the town, the eccentric Alexander Batchelor had decorated the external (and several internal) walls of his home by coating them entirely with sea shells. Enthusiastically ornamented, 'the shell house' can still be seen, though the elaborately shell-encrusted coffin in which Batchelor elected to be buried has not yet been unearthed. The environment around St Andrews, as elsewhere, was a resource, exploited in sometimes unusual ways physically and

intellectually. Frustrated because local residence denied him access to a major hospital, Lit and Phil member Dr John Reid turned to microscopic investigations of 'the structures and actions of some of the Zoophytes obtained from the shore of the bay of St. Andrews' and peered at polyps that grew 'close upon low-water mark'.[16]

Inland, just up the hill towards Craigton, were substantial coal mines. Mining in surrounding areas often unearthed curiosities which (some said) dated way back to the very beginning of the world. The guidebook *St Andrews as It Was and as It Is* called attention to what looked like substantial fossil deposits in the town's seafront cliffs – 'curious specimens of trees and antediluvian vegetables'. Fossils often led to controversy about how to interpret the biblical story of creation.[17] Local minister and Lit and Phil member Charles Lyon was familiar with Lyell's *Geology* and wrote that in some parts of the cliff near the Butts

> and among the rocks at its base, fragments of what are considered tropical palm trees are found in a state of petrifaction. Towards the south-east, at what are called the 'Kinkell Braes', the most singular convolutions and windings of the strata may be observed; while in some spots, the hardest rocks and the most friable sandstone are found side by side, containing vegetable and fossil remains.[18]

Such fossil remains were of considerable interest to the gentlemen of the Lit and Phil. 'Mineralogical specimens' and 'fossil remains' helped draw visitors to its museum, to which 'the public receive[d] ready access'.[19] The first of its Honorary and Corresponding Members, the Reverend Dr John Anderson of Newburgh in Fife, had discovered in the possession of a local woman fossils dug up by workmen 'excavating a water-course for a mill' at Dura Den, about ten miles from St Andrews. 'In these forty yards there were found several genera of fishes new to geology, and not yet figured nor described'. Anderson was particularly interested in one of these fossils, that of the *Pterichthys*, which he was convinced was no fish but 'must have been surely a huge beetle'. Hugh Miller wrote up Anderson's discovery in his popular and stylish geological study, *The Old Red Sandstone, or New Walks in an Old Field*

(1841). By that time the great palaeontologist Louis Agassiz had confirmed Miller's suspicions that the fossil was indeed a fish. Reconstructing or imagining primeval life-forms on the scanty basis of fragmentary remains dug up by workmen could be an intellectually risky business, even if it was just the sort of thing that appealed to eager Lit and Phil members and wider Victorian audiences. Miller had fun with Anderson's artistically enhanced arguments about the Dura Den discovery:

> As a beetle, therefore, he figured and described it in the pages of a Glasgow topographical publication, – *Fife Illustrated*. True, the characteristic elytra [hard wing-cases] were wanting, and some six or seven tubercled plates substituted in their room; nor could the artist, with all his skill, supply the creature with more than two legs; but ingenuity did much for it notwithstanding; and, by lengthening the snout, insect-like, into a point, – by projecting an eye, insect-like, on what had mysteriously grown into a head, – by rounding the body, insect-like, until it exactly resembled that of the large 'twilight shard', – by exaggerating the tubercles seen in profile on the paddles until they stretched out, insect-like, into bristles, – and by carefully sinking the tail, which was not insect-like, and for which no possible use could be discovered at the time, – the Doctor succeeded in making the *Pterichthys* of Dura Den a very respectable beetle indeed.[20]

In the St Andrews Lit and Phil eccentricity, enthusiasm and serious intellectual enquiry met. In the case of Dr Anderson's beetle, they all came together at once.

Pursuing intellectual enquiry and vigorously spurred on by Brewster, the society's members could act at times as an environmental pressure group. In December 1839 they forwarded a petition to the Commissioners of Her Majesty's Woods and Forests, arguing successfully against the sale to private individuals of the communally treasured Abbey Wall with its medieval gateways and towers. The signatories worried such a privatisation would herald the destruction of the cathedral boundaries and so spoil their local heritage.[21] The Lit and

Phil's keen concerns with antiquarianism, local improvement, geology and what we would now call 'ecology' are all bound up with the energetic documenting of St Andrews through the promising new medium of photography.[22]

The society also discussed statistically analysed mortality rates and illnesses among the present-day St Andrews population, speculating about how conditions might be improved. Scrutinising the flora and fauna of the area (in 1838 John Adamson gifted to the society '20 aquatic Birds from St Andrews Bay'), the Lit and Phil combined close attention to the surrounding environment with further-reaching interests in geology, chemistry, and experimental science.[23] The society maintained wide horizons, and nothing signals its alertness to exciting discoveries more clearly than its eager awareness of the arrival of the new medium of photography. Thanks to Brewster, Chambers, and others, there was considerable public interest in photography as soon as news of Daguerre's invention reached Scotland at the start of 1839. On Wednesday 16 January the *Scotsman* newspaper outlined this 'New Method of Taking Views from Nature', explaining how 'M. Daguerre has invented a process for fixing the picture formed on the table of the Camera Obscura'. Quoting a translation from the French *Journal des Debats*, the *Scotsman* explained the new technology in terms of an older one its readers knew well:

Every one knows the effect of the Camera Obscura, by which external objects are delineated in miniature upon a white ground, by means of a lens. Now a better idea of M. Daguerre's discovery cannot be given, than by observing that he has succeeded in fixing on paper the representation of external objects thus produced, with all their degradations of tints and colours, delicacy of lines, rigorous exactness of form, perspective, and different tone of light. Whatever may be the extent of the picture, ten minutes or a quarter of an hour, according to the brightness of the day, is sufficient to produce it.[24]

Daguerre's announcement shocked inventors round the world. In America that April the portrait painter Samuel Morse (who later devised the electric telegraph) confessed his failure to perfect a related

process, and turned instead to helping introduce Daguerre's technology to the United States.[25] For others the Frenchman's breakthrough, derived from work by his mentor Joseph-Nicéphore Niepce, came too late. Researches into photography had a long history in Scotland. Years before moving to St Andrews, the young Brewster 'gave a notice' in 'a Scottish Journal, so early as 1803' of Thomas Wedgwood's experiments with images on glass. Even earlier the 'ingenious and lively' Elizabeth Fulhame, wife of an eighteenth-century Edinburgh surgeon who had studied with the great Scottish Enlightenment chemist Joseph Black, had scandalised some with her scientific work on combining metals and chemical processes to produce images formed by light. Encouraged by London's Joseph Priestley, she had published her 1794 *Essay on Combustion, with a View to a New Art of Dying and Painting*; but her work, famous in its day, was soon ignored.[26]

To other Scottish researchers news of Daguerre's success led to the abandonment of dreams. In 1837 Brewster's fellow Borderer Ambrose Blacklock of Dumfries, then aged twenty-one, had been 'engaged in inventing and perfecting a process of the same description'. Blacklock was reported to have sent 'a short notice of his discovery' to London's *Athenaeum* magazine in early 1838. By 1839 he was showing examples of his experiments to a *Scotsman* journalist who recorded that 'We have before us a page of Boerhaave's Chemistry, copied by his process, and lithographed by himself, and nothing can be more minutely correct. He can take an exact impression of a drawing, a page of a book, or other object, and transfer it to stone in ten minutes.'[27] Scooped, having qualified for the diploma of the Royal College of Surgeons in Edinburgh and published an 1838 treatise on sheep, Blacklock emigrated to India. After an impressive colonial medical career, and the Dumfries publication of his scientific study of cholera, he died at Chittoor in 1873.[28] News of Daguerre's invention came too late for Fulhame and scooped Blacklock. As Robert Chambers knew, it also surprised other British researchers. In *Chambers' Edinburgh Journal* for 30 March 1839 he published an account of 'Painting by the Action of Light'. Though unnoticed by most historians of photography, this was the first substantial account of the topic printed in Scotland outside newspaper reports.[29] *Chambers' Edinburgh Journal* knew that 'painting by the

action of light' was likely to capture its readership's attention, just as it was entrancing the St Andrews Lit and Phil. The *Chambers'* piece signals the popular appeal of the new medium as surely as does the title of Robert Hunt's *Popular Treatise on the Art of Photography*, published in Glasgow two years later.

While it does mention 'a Frenchman named Daguerre', the *Chambers'* article situates photography principally in an English lineage. Mentioning experiments by Wedgwood and chemist Humphry Davy, it concentrates on the 1830s work of 'Mr. Henry Fox Talbot, F.R.S.' in the area of 'Photogenic Drawing'. This was the experiment-based scientific paper whose publication in Brewster's *Edinburgh Journal of Science* in 1826 had led to Talbot's friendship with Brewster. The article in Chambers's magazine depends heavily on Talbot's *Some Account of the Art of Photogenic Drawing*, a paper read before London's Royal Society on 31 January 1839. Published in full in the *Athenaeum* of 9 February, then as a pamphlet, this paper is recognised today as 'the first separate publication on photography'.[30]

Chambers' Edinburgh Journal in early 1839 championed Talbot's work as 'a very wonderful discovery', and encouraged 'further experiment'.[31] Brewster and his friends in the Lit and Phil had already taken up the challenge. The Lit and Phil minutes show that at the meeting of 4 March 1839 members were among the first in Britain to scrutinise 'specimens of drawings executed by Mr. Fox Talbot, by the Photogenic paper by the Solar Rays'. Brewster was corresponding about these not only with Talbot but with Scottish scientific researchers including Brewster's protégé, the Edinburgh University professor James David Forbes.[32] Still, it was Daguerre's work that was widely regarded (for example by the *Scotsman*) as 'infinitely more perfect' than anything achieved in Britain. At the end of spring 1839, Forbes viewed some of Daguerre's pictures in Paris, struck by how they 'surpass all belief'.[33] That summer Dr Andrew Fyfe, lecturer in Chemistry and Professor of Medicine at Edinburgh, published a 'very clear and interesting account of the British process . . . with some improvements of his own' in the fifty-third issue of Robert Jameson's *Edinburgh New Philosophical Journal*. However, in July it was the same magazine's article on Daguerre's work (written by the Royal Society of Edinburgh's

Secretary, Sir John Robison, who, like Fyfe, had been lecturing to the Society of Arts in Edinburgh on the topic in March 1839) which was quoted extensively in the *Scotsman*. Its journalist realised the terminology for the new process was still in flux:

> Of the two terms employed to designate this new art, 'Photographic' and 'Photogenic', the latter, which means 'created by light', or 'born of light', is the more correct when used adjectively with the word 'Drawings' or 'Pictures'. But 'Photogeny', used as a substantive, would be unsuitable, as it might be applied to many objects in nature, unconnected with the art in question. 'Photographic', which means 'drawn or delineated by light', will therefore probably be preferred.[34]

Calling his article 'Photography', this journalist got it right. Yet the terminology remained fluid. *Scotsman* readers were given a further detailed account of the daguerreotype on 28 August 1839, by which time J. S. Memes, an honorary member of the Royal Scottish Academy of Fine Arts, had completed his translation of what was called in English the '*History and Practice of Photogenic Drawing on the True Principles of the Daguerreotype* . . . By the Inventor, L. J. M. Daguerre'. Memes's translation was published in Edinburgh by Adam and Charles Black on Saturday 21 September, a few weeks after the *Scotsman* had mentioned the presence of Brewster and Talbot at the August meeting of the British Association for the Advancement of Science.[35] All this shows how much interest in photography there was in a Scotland where Talbot's pictures were circulating but Daguerre's work prompted the most immediate enthusiasm.

In the 1820s Daguerre had created a striking oil painting of Edinburgh's 'Holyrood Chapel by Moonlight', for which he was awarded the French Legion of Honour. A version of this painting of the Scottish abbey still exists, and shows an eye for picturesque ruins.[36] Daguerre may be best remembered as a photographic pioneer, but he was also a painter. A few years after the first announcement of his photographic breakthrough, audiences flocked to The Diorama in Edinburgh's Lothian Road to see his painting 'The Village of Thiers', a

work 'unapproachable by all attempts that have been hitherto made at imitation'.[37] By then, in 1843, many, many daguerreotypes had been taken in Britain. Yet the most exciting work involving the calotype invented by Talbot had been undertaken in the unlikely setting of St Andrews. Though some aspects of these stories of the Lit and Phil have been examined by scholars, others have been overlooked. Like the parts of Brewster's kaleidoscope, they are far more entertaining, enlightening, and revelatory when combined than when left scattered.

The Lit and Phil's meetings were held in the university's Humanity classroom; then as now the word 'Humanity' was used in the ancient Scottish universities to mean Latin. Modern readers will get a sense of the Lit and Phil's membership from an account of a few of the characters who sat on the Humanity classroom's dark wooden pews on the night of 7 November 1842 when Robert Chambers was elected as an ordinary member.[38] Thomas Gillespie, the ageing St Andrews Professor of Humanity, some of whose recollections were published by Chambers, and who liked to recall in his childhood having seen Robert Burns listening to an old, pipe-smoking woman singing Scots songs in Dumfriesshire, was a minor poet, wit, and storyteller. 'Stout and stiff in his person', he sat at Lit and Phil meetings, 'his chin buried in his neckcloth, and his spectacles spread upon his breast'.[39]

Though 'Literary' in the Lit and Phil's title indicated all sorts of learned interests, Gillespie was also a 'literary' man in the modern sense of the word. Another, more distinguished poet was a fellow member. Gillespie's colleague, William Tennant, in his witty description of Fife festivities in his frisky poem 'Anster Fair' (republished by W. and R. Chambers in 1838 and still available today), is said to have encouraged Byron in his choice of stanza form for *Don Juan*. Professor of Oriental Languages at the university, Tennant also authored the more solemn 1840 *Synopsis of Syriac and Chaldaic Grammar*. He had trouble attending Lit and Phil meetings, and could be discerned approaching some way off: 'You hear the sharp stroke of stilts, and on looking round you see the Professor swinging on his crutches, for he is lame in both feet; his hat is tied by a ribbon under his chin, and his happy face is rosy with buffeting against the wind.' Tennant was lively. Students relished the oratory of his lectures, which he wrote 'first on a slate before he

transferred them to paper'.[40] In his verse, liberally quoted in *St Andrews as It Was and as It Is*, he presented the Reformation carnage in beautiful 'Sanct Andrews town' with its 'sindry steeples, shootin' high, | Amid the schimmer o' the sky'. Long connected with the Fife coastal village of 'Ainster' or Anstruther, Tennant radiated humour as well as intellectual passion. Remembered as 'a large, red-faced man full of quiet fun', at his best he could bring the two together with mock-heroic dash: 'My pulse beats fire – my pericranium glows, | Like baker's oven with poetic heat'.[41]

Tennant associated St Andrews with an 'incessant whirl of parties and feasting'. An old friend urged Chambers to put the professor 'fairly in dalliance with the Comic Muse again', but the grammarian-poet was keener to send manuscript poems to W. and R. Chambers on po-faced biblical topics such as 'The Hebrew Heroines', while Tennant's younger brother, David, regularly regaled Lit and Phil members with lengthy, detailed accounts of his local meteorological observations.[42]

Major Playfair, a member of the council, participated in Robert Chambers's election. Then aged 56, Playfair, like several other members, had retired to the town after years with the Honourable East India Company Service. In the chair at the meeting which elected Chambers, Brewster, as usual, spoke a lot. He tended to dominate proceedings, his manner sharp and decisive as his rapid, determined handwriting. His way of speaking (recorded at length by inspectors who visited the university in 1840) may not have been that of a confident orator, but could seem nervously autocratic.

By 1842 his fellow Lit and Phil members were very used to participating in photography. Brewster later admitted that his 'dealings with light' had made the invention 'a sort of monomania'.[43] The previous year had seen several presentations of 'New specimens of Photography', while Edinburgh instrument-maker Thomas Davidson had twice visited the Lit and Phil with his 'Daguerre's apparatus', discussing portraiture and exhibiting 'the process itself by taking a view of the New College Buildings'. He had worked too with Major Playfair on 'numerous specimens'. In July 1841 Brewster exhibited 'many fine specimens of Calotype or Photographic Pictures, and explained the Process by which they were executed'. The photographic historian

Graham Smith, who has traced this continuing theme through Lit and Phil meetings, points out that in July 1841 Talbot was elected an Honorary Member of the society, and that Brewster and Playfair went on regularly exhibiting their own and others' photographs at meetings between 1841 and 1845.[44] True to the society's blending of science and art, Brewster liked to regard the photographer as able to 'exhibit and fix in succession all those floating images and subtile forms which Epicurus fancied, and Lucretius sung'. Brewster could quote the relevant lines of Lucretius in Latin, though also in an English translation, coming to link photography to the ancient poet's

> images of things,
> Which like thin films from bodies rise in streams,
> Play in the air and dance upon the beams. –
> A stream of forms from every surface flows,
> Which may be called the film or shell of those,
> Because they bear the shape, they show the frame
> And figure of the bodies whence they came. – [45]

At the November 1842 Lit and Phil meeting several professors from Königsberg were elected Honorary Members. Brewster read to the men in the Humanity classroom a substantial letter from Professor Moser of Königsberg outlining 'an abstract of his discoveries relative to the existence of *Latent Light*'. Moser's experiments had led him to conclude that a portion of light became latent when any liquid was converted into a vapour. He argued that 'the same light is disengaged when the vapour is condensed'.[46] Brewster explained that these results might have various applications to the new practice of photography. Because he was in contact with Talbot, Lit and Phil members had access to much of the latest thinking about these new 'sun pictures'. The surviving manuscript of the society's minute book records that as well as detailing theories about 'the double refraction of light' then being formulated at Trinity College Dublin, Brewster explained to Chambers and his other November 1842 listeners that 'in the course of taking *positive calotype photographs*, he was led to the fact that in many of the results attributed by some to *latent light* and by others to *heat* the effect was produced by

the absorption of matter in a state of vapour passing from the object to the surface of the glass or metal upon which the image of that object was impressed'. Whether all his hearers understood what Brewster propounded is debatable. However, they were delighted by the pictures associated with these investigations. Though we cannot say which pictures were exhibited at the conclusion of the meeting, we do know that for some time Brewster and his friends had been adept daguerreotypists, making also their increasingly accomplished calotypes of St Andrews, the surrounding area, and of a number of members of the Lit and Phil.

In England Fox Talbot often photographed his country estate and made occasional visits elsewhere, while on the continent daguerreotypists photographed parts of Paris or travelled to the sites of great antiquities in Egypt, Greece, and Italy, producing such grand albums as Nicolas Marie Paymal Lerebours's *Excursions daguerriennes* (1840–44).[47] Most of the St Andrews photographers, however, concentrated on scenes and people in their small town: it is this concentration which makes St Andrews the first town to be so fully documented through the new visual medium. The Lit and Phil photographers' preoccupation with St Andrews may have been conditioned by the ready availability of local expertise and subject-matter as well as by relative geographical isolation, but was not small-minded. The photographers' powerful attachment to their families and to their historic locale, their mutual intellectual, scientific and technical support network, and the fact that St Andrews with its architectural antiquities was just the sort of place many early, artistically minded photographers – daguerreotypists and calotypists – favoured; all helped place St Andrews at the forefront of the development of photography. An intense fidelity to the local and a passion for photography allowed members of the St Andrews Lit and Phil to turn their small town from a stinky backwater into a tiny city of light.

Now regarded as masterpieces of early photography, photographs taken by those associated with the Lit and Phil are in the Getty Museum, Los Angeles, the Metropolitan Museum and the Museum of Modern Art in New York, and are distributed across others of the world's great collections of early photography, including the celebrated

collection of the National Galleries of Scotland and the larger, remark-able but much less well known holdings of St Andrews University Library. From the outset such pictures were appreciated not only as scientific curiosities but also as works of art. The Lit and Phil minute of the 7 November 1842 evening meeting concludes by noting enthu-siastically that 'Major Playfair, Mr John Adamson and Sir David Brewster exhibited to the society some beautiful specimens of Photo-graphy.'

Having seen these, and subsequently watched Brewster's evanescent portrait appear then disappear as a plate of glass was breathed on at the 30 November meeting, Robert Chambers's interest in photography quickened. So did his interest in the Lit and Phil. On the same day, he heard the distinguished mineral analyst Arthur Connell speak. Connell taught Chemistry at the university, and his class, compulsory for graduating Arts and Medicine students, included 'a short outline of the subject of Light' after which 'the nature of its chemical agencies is pointed out, and their application to Photography in its different branches'.[48] Perhaps he was the world's first professor to lecture on photography as part of a university course. On 30 November, however, he spoke in detail not about photography but about the medicinal spring at the East Bay in St Andrews. As Connell's work developed into a wider-scale analysis of organic matter in spring waters, Chambers arranged for a report of his findings to appear in *Chambers' Edinburgh Journal*, where mention is made of Connell's account given 'at a recent meeting of the St Andrews Literary and Philosophical Society'.[49] More immediately and more prominently, less than a month after Brewster had outlined the German Professor Moser's theory of latent light to the Lit and Phil and had related it to calotype photographs, Chambers devoted the leading article of *Chambers' Edinburgh Journal* to a de-scriptive account of 'Natural Daguerreotyping'.

The Lit and Phil was superlatively 'networked'. Information, the-ories, and news of inventions flowed out from its meetings, as well as coming in from the greater world. In contemporary periodicals such as *Chambers' Edinburgh Journal* scientific material was published alongside what we would now call creative writing, and these two categories permeated each other. Similarly for Lit and Phil members in St

Andrews and elsewhere the sciences and the arts were part of a continuum. In the manuscript on which he was working in the early 1840s Robert Chambers links 'the man of letters' and the 'cultivator of science'. Chambers, in his own person, like many other nineteenth-century thinkers and writers – Lit and Phil members included – combined these constantly. In a small university and a small community such as St Andrews it was and probably still is easier to make such connections than in a much larger, more diffuse society. Poets as well as scientists had set up the Lit and Phil. They shared enthusiasms – the fiction of Walter Scott and Fenimore Cooper, electricity, prehistory, authorship, municipal improvement, photography. Chambers, Playfair, Brewster, and their circle did not devote themselves to any narrow conception of intellectual life. The arts mattered to them, and it should not be assumed that science was always the driving force. After all, they saw photography as an 'art' as well as a scientific topic. Major Playfair may have taken out from the University Library works on chemistry and optics, but he also borrowed that most famous of all artistic critiques of misguided science, Mary Shelley's *Frankenstein*.[50] Pieced together out of all sorts of scraps of knowledge, the proceedings of the Lit and Phil, like the heterogeneously assembled manuscript on which Chambers was working, could be seen as a kind of intellectual Frankenstein's monster. Yet at its best the society was a far-reaching intellectual community, and one whose preoccupations had a subtle but lasting effect.

So this was the intellectual gathering to which Robert Chambers was first welcomed by Brewster on 7 November 1842. Part of the reason that Chambers joined the Lit and Phil was to seek out stimulating society: to mix with interesting and like-minded people. In private he and his wife Anne feared that overwork might have upset his mental balance. His need to find sympathetic companions was part of a conscious effort to cure himself of these afflictions. He returned to the next meeting on the 30th of the same month, the ancient feast-day of Saint Andrew, Scotland's patron saint. For all Chambers's mental troubles, and the perturbation over a close friend's bereavement which next day prompted his anguished question, 'The human life – the human hopes – what are you?', clearly he was making a positive

impression.[51] The secretary of the meeting was so struck by him that he entered Chambers's name twice in the list of those who had attended. He also recorded that Chambers was elected to the society's council, as new councillors were proposed to replace those, like the elderly Thomas Gillespie, who had served their time. Major Playfair had now joined Brewster as among the three vice presidents. Dr John Adamson continued as curator of the developing museum. At every meeting the society's members and associates added specimens to this curious collection. Anne Chambers, a keen and accomplished musician, had donated an Indian harp – gratefully received by the meeting at which her husband became a member. The St Andrew's Day minutes show the society's motley hoard had just been augmented by the 'Robe of a Mandingo Chief'; by a 'Candlestick found in the ruins of the Amphitheatre at Syracuse'; and by 'specimens of lava, fossil shells, and minerals from various parts of the coast of the Mediterranean Sea'.

At the same St Andrew's Day meeting a letter was read from Dr Buist of Bombay, a man with St Andrews connections who proposed an exchange of geological specimens of the coal formations of Fife for a corresponding number of Indian rock samples. If it was fascinated by the vast chronological perspectives of geology and prehistory, the society's intense interest in the new phenomenon of photography also gave it a concern with the minutely transitory and ephemeral. Viewed through the lens of geology, nature was unimaginably ancient; yet, as Brewster's photographic interests indicated, it was also arrestingly fleeting, present just for the duration of a breath.

By 1844 when Brewster ordered Talbot's photographic publication *The Pencil of Nature* for St Andrews University Library, there were already several albums of St Andrews photographs collected.[52] The circle of photographers around Brewster recorded their families taking part in treasured activities: Miss Brewster reading; Major Playfair with his cello; James Thomson (son of a Lit and Phil luminary) with sheet music and a violin. Several of the earliest albums of St Andrews photographs can be connected with members of the Lit and Phil. The Lyon family album belonged to the family of the Reverend Charles Jobson Lyon, Episcopal minister in St Andrews, one of the Lit and Phil's founding council and a man distantly connected to Hugh Lyon

Playfair whose own photographic output was pioneering and considerable.[53] Lyon, whom that champion of the rival Free Kirk Brewster considered 'a zealous antiquary', published his *History of St Andrews* in 1843, anxious, like the St Andrews photographers, 'to revive, as far as possible, the memory of what is gone', and (unlike Brewster) horrified by the *'puritanical democracy'* of the Disruption which he related to the 'fanaticism' of earlier eras.[54] A further St Andrews dynasty, the Govans, included the Lit and Phil member Dr George Govan (another former employee of the Honourable East India Company Service) and Alexander Govan, the proprietor of Govan's the chemists, where several Lit and Phil members purchased chemicals necessary for their photographic experiments. The Govan family album, containing photographs by Alexander Govan, Major Playfair and others, is now preserved among the early photographic treasures of St Andrews University Library. In the photograph of James Thomson by John Adamson in another of these volumes, the Brewster family album (now in the Getty Museum), the exposure may have bleached the music from the pages of Thomson's music book, but the same strong light makes the violin shine, catches the finely chequered suit of the sitter, glows on his swept-back hair.[55]

The best of these portraits of 1840s St Andreans have, like the Lit and Phil itself, a quirky, beckoning inclusiveness that is very hard to resist. The people in some of the early topographical photographs may be present principally to give a sense of spatial and temporal scale to the town's antiquities, so that they seem diminished in comparison with the power of hewn stone and geological formations. Yet in group pictures taken in the Brewster family's garden or in individual portraits – some blurred or faded, others remarkably pristine and characterful – people are present in all their individuality. These images remind us how even as humanity seemed to be being decentred by sciences like geology and cosmology, it might also be rendered special through a new world of alliances between science and art. Frozen in a moment, people were subjected to a tiny death. Yet, in being so 'embalmed', their transitory experience might be treasured as never before. If photography functioned for Brewster and others as a *memento mori*, it was certainly one that could be lived with.

The amalgam of disciplines involved in the Lit and Phil may seem odd. Nonetheless, relationships between them are easier to perceive now than they may have been at the time. It is not quite clear how a photograph (now in the Govan Album), believed to be the 'first American calotype' and depicting a wooded hillside, entered the collections of the local community, but it was surely linked to the Lit and Phil's far-flung network.[56] Perhaps aware that Enlightenment St Andrews had been one of the first universities in the world to teach literary texts in English (the academic subject that we now call 'Eng. Lit.' was then called 'Rhetoric and Belles Lettres'), and certainly true to his passion for internationalism, Brewster brought to St Andrews a little later in the 1840s the Shakespearian scholar William Spalding who, as the university's Professor of Logic, Rhetoric and Metaphysics, became the first teacher of American literature at a British university. Spalding joined the Lit and Phil in 1845.[57] Another of Brewster's distinguished academic appointees was the philosopher James Frederick Ferrier, who became a member of the society in 1846. He deserves to be remembered as the St Andrews professor who coined the word 'epistemology' – soon an internationally used term, and one peculiarly appropriate to the ambitious intellectual scope of the Lit and Phil.[58] Ferrier also coined the term 'agnoiology', the science of knowing nothing. Sadly, that did not catch on.

If some of the terminology used by the Lit and Phil's members is now common currency, other contributions were much more local in their influence, yet, at the same time, no less distinctive. Probably because several teachers from Madras College joined, not just that school's buildings but several of its staff feature among the early St Andrew photographs. One of the most striking shows George H. Gordon, the Madras College writing master, who later emigrated to Louisiana but who was photographed before he left Scotland by John Adamson's brother Robert, working with David Octavius Hill. Bow-tied, bespectacled and mutton-chopped, young Mr Gordon sits confidently on an elaborately carved chair. His dark jacket open over his pale breeches, he holds a quill in the fingers of his left hand as if writing on the parchment by his side. Nevertheless he looks away from his pen, in statuesque contemplation. Perhaps it is simply that his eyes are

narrowed against the sunlight catching the metal fob-watch chain in front of his dark waistcoat, but his pose looks imposing and thoughtful. Though not a member, he has a serious expression summing up what was best about the Lit and Phil which included several of his colleagues. He emblematises the thinker and author, poised for a moment between words.

For evidence of the way the interests of the Lit and Phil permeated the wider life of the burgh of St Andrews there is no better example than Thomas Rodger. Born in 1833, the son of a local house-painter, Rodger began his studies at Madras College, where he encountered several Lit and Phil members; at the age of fourteen he was apprenticed to local chemists. He matriculated from the St Andrews University Chemistry class in 1849, and later studied some physiology at the university, working as an assistant to Dr John Adamson in the Chemistry classes. It was Adamson, one of the Lit and Phil's most active participants, who taught this rather dandified young man with a taste for poetry and Voltaire how to make calotypes, spurring him to borrow from the University Library books such as Robert Hunt's 1844 *Researches on Light . . . Embracing all the Known Photographic Processes* and James Hunter's book *On the Influence of Artificial Light* (which entered St Andrews University Library in 1845).[59] Adamson also took an interest in Rodger's experiments with the daguerreotype, and introduced him to other Lit and Phil members, including Brewster and Major Playfair. Through these and other contacts, Rodger, who in 1849 set up his own photographic studio at the age of sixteen, grew particularly adept at the art of the calotype. According to a caption in the Maitland Album (owned by the family of Brewster's eldest son, and now in the Getty Museum in Los Angeles), it was Brewster and Rodger who worked together to take an impressive salted paper print of Playfair wearing a pale jacket and waistcoat, smiling a little at the camera.[60]

Working first of all in the small garden of New York Cottage close to a stream in St Andrews' pastoral Lade Braes, then in other premises in the town, Rodger combined considerable chemical expertise with a growing artistic talent. Abandoning his ambitions to become a doctor, he became instead a professional calotypist, encouraged to do so by John Adamson, particularly after the death of Dr Adamson's younger

brother, Robert. Taught by members of the Lit and Phil, 'Thomas Rodger, Calotypist' and 'Photographic Artist' became so successful that he was regarded locally as someone who 'to all capable of understanding it, explained the wonderful art'. By the 1850s he was exhibiting award-winning calotype views of St Andrews, as well as portraits of local people. In the following decade he commissioned architect George Rae, who also designed John Adamson's new house on the Scores and the headquarters of the Royal and Ancient Golf Club, to produce plans for a new-build photographic studio at 6 St Mary's Place.[61]

Rae's detailed 1866 plans for this unusually shaped building survive in St Andrews University Library's collections. They show that in addition to its 27-foot-long saloon Rodger's stone-built studio had specially constructed dressing rooms as well as a carefully planned chemical room, apparatus room, and glass-room with several skylights. Here, 'gifted with very fine tastes and high intellectual powers', Rodger practised the art which he had been taught by members of the Lit and Phil.[62] One winter's day he photographed the approach to his new studio with snow clinging to the gate posts and iron railings. His sitters included members of the Lit and Phil such as Brewster, Playfair, and the Madras College modern languages teacher and golfer Samuel Messieux, one of the society's original founders; but they also ranged from Queen Victoria to the shawled, unshaven St Andrews night-watchman and his boy, their bulky lamps dangling from their hands; and local characters like stonemasons Jamie Spence and Bo'sun Thomson, posed outside with their tools beside an old wall and a wooden ladder. In Rodger's sensitive and socially inclusive work the art form which the Lit and Phil members had developed for the town reached its democratic apotheosis. Today, though internally reconfigured, his studio building with its big skylights still stands in the centre of St Andrews. It ought to be a tourist attraction, a small museum and gallery where, as in the heyday of the Lit and Phil, members of the university and the wider community might interact and share knowledge. Instead, as I write, it is used as the university's careers centre. Few of the students who go there for guidance realise that they are entering what is believed to be the world's earliest surviving freestanding, purpose-built photographer's studio building.

With its energetic Principal Brewster and its flourishing Lit and Phil, St Andrews, for all its image as a 'dead village', was a place where knowledge of the modern world was forcefully articulated, whether through Robert Chambers's secret origination of his scandalous book or through the much more public pioneering of photography. Their secrets revealed, their natural magic now better understood, Chambers, Brewster, Playfair and Adamson, along with their friends, pupils and associates come together now as a little assembly more remarkable than they ever seemed to each other, sitting together on cold North Sea nights and balmy summer evenings during meetings of the St Andrews Lit and Phil.

4

The Major

ᗞ

BREWSTER'S SPIKINESS was too much for some people. He could be stimulating company, but could also dominate some of his Lit and Phil colleagues. Fortunately, both in that society and at home he had a neighbour able to resist his bluster. During Brewster's residency much of the rest of St Leonards was occupied by the forceful Hugh Lyon Playfair who lived there with his wife, Jane Dalgleish, and their large family. Known locally as 'The Major' – though in India he had risen to the rank of colonel – Playfair, like Brewster, was a man of great energy and no little irascibility. He had studied physics at St Andrews before pursuing his military career, and was now a formidable presence in the town. His determination soon saw him elected its provost. These two scientific next-door neighbours were often in and out of each other's homes, occasionally quarrelling to the discomfiture of their respective households, but more frequently discussing intellectual interests, especially photography. In 1839, when the Lit and Phil was in its infancy, Playfair was borrowing books on chemistry and optics from the University Library.[1] Both men wanted to learn how to take good pictures. Brewster in St Leonards East and Playfair in St Leonards West struggled, not always good-humouredly, to do so. Beginning with daguerreotyping, they soon graduated to the use of Talbot's new calotypes or, as Brewster and the Major sometimes called them, Talbotypes.[2]

As in his friendship with Talbot, so in his association with his next-door neighbour, Brewster's eagerness to converse with a strong-minded fellow researcher usually got the better of his quarrelsomeness. As his daughter Maria put it, sounding a little relieved, 'The close

neighbourhood and some similarity of temperament occasionally produced clouds on the horizon, but there was mutual warm regard besides a degree of scientific sympathy, leading to a constant intercourse, which was on the whole a source of great interest to both.'[3] Brewster battled on in university politics. He gave lectures to students on matters such as 'the Double Refraction & Polarisation of light'. The Major, retired and musical, played his cello and (having joined the University Library on Brewster's say-so) borrowed considerable quantities of musical scores. On occasion he had himself photographed sitting out in the garden playing the cello in his dark suit, white shirt, dark bow tie, and gleamingly polished shoes.[4]

Like Brewster, the Major, who had earlier developed a theatre for his troops at Dum Dum in India, had a taste for showmanship. He enjoyed wearing elaborate costumes. He had a small private playhouse set up in the grounds of his house. Indeed Playfair's garden, a sort of topiaried kaleidoscope or herbaceous Lit and Phil, was one of the most entertaining aspects of Victorian St Andrews. It mixed artefacts and automata relating to engineering, astronomy, optics, martyrdom, curiosities and encyclopedism, bringing together several of the preoccupations of Playfair and Brewster, not to mention other fellow members of the Lit and Phil like Robert Chambers. A full, but at times scarcely comprehensible, description of it survives from the 1840s when, 'open to the inspection of the public, through the generous liberality of its spirited owner', it was regarded by some as 'one of the chief modern attractions in the city'.

Any description of ours must fail in conveying an adequate conception of this miniature Eden. The flower-garden immediately behind the Major's house, is tastefully decorated by beds of flowers, arranged in figures of every form. Along the stream, which traverses the lower garden, are arranged objects alike scientific, amusing, and beautiful. In the centre stands a magnificent rustic pagoda, ninety feet in height, which may be ascended by safe and convenient ladders erected in the interior. On the top amusing figures of men and beasts are kept in lively rotation by the gentlest breeze; and from a cistern, fitted up in the structure, at the height of fifty feet – into which

water is conveyed by a forcing pump, worked by a water wheel, pipes are conducted downwards, which immediately are made to re-ascend, spouting forth beautiful fountains, which, in their fall downwards, lead to the commotion of amusing theatricals. Westward along the stream is a powerful Archimedes' screw, a Barker's mill, and an amusing group of ladies and gentlemen tripping on light fantastic toe to waltzes and gallopades, played by a sedate old man on an excellent organ, all driven by another water-wheel. Eastward, suspension bridges and curious arches of rock-work, ornamented with flowers and sea plants, are thrown across the stream; and over it, beautiful models of ships are erected. In this portion of the garden are likewise placed monuments to philosophers, poets, warriors, benefactors, and martyrs of every description. Round the greater part of both divisions is conducted a white tablet, a chronological history of the world till a recent date – all the remarkable events of every nation being recorded in historical order with minuteness and accuracy. Along the course of the tablet are also represented the planets and their satellites; according to their relative magnitude and distance from the sun, and the length of the most remarkable line of battle-ships, frigates, and conservatories in the world, an exploration of the whole being calculated to afford several hours of the most rational instruction and most interesting amusement.[5]

In an age when knowledge and theatricality were often bonded in dioramas, great exhibitions, and experimental performances, Playfair's garden was not quite as improbable as it sounds. Its cosmological-cum-historical horticulture, though, was still remarkable. The portrayal of 'the lapse and succession of ages' attracted not just adults but also children and youths. 'Every one who visits St Andrews, and has a moderate share of curiosity, visits [the Major's] garden' proclaimed a mid century guidebook, even if a visiting judge in 1844 dismissed its 'childish and elaborate gimcracks'.[6] Jane Chambers, one of the younger members of the Chambers family who was friendly with the Playfairs' daughter Mary, wrote to her aunt in Edinburgh in November 1842 about various pleasures she had enjoyed in St Andrews that summer, mentioning the Major's recent election as 'our new provost',

I hear every one saying what a capital provost he will make. He is a very clever, active man; and whatever he takes in hand he does well; for example, his garden. *You* never saw any garden more beautifully kept; there is *not a weed* to be seen; and his flower-garden Papa calls quite an elegant drawing-room. If you wish to study History, Astronomy, Chronology, Botany, and many other sciences, the major's garden supplies you with all information. If you want to know the precise distance of the moon from the earth, or any other planet, or in what year any great man lived or died, go to the major's garden, and you will find it in a moment. I very much wish that Mr and Mrs Loudon, and dear Agnes, had paid us a visit this year, as they once intended; it would have been a great treat to them to have seen this famous garden, where there are so many interesting things besides what I have mentioned . . .[7]

Jane Chambers was far from alone in delighting in visiting this demesne with its vinery and greenhouse, and savouring its splendidly coordinated cosmological clutter. Behind this weird mélange, the ancient edifices of St Rule's Tower and the seagull-circled towers of the ruined cathedral rose nobly and impassively, high above Playfair's outline of the universe with its crazily attractive, wind- and water-powered theatricals and its transitory human players.

Early photographs needed long exposure times, and the shots of the Major's garden are sadly blurred. It is difficult to tell exactly what it looked like. For all that one picture clearly shows the high pagoda and a great lean-to glasshouse erected against the perimeter wall by the cathedral, the nature of the theatre remains hard to fathom.[8] The collections of St Andrews University Library include an odd collage created from photographs of real people, several of them Lit and Phil members, cut and pasted on to a theatrical background.[9] This is probably related to 'Portraits of the entire audience in Major Playfair's Private Theatre' exhibited at the Glasgow meeting of the British Association in 1855.[10] There is also a picture, dating from around 1860, of Playfair in costume along with William Macdonald, a fellow Lit and Phil member and Professor of Civil and Natural History at the University of St Andrews. In this photograph Macdonald, dressed like

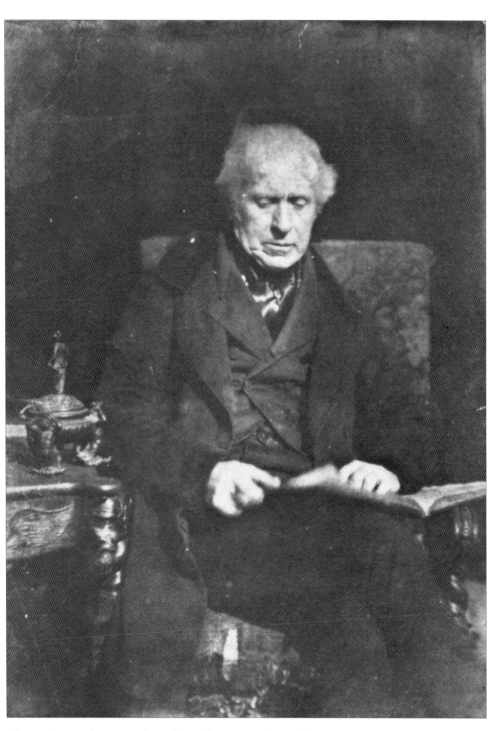

Plate 1: Sir David Brewster by Robert Adamson with David Octavius Hill, around 1843–45; print from calotype negative.

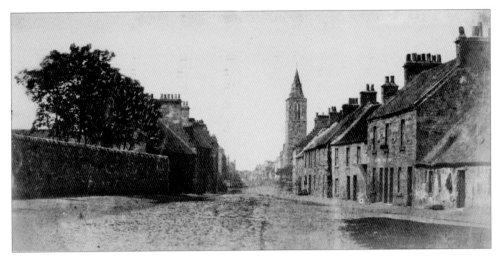

Plate 2: North Street, St Andrews, looking from the Cathedral end towards the steeple of St Salvator's College, University of St Andrews, by Sir David Brewster or Major Hugh Lyon Playfair; print made in 1854 from calotype negative of around 1842.

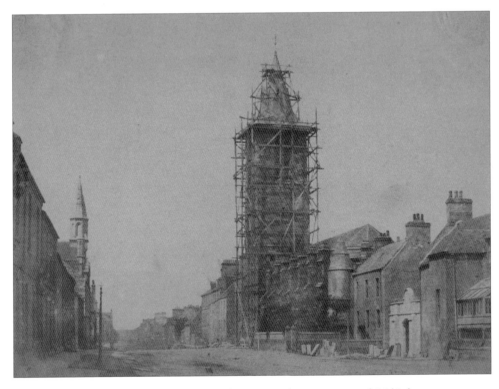

Plate 3: St Salvator's College steeple in North Street under repair around 1845, by an unidentified photographer; print from calotype negative.

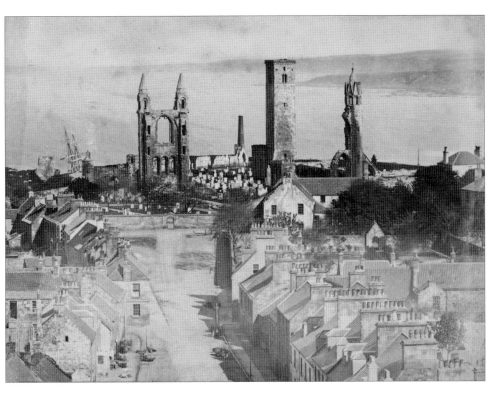

Plate 4: North Street and the Cathedral ruins with the square St Rule's Tower viewed from the steeple of St Salvator's College on an early afternoon around 1850, by an unidentified photographer; print from calotype negative.

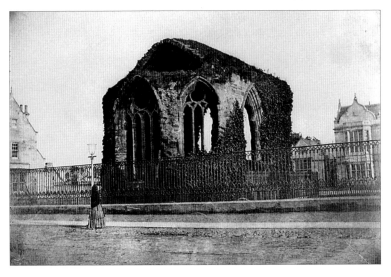

Plate 5: A shawled woman in front of the ruined Blackfriars' Chapel and part of Madras College, St Andrews, around 1844, by Robert Adamson with David Octavius Hill; digital image from original calotype negative.

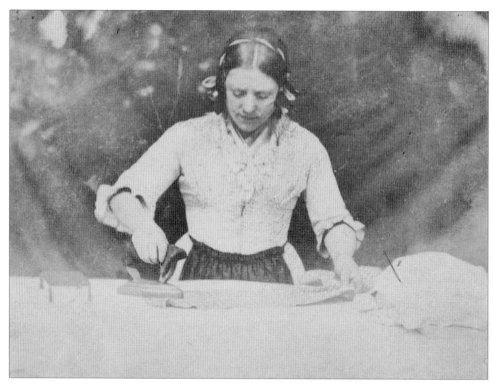

Plate 6: Mrs Lyon's laundry maid, around 1845, by an unidentified photographer; print from calotype negative.

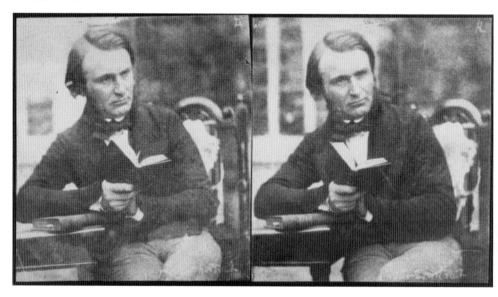

Plate 7: Dr John Adamson, probably around 1849. In an 1851 article and in his 1852 *Treatise on the Stereoscope*, Brewster wrote that 'Dr Adamson of St Andrews, at my request, executed two binocular portraits of himself, which were generally circulated and greatly admired'. Print from stereographic calotype negative.

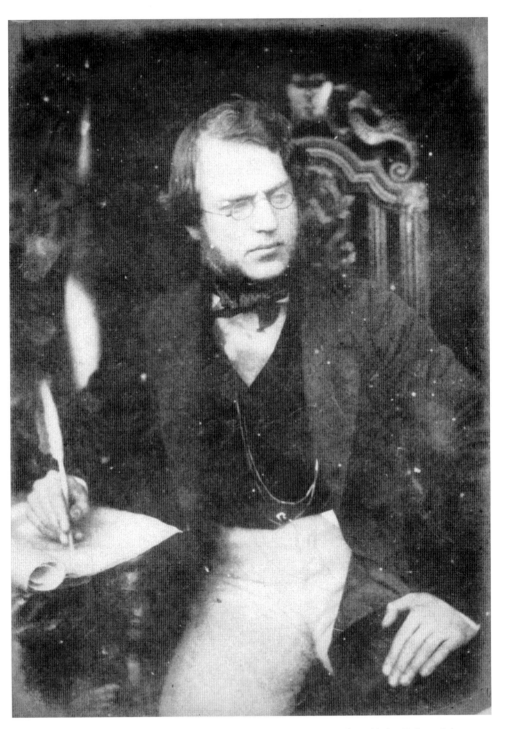

Plate 8: George H. Gordon, Madras College writing master, around 1844, by Robert Adamson with David Octavius Hill; print from calotype negative.

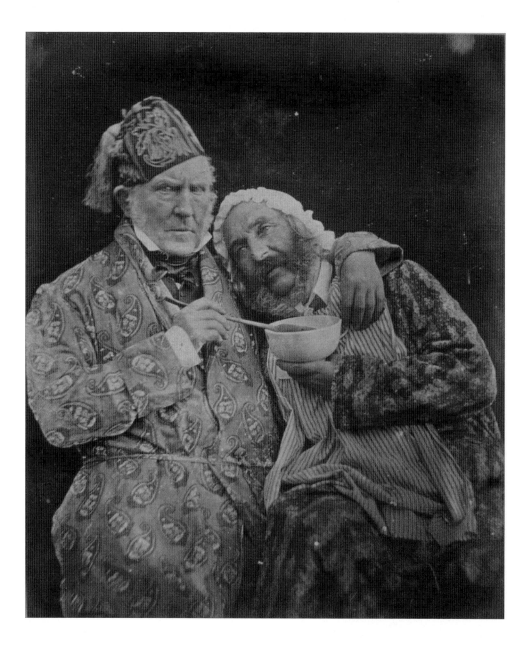

Plate 9: Major Playfair with Professor William Macdonald, Professor of Civil and Natural History, University of St Andrews, by an unidentified photographer, 1850s. This later picture of two men in costume gives a sense of the Major's taste for amateur theatricals, evidenced by the theatre in his 1840s garden. Print from glass negative.

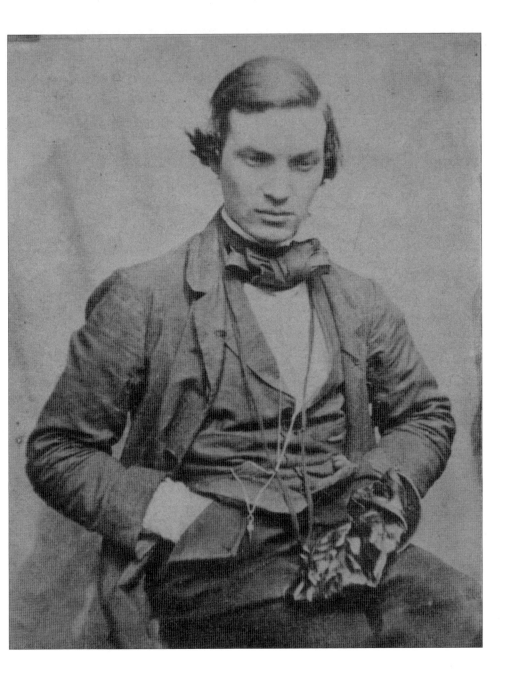

Plate 10: Mr Rodger, around 1855, by an unidentified photographer. The photographer Thomas Rodger (1832–1883) poses with his watch chain and monocle ribbon. Print from calotype negative.

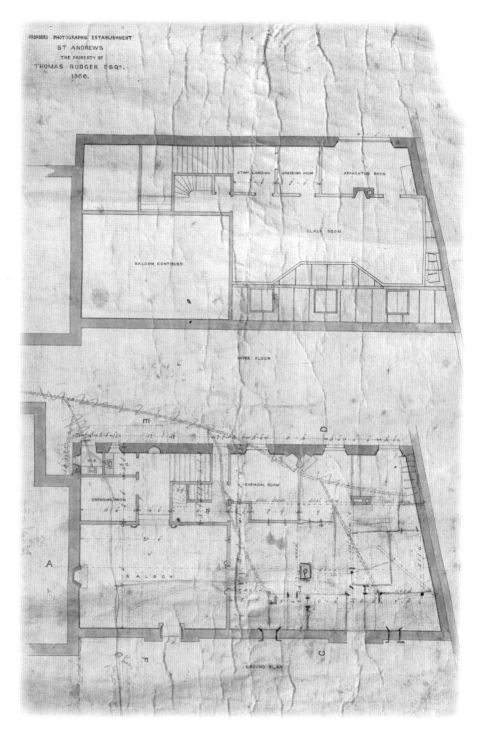

Plate 11: Proposed Photographic Establishment St Andrews, The Property of Thomas Rodger, Esq., 1866. Architectural plan of Rodger's studio which still stands in Market Street and may be the world's oldest surviving purpose-built photographer's studio building.

an infant, nestles against the Major who is wearing a large dressing gown and seems to be feeding Macdonald from a bowl with a big wooden spoon.[11] Few of the early St Andrews portrait photographs are as eccentric as this one, but Victorian photographers often had a taste for posing their sitters in costume. An inherent theatricality characterises several St Andrews calotypes, not least those of Playfair by Playfair – for, perhaps to avoid subjecting his family and friends yet again to pretending to be statues, the Major had a very discernible taste for photographing his bulky good self.

Like numerous self-conscious people in formal paintings, the human subjects of these photographs are often surrounded by props. Playfair poses with a desk, scroll, and optical instruments. Julia, one of his eleven children, sits solemnly for her father. Her right elbow rests on some books. Her right hand holds one finger of her left. The ends of her light scarf are carefully separated, and sunlight catches the central parting in her mid-length straight hair. Wearing a dress with boldly criss-crossing stripes, she looks, in every sense, composed.[12] But it took several years to achieve such photographic results, even when (as in 1842) Playfair worked intensively at his photography.[13] His 'fame' was a local 'household word'; he had commanded artillerymen and been wounded fighting Himalayan Gurkhas; but in photography he was often bamboozled.[14] In 1842 some commentators still remained scornful of the new invention: that spring *Blackwood's Edinburgh Magazine* had suggested with regard to the 'absolutely fearful' likenesses produced by photographers that there was 'but little hope of ever seeing any thing tolerable from any machine'. No camera would 'produce a portrait half so good, natural, or expressive, as a decent artist might produce with a burnt stick'.[15] Brewster and Talbot corresponded regularly about what Brewster liked to call 'the Art' – photography or 'photogenic drawing' or 'calotypes' or 'Talbotypes', but Playfair got increasingly fed up. He failed to produce any 'Talbotypes' that might match Talbot's own work, examples of which Brewster delighted in exhibiting at Lit and Phil meetings. Sometimes consulting with fellow members like the chemistry professor Connell and the physician Adamson, Playfair struggled and struggled.

He had tried to get hold of the best paper: James Whatman's Turkey

Mill, made from rags with gelatin sizing. This was a writing and book paper, lighter in weight than many dedicated watercolour papers, which were made thicker to resist cockling from the water.[16] Playfair spread his Turkey Mill with chemicals using a soft brush, then laying it on cloth to dry it out over a stove in a darkened room. When the paper was dry it was immersed for a minute in a further chemical solution, carefully heated to sixty-five degrees, then plunged into two successive basins of clean cold water to completely remove iodide. These were big sheets, twenty or thirty inches long, and had to be handled with great care. After that each sheet was dried with blotting paper, then exposed to bright sunlight and kept for a week or two before it was used. Even then, before any sheet was ready, a further solution of chemicals and water had to be prepared and spread on the paper by gas light, with more soaking and blotting before it was placed in the large camera. Probably the sensitising process did not need to be so complicated, but the Major, following guidance from Brewster and Talbot and experimenting for himself, did not know that. Once he had taken his photograph, requiring the sitter to stay still for several minutes, there was a need for further application of a solution of nitrate silver and undiluted Gallic acid before the paper was again heated over a stove in a dark room. If the picture did not readily appear, then a second, and sometimes a third, washing in the solution was called for. To make a single picture in this way was chancy, time-consuming, and required delicately measured quantities of a variety of chemicals. Later, in 1847, Brewster gave a lengthy account of this process, supplying advice on how to select and treat paper, with the ideal of producing pictures 'like the oil paintings of some good masters'.[17] To take and develop photographs required more than just photographer and sitter; it convulsed a whole household, as someone who recalled Brewster and his circle in the early days of Scottish photography explained,

> . . . it was expedient to *divest* yourself of your coat, and *invest* yourself in a blouse or old greatcoat, to save your garments from the greenish-black stains and smudgings they were sure otherwise to receive. All available tubs, buckets, foot-pails, wash-hand basins, and every sort of vessel which would contain water, were laid hold of for

the frequent washings and soakings which were required. Every
room which could be darkened was needed for the drying in the
dark. The region of every domestic in a household was invaded, and
servants were kept running perpetually with pails of hot and cold
water, warm smoothing-irons &c. The whole establishment was
turned topsy-turvy while its superiors were bent on photographic
studies.[18]

In such circumstances, great patience was called for. Major Playfair
found patience difficult. By mid August 1842 he was begging Brewster
and Talbot for advice. 'We cannot succeed by the above process either
in obtaining a clear sharp picture (such as taken by Mr Talbot) or of
fixing them with any degree of permanency.' After trying and trying, he
was exasperated. What he wanted was 'further information as a Reward
for most laborious application & disapp[ointe]d expectation for up-
wards of 12 Months'. Playfair recognised the quality of Talbot's
process, but feared he would have to give up and rely instead on the
French system of the showman Daguerre. Reported by Brewster, this
had 'excited great interest' in St Andrews in early 1839, but Brewster
had been delighted to show the Lit and Phil Talbot's rival British
productions with which the members were 'much gratified'. Science
was international; still, as Brewster knew, there were also matters of
national and local pride. Having fought in the Napoleonic era and
having seen Napoleon at St Helena, the Major had a British Army
sense of patriotism, and in any case admired Talbot's 'Art'. For Brewster
it was Talbot, not Daguerre, who was the true 'first Inventor' of
photography. Advising Talbot to patent his work, Brewster had told
him in 1839 that he was 'delighted beyond measure, both from personal
and national feelings that you had anticipated the French Artist in his
beautiful process'. If Brewster and Talbot could help, then, Playfair was
prepared to say, 'we may go on . . . But with the present light we cannot
advance one step & I Regret to say that the Daguerrotype must have
infinitely the ascendancy unless this Art is more easily attainable – With
the other I never have a single failure – with this I never have anything
else'.[19]

Discussing Talbot's work at 'our Society', and telling him there was

'great interest here' in his photographs, Brewster, like his neighbour Playfair, was struggling.[20] Principal Brewster had helped take some daguerreotypes in 1840 in Edinburgh where Thomas Davidson would shortly publish his *Art of Daguerreotyping, with the Improvements of the Process and Apparatus* (1841). Brewster remarked on this to Talbot in what looks like an attempt to get the Englishman to release a little more information about his own process. By October 1840, telling Talbot that one of his Talbotypes 'is truly beautiful, & equals almost the Daguerreotype', Brewster let slip he had been asked to 'write a short Article in the next No[.] of the Edin[bu]r[gh] Review on Photogenic Drawing and the Daguerreotype. As I am very anxious to do justice to your labours I would reckon it a great favour if you could send me any information that you can, or any suggestions that you may think useful.'[21]

So, cajoling Talbot and encouraging him, while also mentioning Davidson's daguerreotypes ('far superior, in the estimation of foreigners & others, to those executed by Daguerre'), Brewster spurred Talbot on. He mentioned having in St Andrews two daguerreotypes by Davidson of scenes in Edinburgh, 'inexpressibly fine, but notwithstanding their beauty, your Photogenic drawings are most generally admired'. Brewster, like Playfair, wanted to make St Andrews a centre for the practice of this new 'Art'. He wrote to Talbot telling him that 'When you have published your method I shall immediately apply it to our beautiful views here which are well adapted for the purpose. – We have also grand & precipitous coasts which will be easily taken.'[22] Cliffs, precipices, and ruins, like Major Playfair's biddable, solemn-faced wife and daughters, could be relied on to remain motionless. In one family picture, apparently taken on a bench in Playfair's garden, the Major with his long grey sideburns and thick but receding hair sits flanked by his spouse and daughter.[23] Their arms are linked in close solidarity. They are trying to keep each other still.

This immobility in front of the camera could be difficult. Talbot reckoned that in strong sunlight sitters had to stay still for thirty seconds (blinking did not help), while an outdoor calotype with a sitter in the shade demanded an exposure time of four or five minutes.[24] The biographer of Dr John Reid, a Lit and Phil member whose researches

were helped by his prized Parisian microscope, recalled how 'Major Playfair of St. Andrews executed a fine calotype, representing Dr Reid in profile sitting at the microscope', but the same writer remembered too that

> Dr. Adamson also has produced several calotypes of [John Reid]; one representing the front face, is a peculiarly faithful and beautiful portrait. It a little perhaps exaggerates the overhanging of the eyebrows, from the effect of the bright sunshine, (to which the face is exposed during a photogenic process,) in causing the brows to contract so as to shade the eyes; but it is a striking and agreeable likeness.[25]

Commentators on early photographs were not slow to complain when things went wrong. Writing in early 1842, an anonymous contributor to *Chambers's Information for the People* thought 'photogenic drawing will be limited in its utility to the taking of representations of buildings, or scenes in still nature' because, though 'various attempts have been made to adapt photogenic drawing to the sketching of miniature portraits from life . . . the slightest movement of the head, while sitting, or even the winking of the eyes, causes derangement in the action of the sun's rays' so that 'all representations from life have less or more a *muzzy* or confused appearance'.[26] Playfair demonstrated he could stand ramrod-steady, leaning on a walking stick and with one elbow on top of a special photographer's posing chair, its back augmented by an upright head-rest that looks devised for the purpose of torture.[27] Other pictures make use of clamps that may have been borrowed from Professor Connell's chemistry lab. Early accounts of photographers often likened posing for them to sitting in the dentist's chair, an experience even less pleasurable in Victorian times than today. Still, if getting sitters to pose properly was awkward, it was the easiest part of the whole process. The technology itself remained recalcitrant. Talbot had sent some of the special Gallic acid ('not to be got here' in St Andrews, Brewster complained) with which Major Playfair was to struggle over the next, frustrating year.[28]

'Enchanted' by the pictures Talbot continued to produce and which were exhibited at the Lit and Phil, Playfair and Adamson bought themselves more advanced equipment, and fiddled with it endlessly.

'My two friends', Brewster wrote, 'are wholly absorbed in the subject, & having got the finest Cameras ever made, both with single and double achromatic Lenses, they will never give up till they master the process'.[29] Brewster admired Thomas Davidson's 'most beautiful Portrait Cameras of which we have two here in constant operation', and thought each cost £5 or £6.[30] In April 1841, a few months before Brewster wrote these words, the Edinburgh optician Davidson had been made an honorary member of the Lit and Phil. Distrusting materials available locally, the St Andrews photographers asked to buy more from Talbot's chemist.

Now, assisted by their Chemistry professor's teenage assistant, W. Holland Furlong (who had studied for a session at the university but got into trouble over 'non-payment of bills'), they seemed to be making progress.[31] Preparing 'his iodized paper by simply washing the paper in a solution of *iodide of silver*, in a strong solution of *iodide of potassium*', Furlong would soon be making his own 'very fine Talbotypes', and Brewster confidently pronounced St Andrews 'the headquarters (always excepting Lacock Abbey) of the Talbotype'.[32] By November 1841 he was sending Talbot a few 'Talbotypes' taken by Adamson, including a 'woe-begone' image of Brewster himself.[33] The process was still very unstable. Playfair travelled to London where he aimed to meet Talbot and get further advice. The Major had been trying repeatedly to make Talbotypes, but had 'again failed'. He was dogged, Brewster wrote, and 'fails in nothing else. His patience is indomitable'.[34]

Playfair's efforts at indomitable patience may have been nourished by his sportsmanship. For the Major was certainly a sportsman, and some of his recreational tastes were as eccentric as his garden. In 1833 he captained a recently formed archery society. Its members – 'Professors and other amateurs' – sought to emulate the Renaissance student archers who had competed for their silver arrow at the Bow Butts, drawing their longbows beside the breakers of the North Sea or, as the Major and his contemporaries called it, the German Ocean.[35] The new archery club attracted about a hundred members. For six guineas they purchased from Messrs Marshall and Sons of Edinburgh an elegant trophy – 'a silver arrow, with gilt feather and barb' – and competed for it in August.[36] They also had their own medal (today displayed in the Museum of the University of St Andrews). But by the end of the 1830s,

when the Lit and Phil was getting under way, the archers' club petered out. Sportsman that he was, the Major accepted that this was hardly the end of the world, and soon turned to other challenges.

His real game was golf, and he was good at it. As a younger man in India he had encouraged his troops to take up the sport. On leave from the army, he had won the St Andrews Golf Club's Gold Medal in the autumn of 1818. St Andrews golf medallists included quite a number of military men, but it was also possible to win as a civilian. Dr James Hunter, one of the founders of the Lit and Phil and Professor of Logic and Belles Lettres, had carried off the medal three times in the decade of Playfair's first triumph. Names of other Lit and Phil regulars feature among the list of medallists, and many of the members followed the game, even if, like the professor of medicine John Reid, they only occasionally took part. Golf in St Andrews was 'a pleasant mode of taking exercise, and is, accordingly, a favourite game with middle-aged men of all ranks and professions'.[37] On the golf course town and gown intermingled. So did people from different social classes; if lower-class men were often caddies – bag carriers – they might also play.

The Major's was very much a golfing family. In 1845 his 'rotund', good-humoured brother, Colonel William, who had also soldiered in India and was a fellow Lit and Phil member, donated the club's Bombay Medal, to be awarded to the runner-up in its spring competitions.[38] By the 1840s good players completed 'the whole round of the course' with a score of 'from 100 to 105 strokes'.[39] If the Major was proud to have won the Gold Medal in his early thirties it must have given him even more satisfaction to win it again in 1840, at the grand age of fifty-four. He even cut six strokes off his previous total, going down from 111 to 105. His golf was 'ruthlessly efficient'. A poem of the 1830s (when the Major had founded the St Andrews Union Club, which later merged with the Royal and Ancient Golf Club of St Andrews) describes him as a 'man of nerve unshaken' who, especially when under pressure 'can play a tearing game'. He was especially skilled at shots using a particular club:

> There's none – I'll back the assertion with a wager –
> Can play the *heavy iron* like the Major.[40]

Then as now golf, 'the *primum mobile* of all', was so important to the life of St Andrews that there were concerns it might overshadow – or better, perhaps, out-dazzle – intellectual life. The Victorian novelist Margaret Oliphant, whose photograph was taken by Thomas Rodger, worried about what her sons were up to when they caroused in the club-house. The fame of the town, she wrote, was 'partly of letters, but I fear still more of golf'.[41] Like living next door to Principal Brewster and sharing his photographic obsessions, playing a leading part in the golfing life of the place was a way to gain influence, and the Major gained influence impressively.

He was unarguably assisted by being part of a formidable dynasty. Hugh Lyon Playfair had a network of local kin which stretched into several areas of St Andrews public life, as well as throughout the British empire. Like his father, several of his sons, and many of his male relatives, Playfair had been a St Andrews undergraduate. More than that, while Hugh was studying Latin, Logic, Physics and Mathematics, his father (James Playfair, Historiographer to the Prince of Wales) had been Principal of the United College – a predecessor of Brewster. The Major was also more distantly related to the early-nineteenth-century geologist and close friend of James Hutton, the St Andrews-educated John Playfair who had become Principal of the University of Edinburgh. If academia ran in the Major's veins, so did St Andrews. At least twenty-three Playfairs were students there in the eighteenth and nineteenth centuries, including the chemist and politician Lyon Playfair (later first Baron Playfair) who corresponded with the Major and Talbot, calling Brewster 'a particular friend'.[42] In the late 1830s and 1840s four Playfairs were among the early ordinary members of the Lit and Phil; three more were among its honorary and corresponding members.

On his mother's side the Major was part of another prominent middle-class St Andrews family. The Lyons too helped to swell the student body and augment the membership of the Lit and Phil. There were Lyon Playfairs and there were Playfair Lyons. The St Andrews Episcopal minister, the Reverend Charles Lyon, was married to Margaret Playfair and their son, St Andrews student Hugh Playfair Lyon, had a name which played a variation on the Major's.[43] Playfair's

pride in his celebrated St Andrean name can be sensed in his florid signature.

On 3 November 1842 the Major was elected to the town council. Next day he was chosen as provost. All the locals recognised him. He was seen with everyone, from Sir Ralph Anstruther (another man 'with continental learning richly stored', who joined the Lit and Phil in the same month as Robert Chambers, and who was pictured with the Major in Charles Lees's 1844 painting *A Grand Match of Golf*) to local working-class characters; the Major was spotted walking along South Street 'with a venerable fish-wife on each arm, sharing their somewhat noisy confidences with an admirable affectation of interest'.[44] Playfair had been thinking for some years about architecture and about his home town, borrowing from the University Library in early 1840 such works as the eighteenth-century Sir William Chambers's *Dictionary of Architecture* and the Statistical Account of St Andrews.[45] The place, one contemporary noted, 'had fallen behind most towns of its size' in several respects. Instead of flat paving stones 'even the best thoroughfares were paved only with round stones, anything but suitable for tender feet; smooth trottoirs were unknown'. More than that, 'as in several old-fashioned Scotch towns', locals had often built on to their houses makeshift porches and other 'projections' which took up part of the public street.[46] Efforts had been made to repair South Street in 1823, but those improvements had vanished. Conscious that the street was 'rough and indented', its pavements 'broken and useless', and the 'din of passing carriages' on its uneven surface 'so loud and disagreeable', the Major realised that if the burgh as a whole were to remain sustainable as a community fit for university and polite townsfolk alike, modernisation was needed. As a scientific investigator he was attuned to modernity; as a former military leader, he was capable, determined, and bossy. Before long he had raised money from the subscriptions of the well-off, from an art exhibition and other events, to have the town's pavements extended, its sewers repaired, and its roadway thoroughly 'macadamized'.[47]

No sooner had the local Road Trustees 'unanimously agreed to macadamize Sixteen feet in the centre of South Street and to lay on each side of the same two feet of Causeway' than Playfair, in his

capacity as provost, was gleefully reporting the fact to the town council at their meeting of 6 July 1843. Never one to pass up an opportunity for improvement, he also 'mentioned that he had arranged with the Surveyor to get the large Stones which would be taken from South Street to relay the Lanes and other parts of the City which are at present in disrepair'. The council approved, just as it was pleased when their provost reported to them on his monitoring of the cleaning out of a dirty local stream, the 'Swilkin Burn', and on his inspection of the old town gateway, the West Port, which he planned to have repaired. The job was soon to be put out to tender, the lowest estimate to be accepted, 'and the work proceeded with immediately thereafter'.[48] The Major was not a man for delay.

Playfair's negotiating skills also supported Brewster's successful campaigning to get government grants to improve St Salvator's College quadrangle. In the mid 1840s its north range was built in a confident Jacobean style incorporating a grand doorway with Roman Doric columns topped by a lion and a unicorn. The Major and the principal liked things done with style. Provost Playfair (who held office for the rest of his life) campaigned and fund-raised vigorously. Though his efforts won him at times the soubriquets 'Playfalse' and 'Playfoul', nonetheless he curbed the bitter infighting which had plagued the local council.[49] He drove through improvements that brought much-needed modern drains, public baths, a new town hall, a library, and whole new streets. From a bowling green (still used today) to a caber-tossing competition (now less well supported), he gave the town a renewed confidence in its identity, enhancing its appeal for locals and visitors alike. If St Andrews had become such a municipal *memento mori* that one guest had come to regard it as 'the best Pompeii in Scotland', Playfair gave it a vital fresh start. He set it on its way to becoming viable in the longer term as an internationally popular university town as well as a golfing and tourist destination.[50]

His initial substantial reform, his *'first child'* as the indefatigable provost liked to call it, was the building of a Madras Infant School with a 'fine playground and shrubberies, on the site of dilapidated cow-houses and depots of manure' opposite Bell Street. In 1843 that old gateway to the town, the West Port, which 'had long assumed the dingy

aspect of a neglected ruin', was completely renovated.[51] Throughout the 1840s, Playfair masterminded what contemporaries recognised as a 'golden age' of town improvements.[52] At the same time, he also preached a gospel of extinction. One photograph in the Brewster Album that has been attributed to John Adamson shows the old Tolbooth or Town Hall, which Provost Playfair soon slated for demolition; but this unusual picture, probably taken by a camera laid directly on top of the cobbled roadway, also records the site of the martyrdom of Paul Craw. The photograph is part of the discourse of Playfair's 'improvements'; yet it memorialises, too, a building about to be lost and so is consonant with the antiquarian interests of the Lit and Phil. At once a beginning and an end, like many of the early images of the St Andrews townscape it implies questions about the passage of time, destruction, and progress.[53] In the summer of 1843, when there was unemployment in many places across Scotland, in St Andrews, Robert Chambers noted,

> Everywhere . . . workmen were to be seen engaged in removing old obstructions and eye-sores, propping up venerable ruins, and creating new beauties and conveniences. While other men would plan, ponder, and hesitate, the major *acts*. Was a railing required in front of Madras college, or a piece of playground to be put in order for its pupils? It was immediately *done*. Was there a street projection, awkward and incommodious, which had been sighed over and lamented hopelessly, helplessly, for ages? It was one fine morning, before breakfast, *gone*.[54]

An old world ended with disconcerting speed; a new world commenced. Bit by bit the town was improved, its changing state documented through photography. 'The greatest doing of the worthy major is the formation of a smooth slab pavement, of from six to twelve feet broad, on each side of the principal street, along with a double row of gas lamps, as handsome as anything of the kind in the metropolis.'[55] Town and gown alike responded to the Major's guidance. It was probably a classically educated wit from the university who penned the Latin-titled poem whose first stanza heartily sets tempo and tone:

Let us sing of the Major not little but much,
For I'm sure in broad Scotland you'll scarcely find such.
St Andrew's Provost – the wonderful man –
The plan of whose being is – ever to plan.
Whose caput has always some new scheme a-brewing,
To bring in improvements where all once was ruin;
You may talk of fine heroes of Greece and of Troy,
A fig for such boobies – The Major's the boy.[56]

Robert Chambers and Playfair were linked in their love of their immediate environment, but also in their realisation that the 'dead village' needed substantial attention. Both men had a wide knowledge of the world (and, in their different horticultural and authorial ways, ambitions to map out the wider cosmos), but this in no way conflicted with their sense of attention to the details of the local. On 1 October 1843 'half in joke, half in desperate anxiety' as Chambers perceived it, the Major put up a notice in the Golfers' club room, appealing for further funds to renovate the town.[57] By then, though, the process seemed unstoppable. The seafront walk along the Scores, long 'unheeded . . . polluted by filth, and interrupted by hillocks' became a neatly levelled promenade, part grass, part gravel; the 'fisher population', for decades an embarrassment to bourgeois citizens, were rescued from their 'state of filth, misery, and degradation'; even coastal erosion was reversed, so that where 'The sea had long been making rapid encroachments at high tides, on the north part of the city property, between the Union Parlour and the Swilcan Burn, which forms part of the golfing ground' the Major 'caused an embankment to be raised along the side, and the portion of ground hitherto exposed to the action of the waves to be covered with earth and sown with grass; so that several acres have been retrieved to the golfing-ground'.[58] This, in nineteenth-century St Andrews, was the essence of economic and environmental sustainability.

Though some of these improvements still lay in the future, by 1842 when Chambers joined the Lit and Phil the Major was just about the best-known person in St Andrews. Chambers came to see him as 'a species of Peter the Great within his burghal jurisdiction'. No doubt

aware that the Major had met Napoleon, Chambers also compared him to France's little general.[59] A man of many parts, Playfair was

> skill'd in many a curious art,
> As chemist, mechanist, can play his part,
> And understands, besides the pow'r of swiping,
> *Electro-Talbot* and Daguerreotyping.[60]

The Major spread the new art through his clan of numerous kinsfolk. Dr George Playfair, a fellow East India Company veteran and member of the Lit and Phil, photographed in 1842 'Three Buddhas. Taken out of a Chinese Temple after capture of a fort', while others in the Major's network sympathetically photographed their servants.[61] In St Andrews University Library's photographic collection the anonymous photograph of 'Mrs Lyon's Laundry Maid' is a rare and striking image of a lower-class woman in the St Andrews community, a domestic servant doing her ironing, or just possibly wielding a piece of photographer's equipment since (as Brewster would point out) 'Mr Talbot also recommends that a warm iron be placed behind the calotype paper while in the camera, to increase its sensibility.'[62] When the Major eventually photographed his own servants he lined them up outside the front door of St Leonards West, military-style, the men presenting their tools and props shouldered like weapons, the women exhibited as they stand to attention beside the equipment of their trades.[63] These people are objects of curiosity, exhibits for the camera's commanding upper-class gaze. Strikingly different are the photographs in St Andrews University Library's Govan Album which show female domestic workers. In these much more sympathetic pictures the women, sewing or ironing, are treated as individuals. Not looking at the camera, they focus intently on their tasks. They are as tellingly photographed as the St Andrews University botanist Charles Howie, attending with concentration to his scientific procedure.[64]

Some of the Major's finest calotypes are found in an album now associated with Robert Tennent, son of Margaret Rodger Lyon and, like his brother Hugh Lyon Tennent, a member of the Edinburgh Calotype Club. This was founded around 1843 and, since the St

Andrews Lit and Phil was not simply a photographers' club, ranks as the oldest photographic society in the world. The Major's relations left for India, Australia, and elsewhere, whilst he remained behind, strutting the streets of his little city, mapping the history of the planet and cosmos through his theatrical garden, experimenting, conversing and arguing with neighbours, playing his cello, reading. For the Major was bookish as well as musical. On 24 September 1845 he even borrowed from the University Library the controversial recent work, *Vestiges of the Natural History of Creation*.[65] Probably he did not know that this anonymously published volume was by his erstwhile fellow member of the Lit and Phil, Robert Chambers. Had Playfair realised his beloved town had been harbouring such a scandalous thinker, his outcry might well have been uncontrollable, giving rise in his weird, theatrical garden of the universe to a sound like the end of the world.

5

Robert and Anne

⁊

IN 1842, JUST A FEW hundred yards from where the Major was continuing his photographic experiments, Anne Chambers worried her husband was going mad. An intelligent woman enthusiastic about music and literature, she had noticed the symptoms for some time. Despite having founded their highly successful Edinburgh publishing firm, the brothers William and Robert were now at loggerheads. Each was a workaholic in his late thirties, but Robert had also seemed from earliest childhood a little set apart from other people. He had been born with a strange genetic deformity: six fingers on each hand, six toes on each foot. A botched childhood operation meant he was unable to play physical sports that involved running and jumping. Instead, from early boyhood he had spent much of his time with books.

Like Anne, Robert loved music. Poetry and song had been essential to their courtship, and remained part of family life. A silhouette of Anne in the 1840s shows her sitting in her crinoline with her hair pinned up in a bun, surrounded by her children and playing a large, elaborately sculpted harp.[1] At the age of three Robert had been able to identify sixty different Scots songs and ballads which his father, a former weaver, sang. That father had done all he could to encourage Robert's love of reading, and bought him the greatest of all Scottish encyclopedias, the *Encyclopaedia Britannica*. Robert read right through it. When his father's business failed and the family could not afford to let him study at university, Robert, like William, had gone into the book business. Robert wanted to be a poet, like his namesake, Robert Burns, whose work fascinated him; or a historical novelist like another of his heroes, Walter Scott, whom he met and who spurred him on in early manhood.[2]

The Kaleidoscope, the magazine Robert had written and published in 1821 when he was nineteen, was short-lived, but, like its namesake, sparkling. He wrote most of it, while William did the printing. At the start of his twenties, walking the streets of the Scottish capital and familiar with its characters, Robert had authored the world's first collection of urban folklore, *Traditions of Edinburgh*. He recorded anecdotes not just about Burns and William Smellie, founder of the *Encyclopaedia Britannica*, but also about old taverns, clubs and songs; about the writers, beggars, rich and poor who had thronged the bustling, stinking city which had been an unlikely capital of the Enlightenment. All through early manhood, Robert had written and written – from studies of Burns, Scott and Scottish history to an *Introduction to the Sciences*, a history of the British Empire and a gazetteer. He made books for a rapidly growing mass audience. Advances in printing technology such as steam-driven presses and cheaply bound editions had helped develop a popular readership eager for general knowledge. Robert the author and the firm of W. and R. Chambers, 'publishers for the people', were at the heart of what has been called 'the greatest transformation in human communication since the Renaissance'.[3] Now Robert was producing an extensive *Cyclopaedia of English Literature*. If the *Encyclopaedia Britannica* had been reincarnated as a single person, pen in hand, it would have been rechristened Robert Chambers. Enlightenment ideals of 'improvement' and more recently fashionable phrenological notions of 'improvability' preoccupied him. In writing he improved not just himself, but also large audiences of readers, many of whom could not afford to go to university or else, like Anne (in an age when universities admitted no women), were forbidden to attend.

But writing was not enough. Driven by the Protestant work ethic with which they had grown up, but also by memories of their father's bankruptcy, Robert and William developed their publishing partnership with relentless ambition. When their father died, still poor, at the beginning of Robert's twenties, that spurred the young author further. Passing his successful bookselling business to his younger brother, James, Robert became a newspaper editor, working for Edinburgh's *Advertiser*. Within two years he was collaborating with William on

Chambers' Edinburgh Journal, providing much of the content for this weekly magazine of popular educational writing and literary entertainment which very soon had a circulation of over 30,000 copies. Robert lacked the scientific expertise possessed by a man such as Brewster. Nevertheless, like Brewster, he was committed to what we now term the public understanding of science. That was part of the popularising project of *Chambers' Edinburgh Journal* which commenced publication in 1832. W. and R. Chambers soon issued a series called Chambers Educational Course (for which Robert wrote several volumes), and numerous other books.

Then, around 1841, things went badly wrong. Physically and psychologically, Robert felt exhausted. His way of life became quite unsustainable. His marriage to Anne was strong and would bring them fourteen children several of whom died in infancy; by 1841 their eldest daughter, Nina, was ten. But, as Anne saw, Robert was suffering from depression and overwork. The move to St Andrews was designed to help, and in many ways it had. Even if sometimes he missed Edinburgh associates, Robert joked about how 'We enjoy our rustication here very much, and I never saw the children healthier or happier.'[4] By late 1842 he was writing to a friend,

> We have enjoyed this summer very much here. It is an extremely pleasant place for such a person as I, presenting literary society, books, means of agreeable exercise, and so forth. I have taken to golf . . . We have a good large house a little way out of town, and the children run about wild [in the w]alks and garden all day.[5]

If anything, it had been Anne whom Robert had seen as 'depressed' that summer. Their two-year-old daughter, Margaret, had died of scarlet fever in March; their new son, William, just three weeks old, had died on the seventeenth of August. Robert had taken Anne to Edinburgh 'to cheer her spirits'.[6]

His spirits rose and plummeted vertiginously. Visiting his dying mother in Edinburgh, he wrote to Anne in St Andrews about feeling 'so depressed'; next morning came another letter: 'I am much better'. He could find no reason for his mood swings, other than 'constant and

intense mental action for so many years'.[7] The pressure had increased with the publication on 20 October of an advertisement for *Chambers's Cyclopaedia of English Literature*. Following hot on the heels of the voluminous, revised *Chambers's Information for the People* and covering everything from 'Anglo-Saxon to the present times', the *Cyclopaedia* was aimed at 'the self-educating everywhere'. It would commence publication in instalments on the third of December 'in weekly numbers', all 'under the care of Mr Robert Chambers, assisted by several gentlemen'.[8]

Exhausted by producing articles week in, week out, for *Chambers' Edinburgh Journal*, he had known for some time that he did not wish to stop writing completely; but he craved a change of scene, of company, of existence. By late 1842 matters reached crisis-point. From St Andrews, he wrote to William proposing that the journal should cease publication in the coming year. He emphasised his renewed need 'to make some considerable change in my course of life'.[9] Robert's letter is dated simply 'Sunday evening'. When he showed it to Anne, they had a row which upset both of them deeply. Next morning, she felt anguished as she wrote from St Andrews,

My dear William,

Robert showed me a letter last night, and I fear you may be greatly startled by it as I was. You will perceive that Robert has now come to the conclusion that his mind is rather unsound, or partly in a *diseased* state and that he fears he cannot long continue this incessant mental excitation. I fear this is too true, he is irritable & sensitive to a degree that you can hardly imagine, or any other know *but myself.* Last night when he gave me the letter to read merely because I did not *all at once jump to his opinions*, but quietly gave a few arguments against some passages, he left me quite disconcerted, & with tears in his eyes said, 'Well if I have not *you* for a friend I have nobody and if *you* do not coincide with me, can I expect others to do so?' I had to convince him that it would have been silly to say that every thing he proposed was right but this would not do, and it was only by writing a kind conciliatory note & sending it to his room that he afterwards spoke calmly, and said he was glad to find me corrected. Now I tell *you* this,

for I think that from this small statement from me you may better understand his case, and be better able to jud[g]e what will be the best course to take. I trust you cannot blame me for exposing this trifling weakness when the motive is so good. To another living soul in this world I would not own that he had a fault, and with the exception of this partial unsoundness, which I trust time may remove – *he is faultless.* Now I will tell you what has occurred to me as a mode of cure. *Travelling.* Now and then if he were to go a few weeks from home, to London, France, or Italy, he might be benefited by that novelty & excitement, & return in a much better frame of mind to his duties. He really wants change & variety, and *he has the idea* that traveling might do him good. Now if you can possibly manage it, *you* should propose it to him, and in reality he might write as much while he was going about seeing new things, as at home sometimes [he is] in no great spirits or heart to do any thing.[10]

Anne went on to explain that she would need to travel with Robert, to prevent him feeling depressed by isolation. Yet in the end, for all that Robert felt his 'sensitiveness and irritability' were producing 'the extremest misery', and that only in amusing company could he 'ever enjoy even *common serenity of mind*', he and Anne did not set off on European travels. Instead, they remained in St Andrews, and Robert, fretting about the 'particularly tasking' demands on him to keep writing leading articles for *Chambers' Edinburgh Journal,* turned his attention to 'other literary tasks'.[11] One of these he kept absolutely confidential, worried it might damage him and his family irrevocably. In this secret, as in so much else, Anne Chambers supported her husband to a remarkable degree.

A few years earlier, apparently at another time when their marriage was under strain, she had written and given to him a poem beginning 'Spirit, spirit, tell me why | Love changes into scorn!' and had answered a resounding 'No' to the question 'Should Love's passion ever change | Causing eyes to weep?' Now in 1842, Anne Chambers was determined 'To make a peaceful home'.[12] Her continuing resolve to do this, to support her husband through his breakdown, to declare him 'faultless', and to act as his amanuensis in his most secret work while superintending her large and still-growing family – to some all this will seem

'Victorian' in the worst sense. Yet to take that attitude is to patronise her. Her meagre surviving correspondence shows bravery, intelligence, and spirit. Writing while her husband wept, Anne shows her mettle. If Robert, sometimes cowed and vulnerable but more often cannily successful, is one of the heroes of this book, then, for all that she is only fleetingly observable, almost always in the background or at most glimpsed making a fair copy of her husband's words, Anne is undoubtedly its heroine.

In St Andrews, whatever her fears, she did not lose her husband to madness; she became, though, intermittently a golf widow. Lovers of the Fife town often sang the joys of golf. In 1842 Anne's old mentor and Robert's trusted elderly correspondent, George Thomson, who had worked with Robert Burns many years before in 'the modern Athens' (as Edinburgh was sometimes called), revealed himself just such an enthusiast:

> If you find it convenient to change your residence, I cannot imagine where you could make a more prudent & agreeable choice than that of St Andrews. There you can live more quietly & less exposed to inroads on your time than in the large society of the modern Athens, and at the same time you can have most excellent society in a narrower circle, & highly advantageous means of educating your numerous family . . .
>
> O that I were near you to join in your cracks [amusing conversation], and to fiddle or accompany a ballad with Mrs. Chambers; and would I were able to wield a club as in former days and have a game at golf with you, so much excelling the English Cricket. O the well remember'd pleasure of driving a teed ba' some twa three hundred yards over the links! The exercise and refreshing sea breeze will add ten years to the pen and ink life you would have at the bottom of the Luckenbooths close [in Edinburgh], and will cheer you on to all the sedentary tasks which you and the pen must still encounter in the mornings and evenings at your literary retreat.[13]

For local people in St Andrews golf remained a traditional and inexpensive pursuit, bringing all sorts together. Writing about it even

improved relations between William and Robert. Apparently assisted by Major Playfair, they pooled their talents in writing about St Andrews in the 1840s. At Robert's suggestion, William took the lead:

> I think anything about St Andrews had best be drawn out by yourself. Do it as you can, and where necessary I could fill in details. I suggest this because the first impressions of a stranger have a certain life and interest about them. You may however wait till the Major gives us some notes which I have asked from him.[14]

The combined talents of William, Robert, and Major Playfair were brought to bear on describing St Andrews to readers of *Chambers' Edinburgh Journal*, but it was Robert, fascinated by the local geology, who supplied the 'Gossip about Golf' in October 1842:

> This quiet venerable university town, where literary and philoso-phical society is agreeably mixed with miscellaneous persons in independent circumstances, happens to be skirted by a links of more than two miles in extent, a fine rolling field, as the Americans would describe it, bearing herbage and furze, and, as usual, open for the recreation of the inhabitants. St Andrews is confessedly the Melton of golf [Melton would have been recognised by readers as the home of fox hunting], for no other place presents ground nearly so well adapted for the amusement, or which is the haunt of so many players. The links is entirely composed of sand blown up from the sea, upon a spot where the waves must have once held sway, for the ancient sea-cliff is still distinctly traceable along the inland verge, although now softened down by time, and reduced to tillage, pasture, and pleasure-ground. With this fine slope on one side, and the German Ocean on the other, the striking outline of pinnacled St Andrews behind, and in front the distant hills of Perth and Forfar shires, extending from the central Grampians down to the Red Head near Arbroath, the whole scene is something more than beautiful; the very spaciousness of a view commanding objects much more than a hundred miles distant from each other, affects the beholder in an uncommon manner.[15]

As much as – perhaps sometimes more than – the university, the golf course was a place for Great Thoughts, as well as for coming face-to-face with the elements of nature. Its open expanses of grass, sea, or sky were replete with hints of beyond. Noting the 'unusually rough character' of some of the ground between the holes, Chambers commented that some powerful players 'can, in the words of a clever local poem, send a ball "smack over – at one immortal go;" lighting upon a fine expanse beyond called the *Elysian Fields*'. Other aspects of the course were much more down to earth, especially the names given to each sandy hollow 'called in the technology of the links a *bunker*'. Social mingling on the course is evident even in the naming of these sand-traps. 'One, where an old woman sometimes waits to sell refreshments for bethirsted players, is called the Ginger Beer Hole.'[16] A famous bunker was (and is) called the Principal's Nose, another Tam's Coo. A would-be poet, anxious about the bunkered shot that 'goes | Gently into the *Principalian Nose*', Robert later penned sonnets to several of the holes on the St Andrews links. His 1843 notebook contains a poem called 'A Lay of Abbey Park' in which one of his daughters explains to a distinguished visitor that her 'Pa . . . good man, had gone to golf'.[17] The golf course was popular, quirky, at times dangerous. Often,

> There might be seen five or six playing along one after another – occasioning such a pell-mell of balls, that quiet promenaders are fain to give the course a wide berth. Some men of leisure are out every day, and never make less than two rounds before dinner, often three, each round being a walk of four miles, to say nothing of the exercise of playing, so that it may well be supposed the golfers are a healthy people. Generally, they are quiet country gentlemen, or retired officers of the army or navy; but several of the professors also play.[18]

Eager to improve his health through golf, in summer 1842 Robert wrote in the morning and then, about two o'clock, walked from his house at Abbey Park to the links where he might 'pop into the club-house to glance at the papers, and be in the way of any agreeable temptation that may arise'. Normally an all-male space (women were not admitted as golfers) the club-house was somewhere for players to

store their clubs and distinctive clothing. The club had its own special 'light scarlet coat'. Members might play a game of whist in the evenings; the club-house boasted a fine 'reading-room for such of these gentlemen as chose to subscribe to it'.[19] Among golfing gentlemen the Playfairs were among the best known, but Robert too established himself as a regular. His daughter noted,

> Papa goes out at 2 o'clock every fine day to enjoy the exercise: he is not yet a very good player, but promises well. Mamma says that Colonel Holcroft told her that he was *two* years before he became a proficient, and now he is one of the best players on the links. I suppose Papa must also go through his apprenticeship. There is a dinner and annual ball given by the members of the Golf Club, and as Papa was a member, he was at both. The ball this year was not so well attended as usual; but Mamma says it was very pleasant; the music was remarkably good (Mackenzie's band from Edinburgh), and the ladies so very well dressed. The gentlemen also looked so well, in their red coats and club-buttons. There was no stiffness or party-spirit shown between the country gentry and the St Andrew's people.[20]

As he golfed, Robert became fascinated with the geological lie of the land. In the midst of such coastal terrain one could not but be aware of the sea, of erosion, and the way landforms were shaped over time. Chambers for years liked to have with him a succession of tiny pocket notebooks. One of these survives with minute pencilled observations on local places like Stravithie, Pipeland, Mount Melville, Clayton and Balone.[21] To golf was to traverse the ground. To traverse the ground was to observe it. As with Major Playfair's garden, the boundary between recreation and science was permeable; there were pleasures on both sides.

On 2 January 1843, in the Humanity classroom at the monthly meeting of the Lit and Phil with the Major in the chair and Sir David Brewster in the audience, Chambers read a scientific paper entitled 'Certain Geognostic Features of the Environs of St Andrews'. Dealing with the recently noted phenomenon of 'raised beaches' (former beaches, now situated above sea-level), its object

was to point out some remarkable examples of raised beaches which Mr Chambers has observed in the neighbourhood of this city. He particularly described a first and a second beach respectively about 60 and 100 feet above the present high-water mark. A third and a fourth or higher levels are comparatively obscure. Mr. Chambers described the exact limits of the first and second raised beaches, and detailed the results of a series of observations on the levels made with the view of ascertaining the height at different parts.[22]

This paper, which partook of every geologist's fascination with the origin and formation of the world, was the precursor of a more substantial work of 1848, *Ancient Sea-Margins, as Memorials of Changes in the relative level of Sea and Land* in which Chambers writes of the 'gentle and beautiful stream' of the Eden estuary and of 'pinnacled St Andrews' which 'looks out upon the sea' nearby. Mingling scientific observations and local attachments in typical Lit and Phil style, he sees St Andrews as 'an anciently civilized and cultivated district, speaking of Christianity both in its Romish and pre-Romish forms, of royal hauntings, and of the commerce of a bypast condition of the country'. Yet he wishes to uncover another history, a geological one compared with which the writings of medieval St Andrews-educated Scottish chroniclers 'are as the news of yesterday'.[23]

He presented a copy of his book to the University Library. Its frontispiece shows a scene 'From the Links of St Andrews Looking South Eastward'. Two golfers stroll past; several women and a top-hatted man watch a child rolling a hoop in a central pool of light; a few farms and the rooftops of St Andrews can just be seen, but look vestigial. What dominate the picture – appropriately enough – are the dark-shaded raised beaches of the landscape, and the hills beyond. Golf is overshadowed. Clouds pass, but the abiding presence is that of a geological phenomenon far grander and more ancient than any human aspects of the vista. Whilst Chambers's interest in the earth's history was public knowledge – he published, examined geological phenomena with Brewster, corresponded with Darwin about the subject – what he did not reveal was that the ideas he mulled over on the golf course went far beyond these shared observations. His thoughts were leading

towards the secret writing and sensational publication of a far more scandalous book, one which would convulse Victorian intellectual life and whose disturbing legacy continues to this day.

In secret at Abbey Park, day after day, Anne copied out the manuscript of this work meticulously in her own handwriting, so that its author's true identity could be concealed from a potential publisher. In correspondence about the manuscript she adopted the codename 'Mrs Balderstone', while Robert styled himself variously 'Sir Roger', 'Ignotus [Unknown]', 'The Unknown', or sometimes 'Mr Balderstone'. These Balderstone aliases were taken from their fictional alter-egos in *Chambers' Edinburgh Journal*.[24] The manuscript which Robert wrote and Anne copied attempted at once to face up to the apparent insignificance of human life when seen from the perspective of geological time, and yet also to articulate some sense of purpose and order in the universe, even as Chambers came to admit that humanity itself might not be sustainable and might become obsolete. It dealt with nothing less than the beginning and the end of the world.

For such an ambitiously wide-ranging survey, Chambers's manuscript was surprisingly short. Unsure what to call it as it neared publication, Chambers eventually settled on the title *Vestiges of the Natural History of Creation*. *Vestiges* was first published in London in 1844, and took up only 390 small, generously spaced pages. Its contents started with an account of 'The Bodies in Space – Their arrangement and formation', then moved on from stars to the formation of the earth and other planets, before the 'Commencement of Organic Life'. The world was tracked through its several geological eras. Drawing on accounts of fossils, such significant moments as the 'First Traces of Birds' and the 'Commencement of Mammalia' were explained before, relatively late in the book, Chambers reached the 'Early History of Mankind' and the 'Mental Constitution of Animals'. He then considered the 'Purpose and General Condition of the Animated Creation'.[25]

If all this sounds daunting, the tone was quite the reverse. One way Robert conveyed a sense of the universe as coherent was through the image of a family. Early in what became his first chapter he presents 'the globe which we inhabit as a child of the sun'. He sees nebulous stars

as 'but stages in a progress, just as if, seeing a child, a boy, a youth, a middle-aged, and an old man together, we might presume that the whole were only variations of one being'. So there are 'in our astral system many thousands of worlds in all stages of formation'. Pondering these, he quotes with approval from an encyclopedia article in which Sir John Herschel writes of the stars as related, linked: 'The resemblance is now perceived to be a true *family likeness*; they are bound up in one chain – interwoven in one web of mutual relation and harmonious agreement, subjected to one pervading influence which extends from the centre to the farthest limits of that great system, of which all of them, the Earth included, must henceforth be regarded as members.'[26]

Making the whole universe from its origins the subject of a natural history, Chambers's book was, a modern scholar has written, 'the literary equivalent of a museum of creation'.[27] This might make it sound comfortingly consonant with the Lit and Phil's natural history collection, looked after with patient dedication by John Adamson. Yet the way in which Chambers's manuscript 'offered readers a guided tour through a museum of creation' also made it potentially unsettling.[28] *Vestiges* was published fifteen years before Darwin's *Origin of Species* (1859). Chambers, then, followed not Darwin but his radical precursor, the French thinker Jean-Baptiste Lamarck ('a naturalist of the highest character'), and advanced a theory of 'transmutation', envisaging a law of progress that allowed lower organisms to give birth occasionally to higher ones.[29] In their implications such theories offended a good number of religious believers, even though Chambers was careful to attribute this progressive system to 'One who is both able and willing to do us the most entire justice'.[30] At times he mixed scientific reasoning with apocalyptic imaginings: 'A chemist can reckon with considerable precision what additional amount of heat would be required to vaporize all the water of our globe.'[31] Elsewhere he is gently domestic as he relates the microscopic to the macroscopic: 'The tear that falls from childhood's cheek is globular, through the efficacy of that same law of mutual attraction of particles which made the sun and planets round.'[32] His was an imaginative, even beguiling book, but very ready to move from literal readings of biblical narratives to 'evidence of an entirely

different kind'.[33] In that tendency, and in the way it acquainted a mass audience with often unsettling scientific ideas, the little volume, for all its homeliness, seemed to many people despicable.

Drawing on a great variety of thinkers – from Brewster and Herschel to the Glasgow astronomer John Nichol and mathematician Charles Babbage – Chambers relentlessly synthesised. In so doing he was building to some extent on the example of the famous Scottish mathematician Mary Somerville, after whom Somerville College, Oxford, takes its name; her 1834 work *The Connexion of the Physical Sciences* had 'established a new literary form, the extended synthetic literature review'.[34] In his own sweeping survey Chambers was attempting to ask 'what does it all mean?' Where the Major's garden might encourage gentle speculation about one's place in history and the universe, or a photograph might place a small, transient human figure against a backdrop of ancient stone, Chambers sought to set out as one linear narrative the onwards movement from the very beginning of time right up to the present moment. Then he speculated about time's end. Though he passed lightly over the point, having asked the question, 'Is our race but the initial of the grand crowning type?', Chambers suggested there might 'yet . . . be species superior to us in organisation, purer in feeling, more powerful in device and act, and who shall take a rule over us' – a distinctly disturbing idea.[35] If one could have taken all the kinds of learning that crammed Playfair's spectacular horticultural and theatrical display or fascinated the St Andrews Lit and Phil – knowledge geological, astronomical, historical, botanical, photographic, electrical, chemical and physiological – and fitted the lot together into one coherent, though sometimes awkward, book, then that volume would have been the one which Chambers, recovering from his own breakdown and facing up to a heightened sense of death, wrote while living with his lively and musical family in the villa called Abbey Park.

Robert's manuscript became 'the most discussed scientific book of the Victorian era'. It 'reinscribed Enlightenment cosmology as evolutionary narrative' and, innovatively in literary terms, it 'created the evolutionary epic in its modern form'.[36] In crucial ways his work 'scooped' Charles Darwin. The modern Cambridge University

professor, James Secord, to whom all today's readers of Chambers are indebted, has produced in his 600-page study of *Vestiges* 'the most comprehensive analysis of the reading of any book since the bible'.[37] Secord shows how Chambers's audience included Queen Victoria, Abraham Lincoln, Darwin, Tennyson, George Eliot, Florence Nightingale, Gladstone, Carlyle, and a myriad of other scientific, ecclesiastical, poetic, radical, and general readers. As one of them, schoolteacher Mary Smith, recalled, *Vestiges* was 'the book that most excited the wonder and curiosity of the reading world'.[38]

The St Andrews author's *Vestiges* caused intellectual upset and even scandal simply because it was, as he put it in the conclusion to the earliest (1844) edition, 'the first attempt to connect the natural sciences into a history of creation'.[39] For a geologically minded Scot like Chambers, the word 'vestige' would have carried particular associations since it had been used by James Hutton in a ringing phrase towards the conclusion of his *Theory of the Earth* where Hutton wrote of how 'we find no vestige of a beginning – no prospect of an end'.[40] Running from the beginning of stars and planets, through the origins of the earth and the enormous history of geology, Chambers's *Vestiges* expounded a divinely preordained 'law of development'. This was perceived in the progress of plants, fish, mammals and humankind. All were part of a connected history. Chambers the Burns enthusiast would have known that Burns had written in a well-known poem about what 'Nature's law design'd', but *Vestiges* sought to be scientific prose, albeit with poetic aspects.[41]

Gathering a remarkable assembly of materials from his scientific reading, and, on occasion, from conversations, Chambers marshalled his evidence, arguing with regard to 'The Vegetable and Animal Kingdoms', for instance, that 'These facts clearly shew how all the various organic forms of our world are bound up in one – how a fundamental unity pervades and embraces them all, collecting them, from the humblest lichen up to the highest mammifer, in one system, the whole creation of which must have depended upon one law or decree of the Almighty, though it did not all come forth at one time.'[42] Such a perception was hardly out of line with the views of Robert's acquaintances. The St Andrews professor John Reid spoke in 1843 of

how his lectures on comparative anatomy traced 'great general laws regulating the organisation and vital actions of all the organized productions of nature' and regarded his lectures as 'well fitted for the students of Divinity' because 'the structures and functions of organized bodies have furnished numerous and most available arguments in Natural Theology'.[43] Yet the range of Chambers's work made *Vestiges* seem much more threatening.

Vestiges perceived a 'higher generative law' which produced through 'natural means' over vast expanses of time the organisms of existence. God was not denied, but seen as working through discernible laws and patterns. Chambers stressed 'the original Divine conception of all the forms of being which these natural laws were only instruments in working out and realizing'.[44] So, in his Fife town of rehabilitated dwellings and stylish gardens, Robert wrote how 'the whole plan of being is as symmetrical as the plan of a house, or the laying out of an old-fashioned garden!'[45] But whilst this divine planning and development was domestic and reassuring, he also acknowledged its almost unimaginable vastness. Writing about our solar system, he suggested in his opening paragraph that 'some faint idea' of its extent 'may be obtained from the fact, that, if the swiftest race-horse ever known had begun to traverse it, at full speed, at the time of the birth of Moses, he would only as yet have accomplished half his journey'.[46]

Robert had probably taken some of his companionable tone from books such as Hugh Miller's 1841 *The Old Red Sandstone*, but in *Vestiges*, he developed to the full his own ability to use engaging images to increase and broaden his work's appeal. He was, after all, a man used to talking to all sorts of people. He was expert too at communicating with a general audience in *Chambers' Edinburgh Journal*, for which he continued writing while at work on *Vestiges*. Though he realised his book was likely to be controversial, nonetheless he argued against 'that timid philosophy which would have us to draw back from the investigation of God's works, lest the knowledge of them should make us undervalue his greatness and forget his paternal character'.[47] Where his friend Brewster admired Newton, the great lawgiver of gravity, Chambers hoped to set out an equally important law:

The inorganic has one final comprehensive law, GRAVITATION. The organic, the other great department of mundane things, rests in like manner on one law, and that is, – DEVELOPMENT.[48]

Chambers's 'development' was in many ways cognate with what Darwin would term 'evolution'. His wish to write one book which traced the whole of natural history was similar to Darwin's later aim in *On the Origin of Species by means of Natural Selection.* Pointing out that Darwin read Chambers's *Vestiges* in the library of the British Museum on 20 November 1844, approaching the book 'not as a sweeping cosmological narrative but as a botched version of his own manuscript', Secord details the 'many ways' in which Darwin had been pre-empted by Chambers in producing 'a book advocating a natural origin for species in a framework of material causation and universal law'.[49]

Though he soon wrote that 'the writing & arrangement are certainly admirable', Darwin was keen to identify scientific errors in Chambers's work. He distanced his own ongoing researches from Robert's project, revealing, surely, a certain anxiety of influence. Darwin re-read *Vestiges* in 1847, and followed the arguments over it closely: they showed him the sort of controversies likely to rage over his as yet unpublished speculations. The great English scientist noted that 'The publication of the Vestiges brought out all that could be said against the theory excellently if not too vehemently.'[50] The reception of *Vestiges* allowed Darwin to observe other people's reactions to a book that was in several ways very similar to the one he was writing, without having to face the music. Indeed, he joined in carping about *Vestiges*, and eventually alluded to that book in *On the Origin of Species* as if *Vestiges* had been an unsatisfactory essay on species origins, instead of a broad thesis about law-governed creation and development.

What Darwin saw in *Vestiges* made him slow down, resolved not to make the sort of scientific errors of detail for which the author of *Vestiges* was pilloried; but, as Secord indicates, it also led Darwin to alter dramatically the balance of his arguments, concentrating less on human origins or the biblical story of Genesis or the general argument for evolutionary change (since the *Vestiges* controversies covered those), and focusing more on the precise mechanism of natural selection.

Darwin avoided, too, Chambers's engaging, friendly tone. Instead he projected a dry, specialist accent hardly designed to appeal to a general audience. Unlike Chambers, he was writing for a scholarly elite. *Vestiges* sold over 20,000 copies in the ten years following its publication, and became 'an extraordinarily successful scientific steady seller'.[51] In the decade following the publication of Darwin's *On the Origin of Species*, the great Victorian scientist's book sold fewer than 10,000 copies.

All this meant that, as one contemporary noted in 1860, Darwin's volume caused less of a row than 'the once famous *Vestiges*'.[52] Having drawn the sting for Darwin's work, *Vestiges* was, Secord points out, 'the one book that all readers of the *Origin of Species* were assumed to have read'. Secord shows too how Darwin differed from Chambers, in maintaining through literary tone and in his person the 'secure gentlemanly status' which Victorian England expected of its scientific men. Often associated with Oxford and Cambridge, and with the aristocracy routinely educated there, 'gentlemanly science was practised in a community whose very existence depended on assumptions about breeding'.[53] A bankrupt's son who had sold books on a street corner and hung out with radicals, Chambers did not have the right credentials; in St Andrews he may have mixed with Sir David Brewster, Major Playfair, and other gentlemen, but he did so in a context where the university, the golf course, and the Lit and Phil all encouraged an atmosphere considerably more open than that of public-school-accented Cambridge cloisters.[54] Nothing could be less aristocratic than the popularising of science which filled *Chambers' Edinburgh Journal* and *Chambers's Information for the People*.

Vestiges occasioned scandal all the more because it came to be associated with folk whom the English gentlemen of science routinely distrusted: women, radicals, the lower classes. Cambridge scientist Adam Sedgwick, who blasted *Vestiges* in the *Edinburgh Review*, scorned what he saw as its 'science gleaned at a lady's boarding school'.[55] Oxbridge dons linked the book to 'washed and unwashed radicals' and wondered if it might be by 'some Scotchman or other'.[56] As his volume progressed through revised editions, Chambers aimed not just to render it scientifically correct, but to make it 'more accessible to the uneducated classes' – something Darwin studiously avoided.[57] *Vestiges* was,

after all, a book which dared to suggest that the earth as one among many planets in numerous solar systems was 'a member of a democracy'.[58] Published at the height of pro-democratic Chartist agitations and started while Chambers was assembling his *Cyclopaedia of English Literature* aimed at 'the middle and labouring classes', *Vestiges* would go into successive cheap editions, its arguments disseminated throughout an increasingly democratic book-world.[59] This democratically accented work's sheer tenacity in weathering storms of abuse horrified many, and surprised even its author: 'What a multitude of books, pamphlets, &c. has that scapegrace book provoked into existence – a wonderful thing for a book so universally condemned by the philosophical world. How devilish ill to kill it is!'[60]

On visits to England, Chambers kept his authorship of *Vestiges* absolutely secret from the established gentlemen of science he met at conferences. He was much more sympathetic to the younger career scientists of the 'magnanimous Brotherhood' of London's Metropolitan Red Lion Association than he was to the gentlemen of Oxbridge. The Red Lions in the 1840s included men like Lyon Playfair, whom Chambers knew through St Andrews family connections with the Major. Edward Forbes, founder of the Red Lions, admired Chambers's work. Later, the Red Lion Club would include Scottish scientist and poet James Clerk Maxwell whose poems would be collected and published with the help of his lifelong friend and biographer, the St Andrews Professor of Greek and friend of Robert Louis Stevenson, Lewis Campbell. The Red Lions were the future of science, Chambers hoped, even as his own work was pilloried by the old-style gentlemanly elite. Men like Brewster and Clerk Maxwell can also be connected with a scientific tradition in energy physics and related fields which has been viewed recently as 'bearing the impress of Scottish Presbyterianism, representing whig and progressive values'.[61] This was more akin to the milieu of Chambers than was the elite world of English private education and Victorian Oxbridge colleges.

Secord sees Chambers as having 'become convinced that the best way forward would be to transform the practice of science. Establishing a people's science thus involved creating new forms of field and laboratory practice.'[62] Scientific insights might come from observations made

Plate 12: Robert Chambers around the time he authored *Vestiges of the Natural History of Creation* (1844), an engraving by T. Brown of a portrait by Sir J. Watson Gordon, reproduced in Lady Priestley's *The Story of a Lifetime* (1908).

Plate 13: Anne Chambers as a young mother, an illustration reproduced in her daughter Eliza's much later memoir. Lady Priestley, *The Story of a Lifetime*.

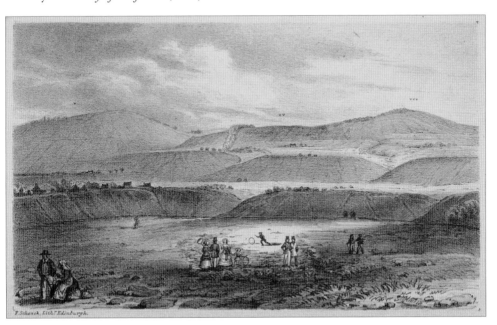

Plate 14: From the Links of St Andrews Looking South Eastward. A lithograph by F. Schenck of Edinburgh used as the frontispiece to Robert Chambers, *Ancient Sea-Margins* (Edinburgh: W. and R. Chambers, 1848).

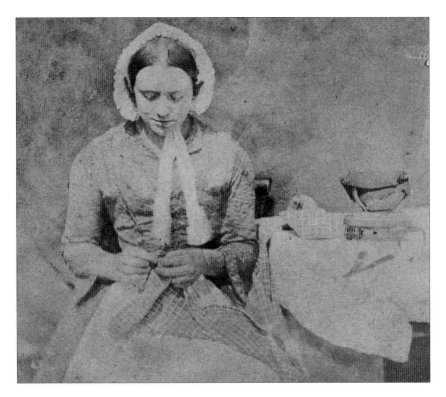

Plate 15: A laundry maid, around 1845, by an unidentified photographer; print from calotype negative. This picture comes from the album of Alexander Govan, Druggist, South Street, St Andrews.

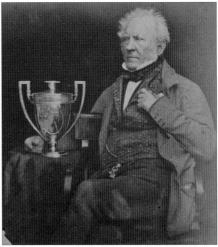

Plate 16: Professor Robert Haldane, Principal of St Mary's College, University of St Andrews, around 1845, by Robert Adamson with David Octavius Hill; print from calotype negative.

Plate 17: Major Playfair with a trophy, around 1850, by an unidentified photographer; print from calotype negative.

Plate 18: Houses being pulled down for 'improvement' in South Street, March 1844, by John Adamson; print from calotype negative. A man identified as Mr John Kennedy stands on the site of the Albert Buildings.

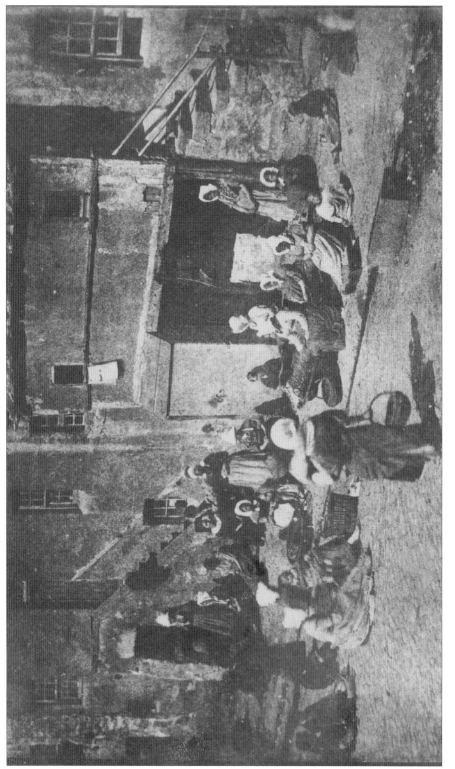

Plate 19: Fisherwomen baiting lines, North Street, around 1845, most probably by Robert Adamson with David Octavius Hill; print from calotype negative.

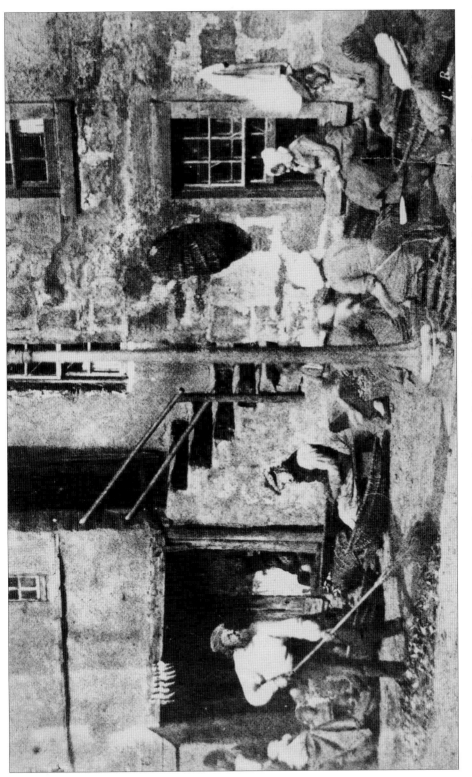

Plate 20: Scene at the same part of North Street (but now with a streetlamp), late 1840s, by Thomas Rodger; print from calotype negative.

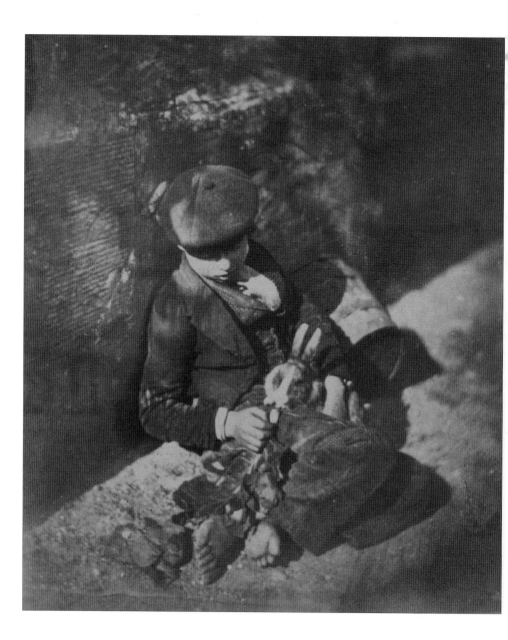

Plate 21: A boy feeding a pet rabbit, around 1850, by an unidentified photographer; print from calotype negative.

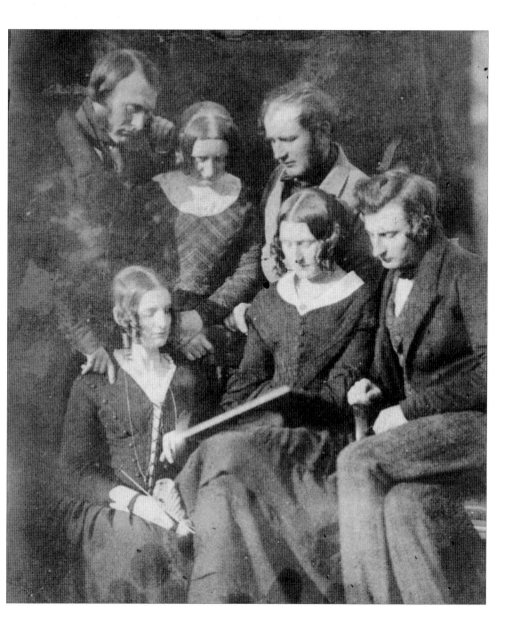

Plate 22: The Adamson family around 1844, with John on the left and Robert on the right, by an unidentified photographer (but probably Robert Adamson with David Octavius Hill); print from calotype negative.

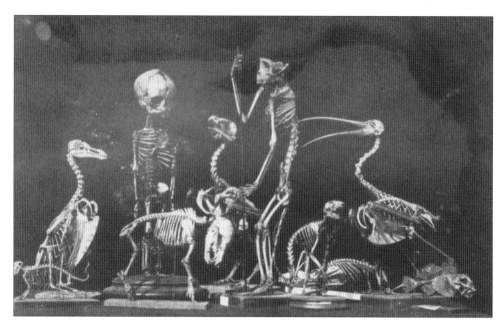

Plate 23: Specimen skeletons from the Museum of the St Andrews Literary and Philosophical Society, around 1865, by John Adamson; print from calotype negative.

Plate 24: Potato Head, around 1855, by John Adamson; print from paper negative. This oval mock-portrait has what seems to be a potato resting on a cloth draped like a jacket and collar.

on the golf links; from conversations at the Lit and Phil; from work associated with popular publications like *Chambers' Edinburgh Journal*, as well as from more arcane and 'gentlemanly' researches. Had Chambers been born almost two centuries later, he might well have relished the knowledge-world of the internet. Like the new practice of photography, *Vestiges* was potentially democratic in approach. Writing in a society that was far from a democracy, Chambers was no ardent Chartist; for all that his work came to appeal to radicals, he remained a keen Victorian capitalist. Yet he was also an admirer of the Robert Burns whose democratic sensibility was so alien to English Oxbridge gentlemen such as Matthew Arnold. For all sorts of reasons, *Vestiges of the Natural History of Creation* provoked an outcry and was sidelined by the Darwin to whom it was nonetheless very important. Only after Chambers's death did Darwin have the grace to admit uneasily to the Scottish author's daughter that 'Several years ago I perceived that I had not done full justice to a scientific work which I believed and still believe he was intimately connected with, and few things have struck me with more animation than the perfect temper and liberality with which he treated my conduct.'[63]

Darwin's phrasing here was circumspect in part because during his lifetime Chambers never allowed his name to appear on the title page of *Vestiges*. Nor did he admit in public to having written it. Like Darwin after him, he sensed his material was likely to be controversial; born without private means, he knew his livelihood and his family's prosperity depended on the success of the firm of W. and R. Chambers. For many its anonymity increased the book's power. Instead of being known to come from St Andrews or Edinburgh, alarmingly, published in London, 'it seemed to emanate from the very centre of English life'.[64] There was much argument over the identity of the author – as there had been decades earlier about the authorship of the Waverley Novels. *Vestiges* could be seen as the greatest literary sensation since Walter Scott's *Waverley*, a narrative whose author's attempts to try and conceal his identity had so fascinated Chambers that he had once written a whole volume, *Illustrations of the Author of Waverley* (1825), teasingly exploring the implications of how one might portray the anonymous writer of a famous book.[65] Was the originator of *Vestiges* Thackeray, or

Babbage, or even Darwin? This mysterious author was the Scarlet Pimpernel of Victorian intellectual life. *Vestiges* was not just a scandalous book. It was a mystery, a puzzle which obsessed mid-nineteenth-century readers. There were repeated guesses at the writer's identity, and as many vehement denials. If the volume itself claimed to detect traces, vestiges, that pointed to a supposed 'Almighty Author', then its readers were fascinated and disturbed as they digested its arguments, seeking to find in it elusive traces of its own authorial creator.[66]

In composing *Vestiges of the Natural History of Creation* Robert Chambers wrote himself out of the breakdown which had originally occasioned his move to St Andrews, and after he had finished he was able to return from the relative seclusion of Fife to re-engage with his busy life in Edinburgh. Most of Chambers's earlier writings had been about Scotland and Scottish history. Written at the start of his forties, *Vestiges* looks far further. It asks the sort of questions that matter to most people, not least in midlife. Yet to suggest *Vestiges* was simply the product of a male midlife crisis tones down the circumstances of its composition. Those were manifestly more extreme.

We cannot know the exact nature of Chambers's breakdown. It was covered up completely by his brother William, who wrote Robert's posthumous biography and explained that the move to St Andrews was 'for some purpose connected with his young family'.[67] However, surviving letters and published hints do suggest the breakdown was serious. Towards the end of 1841 leader articles which Robert regularly contributed to *Chambers' Edinburgh Journal* examined such matters as the importance of working 'With the Grain' of the human personality; to go against the grain is to find oneself 'sitting on a railway carriage going down an inclined plane by its own weight'.[68] It seemed to Chambers and his wife at the time that he might be heading in just such a direction. 'I sink in confusion, bewilder'd and lost' was a line quoted in another leading article.[69] Chambers wrote of 'mortality', 'misfortunes', and of how an apparently healthy man 'may die the next moment'. Reading work he would later draw on in *Vestiges*, he pondered the statistics of 'murder' and 'suicide', sharing them with the audience of the *Journal*.[70] Though in public readers might not have been struck by any connection between such magazine articles and Mr

Chambers himself, in private there were severe strains. Robert wrote to William at one point of 'atrocious family persecutions carried on against me'. As far as his relationship with his brother and business-partner went, he had 'serious fears as to our ever being again a united family, as others are'.[71]

> You and I have made wonderful progress in the world, but there has been one element sadly wanting amongst us all, the cultivation of the social feelings. Many people have more happiness in comparative poverty from being pleasant and kind with one another, than we with all our unexampled prosperity. The . . . causes of this are in my opinion not to be remedied, but we may come to be able to at least give each other no unnecessary offence. It will only be necessary to this that business connections cease. On this point I am as fixed as fate, nor would any thing short of a miracle in either changing my nature or that of my relations make me swerve from it.[72]

In time Robert and William did manage to renegotiate the terms of their partnership in a way that Robert felt allowed him greater freedom. His relationship with Anne too survived and even grew stronger. But, for all that he hid it from his neighbours, it would be wrong to deny the intensity of his crisis. At the end of January 1842 a piece on 'Consolations' in *Chambers' Edinburgh Journal* speaks of 'The ills of life being so numerous and so besetting' and of it being 'a matter of great consequence to have a ready access' to a range of consolations 'to apply' to 'our sores'. The sores detailed are psychological rather than physical. They encompass literary anxieties, including the worries of 'a philosopher whose views go a great way ahead of his age'.[73] The following month saw a leading article, 'Cowed Ones', which examines the psychology of people who are 'cowed and fearful': 'There is some cowed person about almost every house'. Particularly cowed is the 'excessively negative' office-worker whose life passes away, 'his exterior getting all the time more and more cowed-looking, till, at the time when all men are naturally cowed of their vivacity, he becomes a kind of Impersonated Negation'.[74]

This capitalised 'Impersonated Negation' is reminiscent of 'The

Everlasting No' of which Thomas Carlyle had written in a fictionalised account of his own breakdown and recovery in his widely admired *Sartor Resartus*, first published in Britain in book form in 1838. Carlyle, one of the dominant figures in Edinburgh literary life during Chambers's young manhood, had worked for Brewster's *Edinburgh Encyclopaedia* in the 1820s, but his own encyclopedic work had gone hand-in-hand with an approaching mental crisis. Carlyle's crisis involved a typically Victorian sense that traditional religious belief was being eroded, perhaps even killed, by scientific modernity. His mental anxieties had reached their height one day in August 1822 when he was walking down Edinburgh's Leith Walk, the street in which the young Robert Chambers had been a bookseller, but the connections between the two men go deeper than any geographical coincidence.

In *Sartor Resartus* (whose Latin title means 'the tailor reclothed'), Carlyle had fictionalised his own psychological and spiritual crisis, attributing it to a provincial German academic of encyclopedic enthusiasms, Professor Diogenes Teufelsdröckh of Weissnichtwo – in English, Professor Devilsdroppings (or perhaps 'Devil's Pressure') of Don't-know-where. 'Misery raging within', the pressured Teufelsdröckh comes to feel 'quite shut out from Hope'. Though he may think wistfully of 'Martyrs', his 'Doubt has darkened into Unbelief', and he wonders, 'Is there no God, then; but at best an absentee God, sitting idle, ever since the first Sabbath, at the outside of his Universe, and *seeing* it go?' In love with Truth and 'the speculative Mystery of Life', he senses nonetheless that the 'old Temples of the Godhead, which for long have not been rainproof, crumble down'. He feels cut off, cowed, 'cowering and trembling', alone. 'Invisible yet impenetrable walls, as of Enchantment, divided me from all living'. Around him, other people seem at a constant remove: 'In midst of their crowded streets, and assemblages, I walked solitary . . . To me the Universe was all void of Life, of Purpose, of Volition, even of Hostility: it was one huge, dead, immeasurable Steam-engine . . .'[75]

It is not absolutely clear that Robert Chambers experienced a severe loss of religious faith around the time of his own breakdown, but there is certainly evidence that his adherence to formal religion was then slight. He had grown up in a Presbyterian milieu, though he had felt

concerned about the strictness of those who belonged to a '*Scottish Inquisition*'.[76] In Edinburgh he and his family had attended St Cuthbert's Church of Scotland until the point when (apparently in 1832) the minister there had preached against the fledgling *Chambers' Edinburgh Journal*, waving a copy from the pulpit and denouncing what seemed its neutral stance on religion. Robert led his family out of the kirk. Though they went on to attend an Episcopalian Church, he seems to have been wary of Christian enthusiasms in the 1830s and during the years of the Disruption. Robert's mental crisis was not, like Thomas Carlyle's, centred on questions of faith, but he was certainly aware of these. His way of extricating himself from his mental health problems while writing *Vestiges* was in several ways similar to that of Carlyle's protagonist.

Teufelsdröckh, the encyclopedically minded 'Professor of Things in General', is fascinated by 'an incredible Knowledge of our Planet', the Solar System and 'Thousands of human generations . . . swallowed up of Time'. He confronts his 'Everlasting No' with a kind of wilful rebellion. Carlyle moved beyond this to hymn, often in religious language, a 'Gospel of Freedom', which emphasises purposefully directed work – '*Work thou in Welldoing*' – and not least intellectual labour that will create and discover new truths. This need not involve an abandoning of the old truths, but it does require their reclothing. Since 'the Mythus of the Christian Religion looks not in the eighteenth century as it did in the eighth', there is a need to 'embody the divine Spirit of that Religion in a new Mythus'. Carlyle uses 'Mythus' here not to mean untruth, but in the etymological sense of a word, design, or story in which truth may be embodied. From the human spirit a new mythus, or a reclothing of the old had to emerge, and the intellectual effort involved was crucial: work itself could help cure a sense of negation, bringing rediscovery of purpose at a time of crisis. Balancing Carlyle's chapter 'The Everlasting No' is a section, 'The Everlasting Yea'. This concludes by quoting the literary-minded professor's typically over-egged rhapsodic style, as he sets out the cure for his own breakdown and his sense of the powerful, abiding presence of that element of light so beloved of the evangelical Brewster and his circle of early photographers:

But it is with man's Soul as it was with Nature: the beginning of Creation is – Light. Till the eye have vision, the whole members are in bonds. Divine moment, when over the tempest-tost Soul, as once over the wild-weltering Chaos, it is spoken: Let there be Light! Ever to the greatest that has felt such moment, is it not miraculous and God-announcing; even, as under simpler figures, to the simplest and least? The mad primeval Discord is hushed; the rudely-jumbled conflicting elements bind themselves into separate Firmaments: deep silent rock-foundations are built beneath; and the skyey vault with its everlasting Luminaries above: instead of a dark wasteful Chaos, we have a blooming, fertile, Heaven-encompassed World.

I too could now say to myself: Be no longer a Chaos, but a World, or even Worldkin. Produce! Produce! Were it but the pitifullest infinitesimal fraction of a Product, produce it in God's name! 'Tis the utmost thou hast in thee; out with it then. Up, up! Whatsoever thy hand findeth to do, do it with thy whole might. Work while it is called To-day, for the Night cometh wherein no man can work.[77]

The work which Chambers pursued in St Andrews, the construction of his own 'new Mythus', his version of the story of the universe, was just the sort of work-cure Carlyle had recommended. If overwork had contributed to Robert's breakdown, more focused kinds of intellectual activity, mixed with the golfing, familial, social, and other pleasures of St Andrews, allowed him to regain a sense of what life was about. By 1843 *Chambers' Edinburgh Journal*, which often included nuggets of wisdom culled from other authors, was quoting Carlyle under the heading 'LABOUR A CONSOLER',

There is a perennial nobleness, and even sacredness, in work. Were he ever so benighted, forgetful of his high calling, there is always hope in a man that actually and earnestly works; in idleness alone is there perpetual despair. Doubt, desire, sorrow, remorse, indignation, despair itself – all these, like hell-dogs, lie beleaguering the soul of the poor day-worker as of every man; but he bends himself with free valour against his task, and all these are stilled – all these shrink murmuring far off into their caves.[78]

This is a shortened version of the opening of the eleventh chapter of Carlyle's *Past and Present* (1843), which was then a new book. In the same passage Carlyle wrote of how 'the whole soul of man is composed into a kind of real harmony the instant he sets himself to work'.[79] Focusing on the task of writing his book on all creation, Chambers, like Carlyle, rediscovered a mental equilibrium, a restoration of personal and familial balance. Simultaneously he confronted the ultimate mysteries of existence and, for the first time in a coherent way, made scientific sense of them. Where from an anti-democratic stance Carlyle sought to make sense of turbulent human history, the more democratically minded Chambers produced a work which managed to set out a continuous history of the processes which had given rise to the planets, to the earth and to its past and present inhabitants.

Carlyle would be very wary of Chambers's *Vestiges*, but it is striking that one of Chambers's closest friends, Alexander Ireland, whom Robert Chambers had known for many years, was a 'leading promoter' of the philosophical outlook of Carlyle.[80] Ireland was almost the only person other than Anne whom Chambers took fully into his confidence early on – while he was working on the manuscript and publication of *Vestiges*. Carlyle's *Sartor* and Chambers's *Vestiges* are both books which emerge from a period of personal crisis. Each involves facing up to ultimate questions about the significance of existence. Where Carlyle's work was signed and personal, deliberately stylistically eccentric in a full-blown way, Chambers's was published anonymously, its tone reassuring, plain, companionable. If Carlyle's prose has the wild artistic flourish of some Romantic painting, Chambers's is closer to the familiarity of domestic photography. Like the scientific practitioners of the new, potentially democratic art of the calotype, both men managed to captivate the Victorian public, even as their disruptive writings were bound up with society-wide debates.

Robert came to feel more optimistic. Listing a number of rather glum 'Consolations', the article of that title in *Chambers' Edinburgh Journal* in 1842 concluded with a sense of an ordering of things that might, ultimately, be providential rather than random or malign.

There is, lastly, a form of consolation to which I must own I have myself a great attachment, conceiving that it rests upon somewhat larger views of man's position on earth than any of the rest. It consists in a firm reliance on the general good arrangements of a wise and benevolent Providence, which makes evil only an exception from present and apparent good, and often turns even evil to account for what may be a deferred benefit.[81]

Chambers had a continuing sense of what this article calls a 'Great Arrangement' which orders affairs. However trite it may sound, the larger-scale investigation of 'man's position on earth' and earth's position in the universe on which he was then embarking deepened rather than displaced such an intuition. Whether in geology, photography, or in human behaviour Chambers in *Vestiges* enjoyed outlining his 'natural laws' in operation, and saw those, rather than the creation story as interpreted by religious fundamentalists, as the best account of how the universe worked. He regarded these laws as evidence that there was an 'Author of Nature' who had established this 'Divine economy'. He viewed man as 'a progressive being'. All human life was part of 'some greater phenomenon, the rest of which was yet to be evolved'.[82]

For modern, post-Darwinian readers the word 'evolved' here leaps off the page. Chambers's work, initiating the literary genre of the evolutionary epic, certainly underpinned aspects of Darwin's writing on species origins. However, for 1840s readers, *Vestiges* had subtly different resonances. In prompting the imagining of an evolution in which humanity (like, say, those ancient creatures found in fossils) might be only a stage, this evoked in some readers fears of not just individual but species-wide extinction – even the end of the world. Questioning the sustainability of humanity itself, such implications were among the factors that made *Vestiges* so scandalous. Perceived as materialist, the book horrified fundamentalist Christian readers who were also appalled by some of the uses of geological research. Nevertheless, the authorial voice of *Vestiges* argued that the overall harmonious design of the universe encouraged a positive, not a negative, reaction.

There may yet be a faith derived from this view of nature sufficient to sustain us under all sense of the imperfect happiness, the calamities, the woes, and pains of this sphere of being. For let us but fully and truly consider what a system is here laid open to view, and we cannot well doubt that we are in the hands of One who is both able and willing to do us the most entire justice. And in this faith we may well rest at ease, even though life should have been to us but a protracted disease, or though every hope we had built on the secular materials within our reach were felt to be melting from our grasp. Thinking of all the contingencies of this world as to be in time melted into or lost in the greater system, to which the present is only subsidiary, let us await the end with patience, and be of good cheer.[83]

Even when, as here, he gestured towards extinction and the end of the world, Chambers presented *Vestiges* as 'improving the knowledge of mankind, and through that medium their happiness'.[84] Yet many readers found *Vestiges* profoundly depressing. In 1845, the year in which she began to correspond with her future husband, Robert Browning, the poet Elizabeth Barrett pronounced it 'one of the most melancholy books in the world' and, with uneasy jokiness, determined 'not to be a fully developed monkey if I could help it'.[85] Then, as now, readers might attempt to laugh off the consequences of evolutionary thought. 'I do not believe I ever was a fish' contends the eponymous hero of Benjamin Disraeli's 1847 novel *Tancred*, in a passage clearly ridiculing *Vestiges*.[86] Drawing on the work of several geologists, Chambers did indicate the extinctions of many species, but his sense of a great design that tended towards improvement could be regarded as positive and uplifting. Few, however, saw it that way. Those who were repelled by the book regarded it as atheistical. Scientists swooped on its errors of detail. Many thought the whole thing blasphemously wrong-headed. As James Secord points out, they 'read *Vestiges* as a sign the world was coming to an end'.[87]

Vestiges is presented by its author as 'a book, composed in solitude, and almost without the cognizance of a single human being', but it was in reality a work very much developed through public engagement.[88] It speaks approvingly of 'secretiveness' which can 'enable us to conceal

whatever, being divulged, would be offensive to others, or injurious to ourselves'.[89] However, there are often striking resemblances between parts of Robert's 'secret' volume and articles, not least leader articles, published in *Chambers' Edinburgh Journal* during the period of the book's composition. So, for instance, 'Thoughts on Nations and Civilisation', a *Chambers* piece in May 1842, speculates on how among nations 'the grand cause of variation appears to reside in a natural law for the production of varieties'. What is there called 'the variety-producing law' becomes in the section of the 1844 *Vestiges* devoted to 'Early History of Mankind' 'the laws of variety production'. Discussing nations and languages there, Chambers includes in *Vestiges* as a sort of hidden signature his own unusual physical condition: 'The peculiarity of six fingers on the hand and six toes on the feet, appears in like manner in families which have no record or tradition of such a peculiarity having affected them at any former period'.[90] Clearly when the magazine article was written, Chambers was pondering matters such as 'an inherent tendency in human nature to improve' and the need to turn a scientific eye on history itself: 'Researches into history by the light of science is a thing of yesterday, and as yet little has been done for it. But we entertain no doubt that physiology alone could throw more light upon the origin and progress of nations, within the bounds of one small volume, than could be done by a whole library of political history, or the united labours of a score of archaeological societies.'[91] This was one of the many things *Vestiges* sought to do. Gesturing towards such 'new sciences, as chemistry and geology' as well as seeing the work of Cuvier on fossils as a scientific 'Rosetta stone', Robert wrote a July 1842 *Chambers'* article arguing the need to attempt large-scale hypotheses from 'fragmentary and disconnected particulars', and complaining that 'the present tone of the philosophical mind in our country and age is at fault. The constant cry is, give us facts and leave hypotheses alone.' *Vestiges* was Chambers's great, countering hypothesis, a popular cosmological and evolutionary epic produced by a man convinced, rather like Brewster (and, later, Albert Einstein), that 'imagination' might often be 'a means of leading on to fact'. 'We conjecture, we seek evidence in support, and ultimately our guess becomes a truth.'[92]

There are undoubtedly mistakes in the guesswork of *Vestiges*. Yet a

great deal in its marshalling of facts and hypothesising about the development of the universe remains plausible. Chambers's speculations about transmutation have become our still-contested ideas about evolution. His use of the 'nebular hypothesis' which 'almost necessarily supposes matter to have originally formed one mass' before it split apart into star-systems and solar systems – a process *still and at present in progress* – was a Victorian version of our Big Bang.[93] Anyone scrutinising the articles of *Chambers' Edinburgh Journal* in the early 1840s alongside *Vestiges of the Natural History of Creation* would see some very striking overlaps.[94] Similarly Chambers's writing about laws of development for *Vestiges* seems to have had a bearing on writings in the *Edinburgh Journal*, and even on his thinking about local topics in St Andrews. The 'half-meditative game' of golf was a sport made possible in Scotland by the way a law of development had governed land formation: '*Golf* exists in Scotland by virtue of the previous existence of a certain peculiar kind of waste ground called *links*.'[95] True to his belief that intellectual work could be done while walking around, Robert wrote in 1842 that 'Geology may in part be studied as one walks the streets', and called attention to the significance of 'ripple-marks' on paving slabs.[96] His 'Popular Information on Science' column in *Chambers' Edinburgh Journal* just before Christmas that year mentioned the fossilised footprints found on slabs at Corncockle Muir in Dumfriesshire. These slabs 'have been deposited with the Royal Society of Edinburgh'. Chambers, who had become a Fellow of the Royal Society of Edinburgh in 1840, had probably seen them there. Along with other material from the same article about 'vestiges' of ancient creatures, they went on to feature in *Vestiges*.[97]

If strolling or striding across a golf course while 'half-meditatively' noting raised beaches might be a way of doing science, so might riding through the countryside. In the autumn of 1842 Chambers and some friends went on 'an excursion' through the 'stacked fields' of harvest-time in Fife on a route 'which I designed should comprehend three or four places with which sundry historical and poetical associations were connected'. This jaunt in a 'drosky' – a low open-topped horse-drawn carriage, ideal for sightseeing in sunny weather – was just the sort of activity to help renew a man recovering from a mental strain. Starting

from St Andrews, the route took in the village of Ceres with its 'neatly-kept rivulet-bordered green', and the 'classic ground' of the Renaissance tower-house of Scotstarvit, which Chambers knew as the home of the seventeenth-century patron of the great anthology of Scottish Latin poetry, the *Delitiae Poetarum Scotorum*. Expert in the history of poetry, Robert wrote about the trip for readers of the *Journal*, and presented to them substantial extracts from a seventeenth-century poem in which Lady Scotstarvit, as part of a quarrel between neighbours, causes 'all the Scotstarvet [sic] dung-carts to be led past the windows of Lady Newbarns'. Mixing the daft and the learned, Robert was enjoying himself. On the drive back to St Andrews he observed 'the rich vale of the Eden' – not the garden at the beginning of the world but the river which flows into the North Sea just beyond the St Andrews golf links.[98] Eventually 'the Eden vale' and a sketch (probably by Chambers himself) of 'markings on Tarvit Hill' would be incorporated into his scientific study of 'ancient sea-margins' where he would note how 'It was among the hills in the eastern district of Fife that I first observed certain other coincidences speaking strongly of the working of the sea at ancient levels.'[99]

One of the admirable things about Chambers is the way he moves so easily between what we now regard as the poetic and the scientific. Brewster and others did this too, but not with such accessible stylistic ease. In Chambers as in Brewster intellectual and stylistic versatility owe something to the Scottish educational tradition of 'generalism' which to an extent continues today; to the 'Lit and Phil' mentality of open general scientific discussion; and to the two men's shared background as encyclopedists.[100] In conducting his life Robert Chambers also came to be able to meld labour and leisure so the two might enhance each other. In 1843 a summer rural 'Pilgrimage to Balcarres', a Fife bibliophile's mansion connected with the Lindsay family, was written up with verse quotations and extensive extracts from the journal of song-writer Lady Anne Lindsay. 'I only hope', wrote Robert, 'the reader may derive one-tenth of the pleasure which it was the means of giving to myself'.[101] By this time he was well advanced with *Vestiges of the Natural History of Creation* and, excursing with friends through the countryside around St Andrews, manifestly recovered and happy.

Vestiges was not a book full of original discoveries. Its importance lay in synthesis, tone, and form, and – inevitably – Chambers frequently repeated the arguments of other writers. If, for instance, he speculated that humanity might not be the ultimate goal of the development of life, such points had been made before. *Vestiges* quoted from Henry Thomas De la Beche, whose *Researches in Theoretical Geology* Chambers was reading in January 1843 and whom Robert Adamson and D. O. Hill would photograph the following year. De la Beche reached the conclusion that 'whatever changes our planet may suffer, either from external or internal causes, and the necessary conditions exist, life will be created to suit those conditions, even after man, and the terrestrial animals and plants contemporaneous with him, may have ceased to live on the surface of the earth'.[102] Not only this imaging of the end of the human world but also many other ideas in Chambers's work had their forerunners elsewhere, as hostile reviewers of the first and later editions were only too eager to point out:

> all the sections of our author's closely printed book of 394 pages contain not one discovery, or calculation, or proof, or experiment of his own; or the verification of an experiment. All its materials might be culled from such manuals and easy and popular treatises as The London, Edinburgh and Dublin Philosophical Mag. (p.6), Lardner's Cyclopaedia (p.12), Cours de Philosophie Positif (p.18), Papers read to the British Association (p.152), Todd's Cyclopaedia (p.170), Encyclopaedia Britannica (p.182), etc.[103]

However antagonistic, this criticism was shrewd. A remarkable aspect of *Vestiges* is the encyclopedic way it draws on diverse disciplines and speculations in order to assemble the first such popular history of its kind. But Robert's borrowings were not just from books; they were, too, closely tied into the fabric of the St Andrews society around him. This is evident from his reaction to just a few meetings of the Lit and Phil and from his intensive use of the University Library.

It is interesting to see how events at the Lit and Phil's gatherings were digested by Chambers and how they came to inform his writing. So, to take just one example, at the meetings of November and

December 1842 he first watched Brewster's portrait appear then vanish as a plate of glass was breathed on; then heard the photographer and mineral analyst Connell speak; and finally listened to Brewster's outline of the German Professor Moser's theory of latent light – all of these found their way – and rapidly – into *Chambers' Edinburgh Journal*, particularly into his December 1842 article on 'Natural Daguerreotyping'. Beginning with a detailed account of Moser's observation of how an image engraved on a 'piece of black horn' can apparently be transferred on to a silver plate using breath, 'and will become permanent if the vapour of mercury is used', Robert's article shows a clear familiarity with Brewster's interest in the 'camera obscura' and the struggles of other local photographers attempting to make calotypes. Chambers mentions Talbot and the way 'some of the most ingenious practical men of science in the country, vainly, for some time' have attempted 'to imitate' Fox Talbot's 'experiments in photography'. Chambers regards 'the *photographic and Daguerreotype processes*' as 'perhaps the most wonderful of all modern inventions'. Clearly he is coming to share the enthusiasms of Brewster, Playfair, and their St Andrews circle. It is evident that Brewster has shown him Professor Moser's correspondence, but it is also characteristic of Chambers that he moves beyond this in an imaginative and speculative leap, wondering if memory itself might not be related to the photographic process. 'That the impressions on the retina are photographic processes, is, we should say, by no means unlikely.' By association this leads the omnivorous reader Robert to recall a passage from Charles Darwin's ancestor Erasmus Darwin, who had written in his *Zoonomia, or The Laws of Organic Life* of how he could make his eyes hold images. Next, having mentioned both Brewster and Brewster's hero Newton, the encyclopedically minded Robert suggests there may be 'a curious analogy' between 'psychological phenomena' and 'these image-making properties of light'. 'Suppose', he speculates,

> *attention* to be a greater than usual development of electric action in the brain, how strangely akin seem the recent experiments of Daguerre! When attention is languid, or when one is in a state of reverie, something is said by a neighbour: you are not conscious of

more than that some one has spoken; but in a few seconds, or perhaps minutes, by an effort, the words are recalled. May not this be simply an electric evolution upon some impressible medium within, before the photographic impression had faded, catching up its shrinking tints? Newton could recall the spectra by intensely looking for them, or meditating upon them: so, by an effort of the mind, do we recall to *memory* a fact which we once knew, but which has been forgotten.[104]

This line of thinking, stimulated by what he heard at the Lit and Phil and by his discussions with the St Andrews photographers, was important to Chambers, and remains so today. He returns to it in *Vestiges*, in his discussion of the mental constitution of animals. There, having outlined the consciousness and the 'system of mind' through which 'man stands in relation to himself, his fellow-men, the external world, and his God', he goes on to write with regard to human faculties – thoughts, sentiments, and suchlike –

There is a particular state of each of these faculties, when the ideas of objects once formed by it are revived or reproduced, a process which seems intimately allied with some of the phenomena of the new science of photography, when images impressed by reflection of the sun's rays upon sensitive paper are, after a temporary obliteration, resuscitated on the sheet being exposed to the fumes of mercury. Such are the phenomena of memory, that handmaid of intellect, without which there could be no accumulation of mental capital, but an universal and continual infancy. Conception and imagination appear to be only intensities, so to speak, of the state of brain in which memory is produced. On their promptness and power depend most of the exertions which distinguish the man of letters, and even in no small measure the cultivator of science.[105]

What Chambers is talking about here is the concept that we now take for granted when we employ the expression 'photographic memory'. He does not use that very phrase, which seems to have entered the language only in the following decade, when it was used by the travel writer

Nathaniel Parker Willis who had also written of how scenes might 'paint their own picture inside the memory' as 'natural "Daguerreotypes"' as it were'.[106] Yet Chambers's bringing together of photography and memory as analogous processes surely anticipates the now-familiar term 'photographic memory' and it is quite possible that Willis had read both *Vestiges* and Chambers on 'Natural Daguerreotyping'.[107]

In linking photography to memory, Chambers also implies how hauntingly insistent, yet also elusive, photographs can be. Where the chemically knowledgeable Brewster some months later connected photography with reanimation, death, and reincarnation, Chambers here, describing the chemical processes that produce a photograph, uses language of 'obliteration' and resuscitation. Both men, right at the beginning of photography, connect the new medium with death and with a sense of new beginnings. Though the literary styles of Brewster and Chambers are individual, these authors were part of a shared intellectual community. In this community Chambers developed habits of thought – magpie borrowing, irresponsible use of analogy, and imaginative speculative assumption-making – which hostile readers of *Vestiges* detested.

Ironically, one such antagonistic reader was Brewster himself. Ignorant of the identity of the perpetrator of *Vestiges*, he denounced that book as 'poisoning the fountains of science, and sapping the foundations of religion'.[108] By 1845 rumours about the volume's authorship were rife. In July Chambers worried that 'At St Andrews, it is quite concluded upon that Abbey Park was the mint of this strange medal'; when a St Andrews divinity professor asked him in public that same year if he had seen '*that horrible book*', Robert was saved only by an interruption.[109] Other than Anne, the only local person confided in was David Page, a member of the Lit and Phil who came to act as Chambers's assistant on the *Journal*. Page had suspected Robert's authorship of *Vestiges* when William Chambers asked him to review the book for the *Journal* in late 1844. A decade later, once *Vestiges* was in its tenth edition, Page was smarting from having been refused a partnership in W. and R. Chambers. As an editorial assistant, he had been unusually well placed to spot the connections between the unsigned pieces Robert wrote for *Chambers' Edinburgh Journal* and

passages in the anonymously published *Vestiges*. He blabbed the secret to a local journalist, but, for all his bitter language (he wrote that *Vestiges* 'stands bastardized by the moral cowardice that shrinks from avowing its paternity'), not everyone believed him.[110] While reviewing Hugh Miller's book-length reply to *Vestiges*, entitled *Footprints of the Creator*, Brewster had met Chambers at an inn in 1850 and discussed *Vestiges* with him. Robert maintained *Vestiges* was not atheistical; Brewster acquitted him 'of all suspicion of having written that atrocious book'.[111]

Even an 1847 article, 'Vestiges of the Author of "The Vestiges of Creation"', which aligned passages from *Vestiges* with works by 'a certain well-known Essayist, or rather journalist' clearly identifiable as Chambers, failed to convince the public that Robert was the 'cowardly . . . skulking' author.[112] In St Andrews other local readers were less vehemently hostile. 'Too often do you assume, when you ought to prove' a reader pencilled in a nineteenth-century hand in the margins of a copy of *Vestiges* which entered the collections of St Andrews University Library in 1845. '(No hypothesis allowed in natural science) Sir Isaac Newton', the same reader scribbled.[113] But speculative hypothesis and poetically associative leaps – from childhood tears to planets or from weather patterns to the vagaries of the postal service – were at the heart of Chambers's volume: they made it so widely read, so astute, so controversial. His work encouraged the general public to speculate and even make judgements about science. Imaginative speculations remain essential to the power of his writing.

So Chambers, borrowing ideas from people around him, and using his own imagination, assembled his book drawing on information that came to him through his day-to-day interchange with his neighbours. Yet his working method was not entirely one of structured vernacular dealings any more than it was that of the secretive, isolated scholar. Though it has been assumed he relied on his 'large private library at St Andrews', it is now clear Robert took advantage of other local opportunities.[114] He joined St Andrews University Library in late 1842, and made full use of its resources. The library, like the Lit and Phil which had been founded in it four years earlier, was one of several St Andrews institutions in which both academics and

non-academics participated. Academics were able to sponsor people who were not members of the university community so that they could borrow books. This system allowed, for instance, women in St Andrews to gain access to the University Library even though they were not yet permitted to enrol as students or as members of the Lit and Phil. Principal Brewster alone sponsored six women and four men to use the Library around 1840, one of the men being his neighbour Major Playfair.[115] It is not clear who sponsored Chambers's membership, but Brewster is the most likely candidate. Chambers used the Library a good deal until early 1844. He borrowed works quoted in *Vestiges*, such as John Macculloch's three-volume 1837 *Proofs and Illustrations of the Attributes of God* and James Cowles Prichard's *On the Eastern Origins of the Celtic Nations*. From each of these, as from others, Chambers accurately transcribed passages for *Vestiges*. Though he or Anne (in copying his manuscript) or, more likely, his printer repunctuated the quotations, they are accurate by the scholarly standards of the day. Robert was not as sloppy as some of his detractors made out.

He also borrowed writings by scientific authors like William Carpenter (whose work John Adamson too had taken out around the same time), William Sharp Macleay, and the naturalist William Swainson. Chambers was reading widely in recent scientific writing, and his interests were shared by men he saw regularly in St Andrews. Adamson, for instance, borrowed geologist Hugh Miller's *The Old Red Sandstone* in 1844 (Chambers refers to that work in *Vestiges*), while Brewster kept abreast of a remarkable range of experimental developments.[116] Chambers consulted modern scientific works as a learned man among learned men. Yet his library borrowings not just of the *Gentleman's Magazine*, *Blackwood's*, the *Edinburgh Philosophical Journal*, *Jameson's Philosophical Journal*, and volumes of *Philosophical Transactions*, but also of encyclopedias from the *Penny Cyclopaedia* and encyclopedias of anatomy and physiology to his childhood favourite, the *Encyclopaedia Britannica*, might have confirmed his critics' suspicions that he was a dabbler, a populariser, a dilettante.[117]

Robert certainly authored and drew on popular encyclopedias, but then renowned scientists like Brewster also wrote for them in an era and

in a society where science was part of wider cultural dialogues. Robert's audience ranged from the popular readership of *Chambers' Edinburgh Journal* to the more specialist British Association for the Advancement of Science whose meetings he several times attended. Precisely because he took from and, in turn, was able to address these very different kinds of readership, *Vestiges* became an exemplary lightning conductor for ideas of evolution in the Victorian era. In borrowings and tone it fused, as Chambers's admired poet Robert Burns had done, aspects of vernacular and elite culture. This enhanced its appeal for some; for others it made the little book dangerous, heretical, and downright threateningly 'evil'.[118]

The intensity of the scandal generated by *Vestiges* may seem odd today. Our headline writers tend to link the word 'scandal' to the words 'sex' and 'politics', not to the word 'book'. Yet a good deal of the Victorian vilification heaped on Robert's democratically accented volume had strongly sexual, and sometimes sexist connotations. The book was seen as 'foul' like an 'unlawful marriage'.[119] A rich lawyer, Samuel Richard Bosanquet, published an 1845 pamphlet which saw *Vestiges* as a 'harlot . . . a foul and filthy thing, whose touch is taint; whose breath is contamination'.[120] Making Robert's writing sound like a carrier of sexually transmitted disease, such discourse went far beyond the conventional bounds of academic argument. This 'beastly book' caused national and even international controversy.[121]

Vestiges was also a scandal in the original, religious sense of that word. For literal-minded readers of the Book of Genesis, *Vestiges* was (to quote one of the *Oxford English Dictionary* definitions of 'scandal') 'something that hinders reception of the faith or obedience to the Divine law'. We may be less familiar than orthodox Victorian Christians with this definition of 'scandal', but before too readily distancing ourselves from the era which regarded Chambers's book as appallingly scandalous we might remember that we still live in an age when publications can shock fundamentalist believers and even give rise to death threats.

Just how appalling Robert's book could seem, even to highly educated Victorians, is summed up in the attack by Cambridge University proctor and geological investigator Professor Adam Sedgwick.

A luminary of the Church of England, Sedgwick reviewed *Vestiges* at vitriolic length in the 1845 *Edinburgh Review*. He found it utterly depraved:

> If our glorious maidens and matrons may not soil their fingers with the dirty knife of the anatomist, neither may they poison the springs of joyous thought and modest feeling, by listening to the seductions of this author; who comes before them with a bright, polished, and many-coloured surface, and the serpent coils of a false philosophy, and asks them again to stretch out their hands and pluck forbidden fruit – to talk familiarly with him of things which cannot be so much as named without raising a blush upon a modest cheek; – who tells them – that their Bible is a fable when it teaches them that they were made in the image of God – that they are the children of apes and the breeders of monsters – that he has *annulled all distinction between physical and moral*, – and that all the phenomena of the universe, dead and living, are to be put before the mind in a new jargon, and as the progression and development of a rank, unbending, and degrading materialism.[122]

Almost foaming at the mouth, the scandalised anti-materialist Sedgwick sounds rather like a modern religious fundamentalist who has cast Robert Chambers as an 1840s Richard Dawkins. Yet in retrospect Chambers's work can be seen as initiating evolutionary epics not just of a materialist kind still familiar to 21st-century readers, but also those which (like *Vestiges*) allow for divine intelligence and design. Moreover, part of the appeal of *Vestiges* is the opposite of a scandalously 'dirty' threat to 'maidens and matrons'; engagingly and perhaps improbably, the book presents the workings of the cosmos at times in terms of a rather bourgeois domestic humanity. It was far too simplistic to caricature the author of *Vestiges* as a monstrous bearer of atheistic, materialist 'evil', just as it would be facile for us to characterise him as the sort of unfeeling Victorian paterfamilias who went off to his own pursuits – managerial, golfing, geological, or otherwise – abandoning his wife and family. True, Anne Chambers on occasion may have characterised Robert as that. She is seen to bid him adieu in an

affectionately mocking poem – 'Geology calls you, you must not say no' – but she could smile and knew her husband was no monster. Rhyming 'Huttonian joy' with 'the parallel roads of Glenroy' (subject of Chambers's early geological attentions), the poem 'The Geologist's Wife' shows that Anne understood what Robert relished in his excursions. Urging him to dream of her as one ready 'to climb the raised beaches, my own love, with thee', the geologist's wife will tolerate her husband's field trips so long as they do not last too long. If they do, she warns him, he might return to find 'a wife turned to stone'.[123]

For all the scandal the book occasioned, the nature and tone of Chambers's *Vestiges* owes as much to his family life as to his reading of works from St Andrews University Library. Though never mentioned in *Vestiges*, Anne and the Chambers children were important to the book's genesis. Robert's affection for them shines through 'A Lay of Abbey Park', the poem he wrote in St Andrews in 1843 and whose plot involves the bereaved King of the Fairies who sets off in search of 'a wife' – a word which, fortunately, rhymes with 'Fife':

> So he came to St Andrews, where soon the gay spark
> Found his way through the town to sweet Abbey Park.

In the poem the Fairy King rings the front doorbell, is received by Mrs Chambers (to whom he makes an elegant bow), then asks to meet 'the six Misses C.' of whom he has heard reports.

> Mamma thought the offer a capital chance,
> So she called in her troop like an opera dance . . .

Just then Pa Chambers returns from 'the golf' in time to introduce his daughters: Jane, the eldest, who is a full head taller than the Fairy King; then 'The dark gazelle, the Andalusian' Miss Mary ('Who seems already one half a fairy'); then Miss Annie, an honest young blonde who has (like her father) a taste for curiosities; then the twins, 'gentle, benevolent' Jenny and 'pranksome Lizz, full of fun and trick'; then, last, Amelia 'who well can sing'. It is she who wins the visitor's heart: 'And away she tripped as the Fairy Queen, | And at Abbey Park ne'er again

was seen'.[124] Chambers loved the singing and musicality of his 'opera troop'. Dating from around 1844, the silhouette picture of his wife and most of their children shows their infant son James looking at Amelia (aged 6) and Anne (9) while eleven-year-old Mary holds baby William, the two twins (aged 8) dance with each other, and fourteen-year-old Nina, the only girl with her hair up, stands erect reading a book. At the heart of the picture Anne Chambers sits playing her harp, an instrument so large that it towers over all her children.[125] Dating from around this time, a portrait of Anne as 'Mama' shows a slim, dark-haired woman wearing an elegant dress and brooch.[126] Robert loved his 'dear delightful Anne' not least for her musicianship; that harp she gifted to the Lit and Phil was a true reflection of her tastes.[127] His lightly fictionalised spring 1843 pen portrait of her as 'Mrs Balderstone' presents a woman attuned to local life, and with an eye and ear for a bargain.[128]

For all her private sufferings (which included the deaths of two children in 1842), Anne Chambers seems to have remained witty, bright, devoted, and not without her own pursuits, especially her music. She had kept Robert's love letters (most signed somewhat formally 'R Chambers', but just occasionally 'R. C.') from their courtship fifteen years earlier. One of her daughters remembered her in the early 1840s

> Going out to dinner parties in her sedan-chair, accompanied by a host of small runners, at the fashionable hour of five, the prevailing and unfashionable hour being three. She always took with her a tiny linen book improvised by herself, containing in her own handwriting some old ballads. She found it difficult to remember words, but never the accompaniment, which she could always transpose from one key to another to suit her voice at the moment.[129]

Anne ensured her children were happy in St Andrews. Though the length of the mail-coach journey from Edinburgh was so long and fatiguing that her daughter Eliza remembered at the age of five 'sitting on my nurse's knee helpless and sick, the victim of over-fatigue', the young girl liked Abbey Park – 'so quiet and secluded in the midst of intellectual society'. She enjoyed the life of St Andrews whose bellman

or crier would walk through the streets 'in full force' calling out the latest news, often about ships due to leave the harbour. She remembered too the town idiot, jeered at by boys in the street, and the Chambers family's housemaid at Abbey Park 'lighting the fires with "spunks" before matches were invented'. If Eliza, starting school in the Fife town, disliked her schoolteachers and had no awareness of the potentially scandalous book her father was writing, she loved to take walks with him over the next few years. In tune with the sometimes familial and frequently educational tone of *Vestiges*, her recollections suggest the way Chambers was able to combine his own authorial and recreational interests with educating and entertaining his children.

> My father's delight in his leisure hours was to take a troupe of us out to the golf links, or for a ramble among the ruins, trying 'to dibble into our heads a few ideas' on the romantic history of the place. How we loved him, and how we loved his walks . . . As children we knew more of what was under the earth than above, and could recognize at once the striations of ancient glaciers, while around the coast of Fife in later years we knew every ancient sea margin. With such a teacher we never found any difficulty in acquiring natural knowledge.[130]

So, if he might speak to the Lit and Phil about local raised beaches, Chambers shared this material with his children, making them aware of some of the sorts of vestiges of the natural history of creation which he was then writing up in his book. Yet such education went hand in hand with concern for their religious and moral welfare. A manuscript catechism which survives in Robert's handwriting dates from a little after the publication of *Vestiges* but gives probably the best insight into his religious views at the time. Just as he liked to share his scientific work with his children, so, in the catechism, he shared his beliefs. This extended document (now in St Andrews University Library) matters particularly because it confirms the idea that the author of *Vestiges* was not a person who had abandoned religious faith, but rather someone who sought to combine it with scientific thinking. His catechism's significance makes it worth quoting at length.

Q. What are you?

A. A human being.

Q. To what do you owe your existence?

A. To God the Author of the Universe.

Q. How do you know that God is the Author of the universe?

A. The things of the universe could not have made themselves: they must have been made by some Being beyond and superior to themselves and this Being I call God.

Q. How do you describe the universe?

A. It consists, as far as we can see or understand, of a multitude of bodies, calculated, like our own globe, to be theatres of existence for sentient beings.

Q. What do you infer regarding God from what you see of the universe?

A. That he is a Being of infinite Power, Wisdom, and Benevolence; his Power from the vastness of the universe, his Wisdom from its admirable arrangements, and his Benevolence from the enjoyment which, as far as we can see, is every where an essential accompaniment of sentient life.

Q. Do you consider the universe as also ruled and conducted by God?

A. Yes.[131]

The document goes on to stress the 'perfect orderliness' of the world's 'divine government', while emphasising that 'we cannot presume to know the whole counsels of a being so much above us'. In discussing the laws which govern the world, Robert does not shirk the question of 'evil', seen as 'perhaps an unavoidable accompaniment of a system involving so much good'.[132] His catechism's notion of benevolently ordered laws is close to the idea of natural laws of development in *Vestiges*, while the attitude towards evil in the catechism also parallels the book's catechistical, question-and-answer treatment of the same topic. In *Vestiges* Chambers poses the question,

Does God, it may be asked, make criminals? Does he fashion certain beings with a predestination to evil? He does not do so; and yet the

criminal type of brain, as it is called, comes into existence in accordance with laws which the Deity has established. It is not, however, as the result of the first or general intention of those laws, but as an exception from their ordinary and proper action . . . He [the ill-disposed being] is only a part of a series of phenomena, traceable to a principle good in the main, but which admits of evil as an exception. We have seen that it is for wise ends that God leaves our moral faculties to an indefinite range of action; the general good results of this arrangement are obvious; but exceptions of evil are inseparable from such a system, and this is one of them.[133]

Here Chambers may have shocked some by deliberately departing from Calvinist ideas of predestination which were much argued over in Scottish society, but what he writes is broadly consonant with the catechism he scripted for his children. Robert's catechism can appear deistic since it never mentions Christ. However, its assertion that 'there is but one rule of duty in the world, and that is summed in – Love your Neighbour' is a clear reference to Christ's encouragement to 'love thy neighbour as thyself'.[134] Chambers wished to pass on scientific and theological knowledge to his children, bringing them up in his habits of thought and belief. As he put it in the often familially accented Vestiges, 'What is a habit in parents becomes an inherent quality in children'.[135]

The creationism of Vestiges was not a literal-minded insistence on the prosaic accuracy of the biblical narrative in Genesis and elsewhere, but a reading of the entire history of the universe from start to implied conclusion in terms of a divinely ordered creation with its own laws which could not be arbitrarily over-ridden and so might at times result in evil or suffering as well as in benevolent outcomes. Just as Brewster's explorations of photography were bound up with his religious appre-hension of light, so the rediscovery of Chambers's catechism should not be seen as contradicting what he wrote in his most controversial book, but as complementing and clarifying those writings. Vestiges of the Natural History of Creation, reviled by many scandalised believers, should be viewed as a significant book in the development of modern theology.

Whether or not one regards the volume which Chambers wrote at

Abbey Park as critical of religion or as articulating a divine design, *Vestiges* is important to twenty-first-century culture much less for the detail of its scientific arguments than for its innovative literary form. Mentioning not only a plethora of Victorian writers but also many more recent figures who have written on science for mass audiences – authors such as Edward O. Wilson, Stephen Jay Gould, Richard Dawkins, Carl Sagan and Stephen Hawking – the distinguished Canadian academic historian of scientific writing, Bernard Lightman, argues that 'Perhaps the largest debt that current popularizers owe to their predecessor concerns the narrative form they use to convey huge masses of information to their audiences'. Lightman explains that the most signal point of origin for such writers is 'the evolutionary epic presented by Chambers'.[136] Running from the beginning to the end of the world and taking in much beyond, *Vestiges of the Natural History of Creation* might be retitled *A Brief History of Time*. Other modern scholars, such as William Grassie, writing from a different perspective on 'science as epic', agree that 'the evolutionary epic can provide a mythic narrative for our times', though for these writers this narrative is consonant with religious belief.[137] So Chambers's work can be seen as underpinning dialogues on 'The Epic of Evolution' such as that held in Chicago in 1997, sponsored by the American Association for the Advancement of Science (a body modelled on the British Association which Brewster founded) and Chicago's Field Museum of Natural History. Though for much of the twentieth century Chambers's *Vestiges* was relegated to a very dusty attic crammed with out-of-date popular science, in the twenty-first century the fundamental importance of the book is summed up in by James Secord when he states that it 'exercised its most important influence by providing a template for the evolutionary epic – book-length works that covered all the sciences in a progressive synthesis'.[138] Lightman, arguing that Chambers's work can be seen as having had 'an influence far beyond the end of the nineteenth century', maintains simply that 'Chambers's *Vestiges* supplied a template for the ages', and sees it as among the works which 'forever changed the topography of western science'.[139]

Such a contention would have stunned Chambers's friends in the Lit and Phil. For all their ambitions, they had no idea at all that one of their

members was at work on such an epoch-shifting book. For them, surely, it was Brewster's scientific work – not least in areas relating to photography – which was most fascinating. Yet today we do not need to choose between Chambers and Brewster or other members of the St Andrews scientific and literary community in the 1840s. Instead, we can see many of their activities as productively interconnected. The tremors and profound repercussions surrounding Chambers's work in St Andrews may be detected not only in the scientific scandal which followed the publication of *Vestiges* and in its consequences for literary form. They may be detected also, as the next chapter shows, in some of the most astonishing early photographs taken anywhere. Stark and arresting, these St Andrews images are strangely attuned to Chambers's sometimes disturbing work on still-surviving geological vestiges of the natural history of creation.

6

Rock

ℰↄ

TODAY, AS IN Robert Chambers's early Victorian times, one of the most beautiful walks in Scotland is the coastal path which leads two miles south-eastwards from St Andrews over the Kinkell Braes, affording magnificent views across the bay to the little town with its cathedral, castle, university buildings, houses and old stone pier, its long sandy beaches, sea-cliffs, and dark promontories of rock. To stand on a sunlit summer's day and look back at the fifteenth-century spire of St Salvator's, the university chapel, and see beyond to Tentsmuir Forest, the Angus Glens, then for many miles along the Angus coast, is to gaze at an unparalleled vista. One can spend a long time simply staring across at the town Robert Louis Stevenson called 'the light of medieval Scotland', and it is good to do so while sitting by the sea's edge at low tide on a barnacled, sun-dried rock.[1]

Rock is central to several utterly remarkable early photographs taken in St Andrews, dramatic images of geological 'vestiges of creation'. Closely associated with these pictures was one of Robert Chambers's early readers, a local man with a sure nose for vestiges of a very different sort. Dr John Adamson appreciated coastal scenery but his principal preoccupation was sewage. He wrote two substantial reports on St Andrews sanitation. He spoke about the matter at the Lit and Phil. Though today his interest might seem eccentric, other Lit and Phil members, like reforming Victorian intellectuals elsewhere, shared it: in 1842 Robert Chambers alone wrote three pieces on sanitary conditions for *Chambers' Edinburgh Journal*.[2] While Robert enjoyed coastal strolls and lengthy spells on the golf course musing about raised beaches, Dr Adamson paced the less salubrious lanes of the town, glaring at heaps of

shit. Towards the east end of North Street he noted 'offal of every kind'. Behind the houses were 'dunghills filled with mussel-shells, dung from pigsties, &c'. He worried about the 'filth, irregular habits and dissipation' of the fishermen who lived there. The presence of so much excrement was likely to encourage 'typhus' and 'continued fever'. Because of a lack of public toilet facilities in St Andrews, he noted, 'a very disgusting habit prevails of committing nuisance even in the streets, and in all the corners and public walks around the town'.[3]

None of this might interest us much today except that with his brother Robert, Dr Adamson saw the camera as a way to record the social conditions of the poor as well as the portraits of the bourgeoisie.[4] His chemical experiments, his natural history collecting, even his concern with local sanitation – all helped prompt and shape masterpieces of early photography. Dr Adamson's concern with sanitation had a history and a fiery politics. Professor Robert Haldane was scandalised when in August 1840 a town council report suggested that in St Andrews 'the allowances which the poor receive *can be regarded as nothing else than a system of protracted starvation*'. Was the town killing its most impoverished inhabitants? Haldane was even more shocked when within months Major Playfair's predecessor Provost Wallace 'felt himself called upon to go to the meeting of the British Association in Glasgow, and, upon the statements combined in that Report, to proclaim aloud, in the presence of gentlemen assembled from so many parts of the world, the appalling destitution which prevailed in the city of St Andrews'. An indignant Haldane mustered support from three other Lit and Phil members, local doctors Mudie, Thomson and Adamson. Mudie, founding Secretary of the Lit and Phil, had surveyed the 'Sanatory State of this Parish' in July 1840 for the Poor Law Commissioners. Commenting favourably on 'the care which was taken of its few paupers', his report was 'confirmed by my professional brethren, Dr Thomson and Mr Adamson'. The sound of professional men closing ranks is almost audible here as part of a wrangle over whether the town's poor – from 'the dumb boy Spence' and 'six lunatics' to destitute fishermen – should be supported by a 'system of compulsory assessments' or through the existing 'administration of poor's funds by Kirk-sessions'.[5] All this lent importance to Dr Adamson's 1841 survey

of local poverty and conditions which took the form of a *Report on the Sanitary Condition . . . of the Labouring Classes of the city of St Andrews.* Writing it up, he presented challenges and potential remedies. Photographs with which he was involved also document problems and improvements; at times they may seek to conceal how bad conditions were. Despite mentioning 'filth . . . scraped into heaps, which often lie for a day or two before they are supposed to be worth carting away . . . numerous pigsties and cowhouses' and gutters 'usually filled to overflowing with black foetid mud', Adamson put a brave face on things: 'As a whole . . . St. Andrew's cannot be called a dirty town, at least in comparison with other towns.'[6] Yet, collecting and analysing mortality statistics for the Lit and Phil, he also knew that the filthiest part of the place – where the fishermen lived – was the area with the highest death rate.

John and Robert Adamson were the sons of local tenant farmer Alexander Adamson, and his wife Rachel Melville. Four of this couple's clever boys studied at Madras College, then at St Andrews University. Archibald took Latin and Ethics; his brothers John, Alexander, and Robert showed a clear interest in mathematics and chemistry. All the young Adamsons had grown up on the family farm at Burnside, on the stream (or, in Scots, 'burn') known as the Kenly Water near the small village of Boarhills, about four miles south-east of the town. Their handsome, two-storey stone farmhouse fronted on to a neat garden and substantial farm buildings. At harvest time these were over-towered by high, close-packed haystacks whose conical tops made them look like circus-tents built of straw. The surrounding land was fertile, the farm close to the North Sea. Burnside, beside the purling Kenly Water, was a good place to grow up.

Born in 1809, and so almost twelve years older than his brother Robert, John Adamson, the eldest brother, became a student at St Andrews in 1822, the year after Robert's birth. He enrolled for classes in Latin, Greek, Mathematics, Ethics and Chemistry. For part of Robert's boyhood John was far from home. After travels that took him to Edinburgh (where he became a Licentiate of the Royal College of Surgeons in 1829), then to Paris and even to China, John returned to St Andrews and married Esther, the slim, elegant, eldest daughter of

Andrew Alexander, the Professor of Greek in whose class he had once studied. Just after Robert, who had won two mathematics prizes during his years at Madras College, started at St Andrews University in 1836, John became a teacher of chemistry and natural science. He taught at Madras College from 1837 to 1840, so the two brothers would have seen a good deal of each other during Robert's student years. A little later, in 1843, recognising the value of his labours among the poor, the university conferred on John gratis the degree of MD by examination. This hints that his actions had helped placate local men like the influential Professor Haldane; John's concerns with typhus prevention were shared by the medical professor John Reid who had also worked on preventing epidemic fevers. Subsequently in the 1840s Dr Adamson deputised for the Chemistry professor, Connell, whose classes included lecturing on the chemistry of photography.[7]

When Brewster brought details of Talbot's processes to St Andrews, John Adamson was intrigued. Beginning to make his own photographic experiments, he drew on his chemical knowledge. Discussing a problem to do with preparing photographic paper, Brewster, in one of his 1840s articles on photography, paid tribute to 'Dr. Adamson of St. Andrews'.[8] Adamson afterwards claimed he had produced the 'first calotype portrait taken in Scotland'. As an older man he annotated a portrait of his sister in a family album,

> This negative calotype was taken in the spring of 1840 by Mr Fox Talbot's process, and before he had made it public – he explained the process in a letter to Sir D. Brewster, and this picture was obtained by following his directives and using a temporary camera obscura made with a common small lens or burning glass an inch & a half in diameter – it is no doubt the first calotype portrait taken in Scotland ... the sitting lasted nearly two minutes in bright sunshine –[9]

In inking this later note, John Adamson first wrote '1841', then changed the date to '1840' and inserted 'May' after the word 'spring'. Precise dating must remain uncertain, though it is clear that Talbot first published his discovery of the calotype in February 1839 and Brewster was sending Talbot calotypes taken by Adamson by November 1841, so

a date of May 1841 (or even 1840) for Adamson's first, faint picture is not unreasonable.[10] He took up the practice of photography enthusiastically and developed it alongside his extensive documenting of the St Andrews community. His first survey of the place and its sanitation was written in March 1841. Adamson had chemical expertise, and knew that the process was at least possible (he had seen in St Andrews a calotype taken by London artist and spiritualist Henry Collen), but, along with both Brewster and Playfair, he had protracted difficulty in mastering the technique: it was Brewster's 1842 summer visit to Lacock Abbey which proved the turning point.

John Adamson shared his chemical and photographic knowledge with his brother Robert, who had studied Natural Philosophy (as Physics was then called) at St Andrews University during sessions 1836–7 and 1837–8. History and scholarship have not always been generous to Robert Adamson. Though the photographs which he went on to take as part of his commercial and artistic partnership with David Octavius Hill are internationally celebrated, most of the attention has centred on Hill. This is ironic since it is Adamson, not Hill, who was the trained photographer. It was Robert Adamson who set up his own photographic studio, and appears to have taken, then developed, the pictures to which Hill contributed artistic direction. There has been a tendency sometimes to treat Robert Adamson, the Fife tenant farmer's son, as something of a young workman directed by the far more socially prominent and well-networked Edinburgh artist Hill, nineteen years his senior. Adamson, though, was a young genius and fundamental to 'Hill and Adamson'. When their photographs were first exhibited in Edinburgh, they were mentioned in an advertisement as 'Calotype Pictures executed jointly by Mr ADAMSON and Mr HILL'; the word 'jointly' is telling here, but so is the ordering of the names.[11] In 1843, Brewster writes to Talbot about 'fine Calotypes of ancient Church yard Monuments, as well as modern ones taken by Mr Adamson, and also specimens of the fine groups of Picturesque personages which Mr Hill and he have arranged and photographed'.[12] The following year when the physicist Dominique-François Arago presented a collection of calotypes to the French Academy of Sciences in Paris, he spoke of the pictures as taken 'par les soins de MM. Adamson et Hill, et a l'aide

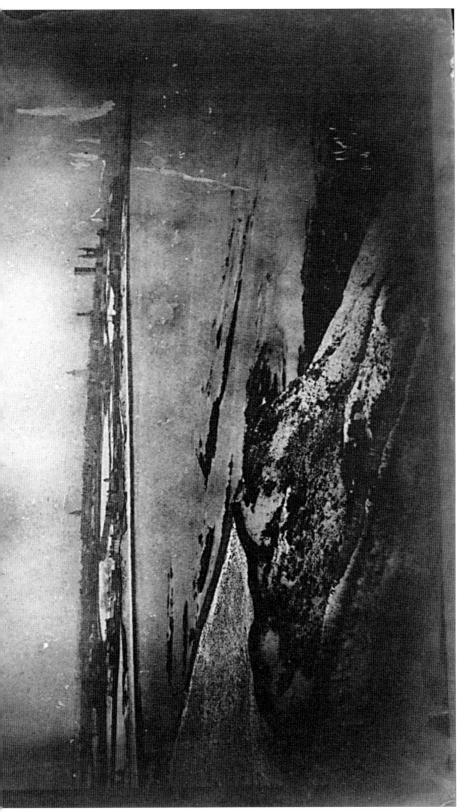

Plate 25: St Andrews from the Kinkell Braes, around 1845, probably by Robert Adamson with David Octavius Hill; print from calotype negative.

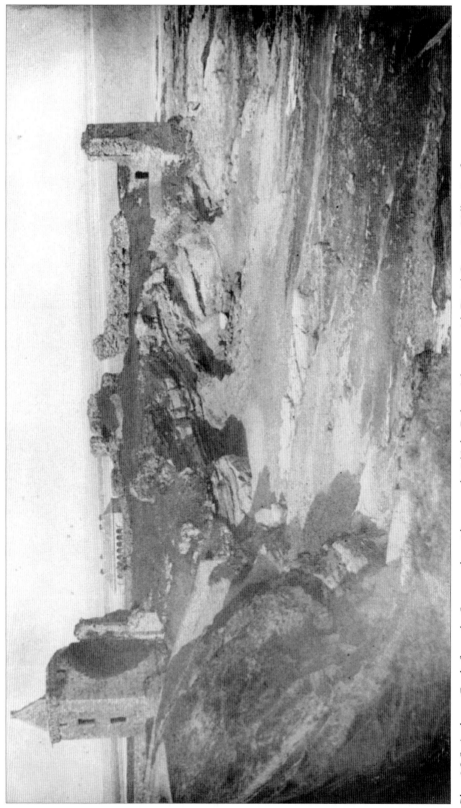

Plate 26: St Andrews Castle from the Scores at low tide, around 1845, by Robert Adamson with David Octavius Hill; print from original calotype negative.

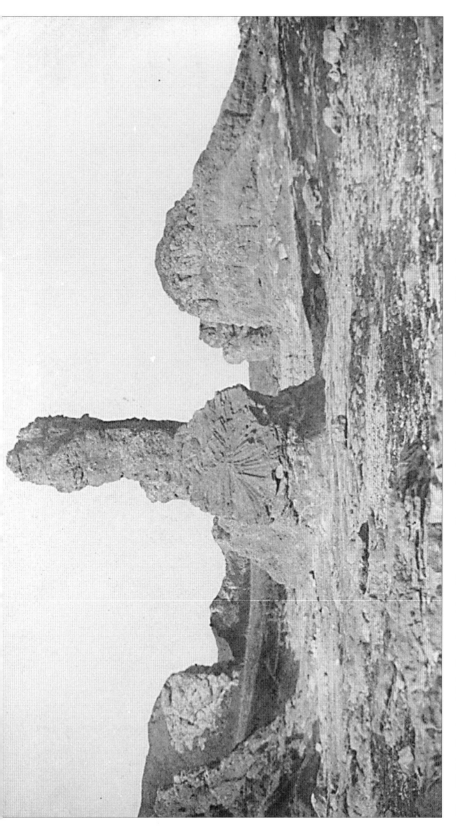

Plate 27: The Rock and Spindle at low tide with surrounding rocks, looking north in the direction of St Andrews, around 1845, by Robert Adamson with David Octavius Hill; print from calotype negative.

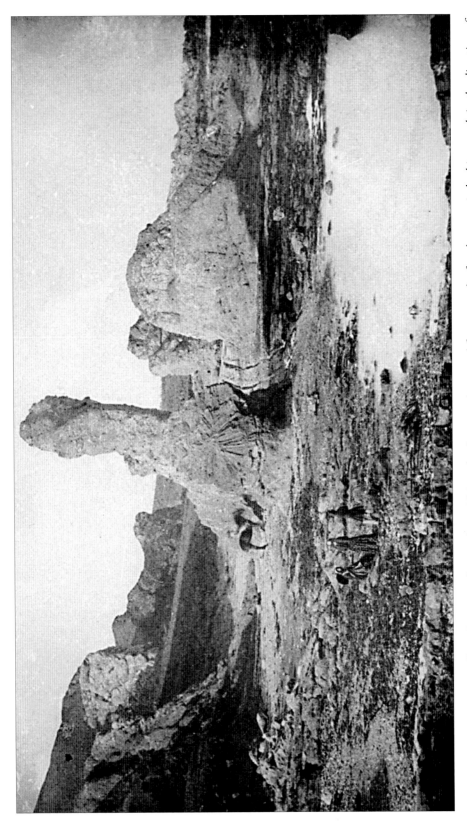

Plate 28: The Rock and Spindle with surrounding rocks, a tidal pool, a boy on a horse and figures on the foreshore, again looking north in the direction of St Andrews, around 1845, by Robert Adamson with David Octavius Hill; print from calotype negative.

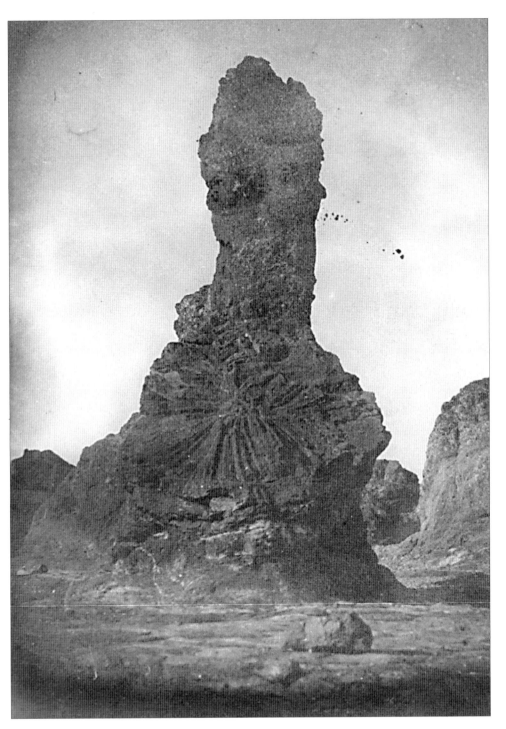

Plate 29: The Rock and Spindle, looking north in the direction of St Andrews, around 1845, by Robert Adamson with David Octavius Hill (possibly involving John Adamson); print from calotype negative.

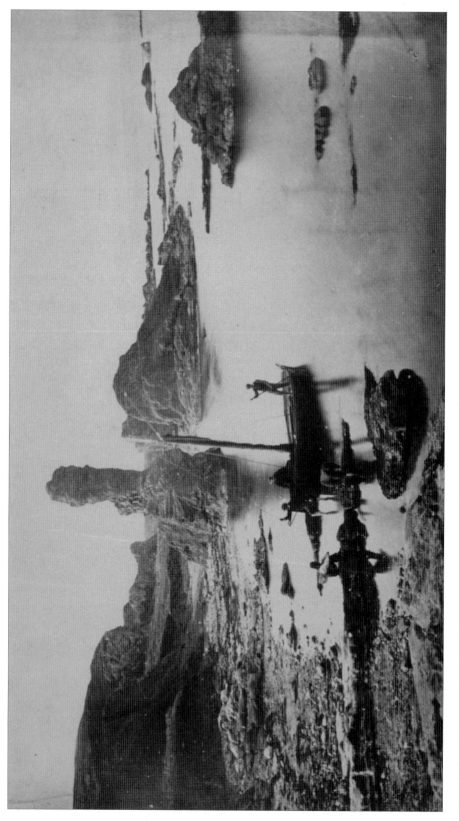

Plate 30: The Rock and Spindle with figures and an apparently incoming boat, looking north in the direction of St Andrews, around 1860, by Thomas Rodger; print from glass plate negative.

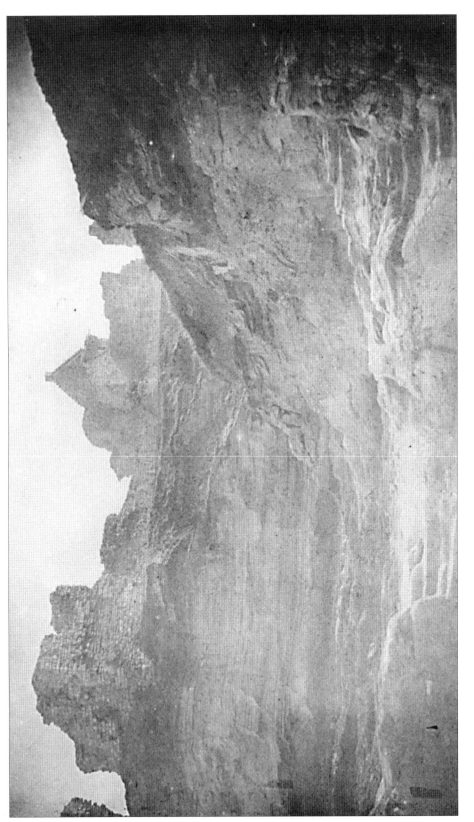

Plate 31: St Andrews Castle from the shore below the cliffs, around 1845, by Robert Adamson with David Octavius Hill; print from calotype negative.

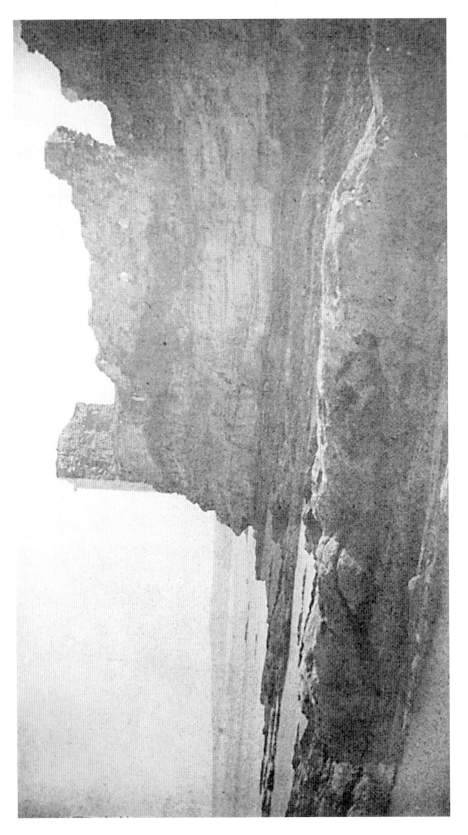

Plate 32: The sea tower of St Andrews Castle on the cliff from the shore, around 1845, by Robert Adamson with David Octavius Hill; print from calotype negative.

d'une chamber noire executée sous la direction immediate de sir David Brewster'.[13] The point in noting that for several contemporaries Adamson's name came first is neither to set Adamson and Hill against each other as rivals nor to see them simply as disciples of Brewster: that would distort utterly the successful nature of their partnership. But we should be alert to the fact that Adamson, far less outgoing than Hill, could be patronised. When the engineer James Nasmyth (whose father had been an artist as well as an inventor), wrote to Hill in 1847, asking 'how does that worthy artist Mr Adamson the authentic contriver & manipulator in the art of light and darkness?' there may be something a little patronising in the use of the word 'worthy', but revealingly Nasmyth, whether jokily or not, calls Adamson an 'artist'.[14]

Robert Adamson's academic training was in science; David Octavius Hill was already a lauded professional painter, illustrator, and arts administrator. As their partnership developed, they found it appropriate to market themselves as a renowned artist partnered by a skilled scientist. In August 1844, in a commercial venture also associated with Hill's brother Alexander (an Edinburgh publisher and seller of engravings), Hill and Adamson announced they were 'Preparing for publication A Series of Volumes, composed of Pictures executed solely by the agency of Light'. None of the titles listed ever appeared. Only one volume, an album of scenes from the town the young Adamson knew best, *A Series of Calotype Views of St Andrews*, would be published by Hill and Adamson, in 1846. Yet the self-presentation in the over-ambitious 1844 advertisement is revealing. Hill comes first as 'D. O. Hill., R.S.A.[,] Secretary of the Royal Scottish Academy of Painting &c'. Adamson is then mentioned in the technical phrase, 'The Chemical Manipulations by Mr. Robert Adamson, late of St Andrews'. Though it sounds odd now, the term 'Chemical Manipulations' would have been readily understood by an educated 1840s audience. A revised third edition of Michael Faraday's *Chemical Manipulation: being Instructions to Students in Chemistry* had been published in 1842. Hill, however, told fellow painter David Roberts in 1845 with regard to the work of calotyping, 'I know not the process though it is done under my nose continually and I believe I never will'. As far as the 'art' of photography was concerned, Hill maintained that 'Until I took it

up the best things I saw were, though chemically fine, artistically nothing.'[15]

When he was considerably older, Hill designed an album title-page (now in Cologne) which generously set the images of John and Robert Adamson above his own.[16] In the 1840s, though, Hill was ready to grant Robert and John eminence as chemical 'manipulators', but not at all as artists: 'I believe also from what I have seen that Robert Adamson is the most successful manipulator the art has yet seen, and his steady industry and knowledge of chemistry is such that both from him and his brother much new improvements may yet be expected.'[17] This division of labour between Hill, the artist, and Robert Adamson, the chemist, came to dominate much of the discussion of their collaboration, leading at times to the complete suppression of Adamson's name. When Walter Benjamin, for instance, admires a portrait photograph produced through the two men's collaboration, Benjamin attributes the picture solely to Hill.[18] However, Robert Adamson's chemical prowess should not imply that he lacked an aesthetic sensibility. Though it has gone unnoticed, Robert's extensive reading as a St Andrews student makes it very clear that he had markedly developed artistic tastes.

Whereas his fellow Physics students borrowed from the University Library little or no imaginative writing, Robert distinguished himself by his appetite for fiction. He shared this with one of his brothers in particular. As a student, John had read works on zoology and mineralogy, showing some interest in Calvinist theology. John's younger sibling, the sturdy Alexander, who eventually took over the farm at Burnside, seems to have been less of a reader, though he had some acquaintance with writings by Walter Scott. But far closer to Robert Adamson in literary tastes was his brother Archibald. Just two years older, Archibald relished Shakespeare, Scott, Fenimore Cooper, and recent novelists. Some of the fiction Archibald read (such as *Ivanhoe*) also interested Robert. It is clear that Robert and Archibald were close not just in age but also in sensibility.[19]

Robert Adamson borrowed the best part of a hundred volumes from St Andrews University Library during his two years as a student, and it is very likely that his eager reading continued throughout his career.[20] When later photographed, he sits by a table, eyeing a pile of books;

more unusually, as calotype poses go, when pictured with his brother Alexander, Robert stands holding several volumes in his right hand.[21] The bulk of his student reading was made up of scientific texts. His enthusiasm extended to works on steam-powered vessels and railroads. He was interested, too, in Brewster's earlier work on optics, borrowing titles such as Brewster's 1813 *Treatise on New Philosophical Instruments with Experiments on Light and Colour*, volumes of the *Edinburgh Encyclopaedia* and *Encyclopaedia Britannica*, and James Ferguson's *Lectures on Select Subjects in Mechanics, Pneumatics and Optics*, which Brewster had enlarged as a young man. These would not have communicated to the teenage Robert details of Brewster's more recent thinking, but John Adamson, curator of the St Andrews Lit and Phil's museum from 1838 onwards, was unusually well placed to do that.

More striking than his scientific reading was Robert Adamson's fondness for Gothic and Romantic fiction. Stories about buccaneers, highwaymen, sailors and adventurers attracted several teenage student readers in St Andrews. Borrowing recent novels such as Charles Sealsfield's *The Indian Chief* or Captain Marryat's *Peter Simple*, Robert shared such an enthusiasm. He also had some interest in biblical prophecies about the end of the world, and in demonology.[22] Like his brother John, he too had a sense of humour, indicated by his borrowing of a brand-new pocket-size joke book called *American Broad Grins*.[23]

A reader from the era and the country of Walter Scott, Robert favoured historical romances. In Mary Shelley's *Valperga*, the young hero is found 'seated on a rock amidst the wide sands left by the retiring sea, listening to the melancholy roar of the tide'. Novels like this conditioned their readers' visual sense and awareness of environment. *Valperga* includes accounts of the ruins of Rome, and descriptions of a castle whose court 'was surrounded by gothic cloisters'. The Castle of Valperga is hardly that of St Andrews, but it is certainly viewed with an eye for visual drama:

> Behind the castle the mountains rose, barren and nearly perpendicular; and, when you looked up, the dark and weatherstained precipice towered above, while the blue sky seemed to rest upon

it. The castle itself was a large and picturesque building, turreted, and gracefully shaded by trees.[24]

Robert Adamson liked this sort of stuff, which helped educate the reader's eye for the picturesque. In another tale he borrowed, *Berkeley Castle, An Historical Romance*, the castle setting prompts a 'soft, pleasing, yet melancholy train of recollections'. This fortification is huge and occupied, standing 'in a most picturesque point of view', but with its Byronic epigraphs and antiquarian notes on tombs, the book offers other landscapes too:

> . . . situated on the summit of the cliff, were some ruins of an ancient chapel supposed to be coeval with those on the rock on the opposite side of the river; but which, from the wasting of the cliff have, during my life, buried themselves in the waters beneath, or been broken into fragments by the extent and depth of their fall.[25]

Again, this is not St Andrews – these cliffs, we are told elsewhere, are 'alabaster', presumably chalk – but passages like this schooled the eye of the future photographer who studied beside the familiar cliff-top ruins of St Andrews castle and cathedral.

As a young man Robert is said to have been apprenticed to a millwright. His employer was probably John Annan of Dairsie near Cupar in Fife, father of the future photographer Thomas Annan who may have known Robert in his youth and who later took over D. O. Hill's studio.[26] Burnside Farm lies very close to Pitmilly Mill on the Kenly Water, so Robert would have been familiar with mill machinery from boyhood onwards – long before he read about mechanical engineering at university. Drawing on nineteenth-century sources, the only detailed account of his boyhood confirms such interests:

> As a boy he was delicate in health and retiring in disposition, with a strong turn for the natural sciences, and an especial aptitude for mechanics, devoting all his spare time to the construction of various models, steam-engines, wheelbarrows and small schooners which he sailed on the burn that ran beside his father's house, and sometimes even building larger rowing-boats, to the no small danger, as we are

informed, of those who ventured their persons therein upon the deep. At one time it seemed probable that he would adopt mechanics as a profession; and, indeed, with this in view, he worked for a year or two in a mill-wright and engineer's shop in Cupar, but his frame was hardly muscular enough, his health scarcely sufficiently robust to bear the severe physical strain involved in such a calling.[27]

This account matches some of Robert Adamson's early photographic oeuvre, which includes photographs of scientific equipment. A calotype of a mechanical model of a pump, taken by him around 1842 and now in the collections of the University of Texas at Austin, shows an eye for stark, balanced composition.[28]

All this should be seen as part of the make-up of the young man who was trained by his brother John to become a calotypist around the age of twenty-one. Yet between Robert's student reading and that early schooling in photography occurred an event which surely shook him psychologically. In June 1838, at the end of seventeen-year-old Robert's second year at university, Archibald, the brother whose literary tastes were so close to his own, died at the age of nineteen. Very little is known about this episode and whether Robert's departure from the university in 1838 is connected with this family tragedy is unclear, but he did not return to his official St Andrews studies.[29] Instead, whereas he seems to have shared imaginative interests with Archibald in the mid and later 1830s, after Archibald's death he began to gravitate towards the photographic concerns of his older brother John and other members of the Lit and Phil circle. Soon, having worked on photography with John and having taken photographs in the town alongside him, there were plans for Robert to abandon the idea of training as an engineer and instead to set up in Edinburgh as a professional calotypist. As yet in Edinburgh the calotype had not caught the public imagination; not until July 1843 was it mentioned in the *Scotsman*.[30] Brewster several times spoke with Dr Adamson about Robert Adamson's plans, and had discussed matters with Robert himself 'who', Brewster told Talbot, 'has been well drilled in the art by his Brother'.[31]

Throughout the summer of 1842 Talbot's advice and their own experiments helped the St Andrews photographers refine their work.

Probably with Robert, John Adamson went round the town and listed in his scrapbook suitable photographic sites and good times of day to photograph them.[32] October saw him 'arrived at great perfection in the art, and his brother the Doctor is preparing a little book containing his best works', which Brewster promised to send to Talbot.[33] Known as the 'tartan album', this tartan-fronted book is among the incunabula of early photography. To some extent it is patterned on the third (1838) edition of the guidebook, *St Andrews as It Was and as It Is*, in whose production Brewster had assisted and which had been exhibited at the Lit and Phil.[34] Including some contemporary people and buildings as well as medieval ruins and structures 'demolished by the followers of John Knox', the album, like the guidebook, encourages the viewer to muse on the ravages of time and, by implication, the fragility of human life. It emphasises antiquity, noting with regard to the historic square tower in the 'Ruins of the Cathedral' that it is 'supposed by many ancient scotch writers to be as ancient as the 4th or beginning of the 5th century – certainly as old as the middle of the 9th century'.[35] Though only one of the photographs in the tartan album is initialled 'RA', different prints of some of its pictures appear in other albums with those initials, so probably Robert Adamson took many of them.[36] Possibly John, who added the captions, was responsible for others, including the photograph of Brewster. By 1842, as well as encouraging John's photographic work, Brewster was also giving Robert his strong backing. Fronted by an oval-framed photograph of Brewster on a tartan background, the album which Dr Adamson assembled presents St Andrews in the best possible light. It calls attention to the place of the town in Scottish history, juxtaposing its picturesque ruins with fine modern sights like the 'Episcopal Chapel' and the Adamsons' neat, harvest-time farm at nearby Burnside. If the album shows ancient ruins and emblems of time's passage, it hints too at well-ordered modernity. The people in the pictures are either top-hatted Victorian gentlemen standing beside the antiquities, or they are thoroughly respectable sitters – 'Sir George Campbell of Edenwood and son', 'Miss Thomson and Miss M. Thomson, daughters of Dr Thomson', the tartanned and bonneted 'Miss Isabella Adamson'. The only people who might be working-class in the album are five neatly arrayed women and two men

with a horse-drawn cart standing in a rural landscape. There are no fishermen, no lunatics, no street folk – not a heap of 'filth' to be seen.[37]

The tartan album could be seen as a bourgeois sanitising of St Andrews. However, looking at the larger corpus of town photographs alongside the 'improving' work of John Adamson and Major Playfair, a more nuanced picture emerges. As a doctor and documenter of local life, in his 1841 *Report*, John knew the earth-floored houses with 'the lowest notion of cleanliness' where poor workers slept on chaff-filled bedding, sometimes without bedclothes, their minimal furniture 'a deal table, a chest of drawers, or only a chest, a cupboard, two or three chairs or stools, with utensils for cooking, eating, and washing clothes'. He was struck sometimes that even very poor families had 'gaudily-coloured prints pasted upon the walls'. He notes with customary precision the breakfasts of 'porridge, with milk and small beer' and dinners of 'broth, made with pork and vegetables or coarse pieces of beef; fried pork, with potatoes; often salt herrings or fresh fish, which are abundant and cheap'. Middle-class distaste and genuine concern mix in his observation that 'there are a certain number of notorious drunkards, and from the quantity of whiskey consumed in public houses ['12,000 gallons annually'], a great part of which must be by inhabitants of the town, it is evident that there is much more tippling among the lower classes than is consistent with the welfare of their families'.[38]

The lower-class inhabitants who interested Dr Adamson most were the fishermen.

As a body, they present many peculiarities; for instance – they associate only with each other: they usually marry the daughters of fishermen, few women not bred in the trade being fitted for the duties of a fish-wife; they employ the whole of their time, not occupied at sea, either in bed or lounging at a corner of the street, in full view of the public-houses, of which there are several for their especial accommodation; and their only enjoyment seems to consist in feasting and drinking, at which they continue as long as their money lasts. In this way they are enjoying themselves in gluttony and drunkenness for one week; and the next, if the weather is unfavourable, they are on the verge of starvation.[39]

Mention of 'starvation' here summons the spectre of mortality and brings Adamson close to the 1840 suggestion of *'protracted starvation'* which had so annoyed Robert Haldane. For all that he had been willing to support Haldane's defence of poor relief, in 1841 Adamson's *Report* does not mince its words. Adamson even describes the situation of the fishermen's end of North Street as a 'moral cancer'. As the Lit and Phil knew, he made a particular study of 'deaths in St Andrew's', collecting and tabulating mortality statistics in a period before there was any official registration of them in the town.[40] The early death of Archibald Adamson in 1838 could only have quickened the doctor's interest in local causes of mortality. John Adamson surveyed diseases from measles to typhus fever, taking a particular interest in the higher mortality rate 'Among the fishermen inhabiting the east end of North-street' where 'there is conjoined both external and internal filth, with irregular habits and dissipation'.[41] His mapping of mortality went beyond his formal obligations as a doctor, and is a topic apparent in some of the most striking St Andrews photographs with which he is associated. His interest in social documentation also links John Adamson to some of the very earliest 'documentary photographs', to use Graham Smith's phrase, even though modern ideas of 'documentary' came to be articulated substantially later.[42]

The fishermen's houses were far too dark to allow John or Robert Adamson to photograph their interiors. Besides, camera-carrying friends of Provost Playfair would not have been welcomed there. For all that they resided just a few hundred yards from the St Leonards of Brewster and Playfair, the fisher folk lived in a style very different from that of their wealthy neighbours. In one of the few early St Andrews pictures of working-class people, taken by Robert and preserved in an Adamson family album, some men standing on a street corner stare resolutely, perhaps even pugnaciously, at the camera. Women and children sit huddled against house walls beside the road. A standing figure in shirtsleeves has his arms defensively folded. Further back along the street a top-hatted figure stands incongruously among the poor.[43] Probably taken in 1842 before Robert moved to Edinburgh, this picture seems confrontational, as if saying, 'Look at the state of these people.' They are most likely some of the fishermen about

whose 'filth' Dr Adamson complained. Stubborn and independent-minded, they had been trying to evade the Major's attempts to regulate their mussel-gathering activities at the 'scalps' (mussel-beds) near the mouth of the River Eden. Fighting for the right to collect mussels as they wished, they resisted efforts forbidding them to 'bait, or dress lines, or nets, or place or cause to be placed any mussels, or other bait, fish, fish creels, baskets, lines, nets or other fishing articles upon any street, road, lane, or other public thoroughfare'.[44] In 1843, the fishermen 'declared their resolution to supply themselves with bait as they had been wont to do or in such other way as they found most convenient', but the town council faced them down and thrashed out an agreement with them during November, recording their names, licensing them, and making them pay.[45] The recalcitrant figures confronting the camera look less than delighted at being photographed by their supposed betters who associated their life with 'starvation', 'cancer', and death.

Associated calotypes show the demolition of old houses in South Street 'Pulled Down for Improvement': another finely composed photograph by John Adamson, balancing dark against light. In it one partially demolished dwelling has an exposed pale interior wall; the adjoining house is similarly shaped but filled with darkness as its end wall is taken down. The foreground is dominated by piles of stones.[46] In the Brewster Album the larger-format photograph of the Old Tolbooth (soon to be demolished), taken with a camera laid on the cobbles of Market Street, is also connected with town improvements.[47] This picture might function as a memorial of the old, but also as part of campaigning to plan for the new. We are accustomed today to the use of photographs for such purposes, as part of urban planning, but St Andrews appears to be the first town, in the English-speaking world at least, where photography was used as part of a redevelopment process. Several St Andrews pictures make use of a compositional balance not just between dark and light but also between the historic past and new developments: a calotype of the harbour has on its left the strong vertical of an industrial chimney (surely that of the gas works), on its right the more attenuated and traditional verticals of the masts of anchored sail-powered vessels. At the centre of the picture, light

catches pale stone slabs laid against a dark end wall: signs of further change, more improvement.

In 1841, commenting on fishermen and fishwives whose 'houses and children are totally neglected', so that the young people 'grow up into fishermen and fishwives as profligate and degraded as their parents', Dr Adamson had thought 'a fish-market' would contribute to the 'improvement' of 'this whole community' and lead to 'a moral reformation' as well as 'physical improvement' – helping to save souls as well as reduce mortality.[48] A few years later, as Graham Smith points out, a local historian was praising Major Playfair for having been 'completely successful' in his efforts to 'reclaim' the fisher-people, having even supplied them with a reading room, a school, and, helped by Robert Haldane, a weekly sermon and the regular distribution of religious tracts. Not everyone approved of the 'all-potent tyrant' Playfair who 'braved' the 'wrath . . . of the fishwife progenie'.[49] One local historian, George Bruce, recalled Provost Playfair as an oppressor, against whom the fisher folk later rebelled.

It was during this period of social improvement and social confrontation, some time between 1842 and 1845, that Robert Adamson (perhaps collaborating with John, perhaps with D. O. Hill) took a pair of striking images of fisherwomen and children sitting on the pavement of the 'Fishergate, St Andrews' with baskets and other accoutrements.[50] Though these pictures may seem at first sight casual, they are very carefully choreographed. Each is a *tableau vivant* of fishwives at the eastern end of North Street. Two exposures have been taken some time apart, yet the woman crossing the street in each stands at the same angle, carrying her basket in an almost identical pose. She has clearly been positioned to be a focal point, contributing depth to the picture, and attracting the eye with her gait. Many other figures retain their positions and even their angles from picture to picture, but some have moved, or been shifted. A child sitting in the gutter in one exposure has migrated on to the pavement in the other. This slightly different photograph also features two additional younger women sitting on the street, side-on to the camera, one dandling an infant, the other extending her slim foot and ankle. It is true that there is a large box and even a heap of what looks like refuse in the gutter on the right of the

picture, but this is a carefully crafted, markedly ordure-free view which makes the fishwives and their children look almost like a scene in an operetta. Lights and darks are finely balanced – even down to the washing hanging on the buildings. If these are street people, they are picturesque ones.

This may be the area of town with the highest mortality rate, but the 'Fishergate' picture speaks far less of that than of local colour. Strikingly, and unlike Robert Adamson's 1842 photograph taken a little further along the same street, there are no men present; there is no confrontation. Instead of being aggressive or defensive the postures are calm to the point of being decorative. This picture commemorates an older, potentially unhealthy way of life that has now been safely improved, even sanitised. Sunny and unthreatening, a variant of it was published in the 1846 *Calotype Views of St Andrews*, where, contrasting with the gravestones of the cathedral, the ancient ruins, and the occasional presence of top-hatted men, it is the only depiction of female life and of lower-class workers. Beautiful in its balanced composition, the photograph can be read as a testament of improvement designed to lead to an economically and socially sustainable community.

This calotype is also a triumph of the male, middle-class eye. It may owe something to a schooling in Dutch genre paintings and modern drawing masters' books such as the *Prout's Microcosm*. Republished in 1841, that popular volume showed sketches of characterfully costumed female workers on a cluttered picturesque street, beside an old house, with one of the women sitting on the edge of a pavement.[51] A book that the student Robert Adamson had borrowed from his university library was Fanny Trollope's *Belgium and Western Germany in 1833*. Filled with visits to historic university and cathedral cities, it explained that walking through the 'mouldering grandeur' of the historic streets of Bruges 'is like looking over a portfolio of Prout's best drawings – but there are very few figures in active movement to enliven them'.[52] The photographic composition of these St Andrews pictures seems alert both to Prout's guidance and to that wish for 'figures in active movement' expressed by Fanny Trollope.

Besides these St Andrews pictures, though, should be set a later

photograph taken in the same location. Again it features fishwives, but the principal figure is a bearded, apparently working-class, man brushing refuse from the gutter. In his white shirt and set against the dark rectangle of an opening off the street, this sweeping figure is striking in a photograph which focuses on the vestiges of filth which preoccupied Dr Adamson and which were linked to his mortality statistics. Yet if, when viewed in this context, mortality may be implied in the scene, the picture also shows how the community may address threats posed by 'filth' and poor sanitation. Attributed to Thomas Rodger, this photograph too is a moral emblem of improvement which may be considered alongside the labours of the Major to reform the town and, particularly, its impoverished fisher folk.

Though they relate to social concerns about a high mortality rate, working-class 'filth', and attempts at redevelopment and social 'reformation', these pictures confront and surmount such issues. Among the most interesting early photographs of people taken in St Andrews, they complement and probably helped encourage Adamson and Hill's much better-known series of studies of fisher folk near Edinburgh, such as the photograph of characteristically costumed Newhaven fishwives sitting beside a creel and being read to by the middle-class Reverend James Fairbairn and James Gall. John and Robert Adamson's manifest interest in the conditions of local fishermen was part of a national concern with the state of the poor which extended from vast surveys by the British Poor Law Commissioners to the novels of Dickens, the Disruption social theorising of Thomas Chalmers, Friedrich Engels's 1845 survey of *The Conditions of the Working Class in England*, and the later photographs of impoverished Londoners taken by John Thomson in the 1870s.

More specifically Dr Adamson's focus on the St Andrews fisher folk and Robert Adamson's photographing them on North Street may have encouraged the 1844 plan for Robert and D. O. Hill to publish an album of calotypes called *The Fishermen and Women of the Firth of Forth.*

This planned series of photographs has been discussed insightfully by Sara Stevenson in her book, *The Personal Art of David Octavius Hill,* but it is important to realise that not just the artistic tastes of Hill but also

the seaside upbringing of Robert Adamson (plus his liking for boats and nautical yarns) may have conditioned this choice of subject. If Stevenson regrets that Hill and Adamson's series was never published as a separate volume, 'so the complete intention of this first "documentary photo-essay" was not made clear at the time', then she recognises the quality of the pictures.[53] It is hard to uncouple Adamson and Hill's concentration on the Forth fishing community from the work of the Adamson brothers in St Andrews. Hill and Adamson appear to have taken not only several splendid pictures of the busy town harbour which was used by fishing boats and larger vessels, but also at least one calotype of a low fisherman's cottage, looking along a less than spotless eastern end of North Street in the area where John Adamson was most concerned about 'filth'. Though it has the ancient St Rule's Tower close to its centre, this photograph is composed to make the most of the fishermen's houses and refuse-strewn roadway in the foreground. Yet, however fascinating the photographs of the St Andrews fisher folk may be, they do not feature in the 'tartan album'. Its only hints of mortality and ruin are in the scenes of eroded ancient stone buildings.

By November 1842 Dr Adamson was showing Brewster this 'little book of Calotype Gems', and sent his and Robert's examples of 'the art' to Talbot with a modest note 'in testimony of the great pleasure we have derived from Your discovery'.[54] On 10 May 1843 Robert Adamson left St Andrews for Edinburgh where, on 19 May, he opened his own photographic studio. Before embarking on his partnership with Hill, Robert took a strikingly stark photograph of Edinburgh's Royal High School; there are two dark figures in the foreground, but the street is otherwise depopulated, the angled, stony masses of the school dominating a view of masonry and monumental emptiness. When this is put together with other images such as one (now in the collection of the Metropolitan Museum, New York) which shows the interior of a ruined building, thought by some to be in St Andrews (but perhaps in Edinburgh), it seems Adamson had a real eye for stony desolation.

By early 1842 a commentator had already noted that 'in Edinburgh, some very beautiful specimens of photogenic drawing of street-scenes have been effected by Mr Howe [sic], miniature painter'.[55] This was James Howie, who took portrait photographs on a New Town rooftop

studio reached by a ladder through a skylight.[56] Setting up his own studio in the resonantly named 'Rock House' on Edinburgh's Calton Hill, Robert Adamson enjoyed an even more elevated and better-lit site. He brought with him not just professionalism but also the kind of calotype photography practised in St Andrews. During and after the 1843 Disruption, numerous calotypes of the early Free Kirk leaders were taken by Adamson and Hill, which were to become widely acknowledged classics of photography. One early commentator mocked 'the fat Martyrs of the Free Kirk', and an Edinburgh caricaturist depicted them rather differently as gaunt grotesques, but to Brewster, Adamson, Hill and most Scots they were more than local curiosities.[57] These modern martyrs were viewed as self-sacrificing, heroic subjects for a remarkable new fusion of science and art. For Hugh Miller, in *The Witness* on 24 June, Adamson's calotypes were 'positively the most surprising and admirable things we have ever seen'.

> Instead of the cold, metallic surface, on which the Daguerrotype raises its slight film of ghostly white, we have the usual paper ground of an ordinary water-colour drawing, with the figure standing out in a deep rich brown, somewhat resembling sepia. The likenesses strike at once; they are not mere approximations to correctness, – they are correctness itself, – features which the features themselves have painted, with all that truth of outline, and of light and shadow, with which they throw their reflections on a mirror. All the expression too, is there – the massive repose of Chalmers – the quiet power of Cunningham – the indomitable power of Candlish, – never were there representations better suited, – for there can be no fiction in the case, – to give mediocre caricaturists the lie. We would recommend to all our metropolitan readers a visit to the study of Mr Adamson.[58]

Some exhibited as preparatory 'Sketches', others as 'Portraits of Clergy-men and Laymen of the Free Protesting Church of Scotland', the calotypes were shown in Edinburgh on 12 July 1843.[59] They served too as studies, preliminary sketches, for D. O. Hill's vast canvas, *The Signing of the Deed of Demission*, on which the artist worked for

decades. This painting records the signing of the foundational document of the new Free Kirk, and commemorates its formal secession from the old. Though in the past it has sometimes been scorned by art historians, Hill's picture is profoundly democratic and, as such, true to its subject. Its focal point, like that of the new church, is the word – both the biblical Word of God and the written document on which the leaders of the Free Kirk are inscribing their names. The word lies on a table, reminiscent of the Presbyterian 'communion table', and, perhaps, of the table in Leonardo da Vinci's *The Last Supper*. The renowned Scottish painter Sir David Wilkie had adapted Leonardo's *Last Supper* in his depiction of figures grouped round a long table in *John Knox Administering the Sacrament at Calder House* (*c*.1839), which had recently been purchased by the Royal Scottish Academy whose secretary was D. O. Hill.[60]

Yet as painted by Hill the long 1843 Disruption table is surrounded not by a few disciples, but by an innumerable Presbyterian throng. The great, barn-like interior which he depicts is utterly jam-packed – mainly with men, but also with several women; children and other onlookers peer through skylights. Each individual is painted with an equal quality of attention, making this crowd scene both remarkably egalitarian and outstandingly photographic. Present in the picture – though you need to look closely – are the photographer Robert Adamson with his camera, and the artist Hill with his sketchbook. Partly because of its origins in the new medium of photography, *The Signing of the Deed of Demission*, which still hangs in Edinburgh's Free Kirk Assembly Halls, is one of the greatest visual representations of democracy. Based on photographs, then later itself photographed for a series of popular postcards, it is a painting in which everyone is special.

Though the Hill and Adamson calotypes associated with this painting are internationally celebrated, there are other striking Adamson calotypes of the period which are much less widely appreciated. Some of these appear in *A Series of Calotype Views of St Andrews* – that sole album of photographs published commercially in Edinburgh by D. O. Hill and Robert Adamson. Sara Stevenson appears to regard these as photographs not just published but also taken by Hill and Adamson, while Larry Schaaf, calling attention to the precise wording

used by the publishers in 1846, has speculated that it is possible some of these photographs were taken by the Adamson brothers and the St Andrews circle of photographers, – not necessarily always working with D. O. Hill.[61] It may be safest to use only the word 'Adamson' of some of the pictures discussed in this present chapter, since at least one of the Adamson brothers seems to have been involved in most of them. Hill may have been connected with a good number of the St Andrews pictures, but what is constant is an Adamson presence.

If the *Series of Calotype Views of St Andrews* is less familiar than the pictures taken in Edinburgh by Adamson and Hill, other even more striking early St Andrews landscape photographs are hardly known at all. Like Adamson's 'tartan album', the *Series of Calotype Views* may be related to the presentation of St Andrews as a 'panorama' of historic 'objects' in the guidebook *Saint Andrews as It Was and as It Is*. The *Series* goes beyond the 'tartan album' in its focus on ruins, images associated with the dead, and coastal scenes. Less widely circulated photographs of the local landscape taken in the early 1840s go further in the direction of the sublime and the confronting of human transience.[62] These pictures show not the fishermen and fishwives whose part of town featured distinctly in John Adamson's mortality statistics; instead, they image mortality much more starkly in their depiction of local geology, and not least one particular rock.

Probably John or Robert Adamson (perhaps both) took a considerable number of photographs of the striking geological feature on the coastline just over two miles south-east of St Andrews, known as the Rock and Spindle. These stunning pictures (not all of which were included in the published St Andrews album) have sometimes been attributed to Hill and Adamson, but Brewster mentioned to Talbot on 9 May 1843 that among 'the very finest things' done by Robert Adamson before he set off for Edinburgh were not just portraits but also calotype 'Landscapes'. At least one of these is a view of the town from the Kinkell Braes which survives bearing the initials 'R.A.'[63] Robert and his brothers would have known from infancy this view and the nearby coastline around the Rock and Spindle, with its several distinctive geological features – Maiden Rock, the low-water and high-water springs on the rocky beach near Buddo Ness, and Buddo Rock –

all of which lie on the coastal path between Burnside Farm and St Andrews. Though they surely brought D. O. Hill to see it, this was very much Adamson territory.

Many of the early St Andrews landscape pictures must be presumed lost – some in the fire that destroyed Brewster's archive in 1903. However, eleven remarkable negatives of the Rock and Spindle survive in Glasgow University Library.[64] The high, pillar-like formation of the rock, still today admired by geologists and tourists, dominates these. Only after some time does the viewer notice human figures on the beach. For all the presence of people, geology is at the heart of these pictures. Humanity is dwarfed, seeming as evanescent as the tidal pool in the foreground. Beautifully composed, one photograph balances the pale pool at the bottom right against a dark swathe of rocky beach on the middle left. The rock formation rears up in between the two. Beyond, on the horizon, rise other ragged cliffs. Like the scandalous manuscript Robert Chambers worked on in St Andrews, these pictures highlight the transience of the human presence in the geological world. To borrow a phrase from *Vestiges*, they depict 'leaves of the *Stone Book*'.[65]

Surely part of the photographer's interest in the scene stems simply from the fact that the Rock and Spindle was a local landmark near the Adamson family farm. Yet, though it may have been near at hand, the pictures of this basaltic phenomenon have a drama that far transcends mere convenience. The rock was just the sort of feature that clearly spoke of the early history of the world. Chambers in *Vestiges* speculates that

Judging from the results and from still remaining conditions, we must suppose that the heat retained in the interior of the globe was more intense, or had greater freedom to act, in some places than in others. These became the scenes of volcanic operations, and in time marked their situations by the extrusion of traps and basalts from below – namely, rocks composed of the crystalline matter fused by intense heat, and developed on the surface in various conditions, according to the particular circumstances under which it was sent up; some, for example, being thrown up under water, and some in the

open air, which conditions are found to have made considerable difference in texture and appearance.[66]

The 1838 guidebook *Saint Andrews as It Was and as It Is* makes clear that the Rock and Spindle were regarded as 'striking geological wonders' and had considerable appeal to Victorian geologists: 'if you are a hammer man [a geologist] these rocks are to you invaluable'.[67] Today the marks of geological hammers can still be seen on the eastern side of the rock.

John Adamson, as is evident from his 1841 published report on St Andrews, had a clear interest in geology. He had taken out books from the University Library with such titles as *Fossil Flora* as well as the book entitled *Fife Illustrated* in which his fellow Lit and Phil member Dr Anderson had published his account of the supposed fossil beetle *Pterichthys*. He borrowed not only scientific works by William Carpenter but also Hugh Miller's 1841 *The Old Red Sandstone* in the spring of 1844, when Chambers – who several times alludes to Miller's book – was putting the finishing touches to *Vestiges*.[68] In *The Old Red Sandstone* Miller pointed out that he had published part of his first chapter 'in *Chambers's* [sic] *Edinburgh Journal*'. Miller's volume admired not only the 'celebrated Cuvier' and 'Lamarck', but also the spectacular geology near St Andrews, and had a liking for scenes where cliffs were moulded into striking formations by 'the incessant lashings of the sea'.[69] Both John Adamson and Robert Chambers obviously shared several of the same fascinations.[70] The most obvious evidence for this is that Adamson borrowed from St Andrews University Library both *Chambers's Information for the People* and, on 24 November 1845, *Vestiges of the Natural History of Creation*.[71] Sometimes it is hard to know which photographs were taken before this date and which after, but the Adamsons' interest in rock, stone, and geology shaped their photography, and the controversies which came to a head in reactions to *Vestiges* were inevitably part of the mix.

Further visual evidence of this geological interest in photography comes from an arresting picture now in the Brewster Album in the Getty Museum, Los Angeles. This image is described as 'splendid' by the art historian Graham Smith who attributes it to John Adamson and

reproduces it as a full-page plate in his book on the Brewster Album, *Disciples of Light*. Smith thinks this picture's 'size implies that it must be dated after May 1843, when the St Andrews group acquired a larger-format camera'. He points out how the camera appears to have been balanced on a boulder, and how 'Large rocks seem to press against the lens'.[72] Though sunlight brightens a line of boulders in the near foreshore, the centre of the photograph is dominated by dark, dramatic peninsulas of rock running out horizontally into the North Sea. We know that the geologically minded John Adamson had an eye for such things since he wrote about how at low tide in St Andrews there are 'strata . . . seen beautifully dissected by the sea, which has washed away the softer clay, leaving a succession of long ridges of sand-rock at regular distances'.[73]

This photograph of rocky peninsulas shows the scene described in 'Kinkell, An Extempore Sketch', a poem published in 1838 by David Page who would soon work with Robert Chambers. A stonemason's son, Page had studied Classics as well as Physics and Chemistry at St Andrews in the same period as Robert and John Adamson's brother Alexander. Resident in the town, Page took up the post of editor of the *Fife Herald* newspaper in the summer of 1839, shortly before becoming one of the early honorary and corresponding members of the Lit and Phil. He was the man who later worked as an editorial assistant on *Chambers' Edinburgh Journal* and the only one of Robert Chambers's employees to whom (in February 1845) Chambers revealed the secret that he was the author of *Vestiges*.[74] For all that the two men soon quarrelled, Page was influenced by Chambers and went on to become a popular Victorian science-writer of 'evolutionary epic', drawing particularly on his long-standing interest in geology.[75] His poem's Kinkell is a site of storm and coastal erosion, associated with nearby Reformation struggles and pregnant with 'Nature's portents', its 'rugged, rock-girt beach' all

> wild confusion! Rock on rock
> Hurled together with fiery shock,
> As from the shrubless headland torn,
> By wind, and wave, and tempest worn,

> They'd thundering reeled with bounding crash
> Down to the water's restless dash.

For this poet who later became a professional geologist the arresting geology of Kinkell with its Rock and Spindle and boulder-strewn beach presents scenes

> as if the hand
> Of Nature in a sportive mood
> Had cast them forth, unfinished, rude,
> And then, with scornful jeer, to man
> Exclaimed, Go, reptile! These my fabrics scan.[76]

However 'sportive', there is something disconcerting in this landscape that reduces the human to the status of 'reptile'. In the relatively short space between the publication of Page's poem and the taking of the photographs near Kinkell works like Miller's *The Old Red Sandstone* had made geology all the more awe-inspiring and, for many, disturbing. Chambers's *Vestiges* was part of this process, and its effects are consonant with these St Andrews coastal photographs. On the horizon of the picture in which the 'rocks seem to press against the lens', beyond the low, dark masses of the successive peninsulas of rock that jut out into the sea, pale, almost spectral, is one final peninsula on which is perceptible the silhouette of St Andrews itself, with St Rule's Tower and the cathedral ruins. This is what Page's Kinkell poem saw (with somewhat unfortunate diction) as 'Across the bay, the sculptured aisles, | Mist-cleaving spires, and castled piles'.[77]

To photograph such a vista in the 1840s required a very deliberate act. Graham Smith points out that the composition of the striking Adamson picture of the rocky peninsulas can be no accident: the vantage point is difficult and has been carefully chosen.

> The distance involved in going to take this view or others in this group is not great, but the inconvenience must have been considerable. Apart from the need to prepare photographic paper at some distance from the subject, the Adamsons' eagerness to clamber over

slippery, seaweed-covered rocks in search of a view suggests that their readiness to experiment was combined with a youthful spirit of adventure.[78]

Expansive, haunting, and, for all its lack of human figures, a little haunted, this and other early St Andrews landscape pictures are, too, images of mortality, their human content dwarfed, spectral, transient in contrast with the abiding rocks.

Other early photographs of St Andrews bring together the most resilient human artefacts – the stonework of the ancient, often eroded buildings – with the geological features that underpin them: these pictures again invite unsettling thoughts of human impermanence. Fox Talbot took a photograph entitled 'The Geologists' at Chudleigh in Devon in 1843. It is an instructional image in which a man with a pointer indicates a layer of rock in a cliff-face, while a bonneted woman looks on.[79] The St Andrews pictures present a much more sustained, stark and disturbing contemplation of stoniness. Taken from the rocks beneath its base, a calotype in the collection known as the Lyon Family Album looks up at the ruins of St Andrews Castle, one of its towers dramatically split at the centre of the picture between light and shadow. The calotype is empty of people, the masonry of the castle seems to be crumbling back towards the strata below. The only hint of modernity is in a few chimney-pots just visible on the horizon at the extreme left.[80]

In other photographs of the castle, taken from the dramatic edge of the 'Scores' or sea-cliffs as the tide recedes, rocks and castle seem to blend together. In the foreground some versions of this view have top-hatted figures perched on the cliff edge, staring out to sea; in several versions the figures have vanished.[81] For all that a more modern structure can be seen beyond the Castle, the predominant sense is of erosion. Human moments are set against geological time and the awesomeness of rock. Local viewers (including local photographers) would have been particularly sensitive to this, knowing that, as the 1838 guidebook pointed out, it had once been possible to play bowls on lawns to the east and north of the castle, but that such areas had been eroded by the sea which now threatened to undermine what remained of the weather-beaten, ruined castle itself.[82] 'The rock on which the city and

castle stand . . . is rapidly wearing away, and . . . has been surprisingly wasted during the lapse of two centuries'.[83]

With their focus on geology and the fleeting human presence, these St Andrews pictures anticipate preoccupations of the Pre-Raphaelite painters in the following decades. Most famously, in the collection of the Tate Gallery in London the Scottish artist William Dyce (who corresponded with D. O. Hill) has a notable oil painting *Pegwell Bay: A Recollection of October 5th, 1858*, where figures on a beach are dominated by towering cliffs in the evening light in a landscape littered with rocks as a comet passes overhead. Dyce's picture, renowned for its suggestion of Victorian anxieties about the significance of geology, was painted some years after the publication of Chambers's *Vestiges* had so shaken Victorian society; the early St Andrews photographs were contemporary with the book, and show us a wider, geological sense of mortality and ruin fully in keeping with Chambers's awareness of vast aeons of time that dwarfed any human presence. Repeatedly what the early St Andrews calotypes present are vestiges. They show St Andrews as a place not just of cliffs and ruins, but even, as one 1844 visitor put it, of 'the ruins of ruins'.[84] Here again is St Andrews as *memento mori*.

As Brewster suggested, these and other early St Andrews photographs speak eloquently of mortality. Some present a treasuring of the particular, an attempt to tell each human 'chapter in the history of the world'. Like Chambers's *Vestiges*, the photographs do two important and seemingly contradictory things at the same time. Both *Vestiges* and the photographs reveal the universe as terrifyingly vast and ancient in design, with consequences that threatened many people's sense of human worth, unsettling them with thoughts of the beginning and end of their world; but even as such fears loomed, the coming together of art and science in photography gave people a way to catch and treasure the minutiae of their lives and the shape of their surrounding environment. Psychologically the unimaginably huge and the minutely immediate could be held in balance, without either overcoming the other.

Neither art nor science emerged supreme; the future belonged exclusively neither to Brewster nor to Chambers. Instead, as in the St Andrews Lit and Phil, they and their insights came together. For all

Brewster's detestation of *Vestiges*, that book's chaptering of the world counterpointed the new chaptering offered by photography. Just as *Vestiges* carried with it a sense of wonder at the design of the earth, an open spirituality in an age when Christianity was (as always) contested, so photography, emerging among the medieval and Reformation ruins of the 'dead village' of St Andrews at the time of the Disruption and soon developing through the calotypes of Adamson and Hill, also articulated a sense of beauty, spirituality, resilience and religious questioning. The connections between the different productions of 1840s St Andrews are not indubitably clear and fixed. They are glancing, reconstellating, kaleidoscopic.

'Rock of Ages' begins a famous eighteenth-century hymn the Victorians loved to sing. Its wording links the certain rock of the church to Christ and to time immemorial. For some Christian believers, modern geology threatened to end the world of those certainties. Rock now carried other, much more unsettling connotations. Age may have intensified the sense of spectral gloom about the Adamsons' photographs of eroding coastline, taken from the crest of the Kinkell Braes. The images look now like descendants of the apocalyptic paintings of John Martin, that sensational imaginer of the end of the world who had also painted glowering Scottish scenes earlier in the nineteenth century. Modern scholarship has linked Martin's work to pre-Victorian and Victorian geology. As well as falling rocks he liked to depict both sacred spires and cities on the edge of ruin and destruction in paintings like *The Destruction of Pompeii and Herculaneum*.[85] There was a vogue for such pictures when Hill and the Adamsons were growing up.[86] George Miller painted *The End of the World* in 1830, all shattered antiquities and wildly darkening sky, while Martin himself in his painting *The Last Man* (*c*.1832) emphasises a lone figure on a darkly delineated coastal precipice.[87]

In his 1827 mock-epic Scots poem about the Reformation, *Papistry Storm'd; or, The Dingin' Down o' the Cathedral*, Chambers's friend William Tennant manages to link the destruction of St Andrews Cathedral to the burning of Troy and to events in ancient Rome and Babylon. However daft and frisky, his poem belongs to the same world view as Martin's paintings when it tells how

Great swallin' surges frae the deep
Come swingin' in wi' frichtsome sweep,
To drown hail cities in their sleep,
And to the weathercocks, to steep
The steeples in salt-water [. . .][88]

This apocalyptic moment happens to be a side-glance towards flood-prone Holland, but it is clear that the focus of his imagination is on St Andrews. The town faces 'the approachin' stowre [violence], | The rushin' down o' kirk and towr' which will reduce its cathedral to ruins just like Priam's palace and the rest of Troy.[89] William Tennant was a staunch member of the Lit and Phil.[90] Photographed by one of the 1840s St Andrews photographers he looks calm and composed, but, for all its comic tone, his poem about the 'dingin' [smashing] down' of the cathedral reinforced the viewing of St Andrews as a place of loss and destruction. The sites it mentions – the Pends, the university, South Street, the cathedral – were all locations the photographers pictured.

When it came to the Kinkell Braes and the rocky coastline the calotypists produced works which spoke – as Professor Tennant spoke – with apocalyptic accents. Tennant's 1843 address on 'Hebrew Poetry' presented poetry as 'the glory of all the sciences' and ended with a ringing celebration of the Old Testament prophets' God 'Who hath measured up the waters in the hollow of his hand . . . and comprehended the dust of the earth in a measure'. As he invoked ancient prophecies about 'the utter desolation that awaits Babylon . . . the calamities impending over Judea . . . "wind and confusion"' and 'specimens of sublimity – of all that is great and overpowering' from 'wasted and desolate Egypt' to other ancient cities 'smitten with desolation', Tennant tapped into a discourse of the sublime and apocalyptic which is evident not just in some of his own poetry but also in the work of John Martin and in the most arresting photographs of the geology and clifftop ruins of 'the best Pompeii in Scotland'.[91]

By the 1840s apocalypse was not only biblical – it was also the stuff of science. In suggesting not just the immeasurable antiquity of the earth but its finitude too in the cosmic scale of things, works like *Vestiges* and *The Old Red Sandstone* gestured both towards the beginning and the

end of the world. The landscape around was not innocent but loaded with ancient significance. It included vast geological 'burial-yard[s]' of fossils 'so ancient that the sepulchres of Thebes and Luxor are but of the present day in comparison'.[92] The spectacular phenomena of geological time might be awe-inspiring but also inhumanly threatening. The St Andrews photographers were the first in the world to fully confront the sublime but also profoundly unsettling power of geology outdoors.[93]

Viewed as a series, the several photographs of the Rock and Spindle now in the collections of Glasgow University Library are stunning. Like the related photographs of St Andrews Castle on its eroding precipice, those of the Rock and Spindle present geology as one of what Tennyson called 'the terrible Muses'.[94] The pictures of the Rock and Spindle are taken from slightly different angles, maximising shadow and moving gradually closer. Repeatedly they show the exposed, apparently shattered circular formation towards the base that looks a bit like a stone bicycle wheel. In one picture the whole formation is photographed from ground-level and to some degree against the light. The effect is overpowering. Funereally dark, the rock tower soars above the viewer and is almost black at the top, as if eclipsing the sun. Showing the enormous power of the non-human, the Adamson photographs of the Rock and Spindle suggest the relentless interrogation of stoniness in Hugh MacDiarmid's poem 'On a Raised Beach'. Dedicated to a celebrated St Andrews resident almost a century later and published in a collection called *Stony Limits*, MacDiarmid's poem speaks of how 'Every stone in the world, | Covers infinite death'. It hints at what the poet, who loved richly arcane vocabulary, calls 'Earth's vast epanadiplosis'.[95] An 'epanadiplosis' is a rhetorical figure which begins and ends with the same word. More than any of the other photographs, the dark close-up of the Rock and Spindle hints how this stone has stood at the time of the viewer's birth and will still stand at the viewer's death. In other pictures from this series we see the tide coming in towards the base of the rock, or left stranded in a big shallow pool. The tides come and go. The rock remains.[96]

On 14 January 1848 Robert Adamson died in St Andrews, perhaps of tuberculosis. He was twenty-six, and had been 'poorly for many months'.[97] David Octavius Hill, who had lost his first wife, Ann

Macdonald, in 1840 after just three years of marriage, felt the loss of his artistic partner keenly. On 18 January 1848 Hill wrote to Noel Paton,

> I have today assisted in consigning to the cold earth all that was earthly of my amiable & affectionate Robert Adamson. He died in the full hope of a blessed resurrection. His truehearted family are mourning sadly especially his brother the Doctor – who has watched him as a child during his long illness. I have seldom seen such a deep & manly sorrow.
>
> Poor Adamson has not left his like in his art of which he was so modest.[98]

Adamson and Hill is a partnership which will be celebrated for as long as photography is valued, and it was Robert Adamson's St Andrews training that was the rock on which the partnership was built. Some years after Robert's death, Hill considered teaming up with John Adamson, but nothing came of it. Instead, John encouraged Thomas Rodger to take up the profession which Robert had followed. Rodger later photographed the Rock and Spindle, bringing to it a sense of calm and balance. Having (like the Adamsons) lost money through his calotyping ventures, Hill moved away from photography for a spell, though later he joined forces with a photographer called Alexander MacGlashan. All lovers of photography revere Hill and Adamson; none reveres Hill and MacGlashan.

After an interval John Adamson returned to his camera later in life, taking measured, sympathetic photographs, not least of the women in his family, and showing on occasion a nice sense of visual humour. Living on in St Andrews, he remained a little-known photographer, for all that he had been a pioneer.

At their best, the pictures the Adamson brothers took in St Andrews still compel the viewer's astonished admiration. They are among the glories of that contemplation of the beginning and the end of the world which was conducted in the small seaside town in the 1840s.

7

Legacies

❧

I N A T I M E L I K E O U R S, filled with talk of climate change and environmental catastrophe, it is not so hard to realise the sort of disturbance that nineteenth-century readers felt when they pondered imposing geological phenomena and when they read books such as *Vestiges*. What shook people was being confronted with consciousness-altering views of their place in creation. First came horror, panic, denial, resentment and misunderstanding; yet early on too came coping strategies, among them scientific ones, which helped sustain and develop a set of values that let people live with the new intellectual challenges. Similar reactions can be sensed today when we try to face up to the treat of global warming. To realise you are perched on the edge of apocalyptic scenarios – pollution of habitats, rising sea levels, population displacements – that will affect not just 'humanity' in general, but your own children, brings everything too close to home. In the nineteenth century, St Andrews was an emblem of the coming together of art and science: first to make manifest a great series of environmental and cosmological marvels and threats, and then to find ways of facing up to them and contemplating them with equanimity or even delight. Today, the Fife town is again up against things: at once on the edge and on edge.

Still guarding its ruins and monuments in the twenty-first century, and still much photographed, this ancient place sometimes likes to think of itself as special, fortunately eccentric, shielded a little from the full brunt of the present day. Yet, like it or not, St Andrews remains a locus for speculation about large-scale historical and environmental shifts. Just as species of birds and moths function as living barometers

for the effects of climate change, so can specific places. Appropriately, the vulnerable seaside burgh which has spoken for centuries of erosion and ruins now speaks insistently of the need for sustainability. Its university, having sustained itself during seven centuries and aiming to go on doing so considerably beyond its official six-hundredth birthday in 2013, has a marked interest in wider questions of environmental change. In the early twenty-first century the university set up the world's first extensively interdisciplinary degree in Sustainable Development, underpinned in part by the earlier work of Christopher Smout, the Historiographer Royal in Scotland, who had established in 1992 in St Andrews the Institute for Environmental History, at that time the only one of its kind in Western Europe.[1] Today, overseen by Professor Jan Bebbington, the St Andrews Sustainability Institute offers core courses such as such as 'Sustainability: ensuring our common future'. Undergraduate students study general issues including 'the history of the concept of sustainable development, environmental protection, international policy agreements, the geopolitics of water use, carbon management and alternative fuels, recycling, global warming, economic growth indicators, and ethics'.[2] Most of them blithely unaware that St Andrews was once the source of a scandalous Victorian book or that it was a remarkable centre for early photography, the Sustainable Development students go on to look in detail at particular case studies in selected areas – both theoretical and practical. Presented in its current form as 'a response to calls for the UN decade for education for sustainable development', the degree programme relates to UN-designated priority areas such as energy and biodiversity, as well as to cross-cutting themes like policy- and decision-making. Contributing departments range from the School of Chemistry (where work on more efficient batteries is being pioneered) to Geography where environmental alteration is charted over millions of years, and Philosophy where questions of 'intergenerational justice' are debated in the context of climate change, exploring, as the St Andrews philosopher Tim Mulgan puts it, 'what are our obligations to these people in the future who are going to be quite likely much worse off than we are'.[3]

All this may sound very far away from Robert Chambers walking across the golf links or John or Robert Adamson lugging a camera and

tripod out on to the rocks around St Andrews Bay. Today the images of coastal geology that startle us most are often satellite photographs; the word 'ecology' had not even entered the English language when Brewster presided at the Lit and Phil. Yet, whether acknowledged or not, the local and international legacies of the circle around the St Andrews Lit and Phil in the early 1840s have been productively long-lasting, and far from the least of these lies in the adaptability of St Andrews itself. If they were suddenly reincarnated in present-day North Street, then the town-planner Playfair, Principal Brewster, Robert and Anne Chambers and the Adamson brothers would very readily recognise much of the town centre and environs. They might be surprised, though, by today's numerous cosmopolitan visitors – golfers and students from America, Europe, China, Japan; and they would be intrigued, surely, by the fact that so many of the university teachers and students are women – for the first time in 600 years, the university has a female principal, Professor Louise Richardson, appointed from Harvard in 2009. Still, Brewster, Playfair and their contemporaries could find their way today without much trouble around the town's main streets and the historic university buildings.

Recently the beautiful King James Library, the room where the Lit and Phil was founded, hosted a visit from the Librarian of Congress, Dr James Billington. Invited to St Andrews by Dr Alice Crawford, he spoke in that historic book room about his vision of a World Digital Library and about the biodiversity of culture and knowledge. Elsewhere, part of the Lit and Phil's diverse collection of biological, zoological, and other specimens remains in St Andrews as part of the Bell Pettigrew Museum. This gallery showcases curiosities, including the fossil fish from Dura Den which bemused investigators and amused Hugh Miller around 1840. After twelve years as curator of this improbable hoard, Pat Willmer, a present-day Biology professor who had developed the natural history legacy of the Lit and Phil into a teaching resource and who had published in such journals as *Ecology* and *Ecological Entomology*, turned her ecologist's eye to the St Andrews University human community and issued an open invitation to colleagues to come and discuss how a sustainability degree might work. From this the St Andrews Sustainability Institute emerged. Its remarkably

interdisciplinary programme has now been seen as a model for other universities, and it would be hard to think of a more exemplary academic achievement, or one more fitted to the ideals of the Lit and Phil when they first set out to establish their museum of natural history.

Other local legacies of Lit and Phil members and their friends are equally important. Just along the road from where Robert Chambers wrote, and a few hundred yards from where Brewster pondered, audiences of five hundred people have gathered in the university's graduation hall to hear some of the world's leading scientists delivering James Gregory Lectures on such topics as 'God and the Big Bang' and 'Global Warming'. Addressing the latter topic, Sir John Houghton, co-chair of the Scientific Assessment for the Intergovernmental Panel on Climate Change, put things simply,

> There have been many definitions of Sustainability. The simplest I know is 'not cheating on our children'; to that may be added, 'not cheating on our neighbours' and 'not cheating on the rest of creation'. In other words, not passing on to our children or any future generation, an Earth that is degraded compared to the one we inherited, and also sharing common resources as necessary with our neighbours in the rest of the world and caring properly for the non-human creation.[4]

These modern Gregory Lectures concentrate on the territory that made Chambers's *Vestiges* so scandalous – the interface between science and religion. Bringing distinguished scientists and theologians together with local people, including schoolchildren, the lectures and ensuing discussions have been made available worldwide through the internet. Accessible to 'town and gown' locally as well as globally, they are the 21st-century equivalent of the St Andrews Lit and Phil, their joint organisers Professor Alan Torrance of the University of St Andrews School of Divinity and Professor Eric Priest of the St Andrews Mathematical Institute.

Awarded the Royal Astronomical Society's Gold Medal in 2009, Professor Priest was described in the citation as 'the world's leading

expert on the magneto-hydrodynamic theory of the Sun'. It is partly through Priest's leadership that other St Andrews scientists have been involved in some remarkable deep-space imaging projects. Showing how young stars can form within the deep and destructive gravity of black holes, Professor Ian Bonnell's work on star formation provides photographs of the beginnings and ends of worlds which are utterly stunning and, like the pictures taken by Hill and Adamson in an earlier century, provoke immediate thoughts about birth, mortality, and transience. Attending to our own planet's surface, Professor Christopher Hawkesworth, like Brewster a Fellow of the Royal Society, has developed physically realistic models for natural processes, tracking evidence for extreme environmental change. Hawkesworth's colleague Bill Austin, a palaeo-oceanographer, charts shifts in the North Atlantic currents and climate over millennia, while elsewhere in the university work has gone on to recalculate the age of the earth, and Dr Christiane Helling is leading a large European Research Council-funded study which examines the importance of dust on climate, travel, and even the ultimate origins of life. Her project draws on astrophysics as well as geology, vulcanology and plasma physics. Often generating stunning visual images, such work makes available the modern cosmological and geological counterparts both of some of the early St Andrews geological calotypes and of Chambers's *Vestiges of the Natural History of Creation*.

Peering at Brewster's microscope and at kaleidoscopes now displayed alongside Major Playfair's archery trophy and other Victorian memorabilia in MUSA (the Museum of the University of St Andrews), daydreaming modern visitors can also enjoy splendid sea views. 'Sleepy' is a word often used of the town but the university, conscious of its blend of setting and intellectual distinction, dislikes being considered 'sleepy'. Tourists come no longer to see a city of the dead; they arrive because the place is easy on the eye. The poet Alastair Reid, who studied in St Andrews and returned to live there for a spell around 1971 when he brought Jorge Luis Borges to visit, has made fun of a Scottish penchant for doom and gloom. In a poem set on the West Sands at St Andrews on a beautifully sunny day he has a woman reacting to the glorious weather simply by saying, 'We'll pay for it, we'll pay for it, we'll pay for it!'[5] It is easy to smile at the way the smashed-up ruins of the

town (a 'Reformation bombsite', as the Australian poet Les Murray memorably styles it) and its Calvinistic-cum-Free-Church legacy encourage dour thoughts.[6] Yet, curiously, aspects of this very legacy of scrutinising ultimate questions, mingling art and science, and staring extinction in the face, are now part of what makes this place such an appropriate location in which to consider our predicament of uncertain sustainability.

Brewster's most important intellectual bequest is to be found not in MUSA but along the road in the modern School of Physics, and in laboratories around the world. Physics at St Andrews has a continuous and distinguished record in optical research which can be traced back to Brewster and his successor William Swan. A cousin of Robert Louis Stevenson, Swan continued Brewster's work on the stereoscope, and in the modern School of Physics optical research remains to the fore. Professor Wilson Sibbett has developed a technique to make titanium sapphire lasers work at ultra-short pulses; Professor Ifor Samuel is a pioneer of unusual light-emitting materials – from clothing to bandages and wallpaper; in 2010 Professors Ulf Leonhardt and Tom Philbin published their study, *Geometry and Light: The Science of Invisibility*, a topic on which they had recently written in *Nature*.[7] Brewster would have been fascinated by the work of his modern St Andrews successors. In common with physicists everywhere, they make use of lasers whose crystals are cut at 'Brewster's angle' – an angle of incidence at which light with a particular polarisation is perfectly transmitted through a surface, without reflection. Nowadays devices all over the planet rely on 'Brewster's angle': it appears that the Victorian scientist's greatest legacy is not to the art of photography but to the now ubiquitous productions of laser physics.

St Andrews is no longer one of the world's key sites for the practice of the photographic art. Yet it remains a place where photography can be studied from unusual angles. A 2010 paper whose lead author is Dr Dhanraj Vishwanath of the School of Psychology explains a recently harnessed photographic technique used by artists and film-makers – 'tilt-shift miniaturisation' – where objects are set in a blurred background in order to make them appear tiny. 'When photographers artificially add blur they trick the visual part of the brain into calculating

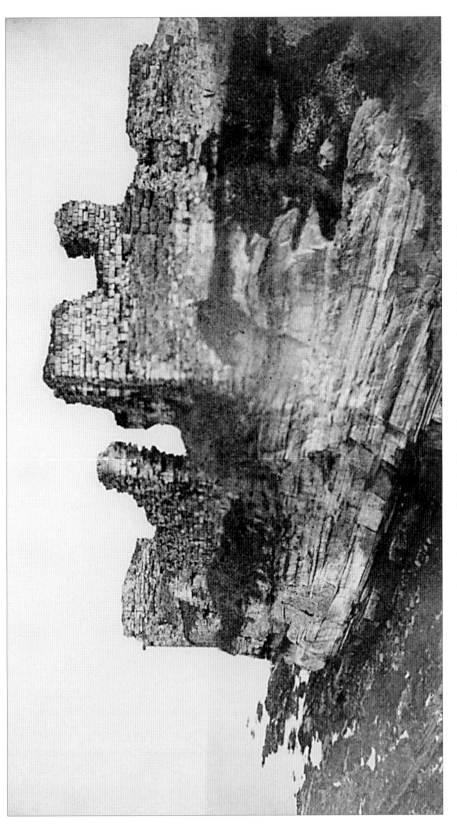

Plate 33: St Andrews Castle, looking along the rock strata of the cliff from The Scores, around 1845, by Robert Adamson with David Octavius Hill; print from calotype negative.

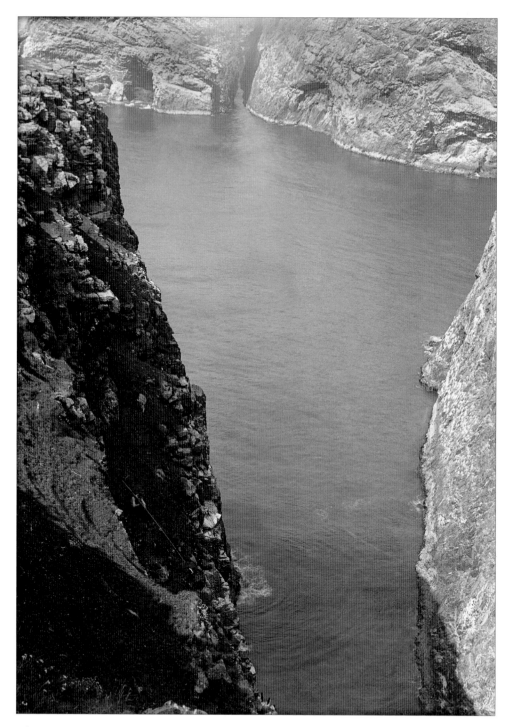

Plate 34: 'C. W. [Charles Waterston] fowling on grassy slope above cliffs and gorge on the west side of Mingulay', 19 June 1905, by Robert Moyes Adam; image from a quarter-plate glass negative.

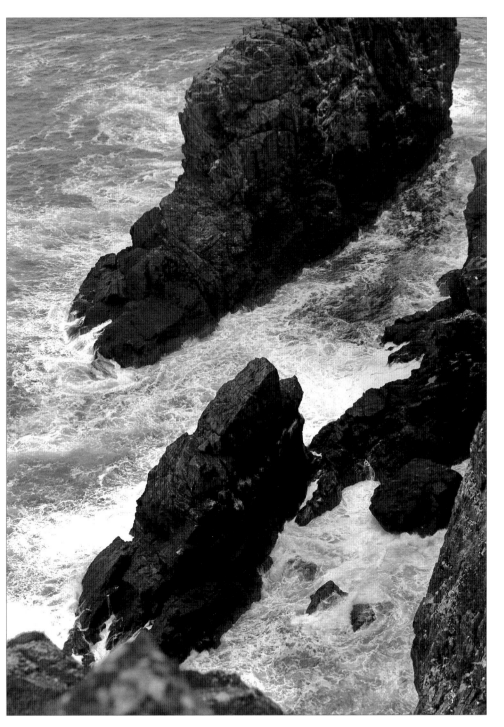

Plate 35: 'Seas breaking at base of Red Boy Stack, Tom a Reithean headland, Mingulay', 28 July 1922, by Robert Moyes Adam; image from quarter-plate glass negative.

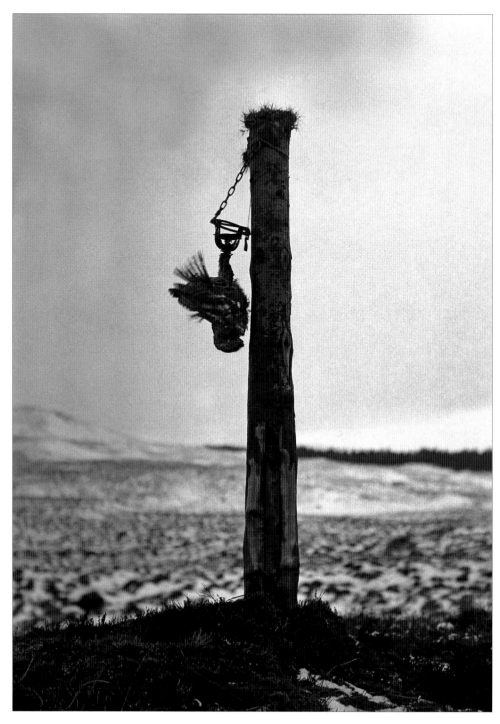

Plate 36: 'Pole trap on hillside behind Forest Lodge, Loch Tulla', 1 January 1907, by Robert Moyes Adam; image from quarter-plate glass negative.

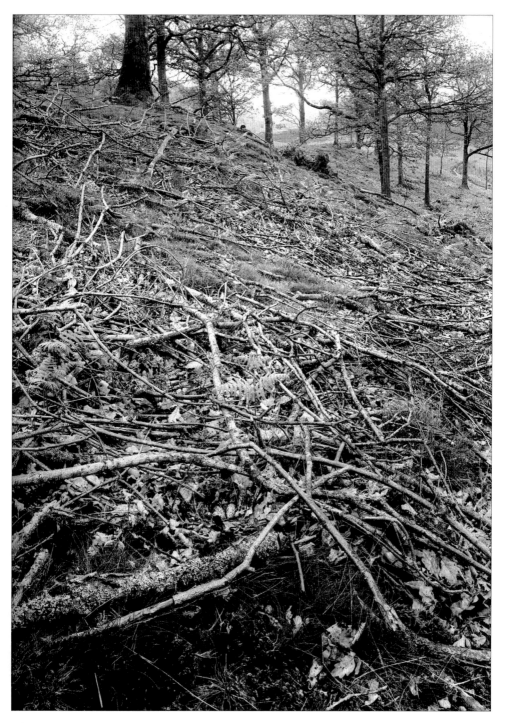

Plate 37: 'Sandpiper's nest with four eggs, among dead leaves and branches in oak copse, near Duchray House, Aberfoyle', 12 June 1909, by Robert Moyes Adam; image from half-plate glass negative.

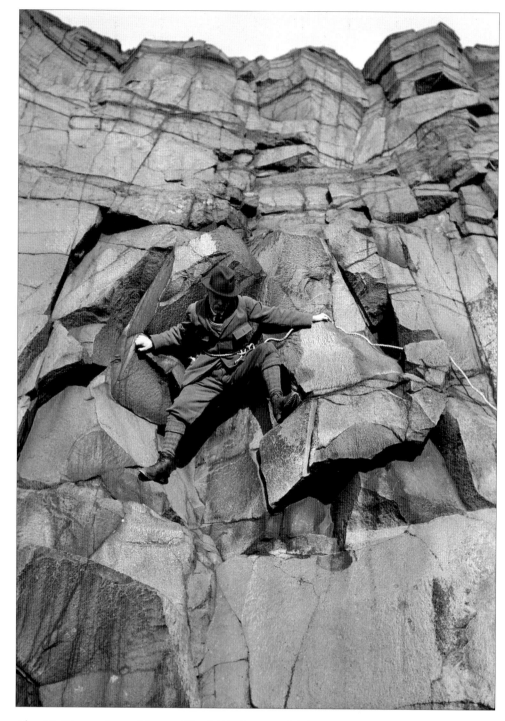

Plate 38: 'Descending a chimney, Harold Raeburn on Salisbury Crags, Edinburgh', February 1920, by Robert Moyes Adam; image from 5x4-inch glass negative.

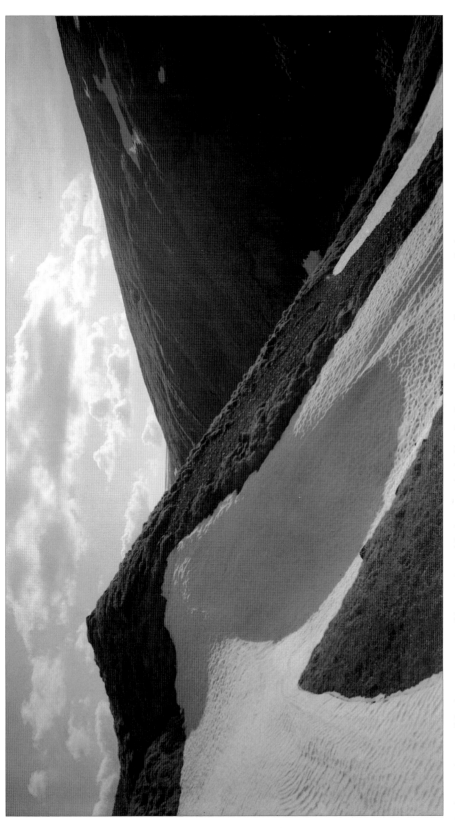

Plate 39: 'Monadhliath Mountains, Abhainn Cro Chlach, six and a half miles from Dalbeg, Findhorn source', 4 May 1953, by Robert Moyes Adam; image from half-plate glass negative.

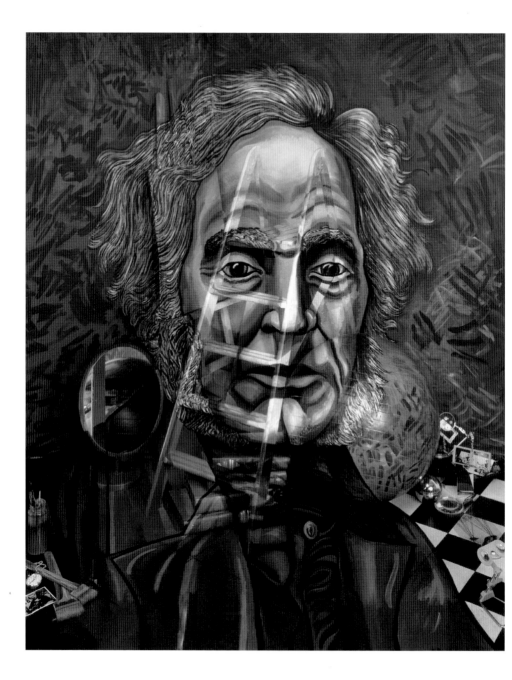

Plate 40: Sir David Brewster by Calum Colvin, one of the collaged and photographed images from Colvin's 2009 exhibition of stereoscopic portraits, *Natural Magic*. A print of the Brewster image is now owned by the University of St Andrews.

that the objects in the picture are close up.' Dr Vishwanath shows how this 'forces you to see' the subject of the photograph 'closer and smaller like a toy'.[8] To illustrate this first piece of empirical research to report an important link between retinal blur and the perception of space and distance, Dr Vishwanath modified an aerial photograph of part of St Salvator's quadrangle buildings, the construction of whose north range in 1845–6 was overseen by Sir David Brewster, who would have enjoyed Vishwanath's research.

In recent decades, the University of St Andrews has tended to live financially, as in other ways, on the brink. There has not been money to make large-scale purchases to augment the photographic collections. Nevertheless, because of a growing awareness of the importance of St Andrews in the development of photography, and particularly Scottish photography, librarians and curators over the years have made efforts to attract work which builds on the early collections, particularly in the area of environmental photography and the recording of Scottish places and communities. This is one of the legacies of Brewster's work in St Andrews: that in the field of photography he and his circle gave the place a magnetic allure which has allowed it to go on gathering pictures for its archive. Now containing almost 750,000 images, the collections of photography in St Andrews are by far the largest in Scotland, and surely deserve to have a substantial gallery devoted to their exhibition. For many years there have been wrangles in Edinburgh about where a Scottish National Gallery of Photography might be established. Several plans have fallen through. It might make good sense to have a distributed Scottish national collection of photography, with a Museum of Early Photography located in St Andrews and enjoying extensive digital outreach.

The St Andrews photography collections extend from anatomical images by Edward Muybridge to pioneering pictures of South-East Asia, but many have some local connection. The holdings of published 1860s photographs of the now fast-eroding environments at Angkor Wat are by a photographer – John Thomson – with known St Andrews links. Photographic historian Richard Ovenden has pointed out that Thomson trained as an optician in Edinburgh, attending the Edinburgh School of Arts, one of whose directors was Brewster; the young

Thomson was also photographed in St Andrews (quite probably by Thomas Rodger) in the uniform of the Fife Volunteers.[9] As befits the collection's local origins, there are many later images of Fife and especially of St Andrews in the photographic holdings of the University Library. It is in topographical pictures, whether taken by the Dundee commercial company of Valentine or by modern photographers, that the collection is richest. Many of these pictures are simply factual records of places, but others are 'environmental' in a more profound sense, one very much in keeping with the work of the early St Andrews photographers.

Robert Smart, the now-retired Gaelic-speaking Keeper of the University Library's Special Collections is a shrewd, quietly spoken man used to operating largely below the radar of university politicians. Smart was substantially responsible for bringing to St Andrews the archive of the little-known environmental photographer Robert Moyes Adam. Adam's work is just beginning to attract attention, and is seldom discussed outside Scotland. In style and quality the best of it is fruitfully consonant with the legacy of the early St Andrews photographers. If we can read some of the early Adamson pictures of St Andrews in terms of geological time and erosion, these themes are also present at times in Adam's images, but have a more immediately evident link to such topics as environmentalism. Tom Normand, the contemporary St Andrews art historian who produced the first full-scale history of Scottish photography, sees Adam as 'perhaps, one of the first photographers to consciously document the environment from the point of view of an environmentalist', and argues he 'attempted to be the conscience of nature in the modern world'.[10] As global interest in sustainability grows, the best of Adam's work holds its own in international company. Recently Adam's work has proved valuable to ecological science, but it matters most as one of the artistic treasures of the St Andrews Photographic Archive – now curated by Marc Boulay.

Born in 1885, Robert Moyes Adam was the son of a Congregational minister. He studied science at Edinburgh's Heriot Watt College, then drawing at Edinburgh College of Art, and Botany at Edinburgh University. Adam bought his first camera at the age of fourteen. Four years later he got a job as an assistant gardener at the Royal Botanic

Gardens in Edinburgh, though his main work was helping prepare lecture drawings for the Professor of Botany; later reclassified as a 'botanist', he went on to be in charge of the Botanic Gardens' studio, taking botanical photographs for his work (he retired in 1949), and making excursions across Scotland in his spare time and after retirement, photographing mountainous landscapes.[11] Though a good many of Adam's pictures are workmanlike commercial and educational products, his best photographs, like good poetry, show a minute attentiveness and a developed sense of pattern: an artistic vision attuned to the environmentally fragile.

Imaging much of his country, from St Andrews to the outer isles, Adam was at heart a photographer of flowers and of rural Scotland. At the age of twenty, in 1905, he took his camera on an expedition to the Outer Hebridean island of Mingulay, a place so remote that it came to be regarded as unsustainable and its population was evacuated three years later. Documenting the people and landscape of this community, Adam produced some remarkable pictures which combine a sensitive appreciation of a way of life facing extinction and a sense of monumental landscape, especially rockscape. Here again is an art on the edge – both physically and in terms of its awareness of a world that was ending. A magnificent photograph, taken on 19 June 1905, shows Adam's friend Charles Waterston with a fowling pole (a tool used to stun nesting sea-birds prior to harvesting them) on a 'grassy slope above cliffs and gorge on the west side of Mingulay'.[12] This vertiginous picture looks through a triangular void between cliffs at a calm expanse of sea hundreds of feet below. Craggily framing the water are a dark cliff on the left, with pale, sunlit cliffs to the right and along the top of the exposure. It takes a keen eye to realise that there is a human being in the shot, reclining on a grassy patch far down the dark cliff-face on the left, and holding a long pole. In its historical context, this man on the brink symbolises the Mingulay community, itself on the brink of extinction. Yet the figure also has a peculiarly relaxed, even sporting dignity. If he lends scale to the picture, he does so almost comically, reduced to near insignificance by the surrounding sublimities of nature.

Adam's early Mingulay pictures were taken before the earliest work of Ansel Adams (who was aged three when Adam visited Mingulay in

1905), and it is not clear that Adam ever came to see any of the great American photographer's work; however, it is with the oeuvre of Adams that some of R. M. Adam's finest photographs may be compared – works such as his dramatic 1922 image of 'Seas breaking at base of Red Boy Stack, Tom a Reithean headland, Mingulay'. The Scottish photographer evolved his own very fine sense of wild slopes, dramatic lights and darks, and of the monumentality as well as the fragility of nature that makes his photography hauntingly valuable. As one might expect of a trained botanist, Adam photographs minutiae with distinction; with his environmentalist's gaze he also shows just how and where these minutiae are situated in the landscape. One of his many, many photographs of birds' nests, a 12 June 1909 half-plate glass negative of 'Sandpiper's nest with four eggs, among dead leaves and branches in oak copse, near Duchray House, Aberfoyle', is mainly composed of a latticework of twigs and branches lying on a dramatically tilted grassy slope with mature trees on the horizon. The picture shows the weave of nature itself, of which nest and eggs are part.[13]

It is very tempting to use words like 'patient' and 'loving' to describe Adam's camerawork. Though he took many landscape shots of a conventional, even pedestrian, nature, it is his very pedestrianism, his willingness to walk and get close to the landscape, which produces some of his finest pictures. He comes measurably close to nature as his lens peers down into a nest, or over a precipitous cliff edge. Like Adamson on the beach at St Andrews in the preceding century, Adam has a keen awareness of the drama of rock, and of how rock formations can seem to challenge our sense of humanity. One of his most arresting photographs shows a hatted climber dangerously negotiating his way down a cliff, facing the camera and awkwardly splayed against the rock face; in other pictures, like the one of an old woman and her cat beside the window frame of her thick-walled Hebridean cottage, stone speaks of mortality in dialogue with a human presence.[14] Used to being attached to a rope as he clambered down cliff-faces with his camera, Adam's sense of mortality was keen, not least when it came to the natural environment. If his pictures of gannet colonies on steep rock-faces teem with life, then one of the most gauntly stunning natural history photographs ever taken is his image of a bird of prey dangling

upside down at the end of a metal chain as it hangs caught in a 'pole trap on hillside behind Forest Lodge, Loch Tulla'.[15]

Adam's most potent photographs combine lyricism with a documentary quality. It is easy to read into them a sense of spirituality. In 2008 I met an old lady called Margaret Street who recalled several times encountering R. M. Adam in Edinburgh when, after coming back from the kirk on a Sunday morning, he was taking sherry with his friends John Anthony (author of *The Flora of Sutherland*) and Jenny Anthony who was, Margaret Street pointed out to me, the sister of the pioneer of documentary film-making, John Grierson. Adam's network of photographic contacts may have been slight, but it was significant; his relatively rare photographs of men at work, such as the 1931 'Landing the Herring Catch at Mallaig Harbour pier, drifters moored alongside wharf' may be set beside the images of Grierson's much better known 1929 film about the herring industry, *Drifters*.[16] Yet the ability to capture the spirit of place in a single still image – the photographic spirituality of the pictures, if you like – sets Adam's best work apart.

His images can have a powerful resonance, as in the memorable photograph of 'Ionic cross, Sound of Mull' where Adam has combined a shot of the tall, bare, upright Celtic cross with the dramatic sky from another photograph to enhance the power of the picture. When one realises that the photograph is taken in 1919, it is very tempting to read it as the human counterpart to the gaunt wooden pole from which hangs the dead bird – and as an elegy for the dead in World War I. In the St Andrews University Library collection such powerful pictures hold their own when set beside the remarkable photographs of the Rock and Spindle or the cliffs of St Andrews Castle taken about eighty years earlier. It is in part because Brewster and his circle were so engaged in photographing their own environment in St Andrews that later gatherings of photography such as the environmental work of R. M. Adam have come to be added.

Yet, however starkly elegiac at times, and however alert to the degradation of habitat, Adam's work has not functioned as an endpoint as far as environmental work from St Andrews is concerned. Instead, like the work of the early photographers, it has served as a stimulus. In an interesting development, the contemporary St Andrews

botanist, my near-namesake Professor Robert M. M. Crawford, has made scientifically imaginative use of Adam's photography in his own work on climate change and sustainability. So the St Andrews photographic legacy of which Adam's work is now a distinguished part helps nourish ways in which we come to terms today with the word 'sustainability'. Revisiting the site of an Adam photograph of sand dunes on a beach on the Outer Hebridean island of Vatersay, R. M. M. Crawford re-photographed the scene eighty years later for his book on *Plants at the Margin: Ecological Limits and Climate Change* (2008), a global survey of its subject. Crawford concludes that on Vatersay 'Despite evidence of continuing erosion activity there has been no significant retreat of the position of the dunes' and that 'Cycles of erosion and regeneration appear to be operating.'[17] An internationally distinguished botanist, Crawford is also an enthusiastic landscape photographer and has found the work of the photographer-botanist Adam inspirational. Crawford recognises in Adam a photographer with a keen sense of environment, and finds it 'fascinating . . . to revisit quite a number of his sites', using Adam's photographic data in several studies of environmental change.[18]

R. M. M. Crawford was one of the scientists who participated in a project which I organised around the turn of the millennium, inspired in part by the example of the Lit and Phil where scientists and poets were at one. Entitled *Contemporary Poetry and Contemporary Science*, the project was published by Oxford University Press in 2006. It brought together an international grouping of poets and scientists and it saw two 21st-century St Andrews professors – the poet John Burnside and R. M. M. Crawford – meeting to discuss their work. As a result of this collaboration, John wrote an essay and a poem and Bob responded to the poem. John's essay, which begins in the Fife landscape a little south of St Andrews, develops into a manifesto piece:

As a poet, I want to suggest the importance of those elements of life that have hitherto been considered minor, commonplace, even trivial. The beauty of the real, as opposed to the virtual. The starlit darkness of the actual night, the salt and physicality and achieved grace of real bodies, the pleasure of walking as opposed to driving. A

view of identity that sets terrain and habitat before tribal allegiances, the integrity of place before the idea of nation or state, the pagan calendar before the atomic clock. A philosophy of dwelling that includes all things, living and non-living, and informed by the philosophy of *ahimsa*, of doing, if not no harm, then the absolute minimum of harm. At the beginning of a new century, I am interested in finding what Heidegger called a new way of thinking, and to propose that art contributes, in subtle but cumulative ways, to the examined life.[19]

Perhaps at times John Burnside can come over as rather messianic in tone – a lot of other poets have noticed the starlit darkness of actual nights. Yet when he concludes with a wish for 'poetry as ecology, ecology as poetry', and urges the reader of his essay to 'Imagine a science of belonging', then he articulates something strong in contemporary thought. In Burnside's poem 'History', in his novel *Glister* and elsewhere these thoughts and intuitions are articulated with finer artistic resonance. When R. M. M. Crawford gave Burnside a photograph of a recreation of a long-abandoned Icelandic settlement, John produced in his poem 'Steinar Undir Steinahlithum' images of 'a failure in the science of belonging, | an aberration, fading on the air', and Bob, pondering his own photograph and environmental changes such as volcanic eruptions which have affected communities 'all the way from Iceland to the Hebrides', responded to John's poetic eloquence at the same time as musing on death:

> Finding a human settlement, dead but not yet buried, is comparable to discovering an uninterred corpse. [. . .]
>
> A people whose population has so often risen, then plunged to the verge of extinction and back, does not readily disappear. These folk may at times have 'trailed through the mist | to try their luck elsewhere', but they still survive. I find Burnside's poem intensely sympathetic as it conjures their hardness and tenacity to the land with their farms, perched between the mountains and the sea – an awe-inspiring model of human resourcefulness and courage in maintaining a light in the darkness of the boreal night.[20]

In the early twenty-first century the art form practised with most distinction in St Andrews is not photography but poetry. Though there is no direct connection between poetry and photography, both thrive on resonant images which move their audience. Roland Barthes compared photographs to haiku, while Walter Benjamin, confronted by a Hill and Adamson calotype of a Scottish fishwife, was moved to quote verses by Stefan George.[21] Strikingly, just as the photography of early St Andrews came to carry a strong environmental resonance, and speaks of those intellectual concerns about the beginning and the end of the world which Chambers's *Vestiges* highlighted, so now the poetry most closely connected with St Andrews is at once locally rooted and inflected according to our own sometimes apocalyptic global concerns. Opposite the castle which the early photographers so liked to photograph in the 1840s stands the later Castle House, a seafront stone mansion of the late nineteenth century, whose modern soubriquet, 'The Poetry House', might confirm visitors' intuitions about St Andrews as dreamily eccentric and unworldly. Yet the Poetry House is now a focal point for its art form, and forms part of the university's School of English where poets John Burnside, Douglas Dunn, Kathleen Jamie, Don Paterson, and the present writer have worked for over a decade. Douglas has now retired, and Kathleen has moved recently to a chair elsewhere, but another poet, Jacob Polley (author of *The Brink*), arrived in 2010, helping ensure that the community of St Andrews poets remains exceptional. For decades the town has hosted Scotland's international poetry festival, StAnza, organised by local people. Poetry in St Andrews does not belong to the university but is a town-and-gown activity, very much in the spirit of the original Lit and Phil.

I remember encountering John Burnside in Market Street around the time he published his novel *Glister* in 2008. He told me it was set in a place that was a nightmare version of St Andrews. Reading the book, I found that idea odd: the fictional town seemed much more like an industrial site, but John's remark stuck in my mind. *Glister* presents a coastal community dominated by ruins, but these are not the remains of a castle or cathedral but of abandoned ships and 'the ruins of the old chemical plant' from which materials have long since leaked into a local environment 'irredeemably soured, poisoned by years of run-off and

soakaway from the plant'. Fishermen find 'mutant sea creatures washed up on the shore' near this 'town that remembers its dead, a town where everyone remembers together, guarding their ancestors in their ancient solitude'.[22] An apocalyptic imagining, *Glister* speculates that its town needs to 'pull everything down and start over', to achieve both a decisive ending and a new beginning.

John Burnside thinks a lot about such issues in the context of environmentalism. I used to notice copies of *The Ecologist* magazine each time I passed his office window, and he has co-edited an anthology, *Wild Reckoning*, in commemoration of the pioneering environmental activist Rachel Carson. *Glister* is a poetically structured novel which includes a mysterious figure – the Moth Man – who 'can *read* the landscape' and who (in what is perhaps an unconscious echo of Brewster's title) understands 'little pieces of natural magic'. In the end, this figure, glimpsed as 'The angel of death', perpetrates a strange killing which may also mark a new start. What happens seems designed to shock Burnside's protagonists and his readers into a realisation that they have to face up to what is going on around them, however they want to blank it out. As his narrator puts it, they need to move beyond

an offence the whole town has been mired in for decades: the sin of omission, the sin of averting our gaze and not seeing what was going on right in front of our eyes. The sin of not wanting to know; the sin of knowing everything and not doing anything about it. The sin of knowing things on paper but refusing to know them in our hearts. Everybody knows *that* sin. All you have to do is switch on the TV and watch the news. I'm not saying we should try to help the people in Somalia, or stop the devastation of the rainforests, it's just that we don't feel anything at all other than a mild sense of discomfort or embarrassment when we see the broken trees and the mudslides, or the child amputees in the field hospitals – and it's unforgivable that we go on with our lives when these things are happening somewhere. It's *unforgivable*. When you see that, everything ought to change.[23]

Glister's sense of a chemically poisoned coastal landscape which prompts a realisation that a whole way of life must change is eerily

similar to the fears of John's St Andrews colleague Meaghan Delahunt whose 2008 novel *The Red Book* is set in the aftermath of the chemical-plant disaster at Bhopal in India. Burnside's prose is often bleak, even apparently despairing. He writes with what can seem a convert's fervour. As a person who worked in the computer industry for some years as a 'knowledge engineer' his poetry and fiction are powered not least by the convictions of someone who has realised that the screen world, the virtual world must never be allowed to blind us to the physical world of the planet. In an age when our jobs, our televisions, and giant corporations all seem to be encouraging us to migrate from an older 'real' world towards a virtual zone, a second life without taste or smell, Burnside's prose reminds us of the stink, but also the environmental delicacy of a real world too easily blanked out in the midst of our screen-dominated culture.

Maybe that is one of the functions of poets in our era. It is certainly something that all the poets who have taught recently at St Andrews deal with in their work. Kathleen Jamie has a liking for the sort of place that 're-calibrates your sense of time' and makes people face up to big, uneasy questions. Her prose book, *Findings*, is full of fine observation of the natural world, but its phrasing – as when she mentions 'sparrows – what few sparrows are left' – is attuned to the worries of the twenty-first century. She notes that 'one beach in New Zealand already has plastic sand – 100,000 grains to every square metre'; and she wonders, 'if it's still possible to value that which endures, if durability is still a virtue, when we have invented plastic, and the doll's head with her tufts of hair and rolling eyes may well persist after our own have cleaned back down to bone'. Deftly and attentively, *Findings* presents small local interactions with nature, from looking for a corncrake in a field to visiting an ancient Orkney tomb, but in so doing the book also confronts much larger questions:

> They say the day is coming – it may already be here – when there will be no wild creatures. That is, when no species on the planet will be able to further itself without reference or negotiation with us. When our intervention or restraint will be a factor in their continued existence.[24]

For Jamie, for whom watching whales can be 'like a kind of theology', this is an important issue, and it is one equally pertinent to her colleagues at the Scottish Oceans Institute, just a few hundred yards along the coast from the Poetry House. These colleagues use a substance like Velcro to attach satellite-tracking devices to seals and other marine creatures, so that they can follow and understand their movements through the seas. By so doing, they hope to increase scientific knowledge, but also to help conserve seal populations, and again to examine creatures which may act as barometers, helping us sense the effects of climate change. Now sold around the world, the tracking system developed in St Andrews allows Antarctic seals to send back oceanographic data about water temperatures, currents, and wind-speeds. So the scientists in Fife have become co-workers with 'elephant seals with attitude' as Professor Dave Paterson, the Head of Biology, puts it.

Other biologists such as Professor Anne Magurran use the Oceans Institute as a base for their worldwide work on the conservation of biological diversity. Magurran's pioneering books *Ecological Diversity and its Measurement* (1988) and *Measuring Biological Diversity* (2004) are indications that, though her specialist research is on fish species in the Caribbean and Central America, her project has global implications. She has a long-standing interest in the structuring of what she calls 'ecological assemblages'. When Kathleen Jamie writes admiringly of poetry that has a 'dense web wherein no sound is left alone and unsupported, unless for good reason', and states that this poetry's verbal 'music enacts the ecology it describes, it's the soundscape of an interconnected, secure community', she locates in language something which the 'findings' of Anne Magurran articulate scientifically through the study of 'ecological assemblages' of marine creatures.[25] Jamie may be speaking metaphorically, but metaphor is vital to poetry and the distance between the Poetry House and the Scottish Oceans Institute with its affiliate the Centre for Research into Ecological and Environmental Modelling is not as great as one might think. Here nothing is ever very far from anything else.

Jamie's poem 'The Puddle' was once published as a card by the Poetry House, and carried the subtitle 'St Andrews'. I know, because I asked her, that the poem's images come from some playing fields on the way

into St Andrews from the north, fields which often flood and are close
to the golf links. In Jamie's collection, *The Tree House*, however, the
same poem carries no St Andrews subtitle. The poet deliberately got rid
of specific place-names, letting her poems speak all the more eloquently
of the whole earth and our place on it – wherever and whoever we may
be. Using beautifully accurate marine imagery, 'The Puddle' presents
scenes where 'curlews | insert like thermometers | their elegant bills'. It
is constituted, like Jamie's prose, by precise, but also intensely felt,
observation. Just as *Findings* engages with sustainability, mortality, and
the natural world, so this poem in its conclusion does not shirk difficult
questions:

> Is it written
> that we with a few
> years left, God willing,
> must stake our souls
> upright within us
> as the grey-hackled heron
> by a pond's rim,
> constantly forbidding
> the setting winter sun
> to scald us beautifully,
> ruby and carnelian?
> Flooded fields, all pulling
> the same lustrous trick,
> that flush in the world's light
> as though with sudden love –
> how should we live?[26]

Thinking about how to live is still a question St Andrews provokes, if
only because it has been so manifestly lived in for many centuries; the
present here must always accommodate the past. While in the 1840s
St Andrews as a city of the dead helped shape the work of the early
photographers, and while some of their most remarkable photographs
and theoretical writings about photography confronted time, endur-
ance, death and resilience, today poetry is the local art-form that most

insistently faces up to such issues. John Burnside's poem 'History', which carries the subtitle 'St Andrews: West Sands; September 2001', engages with one of the most dramatic reminders of mortality so far afforded by the twenty-first century, the attack on the World Trade Center in New York. Yet, set entirely in modern-day St Andrews where kites are being flown on the long sandy beach and where the nearby Royal Air Force base produces 'that gasoline smell from Leuchars gusting across | the golf links', the poem nowhere mentions New York or the World Trade Center. Instead, fearful and alert, its speaker kneels in the sand, gathering shells with his son Lucas. It is, though, far from a poem of escapism. Rather, the poet uses the local environment and his reflections on it to face up to the shock of the destruction of the twin towers, and larger anxieties that go beyond terrorism to potential environmental catastrophe.

> Sometimes I am dizzy with the fear
> of losing everything – the sea, the sky,
> all living creatures, forests, estuaries:
> we trade so much to know the virtual
> we scarcely register the drift and tug
> of other bodies
> scarcely apprehend
> the moment as it happens: shifts of light
> and weather
> and the quiet, local forms
> of history: the fish lodged in the tide
> beyond the sands;
> the long insomnia
> of ornamental carp in public parks
> captive and bright
> and hung in their own
> slow-burning
> transitive gold;
> jamjars of spawn
> and sticklebacks
> or goldfish carried home

from fairgrounds
 to the hum of radio
but this is the problem: how to be alive
in all this gazed-upon and cherished world
and do no harm[27]

John Burnside's 'History' is a very locally rooted poem, yet one just as utterly aware of global preoccupations as are the academics at work in the Centre for the Study of Terrorism and Political Violence situated on the Scores a few hundred yards from John's office, or the scientists of the Scottish Oceans Institute. It may not be a good thing to think about death too much, but it is far more dangerous and evasive not to. When poets, scientists or theologians confront death, they are also asking simple, difficult questions about the meaning of life.

It could be said that the issues now facing humanity and the planet are of a far greater magnitude than were the Victorian concerns about cosmology or theology. Yet one should not underestimate how unsettling those anxieties were in the mid nineteenth century, or how heated the arguments around them became. If we can see that the new art of photography as well as kinds of science and imaginative writing all came together to address and articulate such challenges, then that may at least suggest that a similar confluence of kinds of imagination and knowledge is keenly required today.

Though it is only one small site, St Andrews remains a good location for reflections and activities of this sort. When I moved there over twenty years ago, I was partly attracted to the place because its history had already inspired me to write poems in my first collection, *A Scottish Assembly*, with such titles as 'Sir David Brewster invents the Kaleidoscope'. Two decades on, as oystercatchers still flit close to the edge of the waves, I have come to value all the more its odd combination of marginality with intellectual and imaginative centeredness.

I love how it comes right out of the blue
North Sea edge, sunstruck with oystercatchers.
A bullseye centred at the outer reaches,
A haar of kirks, one inch in front of beyond.[28]

Sometimes my own poetry has engaged with technologies and with minority languages as metaphors for biodiversity, but it is hard to live or work beside the sea without being influenced in perhaps subtler ways. Just as they did in the era of Hill and Adamson, so today interactions between tides and rock provoke much wider speculations on beginning and ending, shaping and reshaping, durability and change. Having spent a good deal of my working life in top-storey, seafront offices in the university's School of English looking out over St Andrews Castle to the North Sea beyond, I fear I have too little to show for this. Only rarely have I managed to articulate something of the need for attunement with natural processes which lies deep in many people and which the ebb and flow of tides can bring out:

> Fast in the tides' flow
> Each day rough boulders, rounding,
> Wear away oceans.

> Oceans wear away
> Boulders each rough day, rounding,
> In the tides' fast flow.[29]

One of the things poems can try to do is express a sense of at-one-ness with the rhythms of the wider cosmos. Like photographs, poems catch this only momentarily, providing an aperture into a special way of looking and (since, unlike photographs, poems use language) of listening. This may seem very little to accomplish, but in an age which has often seemed determined to turn away from the rhythms of nature, it may be important to attempt.

In his book *The Song of the Earth* the literary critic Jonathan Bate presents poems as if, at their best, they are little, well-formed verbal ecosystems, their sounds and forms attuned to one another, harmoniously functioning; in this way the good poem might be seen as a model of the good world. Yale University Press has even published a recent book about poetry and ecology called *Can Poetry Save the Earth?* That volume's author, John Felstiner, asks idealistically,

If poems touch our full humanness, can they quicken awareness and bolster respect for this ravaged resilient earth we live on?

Can poems help, when the times demand environmental science and history, government leadership, corporate and consumer moderation, nonprofit activism, local initiatives? Why call on the pleasures of poetry, when the time has come for an all-out response?

Response starts with individuals, it's individual persons that poems are spoken by and spoken to. One by one, the will to act may rise within us. Because we are what the beauty and force of poems reach toward, we've a chance to recognize and lighten our footprint in a world where all of nature matters vitally.[30]

This sounds very idealistic, but sometimes nothing is more necessary than idealism. If we lack the idealism sounded by poets and harnessed by scientists, then it is unlikely we will be effective in solving the problems of climate change and environmental pollution that now beset our civilisation and our planet.

Poetry, however, does not exist to save the planet any more than photography does. Like photography it is a medium in its own right. Yet one can never predict the uses to which it may be put. Just as a few decades ago, it might have appeared insane even to ask the question 'can poetry save the earth?', so it might have seemed very eccentric to suggest in earlier eras of photography that the medium itself, or the archives in which it has been collected, might be environmentally valuable. Today, however, there are both considerable bodies of photography and of poetry linked to ecological concerns, and a growing amount of critical writing which theorises the work in terms of ecological awareness. Many people wish to find the best way, as the St Andrews poet and professor Don Paterson puts it at the end of one of the versions of Rilke that make up his *Orpheus*, to 'be true | and hear the Earth, to sing of what she sings'.[31] Recently awarded the Queen's Gold Medal for Poetry, Paterson is a celebrated poet, but his celebrity has neither curbed his bleak Dundonian girn nor distracted him from his deep commitment to the art form of poetry, attempting to tune in ever more attentively to 'the Earth, to sing of what she sings'.[32] I hope that the ecologically attuned poetry now emanating from St Andrews matters because its ear

and craftsmanship allow it to articulate powerfully and distinctively the sense of connection most people feel to an imperilled natural world. Such a sense sets this poetry subtly apart from earlier Romantic 'nature poetry' in general, though so-called 'eco-poetry' certainly has a root in Romantic verse. Probably it was Robert Burns in 'To a Mouse' who first clearly articulated our sense of endangered environment: 'I'm truly sorry Man's dominion | Has broken Nature's social union'.[33] Today such sentiments may be commonplace, but few clusters of poets revoice them more acutely than the poets associated with the Poetry House.

In St Andrews these voices were consciously assembled. When I arrived at the university in 1989 the poet Douglas Dunn was a writer in residence and wanted to stay on. I wrote to the then university principal, Struther Arnott, saying I thought he could do nothing better for the English Department than appoint Douglas to a permanent post – which happened a year later. Dunn is most celebrated as the author of a 1985 collection of poems, *Elegies*. Written in memory of his first wife, that book won the Whitbread Prize, one of Britain's major literary awards, and was compared by reviewers to Tennyson's *In Memoriam* as well as to Thomas Hardy's greatest elegiac love poems. Its heartfelt, deft and tactful drafts now in the University Library's extensive Dunn archive, *Elegies* is a great book which faces up to death, grief, and mourning. Like Douglas's other work, it also has in it a deep sense of 'Land Love' and alertness to the earth:

> Dusk is a listening, a whispered grace
> Voiced on a bank, a time that is all ears
> For the snapped twig, the strange wind on your face.[34]

For all that he worked like a Trojan and (as poets must) sometimes chafed against the constraints of academia, Dunn, whose time at St Andrews saw him become the director of Scotland's first university degree in creative writing, was probably attracted to the Fife town in part as a place of contemplation. 'Only in St Andrews' is the title of one of his recent poems. As do many people, he relishes the place's specialness.

Later, when I was involved in recruiting John Burnside, Meaghan Delahunt, Kathleen Jamie and Don Paterson to the university, its

location, history and character as well as its writerliness helped attract them. Sometimes a place seems to play a part in calling people to itself; or, more accurately perhaps, once a pattern has been established it becomes easier to develop. If this has happened in the case of poetry here, not least poetry particularly attuned to our relations with the natural environment, then in some ways this is similar to what happened with photography. Just as in the nineteenth century it was a coming together of scientific and artistic impulses which resulted in the significant work produced in 1840s St Andrews, so today we need to realise that neither science nor art alone can equip us fully to come to terms with the challenges we face. As if to emblematise this, there are ambitions to turn the seafront St Andrews house where Robert Chambers lived towards the end of his life into an Institute for Advanced Study, a place where academics from the humanities, social sciences, sciences and divinity can meet with members of the general public and visitors from other universities to discuss major issues such as sustainable development. This commitment to multidisciplinary discussion, making use of the home of the polymathic Chambers, is yet another legacy of Victorian St Andrews, one fitted to the twenty-first century.

Whereas the students in Victorian St Andrews were predominantly Scottish, the university is now very much international in orientation. It draws students from over a hundred countries; about a third of the undergraduates come from Scotland. As early as 1966 St Andrews determined to become 'Scotland's International University'. While today the Scottish-international character of the university and the town are, like an intense interest in sustainable development, a strength of the place, they also present a challenge. In some ways this is a national challenge: can St Andrews – or Scotland as a whole – develop its distinctive identity in an era of globalisation while staying to some extent an international player, or will it have to be content with having as its image that of a quirky, flavoursome colonial outpost, an outlying offshoot of larger cultures elsewhere? If there are political and economic challenges facing St Andrews, there are also environmental ones. The students who come from all over the world – whether to study English or Classics, Philosophy or Physics, Theology, Computer Science or

Sustainable Development – are responsible for a considerable carbon footprint. Contradictions and paradoxes in the nature of the university have not yet been solved, any more than they have in the wider world, but at least St Andrews is very aware of them. Prefacing a book by St Andrews geographer Charles Warren, the historian T. C. Smout stated in 2001 that 'The way we treat the environment has become an inescapable central problem of life', and worried that 'The issues demand the long-term vision that politicians no longer seem to possess.'[35]

In the face of failures of long-term political vision, a common solution is for individuals and institutions to 'act local, think global'. Working beside the East Sands, Professor Andrew Brierley of the Scottish Oceans Institute attempts to understand the abundance and distribution of tiny creatures inhabiting the oceans – zooplankton. Using acoustic technology to examine echoes bounced back from these organisms, he and his research group construct a detailed account of how zooplankton populations and distribution are altering, and calculate the consequences of this for other species – particularly fish – which feed on them. Brierley is a member of the St Andrews Centre for Research into Ecological and Environmental Modelling, but his work has repercussions that extend far beyond north-east Fife. Collaborating with Michael Kingsford of Australia's James Cook University, he published in the journal *Current Biology* an alarming 2009 global review of 'Impacts of Climate Change on Marine Organisms and Ecosystems' which sets out how the 'greenhouse' effect in the earth's atmosphere 'is unprecedented in at least the last 22,000 years and has already had direct physical consequences for the marine environment and organisms living there'.[36]

St Andrews remains, as throughout its history, honeycombed with intimate connections. Students, professors, scientists, librarians, poets exit through old stone doorways only to reappear – after seconds, or after decades – as if they had never been away. Sometimes, indeed, in the streets of the old town people can be recalled suddenly from the distant past with all the immediacy of a photograph. Douglas Dunn has written of this sensation in a poem called 'Body Echoes', where, viewed from a room in the Poetry House, a St Andrews garden caught in

'Ambrosial light' triggers a sensation in the poet as if years have 'Unwound themselves in a reversed photoflood'.[37]

In Dunn's lyric poem, the echoes sensed in the 'photoflood' of St Andrews spring sunshine are personal; but the place is also subject to oddly institutional echoes, productively recalling and re-engaging with the work of the past. Recently the university added to its collections a striking photographic portrait of Sir David Brewster. Newly created by the photographer Calum Colvin, it is a stereoscopic image of Brewster, part photograph, part painting and collage. Writing about it in *Nature*, the art historian Martin Kemp (who was one of the first scholars to appreciate the importance of Brewster and the St Andrews photographic collections), states that 'Colvin has used Brewsterian magic to blend sitter and scientific activity in a remarkable way.'[38] The Brewster portrait is one of a series of works (another is a self-portrait of the photographer entitled 'Natural Magick') in which Colvin draws on his characteristic technique of making large colour photographs of carefully assembled tableaux of objects which have been painted so that when photographed from a carefully chosen angle they form a very different image. In the Brewster image the St Andrews professor's vast portrait head seems to contain a stepladder and looks mounted on a pile of books. The ladder for Colvin symbolises intellectual ambition, though it may also recall the short ladders that feature in some of the most famous early photographs by Brewster's friend Fox Talbot. In Colvin's portrait the ladder seems to enter Brewster's brain, so that the photograph is very much one of psychological interiority. In the style of the early 1840s photographs, Brewster is surrounded by various props, including a mirror, an orb, and a watch: this is a portrait of a man much exercised by optics, astronomy, time. On a table, partly incorporated into Brewster's right shoulder, lie two crossed brushes used in the preparation of photographic paper, and other small objects including a stereoscopic image of Brewster's St Andrews friend John Adamson.

This 21st-century after-echo of Brewster is very much an image of a scientific investigator of the universe; it is also a striking new work keyed closely to the particular development of photography in St Andrews. Colvin's photograph manages to be both a postmodern

collage and true to its Victorian subject. The photographic historian Tom Normand points out that it revisits 'that core debate of the nineteenth century' about 'the relationship of the photograph to the discrete realms of art and science'.[39] Recently I took Calum Colvin to see the Adamson family's memorial in the graveyard of St Andrews Cathedral, and showed him Robert Adamson's signature in the 1830s matriculation album. I rather hope this modern photographer may create an artistic tribute to the greatest of early Scottish photographers. When I went to look at Colvin's Brewster portrait in St Andrews it was on display on the ground floor of the building where an after-dinner discussion about apocalypse and global warming had taken place following Sir John Houghton's James Gregory lecture.

I think of all this on a sunny summer's day when, having walked to the Rock and Spindle, my children and I return to climb the old stone spiral staircase to the top of St Rule's Tower in the middle of the cathedral ruins. Older than the surrounding masonry, the square tower was built almost a millennium ago, close to the site of an earlier church. From its top you enjoy a magnificent view out to sea as well as of St Andrews and the surrounding farms, forest, villages and hills, as far as the beginning of the Grampian mountains to the north. Most immediately, the tower soars above the graves packed inside the roofless cathedral walls. If I clambered over the protective wooden guard-rail, I would see from up here the table-shaped memorial slab on which are inscribed the names of Robert Adamson and his brothers along with the names of several generations of their local ancestors. At the foot of the tower itself is a memorial tablet to Robert Chambers, though Anne Chambers is buried far off, in London's Highgate Cemetery. Many other members of the Lit and Phil are interred round about.

Surveying these surroundings gives a clear sense of what architects term the medieval cathedral's 'footprint': it was once the largest church in Scotland, for all that it is now shattered, its remaining spires affording dizzy perches for seagulls who take off and skim out over the great stone pier that curves beyond St Andrews harbour. Looking down, it strikes me that the word 'footprint' carries several senses in this place now. For Robert Chambers 'footprint' was the English translation of the Latin 'vestigium' – vestige – a word which originally meant simply a footprint,

or sometimes a track that indicated one's line of travel, and which came to be used occasionally of the path or orbit of a planet. Five years after Chambers published his *Vestiges of the Natural History of Creation*, Hugh Miller responded with a book called *Footprints of the Creator*, a title which signals among other things that clever Victorians like Chambers and Miller who had never gone to university still knew the connection between 'vestiges' and 'footprints'. For us, though, the word 'footprint' is now most commonly heard in the expression 'carbon footprint', a term central to arguments about sustainability. We have become conscious of leaving our footprints not just on the planet's surface, but also above it in the atmosphere as if, unthinkingly, for many generations we have been tramping muddy-bootedly across the sky.

From the summit of St Rule's Tower I look towards the trees around Abbey Park. The villa where Robert and Anne Chambers worked on the manuscript of *Vestiges* has been lying derelict and there are plans to convert into a hotel. Looking further off, my children, Lewis and Blyth, can spot their school, Madras College, as well as other familiar land-marks almost unchanged since they were photographed from this same high vantage-point in the 1840s by the athletic student William Furlong. Beyond Madras we can see our family home where Alice, my wife, is at work editing a book called *The Meaning of the Library*, which celebrates the four-hundredth anniversary of the founding of that King James Library where, in 1838, the Lit and Phil was established. Turning round, the children and I survey the coast towards the Eden estuary. South-east lie the Kinkell Braes and the Rock and Spindle which early photographs present as a representation of sublime geology, a sometimes frightening emblem which, like the castle on the cliffs and St Rule's Tower itself, alerts the viewer to the transience of human life. Lastly, we look towards the little building of St Leonard's chapel, now six hundred years old, familiar alike to my children and to its one-time neighbours, the families of Playfair and Brewster. Brewster is remembered now, if at all, as a scientist; Robert Chambers, vaguely, as a man of letters. Both wrote poetry and each was fascinated by scientific discovery. They lived before the arrival of the notion of science and the arts as 'two cultures' – an idea the twentieth century came to be lumbered with.

If we are to respond to the issue of global sustainability we will need to think about it holistically, not just as followers of our own particular specialisms. As inspirations Victorian institutions such as the Lit and Phil will be at least as helpful as those of arcane modern sub-disciplines. Only by taking a large-scale view at the same time as caring for our immediate local environment can we rise to the challenge, 'how should we live?' There is a place for local piety, but the future will require more from us than parochial nostalgia. From the tower my children and I look out to where the university is planning a wind-farm, and to the North Sea which the Scottish Government wishes to harness as part of the world's most ambitious tidal power and carbon capture project. I see the whole small town of St Andrews extending in the sunlight, and realise both why Robert Louis Stevenson saw it as 'the light of medieval Scotland', and why many people now regard it as almost insignificant.[40]

The sea is intensely blue, the wind is rising. The white horses roll in towards the East and West Sands and below the Kinkell Braes where 1840s photographers set their camera down on the rocky foreshore, close to where the Scottish Oceans Institute now stands. A few years ago I wrote a poem called 'Impossibility', in which an author lives out there, beneath the waves of St Andrews Bay. Today I think of Andrew Brierley's words about life in the marine environment – 'unprecedented change'. Only this morning, not long before another global conference on climate change, I was reading the paper Brierley co-authored, which, building on the findings of the Intergovernmental Panel on Climate Change, concludes by painting a darker picture,

Emissions to date have already committed the planet to a warming of 2.4 degrees C above pre-industrial levels, i.e. beyond the 2 degrees C threshold for 'dangerous anthropogenic influence'. If emissions continue, it is not outrageous to expect CO_2 to reach 1000ppm, with an associated warming of 5.5 degrees C, by the end of the century, which would bring about the extinction of many species . . . Despite options for intervention, it may already be too late to avoid major irreversible changes to many marine ecosystems. As history has shown us, these changes in the ocean could have major consequences for the planet as a whole.[41]

In conversation, Brierley worries that some of these changes may occur sooner than we think: 'You can say no Arctic sea ice by 2020 – really, really soon. Certainly no summer sea ice in the Arctic by 2020.'[42] With all this on my mind, standing looking out over the town, the university, the cliffs and the sea on a breezy, sunlit summer's day in the early twenty-first century, I link hands with my children and smile, bearing in mind the dauntingly simple conclusion of Don Paterson's version of a sonnet by Rilke. The words are, *'Now change your life'*.[43]

Notes

ొ

CHAPTER 1 *Setting the Scene*

1 The work in particular of David Bruce, Martin Kemp, Alison D. Morrison-Low, Larry J. Schaaf, Graham Smith, and Sara Stevenson is acknowledged separately in the text and notes of the following chapters.

2 See especially James Secord, *Victorian Sensation: The Extraordinary Publication, Reception, and Secret Authorship of 'Vestiges of the Natural History of Creation'* (Chicago and London: University of Chicago Press, 2000), 79–80.

3 Alastair Reid, 'Scotland', in *Inside Out: Selected Poetry and Translations* (Edinburgh: Polygon, 2008), 35. This poem was originally entitled 'St Andrews'.

4 *The Letters of Charlotte Brontë, Volume Two, 1848–1851*, ed. Margaret Smith (Oxford: Clarendon Press, 2000), 648 (to Ellen Nussey, 24 June [1851]) and 718 (to James Taylor, 15 November 1851), 718. See also Heather Glen, *Charlotte Brontë: The Imagination in History* (Oxford: Oxford University Press, 2002), 218–19.

5 The phrase is James Secord's, from his *Victorian Sensation*.

CHAPTER 2 *A Magician in the City of the Dead*

1 John Murray to Byron, 22 September 1818, in Samuel Smiles, *Memoir and Correspondence of the late John Murray*, 2 vols (London: John Murray, 1891), I, 398.

2 Byron, *Don Juan*, Canto the Second (1819), stanza XCIII.

3 James Flint, *Letters from America* (Edinburgh: W. & C. Tait, 1822), 19, 20.

4 [Peter Roget], 'History of Dr Brewster's Kaleidoscope', *Blackwood's Magazine*, June 1818, 337; David Brewster, *A Treatise on the Kaleidoscope* (Edinburgh: Constable, 1819), 7.

5 *Oxford English Dictionary* (*OED*), second edition: 'Kaleidoscope'.

6 Brewster, *Treatise on the Kaleidoscope*, 71; see Martin Kemp, ' "Philosophy in Sport" and the "Sacred Precincts": Sir David Brewster on the Kaleidoscope and Stereoscope', in B. Castel, J. A. Leith and A. W. Riley, ed., *Muse and Reason: The Relation of Arts and Sciences 1650–1850* (Ottawa: Queen's Quarterly for the Royal Society of Canada, 1994), 215.

7 Robert Chambers, *The Kaleidoscope*, 12 January 1822, 14.

8 Brewster, *Treatise on the Kaleidoscope*, 1.

9 Ibid.

10 The accents on the words and the smooth breathing at the start of *eidos* have been missed out, though by the time of the passage's re-publication at the start of Brewster's *The Kaleidoscope: its History, Theory and Construction* (London: John Murray, 1858) these omissions had been corrected.

11 Brewster, *Treatise on the Kaleidoscope*, 64, 113.

12 Ibid., 121, 125.

13 Ibid., 64, 111.

14 Ibid., 8, 63, 134.

15 Brewster quoted in M. M. Gordon, *The Home Life of Sir David Brewster* (Edinburgh: Edmonston and Douglas, 1869), 97.

16 Chris Otter, *The Victorian Eye: A Political History of Light and Vision in Britain, 1800–1910* (Chicago: University of Chicago Press, 2008), 39.

17 D[avid] B[rewster], 'On the Effects of the French Revolution upon Science and Philosophy', *Edinburgh Magazine, or Literary Miscellany*, 16 (1800), 377–82; on Jameson's Cuvier see Ralph O'Connor, *The Earth on Show: Fossils and the Poetics of Popular Science, 1802–1856* (Chicago: University of Chicago Press, 2007), 61–7.

18 *Oxford Dictionary of National Biography*, (2004) (hereafter *ODNB*), Robert Jameson (1774–1854).

19 See A. D. Morrison-Low, 'Published Writings of Sir David Brewster: A Bibliography' in A. D. Morrison-Low and J. R. R. Christie, ed., *'Martyr of Science': Sir David Brewster 1781–1868* (Edinburgh: Royal Scottish Museum Studies, 1984), 111.

20 Larry J. Schaaf, *The Photographic Art of William Henry Fox Talbot* (Princeton and Oxford: Princeton University Press, 2000), 15 and 235, n. 26; see also Larry J. Schaaf, *Out of the Shadows: Herschel, Talbot, & the Invention of Photography* (New Haven and London: Yale University Press, 1992), 33–4.

21 See Schaaf, *Out of the Shadows*, 55.

22 'Occasional Notes, Painting by the Action of Light', *Chambers' Edinburgh Journal*, 30 March 1839, 77–8.

23 Sir David Brewster, *Letters on Natural Magic Addressed to Sir Walter Scott, Bart.* (London: John Murray, 1832), 1.

24 John Baptista Porta, *Natural Magick* (London: John Wright, 1669).

25 For a fuller account see Schaaf, *The Photographic Art*, 20–22.

26 Gordon, *The Home Life*, 57.

27 Robert to William Chambers, 'Thursday morning' [?1843], National Library of Scotland (NLS) Dep. 341/93, letter 55.

28 Gordon, *The Home Life*, 71.

29 Brewster, letter to J. D. Forbes, 11 February 1830 (St Andrews University Library), cited in William Cochran, 'Sir David Brewster: An Outline Biography', in Morrison-Low and Christie, ed., *'Martyr of Science'*, 13.

30 A copy of this lithograph of Brewster, 'after Daniel Maclise' is in the collection of the National Portrait Gallery in London (NPG D1096).

31 *St Andrews as It Was and as It Is; Being the Third Edition of Dr* [James] *Grierson's Delineations* (Cupar: G. S. Tullis, 1838), 210.

32 *St Andrews as It Was and as It Is*, 80.

33 Samuel Johnson, *A Journey to the Western Isles of Scotland*, ed. R. W. Chapman (London: Oxford University Press, 1974), 7, 6, 5, 8; John Adamson, *Report on the Sanitary Condition and General Economy of the Labouring Classes in the City of St. Andrews* (London: The Poor Law Commissioners, 1842), 270.

34 *St Andrews as It Was and as It Is*, 161.

35 Walter Scott, journal entry for 16 June 1827, quoted in Robert Crawford, ed., *The Book of St Andrews: An Anthology* (Edinburgh: Polygon, 2005), 121.

36 *St Andrews as It Was and as It Is*, 79; on this guidebook and early photography see Ralph L. Harley, Jr and Joanna L. Harley, 'The "Tartan Album" by John and Robert Adamson, *History of Photography*, 12.4 (1988), 295–316.

37 John Adamson, *Report*, 269.

38 Andrew Lang, 'Almae Matres', in Robert Crawford, ed., *The Book of St Andrews: An Anthology* (Edinburgh: Polygon, 2005), 66.

39 Brewster, 28 July 1840 interview in *Report of the St Andrews' University Commissioners (Scotland)* (London: William Clowes for Her Majesty's Stationery Office, 1845), 95.

40 Lord [Henry] Cockburn, *Circuit Journeys* (Edinburgh: David Douglas, 1888), 228 (Cockburn was writing in the spring of 1844).

41 John Herschel, *Preliminary Discourse on the Study of Natural Philosophy* (London: Longman, 1830), 10, 12. Herschel alludes to Newton on the shore on pp. 269–70.

42 David Brewster, *The Life of Sir Isaac Newton* (New York: Harper and Brothers, 1840), 10 and 300–01. Brewster's *Life of Sir Isaac Newton* was first published in 1831.

43 Gordon, *The Home Life*, 166.
44 *St Andrews as It Was and as It Is*, 187.
45 Gordon, *The Home Life*, 165.
46 *St Andrews as It Was and as It Is*, 183.
47 Gordon, *The Home Life*, 161–2.
48 John William Ward, letter of 27 November 1821, cited in Schaaf, *The Photographic Art*, 8.
49 Schaaf, *The Photographic Art*, 11.
50 Constance Talbot, letter to Lady Elisabeth Talbot, 'Monday' [15 August 1836], quoted in Schaaf, *Out of the Shadows*, 20.
51 Sir David Brewster, *The Martyrs of Science* (London: John Murray, 1841), 57–8, 117.
52 Brewster, *The Martyrs of Science*, 117.
53 James Ferguson, *Astronomy, explained upon Sir Isaac Newton's Principles*, with Notes and Supplementary Chapters by David Brewster, Second Edition, 2 vols (Edinburgh: Stirling & Slade, 1821), I, 1, 5.
54 Brewster, *Natural Magic*, quoted in Kemp, ' "Philosophy in Sport" ', 206.
55 Brewster, *The Martyrs of Science*, 266–7.
56 Gordon, *The Home Life*, 167.
57 [David Brewster,] 'Decline of Science in England and Patent Laws', *Quarterly Review* 43 (1830), 305–42.
58 Gordon, *The Home Life*, 169.
59 The microscope (now in the collection of the Museum of the University of St Andrews) is illustrated and described at http://www-ah.st-andrews.ac.uk/mgstud/reflect/david.html (accessed on 25 July 2008).
60 On the Davidson camera see A. D. Morrison-Low, 'Brewster, Talbot and the Adamsons: The Arrival of Photography in St Andrews', *History of Photography*, 25.2 (2001), 135–6.
61 Brewster to Talbot, 28 November 1840, National Museum of Photography, Film and Television, (hereafter NMPFT) Bradford, Talbot Correspondence Project document number 4169. This museum is now also known as the National Media Museum. In the present book documents from this archive are cited by their Talbot Correspondence Project numbers.
62 Brewster to Talbot, 4 February 1841, NMPFT 4190.
63 Ibid.
64 Brewster to Talbot, 12 June 1841, NMPFT 4276.
65 Brewster to Talbot, 1 July 1841, NMPFT 4291.
66 Brewster, *Quarterly Review*, 43 (1830), 323.
67 Gordon, *The Home Life*, 167.
68 Brewster to Talbot, 27 July 1841, NMPFT 4317.
69 Brewster to Talbot, 26 July 1841, NMPFT 4315 (see also Brewster to Talbot, 27 July 1841, NMPFT 4317).

70 Talbot (1841 letter) cited in Schaaf, *Out of the Shadows*, 116.

71 Brewster to Talbot, 5 October 1841, NMPFT 4339.

72 Brewster to Talbot, 10 July 1842, NMPFT 4541.

73 Brewster to Talbot, 20 August 1842, NMPFT 4583.

74 [David Brewster,] 'Photography', *North British Review*, August 1847, 466; Brewster to Talbot, 29 October 1842, NMPFT 4635; see also Graham Smith, *Disciples of Light: Photographs in the Brewster Album* (Malibu: The J. Paul Getty Museum, 1990), 97.

75 Jane Gibson Chambers, 'Letter from a Niece' (in National Library of Scotland, n.p., n.d.), 2.

76 Brewster to Talbot, 18 November 1842, NMPFT 4647.

77 'Enemy-Makers', *Chambers' Edinburgh Journal*, 26 March 1842, 73.

78 I owe this information to Sondra Cooney, who is writing Chambers's biography.

79 *The Best Laid Schemes: Selected Poetry and Prose of Robert Burns*, ed. Robert Crawford and Christopher MacLachlan (Edinburgh: Polygon, 2009), 69.

80 King James VI, *Basilicon Doron*, ed. James Craigie, 2 vols (Edinburgh: Blackwood for the Scottish Text Society, 1944–50), I, 74.

81 [Maria Brewster,] *The Covenant: or, The Conflict of the Church, with Other Poems Chiefly Connected with the Ecclesiastical History of Scotland* (Edinburgh: John Johnstone, 1842), 88. Maria Brewster is identified as the author of this work in the catalogue of St Andrews University Library, and in a penciled addition to that library's copy of the book.

82 This picture, taken on 19 October 1843, is reproduced as plate 3 in Anne M. Lyden et al., *Hill and Adamson: Photographs from the J. Paul Getty Museum* (Los Angeles: The J. Paul Getty Museum, 1999).

83 Hugh Miller, quoted in Owen Dudley Edwards and Graham Richardson, ed., *Edinburgh* (Edinburgh: Canongate, 1983), 204–05.

84 Brewster to Talbot, 3 July 1843, NMPFT 4839.

85 Lord Cockburn, quoted in Sara Stevenson, *The Personal Art of David Octavius Hill* (New Haven: Yale University Press, 2002), 14; in her note 35 on p. 166, Stevenson suggests D. O. Hill himself recalled Cockburn's words.

86 *ODNB*, Thomas Duncan (1807–45).

87 See Sara Stevenson, *David Octavius Hill and Robert Adamson: Catalogue of their Calotypes taken between 1843 and 1847 in the Collection of the Scottish National Portrait Gallery* (Edinburgh: National Galleries of Scotland, 1981), 215, 'Art 1', which reproduces the calotype of this painting.

88 [Maria Brewster,] *The Covenant*, 67–8.

89 Ibid., 73.

90 Brewster to Talbot, 18 November 1843, NMPFT 4897.

91 *ODNB*, George Cook (1772–1845).
92 *ODNB*, Robert Haldane (1772–1854); see also R. G. Cant, *The University of St Andrews*, revised edition (Edinburgh: Scottish Academic Press, 1970), 117.
93 [Maria Brewster,] *The Covenant*, 67, 73.
94 This photograph, now in the collection of the Scottish National Portrait Gallery, is reproduced in David Bruce, *Sun Pictures: The Hill-Adamson Calotypes* (London: Studio Vista, 1973), 232–3.
95 See Raymond Lamont Brown, *The Life and Times of St Andrews* (Edinburgh: John Donald, 1989), 136.
96 See Larry Schaaf in *Sun Pictures, Catalogue Eleven* (New York: Hans P. Kraus, Jr [2002]), 15.
97 Brewster to Talbot, 20 August 1842, NMPFT 4583.
98 Cockburn, *Circuit Journeys*, 234.
99 [Sir David Brewster,] 'Photogenic Drawing, or Drawing by the Agency of Light', *Edinburgh Review*, CLIV, January 1843, 330, 309, 310.
100 Brewster, 'Photogenic Drawing', 310–11.
101 Ibid., 312.
102 Ibid., 316, 327.
103 Ibid., 329–31.
104 [Anon.,] 'Photogenic Drawing', in William and Robert Chambers, eds, *Chambers's Information for the People* (Edinburgh: William and Robert Chambers, 1842), 2 vols, II, 253. See also Susan Sontag, *On Photography* (New York: Farrar, Straus and Giroux, 1977); Roland Barthes, *Camera Lucida: Reflections on Photography*, trans. Richard Howard (London: Flamingo, 1984); Philippe Dubois, *L'Acte photographique* (Paris and Brussels: Nathan/Labor, 1983).
105 [David Brewster,] 'Photography', *North British Review*, August 1847, 502.
106 [Brewster,] 'Photography' (1847), 480; 'The Scientific Meeting at York', *Chambers' Edinburgh Journal*, 23 November 1844, 321.
107 Susan Sontag, *On Photography*, 15.
108 See, e.g., David E. Stannard, 'Sex, Death, and Daguerreotypes: Towards an Understanding of Image as Elegy' in John Wood, ed., *America and the Daguerreotype* (Iowa City: University of Iowa Press, 1991), 73–108.
109 [Hugh Miller,] 'The Two Prints', *The Witness*, 24 June 1843.
110 Roland Barthes, *Camera Lucida*, trans. Howard, 6, 13–14, 49, 64, 77, 79, 80–81, 85, 88, 92.
111 A. D. Morrison-Low, 'Brewster, Talbot and the Adamsons', 134.
112 Brewster to Talbot, 18 November 1843, quoted in Graham Smith, 'W. Holland Furlong, St Andrews and the Origins of Photography in Scotland', *History of Photography*, 13.2, April–June 1989, 139; the photograph is reproduced on page 140.

113 See Schaaf, *Sun Pictures, Catalogue Eleven*, 16.

114 This photograph and its caption are reproduced in Smith, *Disciples of Light*, 139.

115 See Smith, *Disciples of Light*, 28; this photograph is reproduced as figure 5 in Alison D. Morrison-Low, 'Dr John and Robert Adamson: An Early Partnership in Scottish Photography', *Photographic Collector* 4 (1983), 199–214.

116 [Maria Brewster,] *The Covenant*, 72 and 97.

CHAPTER 3 *Lit and Phil*

1 Thomas Carlyle, *Sartor Resartus* (1836; repr. London: Dent, 1984), 12.

2 Charles Darwin, *The Voyage of the Beagle* (1839; repr. London: Dent, 1972), 9.

3 See Simon J. Knell, *The Culture of English Geology, 1815–1851* (Aldershot: Ashgate, 2000), 51.

4 Ibid., 49–111, and Martin J. S. Rudwick, *The Great Devonian Controversy: The Shaping of Scientific Knowledge among Gentlemanly Specialists* (Chicago: University of Chicago Press, 1985), 17–41.

5 Literary and Philosophical Society, St Andrews, Proceedings (Ms in St Andrews University Library, UY8525), 1; see also Brewster, 23 July 1840 interview in *Report of the St Andrews' University Commissioners (Scotland)* (London: William Clowes for Her Majesty's Stationery Office, 1845), 93–4 (hereafter cited as *Commissioners' Report*).

6 Dr John Reid, interview, 5 May 1843, in *Commissioners' Report*, 154.

7 Literary and Philosophical Society, St Andrews, Proceedings, Honorary Members, 7 January 1839.

8 Charles Darwin, *Autobiographies*, ed. Michael Neve and Sharon Messenger (London: Penguin Books, 2002), 24, 25.

9 Robert Haldane, 1840 interview in *Commissioners' Report*, 93.

10 Lydia Fraser, letter to Hugh Miller, 9 December 1834, quoted in Elizabeth Sutherland, *Lydia, Wife of Hugh Miller of Cromarty* (East Linton: Tuckwell Press, 2002), 36–7.

11 See John Adamson, *Report on the Sanitary Condition and General Economy of the Labouring Classes in the City of St. Andrews* (London: The Poor Law Commissioners, 1842), 275–6.

12 *Saint Andrews as It Was and as It Is* (Cupar: G. S. Tullis, 1838), 82.

13 See Ralph L. Harley, Jr. and Joanna L. Harley, 'The "Tartan Album" by John and Robert Adamson', *History of Photography*, 12.4 (1988), 296.

14 *Saint Andrews as It Was and as It Is*, 80.

15 Sir George Makgill of Kemback, 'Ane auld ballad upon a new Knychte' (a poem about Provost Playfair), quoted in Hugh Playfair, *The Playfair Family* (Blackford, Somerset: privately published, 1999), 92.

16 John Reid, *Physiological, Anatomical and Pathological Researches* (Edinburgh: Sutherland and Knox, 1848), 602.

17 *Oxford Dictionary of National Biography* (hereafter *ODNB*), John Reid (1809–49).

18 C[harles] J[obson] Lyon, *History of St Andrews* (Edinburgh: William Tait, 1843), 2 vols, I, 11, 10.

19 *Saint Andrews as It Was and as It Is*, 81; Charles Roger, *History of St Andrews, with a Full Account of the Recent Improvements in the City* (Edinburgh: Adam and Charles Black, 1849), 119.

20 Hugh Miller, *The Old Red Sandstone, or New Walks in an Old Field* (1841; repr., London: Dent, n.d.), 183–4.

21 Graham Smith calls attention to this aspect of the work of the Lit and Phil in his *Disciples of Light: Photographs, I, the Brewster Album* (Malibu: The J. Paul Getty Museum, 1990), 49.

22 *Saint Andrews as It Was and It Is*, 249.

23 St Andrews Lit and Phil Proceedings quoted in Graham Smith, *Disciples of Light*, 28.

24 'New Method of Taking Views from Nature', *Scotsman*, 16 January 1839, 2.

25 For Morse's accounts of his attempts see the *New York Observer*, 20 April 1839; see also Larry J. Schaaf, *The Photographic Art of William Henry Fox Talbot* (Princeton and Oxford: Princeton University Press, 2000), 15.

26 See [David Brewster,] 'Photography', *North British Review*, August 1847, 469; also Larry J. Schaaf, *Out of the Shadows: Herschel, Talbot, & the Invention of Photography* (New Haven and London, 1992), 23–5.

27 'Photography', *Scotsman*, 3 August 1839, 3.

28 Ambrose Blacklock (1816–73), *Do Small-Pox and Cow-Pox afford any Protection from Asiatic Cholera? With Some Observations* (Dumfries: W. C. Craw, 1866); the same Blacklock authored the 1838 London-published *Treatise on Sheep and the Wool Trade*; other information comes from his obituary in the *Madras Medical Journal*, 1 March 1873, available as an offprint in the Ewart Library, Dumfries (Db151 (8BLA)8).

29 Drawing on the *Literary Gazette*, a shorter report on Talbot's work appeared under the heading 'Royal Society' in the *Scotsman*, 16 February 1839, 4.

30 Schaaf, *Out of the Shadows*, 55.

31 'Occasional Notes, Painting by the Action of Light', 78.

32 Smith, *Disciples of Light*, 27–8.

33 James David Forbes, letter to John Herschel, 9 July 1839, quoted in Schaaf, *Out of the Shadows*, 177, n. 4; Herschel (who published a pioneering paper on photography in early 1839) had encouraged Forbes to see Daguerre's work.

34 'Photography', *Scotsman*, 3 July 1839, 3; on Fyfe see Roger Taylor, *Impressed by Light: British Photographs from Paper Negatives, 1840–1860* (New York, Washington, New Haven and London: The Metropolitan Museum/National Gallery of Art/Yale University Press, 2007), 318.

35 'British Association of Science', *Scotsman*, 31 August 1839, 2.

36 Daguerre's painting 'Ruins of Holyrood Chapel', now in the Walker Art Gallery, Liverpool, is reproduced in Janet E, Buerger, *French Daguerreotypes* (Chicago: University of Chicago Press, 1989), 15.

37 '*Now Open*, The Diorama, Lothian Road' (advertisement), *Scotsman*, 3 August 1842, 1.

38 In this section much of the information about the society and its meetings, and the contents of the museum, comes from the manuscript minute book and proceedings of the St Andrews Literary and Philosophical Society (St Andrews University Library UY8525).

39 Rev. J. W. Taylor, quoted in Matthew Forster Conolly, *Memoir of the Life and Writings of William Tennant, LLD* (London: James Blackwood, 1861), 104–5.

40 Ibid.

41 William Tennant, from 'Papistry Storm'd' in Robert Crawford, ed., *The Book of St Andrews* (Edinburgh: Polygon, 2005), 50; Lydia Miller, quoted in Elizabeth Sutherland, *Lydia*, 13; *The Comic Poems of William Tennant*, ed. Maurice Lindsay and Alexander Scott (Edinburgh: Scottish Academic Press for the Association for Scottish Literary Studies, 1989), 5 ('Anster Fair').

42 Tennant to Robert Chambers, 13 April 1844 (National Library of Scotland (hereafter NLS) Dep. 341/96, letter 136); [George Thomson to] Robert Chambers, 16 November 1842 (NLS Dep. 341/90, letter 71); William Tennant to Robert Chambers, 13 April 1844.

43 Brewster, letter to Talbot, 13 November, 1847, quoted by Larry Schaaf in *Sun Pictures, Catalogue Eleven* (New York: Hans P. Kraus, Jr [2002]), 8.

44 Smith, *Disciples of Light*, 37–9.

45 Creech's Lucretius, quoted in [David Brewster,] 'Photography', *North British Review*, August 1847, 467.

46 Quotations are from the minute book of the Lit and Phil, but for further information on Moser's theories see M. Susan Barger and William B. White, *The Daguerreotype: Nineteenth-Century Technology and Modern Science* (Washington: Smithsonian Institution Press, 1991), 62.

47 See Buerger, *French Daguerreotypes*, 27–49.

48 Connell, 5 May 1843 interview in *Commissioners' Report*, 150.

49 'Organic Matter in Spring Waters', *Chambers' Edinburgh Journal*, 1 July 1843, 184.

50 University of St Andrews Library Receipt Book, Readers, 1839–47 (St Andrews University Special Collections LY208) 398.

51 Robert Chambers [to Alexander Ireland, 1 December 1842] (NLS Dep. 341/110, letter 20).

52 See Schaaf, *The Photographic Art*, 178; also Schaaf, *Out of the Shadows*, 138–40.

53 The Lyon family album is detailed in Schaaf, *Sun Pictures: Catalogue Eleven*, 15–40.

54 Brewster, 29 July 1840 interview in *Report*, 100; C[harles] J[obson] Lyon, *History of St Andrews* (Edinburgh: William Tait, 1843), 2 vols, I, ix, xix, xx.

55 These pictures from the Brewster Album are reproduced by Smith in *Disciples of Light*.

56 See University of St Andrews Library Photographic Archive, ALB6–95–1; the picture is believed to date from around 1845 and so, if the dating is correct, this calotype predates the works detailed in Dolores A. Kilgo, 'The Alternative Aesthetic: The Langenheim Brothers and the Introduction of the Calotype in America', in John Wood, ed., *America and the Daguerreotype* (Iowa City: University of Iowa Press, 1991), 27–57.

57 On Spalding see Robert Crawford, 'Internationalizing English Studies', in Crawford, ed., *Launch-Site for English Studies: Three Centuries of Literary Studies at the University of St Andrews* (St Andrews: Verse, 1997), 57–60; on the place of St Andrews in the development of university English Literature studies see Robert Crawford, ed., *The Scottish Invention of English Literature* (Cambridge: Cambridge University Press, 1998).

58 *Oxford English Dictionary*, second edition: 'Epistemology'.

59 Thomas Rodger's library borrowings for 1850–51 are recorded on p. 1066 of the St Andrews University Library Borrowings Register for Students, LY 207 17, where he is described as 'assistant to Dr Adamson'. It is likely that Adamson encouraged him to borrow the photography-related books as part of his training, and it is quite possible that the early photography books in the University Library were used in teaching by Adamson and by Professor Connell (whose Chemistry class John Adamson took when the professor was ill). The order for James Hunter's book is recorded in the Library Order Book for 1841–61 (UYLY 311/1).

60 This photograph is reproduced as figure 3 in Anne Lyden, 'St Andrews Material in the Collections of the J. Paul Getty Museum', *History of Photography*, 25.2 (2001), 173.

61 The plan of Rodger's studio held in St Andrews University Library is reproduced in Martin Kemp, ed., *Mood of the Moment: Masterworks of Photography from the University of St Andrews* ([St Andrews:

Crawford Arts Centre,] n.d.), unnumbered pages; for biographical information about Rodger see Karen Johnston's essay in the same publication, and the biographical entry in Roger Taylor, *Impressed by Light*, 364; also Robert N. Smart, *Biographical Register of the University of St Andrews, 1747–1897* (St Andrews: University of St Andrews Library, 2004), 757.

62 Rodger's 1883 obituary in the *British Journal of Photography*, quoted by Larry J. Schaaf in Taylor, *Impressed by Light*, 364.

CHAPTER 4 *The Major*

1 See University of St Andrews Library Receipt Book, Readers, 1839–1847 (St Andrews University Special Collections LY208), 397.

2 See the invaluable account by A. D. Morrison Low, 'Brewster, Talbot and the Adamsons: The Arrival of Photography in St Andrews', *History of Photography*, 25.2, Summer 2001, 130–41.

3 Gordon, *Home Life*, 165.

4 National Museum of Photography, Film and Television, (hereafter NMPFT) Bradford, Brewster to Fox Talbot, 23 May 1838, 3677; the photograph of the Major playing his cello is reproduced in Graham Smith, *Disciples of Light: Photographs in the Brewster Album* (Malibu: The J. Paul Getty Museum, 1990), figure 9.

5 Charles Roger, *History of St Andrews, with a Full Account of the Recent Improvements to the City* (Edinburgh: Adam & Charles Black, 1849), 174–5.

6 *Fletcher's Guide to St Andrews* (St Andrews: Melville Fletcher [1859]), 44 (this guidebook also contains a full description of the garden); Lord [Henry] Cockburn, *Circuit Journeys* (Edinburgh: David Douglas, 1888), 234.

7 Jane Gibson Chambers, 'Letter from a Niece in the Country to her Aunt in Town', printed letter to Miss Chambers, 8 Atholl Place, Edinburgh dated 'St Andrews, Nov. 24, 1842', National Library of Scotland (NLS) Dep. 341/85, item 33.

8 One of the clearest prints of this calotype is in the Edinburgh Calotype Club album compiled by Hugh Lyon Tennent and now in the National Library of Scotland. This is available digitally through the National Library's website 'Pencils of Light' online exhibition, http://www.nls.uk/pencilsoflight – as part of volume 1.

9 University of St Andrews Library Photographic Archive, ALB6–83–2 shows Major Playfair's Theatre.

10 See the database of 'Photographic Exhibitions in Britain 1839–1865, Records from Victorian Exhibition Catalogues' hosted by De Montfort University at http://peib.dmu.ac.uk (accessed 26 July 2008).

11 University of St Andrews Library Photographic Archive, ALB1–130.

12 This photograph is in the album one of the albums of the Edinburgh Calotype Club (at I, 36), and is available digitally through the National Library of Scotland's website at http://www.nls.uk/pencilsoflight (accessed 25 July 2007).

13 See Smith, *Disciples of Light*, 38.

14 Roger, *History*, 174; *Oxford Dictionary of National Biography* (*ODNB*), Hugh Lyon Playfair (1786–1861).

15 [Anon.,] 'Things of the Day: Photography', *Blackwood's Edinburgh Magazine*, April 1842, 518.

16 I am grateful to Larry Schaaf for technical details about this paper (private correspondence, 26 October 2009).

17 [David Brewster,] 'Photography', *North British Review*, August 1847, 482.

18 Robert Graham, 'The Early History of Photography', *Good Words*, 1874, 450, cited in Smith, *Disciples of Light*, 82.

19 Playfair to Brewster for forwarding to Fox Talbot, 15 August 1842, NMPFT, 4577; Brewster to Talbot, 4 February 1839, NMPFT, 3789; Brewster to Talbot, 14 March 1839, NMPFT, 3836.

20 Brewster to Talbot, 7 April 1839, NMPFT 3855.

21 Brewster to Talbot, 5 October 1840, NMPFT 4141.

22 Brewster to Talbot, 23 October 1840, NMPFT 4151.

23 See the photograph in the Edinburgh Calotype Club's albums (I, 31) available digitally through the National Library of Scotland's website at http://www.nls.uk/pencilsoflight/browse.htm (accessed 25 July 2008).

24 Talbot quoted in Larry J. Schaaf, *The Photographic Art of William Henry Fox Talbot* (Princeton and Oxford: Princeton University Press, 2000), 96.

25 George Wilson, *Life of Dr John Reid* (Edinburgh: Sutherland and Knox, 1852), 97.

26 William and Robert Chambers, ed., *Chambers's Information for the People*, New and Improved Edition (Edinburgh: W. and R. Chambers, 1841–2), 2 vols, II, 253.

27 See the photographs in the Edinburgh Calotype Club's albums (I, 33 and II, 5) available digitally through the National Library of Scotland's website at http://www.nls.uk/pencilsoflight/browse.htm (accessed 25 July 2008).

28 Brewster to Talbot, 15 May 1841, NMPFT 4258.

29 Brewster to Talbot, 14 October 1841, NMPFT 4342.

30 Brewster to Talbot, 27 October 1841, NMPFT 4349.

31 See Robert N. Smart, *Biographical Register of the University of St Andrews* (St Andrews: University of St Andrews Library, 2004), 310; also Roger

Taylor, *Impressed by Light: British Photographs from Paper Negatives, 1840–1860* (New York, Washington, New Haven and London: The Metropolitan Museum, National Gallery of Art, and Yale University Press, 2007), 317–8.

32 [David Brewster,] 'Photography', *North British Review*, August 1847, 476; Brewster to Talbot, 27 October 1841, NMPFT 4349.

33 Brewster to Talbot, 10 November 1841, NMPFT 4362 (see also Brewster to Talbot, 14 November 1841, NMPFT 4366).

34 Brewster to Talbot, 7 November 1841, NMPFT 4357.

35 *Saint Andrews as It Was and as It Is* (Cupar: G. S. Tullis, 1838), 161.

36 Charles Roger, *History of St Andrews* (Edinburgh: Adam & Charles Black, 1849), 121.

37 George Wilson, *Life of Dr John Reid* (Edinburgh: Sutherland and Knox, 1852), 99.

38 George Fullerton Carnegie, 'Golfiana, or Niceties connected with the Game of Golf' (1833, rev. ed., 1842) in Robert Clark, ed., *Golf: A Royal and Ancient Game* (London: Macmillan, 1893), 164; hereafter cited as 'Golfiana'.

39 [Robert Chambers,] 'Gossip about Golf', *Chambers' Edinburgh Journal*, 8 October 1842, 298. (See note 15, chapter 5, for more on the attribution of this piece to Robert Chambers.)

40 'Golfiana', 165.

41 'Golfiana', 163; Margaret Oliphant, *A Memoir of the Life of John Tulloch* (Edinburgh and London: William Blackwood and Sons, 1888), 122; Rodger's photograph of Margaret Oliphant (taken around 1862) is item ALB1–117 in the University of St Andrews Library Photographic Archive.

42 *ODNB*, Lyon Playfair (1818–98); Lyon Playfair, letter to Fox Talbot, 6 November 1851, in the digital archive of 'The Correspondence of William Henry Fox Talbot' (LA51–075) maintained by De Montfort University and accessible through http://foxtalbot.dmu.ac.uk/letters (accessed 25 July 2008).

43 Information about Playfair's relatives is drawn from Smart, *Biographical Register*.

44 'Golfiana', 169; *ODNB*, Hugh Lyon Playfair.

45 Library Receipt Book, Readers, 1839–47 (LY208), 397.

46 'A Day in St Andrews', *Chambers' Edinburgh Journal*, 20 January 1844, 40.

47 Roger, *History*, 164.

48 St Andrews Town Council Book, 3 November 1837–9 May 1844, manuscript volume in St Andrews University Library Special Collections (B65/11/12), 292–3.

49 For Playfair's sobriquets see Graham Smith, 'Hill and Adamson at St

Andrews: The Fishergate Calotypes', *Print Collector's Newsletter* 12 (1981), 34–6.

50 Henry Cockburn, *Journal*, in Clark, ed., *Golf*, 240.

51 Roger, *History*, 167.

52 Ibid., 163.

53 See Smith, *Disciples of Light*, 52, where this photograph is reproduced and discussed.

54 'A Day in St Andrews', 41.

55 Ibid.

56 [Anon.,] 'Paula Majora Canamus', in *Memoirs of Sir Hugh Lyon Playfair* (St Andrews: M. Fletcher, 1861), 1.

57 Ibid.

58 Roger, *History*, 169.

59 'A Day in St Andrews', 40, 42.

60 'Golfiana', 168.

61 Dr George Playfair's photograph of the Buddhas is in University of St Andrews Library Photographic Archive, ALB6–107.

62 University of St Andrews Library Photographic Archive, ALB6–32–6; [David Brewster,] 'Photography', *North British Review*, August 1847, 474.

63 University of St Andrews Library Photographic Archive, ALB6–90.

64 See item in the previous note, as well as University of St Andrews Library Photographic Archive, ALB6–54–3, A Laundry Maid; also ALB6–55–1, Mr Charles Howie.

65 Playfair's borrowing of *Vestiges* is recorded on page 542 of the relevant St Andrews University Library Receipt Book.

CHAPTER 5 *Robert and Anne*

1 This silhouette is reproduced in C. H. Layman, ed., *Man of Letters: The Early Life and Love-Letters of Robert Chambers* (Edinburgh: Edinburgh University Press, 1990), Plate 10; also in James A. Secord, *Victorian Sensation: The Extraordinary Publication, Reception, and Secret Authorship of 'Vestiges of the Natural History of Creation' (Chicago: University of Chicago Press, 2000), 96.*

2 Information on Chambers's early life is drawn from *Memoir of Robert Chambers with Autobiographic Reminiscences of William Chambers* (Edinburgh: W. & R. Chambers, 1872).

3 Secord, *Victorian Sensation*, 2.

4 Robert Chambers to George Thomson, 4 July 1842, National Library of Scotland (NLS) Dep. 341/109, letter 18.

5 Robert Chambers to D. R. Rankine, 8 December 1842 (NLS Dep. 341/109, letter 5).

6 Ibid.

7 Robert to Anne Chambers, 23 November 1842 (NLS Dep. 341/82, letter 32).

8 Advertising flyer, 'New Work of Messrs. Chambers', dated 20 October 1842 (NLS Dep. 341/125).

9 Robert to William Chambers, 'Sunday evening' (NLS Dep. 341/82, letter 30).

10 Anne to William Chambers, 'Abbey Park, Monday' (NLS Dep. 341/82, letter 31).

11 Robert to William Chambers, 'Sunday evening' (NLS Dep. 341/82, letter 30).

12 Anne Chambers, 'Invocation to the Spirit of Love', initialled and dated 'May 13, 1838' (NLS Dep. 341/109, item 35).

13 [George Thomson to] Robert Chambers, 16 November 1842, NLS Dep. 341/90, letter 71.

14 Robert to William Chambers, undated [?1842 or 1844] letter, NLS Dep. 341/93, letter 53.

15 [Robert Chambers,] 'Gossip about Golf', *Chambers' Edinburgh Journal*, 8 October 1842, 297. Robert Chambers can be identified as the author of this piece from the records in the relevant volume of his firm's account books covering contributors' fees for articles in *Chambers' Edinburgh Journal* (National Library of Scotland MS Dep 341/367). Other attributions below are made based on evidence from the same source.

16 Ibid., 298.

17 Robert Chambers et al., 'The Nine Holes of the Links of St Andrews', in Robert Clark, ed., *Golf: A Royal and Ancient Game* (London: Macmillan, 1893), 196; William Chambers, *Memoir of Robert Chambers*, 271.

18 [Robert Chalmers,] 'Gossip about Golf', 298.

19 Ibid.

20 Jane Gibson Chambers, 'Letter from a Niece in the Country to her Aunt in Town', printed letter 'To Miss Chambers, 8 Atholl Place, Edinburgh' dated 'St Andrews, Nov. 24, 1842', NLS Dep. 341/85, item 33.

21 See the very small memorandum book at NLS Dep. 341/16. Though this item may date from 1847, it is known that Chambers kept earlier, similar notebooks.

22 Minute book of the St Andrews Literary and Philosophical Society, 77–8 (2 January 1843), St Andrews University Library.

23 Robert Chambers, *Ancient Sea-Margins* (Edinburgh: W. & R. Chambers, 1848), 53, and frontispiece.

24 For more on these codenames see Secord, *Victorian Sensation*, 368.

25 Robert Chambers, *Vestiges of the Natural History of Creation and Other Evolutionary Writings*, ed. James A. Secord (Chicago and London: University of Chicago Press, 1994), table of contents.

26 Chambers, *Vestiges*, ed. Secord, 23, 8, 20, 12.
27 Secord, 'Introduction' to Chambers, *Vestiges*, ed. Secord, xiv.
28 Bernard Lightman, *Victorian Popularizers of Science: Designing Nature for New Audiences* (Chicago: University of Chicago Press, 2007), 221.
29 Chambers, *Vestiges*, ed. Secord, 230.
30 Ibid., 386.
31 Ibid., 29.
32 Ibid., 24.
33 Ibid., 139.
34 Lightman, *Victorian Popularizers of Science*, 22.
35 Chambers, *Vestiges*, ed. Secord, 276.
36 Secord, *Victorian Sensation*, 527; Lightman, *Victorian Popularizers of Science*, 221.
37 Secord, *Victorian Sensation*, 109, 429, 2.
38 Smith, quoted in Secord, *Victorian Sensation*, 15.
39 Chambers, *Vestiges*, ed. Secord, 388.
40 James Hutton, 'Theory of the Earth', *Transactions of the Royal Society of Edinburgh*, I, Pt ii (1788), 304.
41 *The Poems and Songs of Robert Burns*, ed. James Kinsley (Oxford: Clarendon Press, 1968), 3 vols, I, 118 ('Man was Made to Mourn').
42 Chambers, *Vestiges*, ed. Secord, 196–7.
43 John Reid, 5 May 1843 interview in *Report of the St Andrews' University Commissioners (Scotland)* (London: William Clowes for Her Majesty's Stationery Office, 1845), 155.
44 Chambers, *Vestiges*, ed. Secord, 231.
45 Ibid., 232.
46 Chambers, *Vestiges*, ed. Secord, 1–2. Chambers massively underestimated the distances and times involved.
47 Chambers, *Vestiges*, ed. Secord, 233.
48 Chambers, *Vestiges*, ed. Secord, 360.
49 Secord, *Victorian Sensation*, 429.
50 Charles Darwin, quoted in Secord, *Victorian Sensation*, 430–31.
51 Lightman, *Victorian Popularizers of Science*, 34.
52 Richard Church, quoted in Secord, *Victorian Sensation*, 511.
53 Secord, *Victorian Sensation*, 39, 425, 420.
54 Somewhat confusingly, in British parlance 'public-school' means what in America is more straightforwardly termed 'private-school' education.
55 A. Sedgwick to M. Napier, 31 May [1845], quoted in Secord, *Victorian Sensation*, 244.
56 See Secord, *Victorian Sensation*, 227, 234.
57 Chambers to Alexander Ireland, [July–August 1845,] NLS Dep. 341/113/48–49, quoted in Secord, *Victorian Sensation*, 144.
58 Chambers, *Vestiges*, ed. Secord, 32.

59 Advertisement, 'New Work of Messrs. Chambers', dated 20 October 1842 (NLS Dep. 341/125).

60 Robert Chambers to Alexander Ireland, 'Wednesday evening' (NLS Dep. 341/110, folio 57).

61 Lightman, *Victorian Popularizers of Science*, 7. Lightman is referring to the work of Crosbie Smith in *The Science of Energy: A Cultural History of Energy Physics in Victorian Britain* (Chicago: University of Chicago Press, 1998).

62 Secord, *Victorian Sensation*, 391.

63 Charles Darwin to A. Dowie, 24 March 1871, quoted in Secord, *Victorian Sensation*, 510.

64 Secord, *Victorian Sensation*, 10.

65 See Secord, *Victorian Sensation*, 39, 180, 365–6.

66 Chambers, *Vestiges*, ed. Secord, 359.

67 William Chambers, *Memoir of Robert Chambers*, 271.

68 'With the Grain', *Chambers' Edinburgh Journal*, 30 October 1841, 321.

69 'Enough', *Chambers' Edinburgh Journal*, 11 September 1841, 265.

70 'Regularity of Occasional Things', *Chambers' Edinburgh Journal*, 18 September 1841, 273; on page 274 of this article Chambers quotes a long passage used again in *Vestiges*, ed. Secord, 330.

71 Robert to William Chambers, 'Thursday morning' [?1843], NLS Dep. 341/93, letter 58; Robert to William Chambers, 'Monday afternoon' [?1842], NLS Dep. 341/93, letter 59.

72 Ibid.

73 'Consolations', *Chambers' Edinburgh Journal*, 29 January 1842, 9.

74 'Cowed Ones', *Chambers' Edinburgh Journal*, 26 February 1842, 41.

75 Thomas Carlyle, *Sartor Resartus*, ed. Kerry McSweeney and Peter Sabor (Oxford: Oxford University Press, 1987), 123–7.

76 *Man of Letters: The Early Life and Love-Letters of Robert Chambers*, ed. C. H. Layman (Edinburgh: Edinburgh University Press, 1990), 51.

77 Carlyle, *Sartor Resartus*, 129, 134–5, 13–40, 147, 149.

78 'Labour a Consoler', *Chambers' Edinburgh Journal*, 29 July 1843, 224.

79 Thomas Carlyle, *Past and Present* (New York: William H. Colyer, 1843), 112.

80 Secord in 'Introduction' to Chambers, *Vestiges*, ed. Secord, xviii.

81 'Consolations', *Chambers' Edinburgh Journal*, 29 January 1842, 9.

82 Chambers, *Vestiges*, ed. Secord, 384, 379, 385.

83 Ibid., 386.

84 Ibid., 387.

85 Elizabeth Barrett to J. Martin [25] January 1845, quoted in Secord, *Victorian Sensation*, 167.

86 See Secord, *Victorian Sensation*, 189.

87 Ibid., 13.

THE BEGINNING AND THE END OF THE WORLD

88 Chambers, *Vestiges*, ed. Secord, 387.

89 Ibid., 353.

90 'Thoughts on Nations and Civilisation', *Chambers' Edinburgh Journal*, 21 May 1842, 137; *Vestiges*, ed. Secord, 283, 282.

91 Ibid., 138.

92 [Robert Chambers,] 'The Easily Convinced', *Chambers' Edinburgh Journal*, 2 July 1842, 185–6.

93 Chambers, *Vestiges*, ed. Secord, 27, 20–21.

94 So, for instance, where Robert's leading article on 'Languages' in *Chambers' Edinburgh Journal* for July 30, 1842, points out first of all that Chinese lacks the consonants '*b, d, r, v,* and *z*' and that 'the word Christus they call *Kuliss-ut-oo-suh*', then goes on to quote a Delaware Native American word '*Kuligatschis*, meaning "Give me your pretty little paw"', in *Vestiges* we are told on page 289 of the first edition that Chinese lacks '*b, d, r, v,* and *z*' with the result that 'the word Christus they call *Kuliss-ut-oo-suh*', while on page 290 Chambers cites the Delaware word '"*kuligatschis*", meaning "give me your pretty little paw"'.

95 [Robert Chambers,] 'Gossip about Golf', *Chambers' Edinburgh Journal*, 8 October, 1842, 297.

96 [Robert Chambers,] 'Popular Information on Science: Ripple-Marks and Tracks of Animals on Rock-Surfaces', *Chambers' Edinburgh Journal*, 24 December 1842, 387.

97 Ibid.; see also Chambers, *Vestiges*, ed. Secord, 101–03.

98 [Robert Chambers,] 'A Day in the East of Fife', *Chambers' Edinburgh Journal*, 29 October 1842, 321–2.

99 Robert Chambers, *Ancient Sea-Margins* (Edinburgh: W. & R. Chambers, 1848), 62, 66, 65.

100 On the Scottish tradition of educational generalism see George Elder Davie, *The Democratic Intellect* (Edinburgh: Edinburgh University Press, 1961).

101 [Robert Chambers,] 'A Pilgrimage to Balcarres', *Chambers' Edinburgh Journal*, 7 October 1843, 298.

102 H. T. De la Beche, *Researches in Theoretical Geology* (London: Charles Knight, 1834), 398; Chambers borrowed De la Beche's work from St Andrews University Library on 14 January 1843, then again on 26 January (see page 474 of the Library Receipt Book, Readers, 1839–47 (LY208) – hereafter cited as 'Library Receipt Book'); see also *Vestiges*, 114 for mention of De la Beche's book. The Hill and Adamson calotype of De la Beche is reproduced in Adrian Budge, 'Yorkshire and Photography – The Early Years', *The Photographic Collector*, 4.1 (1983), 12.

103 S. R. Bosanquet, *'Vestiges of the Natural History of Creation': Its Argument Examined and Exposed*, Second Edition (London: John Hatchard and Son, 1845), 10–11.

104 [Robert Chambers,] 'Natural Daguerreotyping', *Chambers' Edinburgh Journal*, 3 December 1842, 361–2.

105 Chambers, *Vestiges*, ed. Secord, 342–3.

106 Nathaniel Parker Willis, *The Convalescent* (New York: Charles Scribner, 1859), 435, and *Life, Here and There: or Sketches of Society and Adventure at Far Apart Places* (New York: Baker and Scribner, 1850), 341, both quoted in Kate Flint, 'Photographic Memory', *Romanticism and Victorianism on the Net*, 53, February 2009. In her article in this electronic journal, Flint points out that the *OED*'s citation of Willis's use of the expression 'photographic memory' is inaccurate.

107 Douwe Draaisma, *Metaphors of Memory: A History of Ideas about the Mind* (Cambridge: Cambridge University Press, 2000), 103–37, presents an account of the development of photography as a metaphor for memory in the later nineteenth century. Chambers's writing deserves to be seen as an early and, given its wide circulation, influential part of that.

108 [David Brewster,] Review of *Vestiges of the Natural History of Creation*, *North British Review*, 3 (1845), 471.

109 Chambers, quoted in Secord, *Victorian Sensation*, 376, 378.

110 Secord, *Victorian Sensation*, 395–7; Lightman, *Victorian Popularizers of Science*, 236, quoting Page's *The Past and Present Life of the Globe* (Edinburgh: Blackwood, 1861), 209.

111 Chambers, letter to Alexander Ireland, 14 January 1850, quoted in Secord, 397.

112 [Anon.,] 'Vestiges of the Author of "The Vestiges of Creation"', *Macphail's Edinburgh Ecclesiastical Journal and Literary Review*, November 1847, 251.

113 Pencil marginalia on *Vestiges of the Natural History of Creation*, Third Edition (London: John Churchill, 1845), 168 and 16 (St Andrews University Library sQH53.C4); Major Playfair's borrowing of *Vestiges* on 24 September 1845 is recorded on page 542 of the relevant Library Receipt Book.

114 Secord, *Victorian Sensation*, 97.

115 Library Receipt Book, front inside cover.

116 Ibid., 291; Chambers, *Vestiges*, ed. Secord, 64 (Chambers here refers to Miller's book by its subtitle).

117 Library Receipt Book, 474–6.

118 Bosanquet, *'Vestiges' . . . Exposed*, 4.

119 Adam Sedgwick in 1845, quoted in Secord, *Victorian Sensation*, 23.

120 Bosanquet, *'Vestiges' . . . Exposed* (1845), quoted in Secord, *Victorian Sensation*, 14.

121 [Adam Sedgwick,] review of *Vestiges*, *Edinburgh Review*, lxxxii (1845), 4, quoted in Secord, *Victorian Sensation*, 21.

122 Ibid., 3, but this time quoted in Nicolaas A. Rupke, *The Great Chain of History* (Oxford: Clarendon Press, 1983), 177.

123 These verses, written 'when her husband was setting off on one of his excursions', are published in Lady Priestley, *The Story of a Lifetime* (London: Kegan Paul, Trench, Trubner & Co., 1908), 47. Though Lady Priestley attributes them to Anne, in an email to the present writer (15 September 2010), Professor Sondra Miley Cooney points out that the verses exist in Robert's hand in several manuscripts.

124 William Chambers, *Memoir of Robert Chambers*, 272–3.

125 Again, this is the picture reproduced as plate 10 in C. H. Layman, ed., *Man of Letters: The Early Life and Love-Letters of Robert Chambers* (see note 1 above).

126 This is reproduced in Lady Priestley, *The Story of a Lifetime* (London: Kegan Paul, 1908), opposite page 27.

127 Layman, ed., *Man of Letters*, 164.

128 [Robert Chambers,] 'Lumberers', *Chambers' Edinburgh Journal*, 1 April 1843, 81

129 Ibid., 44.

130 Lady Priestley, *The Story of a Lifetime*, 44, 46–7.

131 Robert Chambers, 'A Catechism' (St Andrews University Library MS BX9184.C5).

132 Ibid.

133 Chambers, *Vestiges*, ed. Secord, 356–7.

134 Matthew, xix, 19 (Authorized Version).

135 Chambers, *Vestiges*, ed. Secord, 357.

136 Lightman, *Victorian Popularizers of Science*, 500.

137 Ibid., 501.

138 Secord, *Victorian Sensation*, 461.

139 Lightman, *Victorian Popularizers of Science*, 502.

CHAPTER 6 *Rock*

1 Robert Louis Stevenson, 'The Coast of Fife', in *Further Memories*, vol. XXVI of the Skerryvore Edition of Stevenson's *Works* (London: Heinemann, 1925), 91.

2 These articles are itemised on pp. 81–2 of the W. and R. Chambers account book which covers *Chambers' Edinburgh Journal* (NLS Dep 341/367).

3 John Adamson, 'Report on the Sanitary Condition and General Economy of the Labouring Classes in the City of St Andrews' in *Reports on the Sanitary Condition of the Labouring Classes* (London: Poor Law Commissioners, 1841), 270. Hereafter cited as 'Report'.

4 On Adamson's campaigning see Graham Smith, 'John Adamson,

Sanitary Reform and the St Andrews Fishing Community', *History of Photography*, 25.2 (2001), 181–2.

5 All quotations from Rev. Dr [Robert] Haldane, *Remarks on a Report by a Committee appointed by the Town Council of St Andrews to Inquire into the Condition of the Poor in that City* (Cupar: Fifeshire Journal Office [1841]), 12, 3, 22, 15, 3–4.

6 Adamson, 'Report', 271.

7 Information from Robert N. Smart, *Biographical Register of the University of St Andrews 1747–1897* (St Andrews: University of St Andrews Library, 2004), 5.

8 [David Brewster,] 'Photography', *North British Review*, August 1847, 476.

9 The photograph and Adamson's caption are reproduced as figures 8 and 9 in A. D. Morrison-Low, 'Dr John and Robert Adamson: An Early Partnership in Scottish Photography', *The Photographic Collector*, 4.2 (1983), 208–09.

10 See chapter 4 of the present book. On the dating of Talbot's earliest publications see Larry J. Schaaf, *The Photographic Art of William Henry Fox Talbot* (Princeton and Oxford: Princeton University Press, 2000), 21.

11 Advertisement for 'Mr D. O. HILL'S PICTURE', *The Witness*, 8 July 1843.

12 Brewster to Fox Talbot, 18 November 1843, quoted in Sara Stevenson, *David Octavius Hill and Robert Adamson: Catalogue of their Calotypes Taken Between 1843 and 1847 in the Collection of the Scottish National Portrait Gallery* (Edinburgh: National Galleries of Scotland, 1981), 10.

13 Dominique-François Arago, quoted in Heinrich Schwartz, 'The Calotypes of D. O. Hill and Robert Adamson: Some Contemporary Judgements', *Apollo*, February 1972, 124, and in Stevenson, *David Octavius Hill and Robert Adamson*, 12.

14 James Nasmyth to D. O. Hill, 27 March 1847, quoted in Sara Stevenson, *The Personal Art of David Octavius Hill* (New Haven: Yale University Press, 2002), 13.

15 D. O. Hill to David Roberts, 12 March 1845 (National Library of Scotland TD 1742), quoted in Stevenson, *The Personal Art of David Octavius Hill*, 17.

16 This title page is reproduced on page 19 of Stevenson, *The Personal Art of David Octavius Hill.*

17 D. O. Hill to David Roberts, 12 March 1845 (National Library of Scotland TD 1742), quoted in Stevenson, *The Personal Art of David Octavius Hill*, 17.

18 Walter Benjamin, 'Little History of Photography', in *The Work of Art in the Age of Its Technological Reproducibility, and Other Writings on*

Media, ed. Michael W. Jennings, Brigid Doherty, and Thomas Y. Levin, trans. Edmund Jephcott et al. (Cambridge, Mass.: Belknap Press, 2008), 274ff.

19 Details of the Adamson brothers' literary tastes rely on their several entries in the Library Receipt Book, 1825–37, Students and Library Receipt Book, 1836–43, Students in the archives of St Andrews University Library. Entries have been checked against the *Catalogus Librorum in Bibliotheca Universitatis Andreanae, Secundus Literarum Ordinem Dispositus* (St Andrews: Robert Tullis, 1826) and against shelf registers.

20 See Robert Adamson's entries in Library Receipt Book, 1836–43, Students (St Andrews University Muniments LY 207 16), 12 and 253.

21 See Sara Stevenson, *David Octavius Hill and Robert Adamson*, 37 (Robert Adamson b) and 156 (Group 4).

22 The first work Robert Adamson borrowed from St Andrews University Library was George Stanley Faber's *A Dissertation on the Prophecies, That Have Been Fulfilled, Are Now Fulfilling, or Will Hereafter be Fulfilled*; he later borrowed a volume recorded simply as 'Demonology', perhaps Walter Scott's 1831 *Letters on Demonology and Witchcraft*.

23 Rigdum Funnidos, Gent., ed., *American Broad Grins* (London: Robert Tyas; Edinburgh: John Menzies, 1838). Sadly several of the jokes are flat, or racist, or both, though some just about survive: 'AMERICAN DEFINITIONS: *Rigid Justice.*—A juror in a murder case, fast asleep.' (page 56). This and a good number of the other texts Robert Adamson borrowed are still in the collections of St Andrews University Library.

24 [Mary Shelley,] *Valperga: or, The Life and Adventures of Castruccio, Prince of Lucca*, 3 vols (London: G. and W. B. Whittaker, 1823), I, 86, 183, 182.

25 Grantley F. Berkeley, *Berkeley Castle, An Historical Romance*, 3 vols (London: Richard Bentley, 1836), I, 18, 5, 59, 255.

26 Stevenson, *The Personal Art of David Octavius Hill*, 12, 48, and 166 n. 28; *Oxford Dictionary of National Biography* (*ODNB*), Thomas Annan (1829/30–87).

27 John M. Gray, 'Robert Adamson', in Calotypes by D. O. Hill and R. Adamson Illustrating an Early Stage in the Development of Photography, Selected from his Collection by Andrew Elliot ([Edinburgh:] Printed for private circulation, 1928), 11; Sara Stevenson argues convincingly for the provenance of this account in note 16 on p. 165 of *The Personal Art of David Octavius Hill*.

28 This picture is reproduced in Richard R. Brettell et al., *Paper and Light: The Calotype in France and Great Britain* (Boston: David R. Godine, 1984), 21.

29 On Archibald Adamson, see Smart, *Biographical Register*, 4.

30 'Mr D. O. Hill's Picture' (advertisement), *Scotsman*, 8 July 1843, 1.

31 Brewster to Talbot, ?15 August 1842, NMPFT 4573.

32 Sara Stevenson calls attention to this scrapbook ('in the collection of the Royal Museum of Scotland, T.192.1.2') in *The Personal Art of David Octavius Hill*, 11 and 166 n. 23.

33 Brewster to Talbot, ?15 August 1842, NMPFT 4573; Brewster to Talbot, 22 October 1842, NMPFT 4628.

34 See Ralph L. Harley, Jr and Joanna L. Harley, 'The "Tartan Album" by John and Robert Adamson', *History of Photography*, 12.4 (1988), 295–316, where the album is discussed and reproduced.

35 These captions by John Adamson are reproduced in the Harleys' article (see preceding note), 308 and 310.

36 Compare the photographs now in Edinburgh which are reproduced with the 'RA' initials in A. D. Morrison-Low, 'Dr John and Robert Adamson', 198–214.

37 See Ralph L. Harley, Jr. and Joanna L. Harley, 'The "Tartan Album"', 308, 311, 313–16.

38 Adamson, 'Report', 273, 277, 276.

39 Ibid., 276.

40 Ibid., 285.

41 Ibid., 280.

42 Smith, *Disciples of Light*, 53.

43 Ibid., 53, for a reproduction of this picture in the Adamson Album, National Museums of Scotland, Edinburgh, which is initialled 'R. A.'

44 George Bruce, *Wrecks and Reminiscences of St Andrews Bay* (1884), quoted in Smith, 'John Adamson, Sanitary Reform and the St Andrews Fishing Community', 186.

45 St Andrews Town Council Book, 3 November 1837–9 May 1844, manuscript minute-book in St Andrews University Library Special Collections (B65/11/12), 329 recto.

46 Reproduced in Larry J. Schaaf, *Sun Pictures, Catalogue Eleven* (New York: Hans P Kraus, Jr, [2002]), 23.

47 Reproduced in Smith, *Disciples of Light*, 52.

48 Adamson, 'Report', 285–6.

49 An anonymous poem, 'Ane Auld Ballad upon a New Knychte' quoted in Smith, 'John Adamson, Sanitary Reform and the St Andrews Fishing Community', 186.

50 See Larry Schaaf's fine discussion of this picture's composition and attribution in *Sun Pictures, Catalogue Eleven*, 74–5.

51 On such drawing books and photography, see Martin Kemp, 'Talbot and the Picturesque View', *History of Photography*, 21.4 (1997), 270–82. A picture from Samuel Prout's *Prout's Microcosm* (1841) is reproduced on p. 278 of this article.

52 Mrs [Frances] Trollope, *Belgium and Western Germany in 1833* (Brussels: L. Hauman, 1835), 21, 18.

53 Sara Stevenson, *The Personal Art of David Octavius Hill* (New Haven and London: Yale University Press for the Paul Mellon Centre for Studies in British Art, 2002), 69. Hill and Adamson's calotype, *Newhaven Fishwives with the Reverend James Fairbairn and James Gall*, 16 July 1845, is reproduced on p. 74 of this volume.

54 Brewster to Talbot, 2 November 1842, NMPFT 4638; John Adamson to Talbot, 9 November 1842, NMPFT 4645.

55 [Anon.,] 'Photogenic Drawing', in William and Robert Chambers, ed., *Chambers's Information for the People* (Edinburgh: W. and R. Chambers, 1841–2), 2 vols, II, 253.

56 On Howie see Sara Stevenson, *The Personal Art of David Octavius Hill* (New Haven: Yale University Press, 2002), 12.

57 Lady Eastlake (1843) quoted in Sara Stevenson, 'Robert Adamson and David Octavius Hill' in John Ward and Sara Stevenson, *Printed Light: The Scientific Art of William Henry Fox Talbot and David Octavius Hill with Robert Adamson* (Edinburgh: HMSO Books, 1986), 40; 1843 cartoon, 'The Disruption!', National Museums of Scotland, reproduced on the SCRAN database (Scran ID number 000–100–067–697–C). For a splendidly full account of the partnership between Hill and Adamson see Stevenson, *The Personal Art*.

58 [Hugh Miller,] 'The Two Prints', *The Witness*, 24 June 1843.

59 See Stevenson, *Printed Light*, 31.

60 See Duncan Macmillan, *Scottish Art 1460–1990* (Edinburgh: Mainstream, 1990), 191, and Sara Stevenson, *David Octavius Hill and Robert Adamson*, 8–9.

61 See Stevenson, *The Personal Art*, 84; Larry Schaaf, *Sun Pictures, Catalogue Eleven*, 9.

62 *Saint Andrews as It Was and as It Is* (Cupar: G. S. Tullis, 1838), 74.

63 See A. D. Morrison-Low, 'Dr John and Robert Adamson', 198–214; the photograph from Kinkell Braes is reproduced as figure 4 on page 204.

64 See Larry J. Schaaf, *Sun Pictures, Catalogue Eleven*, 26 and 84; on the destruction of Brewster's archive see A. D. Morrison-Low, 'Brewster and Scientific Instruments' in A. D. Morrison-Low and J. R. R. Christie, ed., *'Martyr of Science': Sir David Brewster 1781–1868* (Edinburgh: Royal Scottish Museum Studies, 1984), 59.

65 Robert Chambers, *Vestiges of the Natural History of Creation and Other Evolutionary Writings*, ed. James A. Secord (Chicago: University of Chicago Press, 1994), 57.

66 Chambers, *Vestiges*, ed. Secord, 48.

67 *Saint Andrews as It Was and as It Is*, 230.

68 St Andrews University Library Receipt Book, Readers, 1839–47 (LY208), 290, 291.

69 Hugh Miller, *The Old Red Sandstone, or New Walks in an Old Field* (1841; repr. London: Dent, n.d.), 11, 58, 61, 206.

70 Dated to *c*.1845, this photograph is item ALB 7 38 2 in St Andrews University Library.

71 John Adamson's borrowings of the Chambers works are marked on pp. 275 and 276 of Library Borrowings Register, Students, University of St Andrews Library, LY 207 17.

72 Graham Smith, *Disciples of Light: Photographs in the Brewster Album* (Malibu: The J. Paul Getty Museum, 1990), 54; the photograph of St Andrews under discussion is reproduced as Plate 4 in Smith's book.

73 Adamson, *Report on the Sanitary Condition*, 269.

74 See James A. Secord, *Victorian Sensation: The Extraordinary Publication, Reception, and Secret Authorship of 'Vestiges of the Natural History of Creation'* (Chicago: University of Chicago Press, 2000), 368.

75 Bernard Lightman, *Victorian Popularizers of Science: Designing Nature for New Audiences* (Chicago: University of Chicago Press, 2007), 223–38.

76 David Page, *The Suicide, and Other Poems* (Edinburgh: M. Paterson, 1838), 288, 289; on Page's studies at St Andrews see Robert N. Smart, *Biographical Register of the University of St Andrews 1747–1897* (St Andrews: University of St Andrews Library, 2004), 677.

77 Page, *The Suicide*, 291.

78 Smith, *Disciples of Light*, 54.

79 Talbot's picture is reproduced in Roger Taylor, *Impressed by Light: British Photographs from Paper Negatives, 1840–1860* (New Haven and London: Yale University Press, 2007), 15.

80 This picture is reproduced in *Sun Pictures, Catalogue Eleven*, 21.

81 A picture of this view (with figures) is reproduced in *Sun Pictures, Catalogue Eleven*, 27; another (without the figures) is reproduced in Heinrich Schwartz, *David Octavius Hill: Master of Photography* (New York: Viking Press, 1931), plate 68.

82 See Ralph L. Harley, Jr and Joanna L. Harley, 'The "Tartan Album"', 306, n. 46.

83 *Saint Andrews as It Was and as It Is*, 245.

84 Lord [Henry] Cockburn, *Circuit Journeys* (Edinburgh: David Douglas, 1888), 228.

85 See Ralph O'Connor, *The Earth on Show: Fossils and the Poetics of Popular Science, 1802–1856* (Chicago: University of Chicago Press, 2007).

86 Lord [Henry] Cockburn, *Circuit Journeys* (Edinburgh: David Douglas, 1888), 230–31.

87 See William Feaver, *The Art of John Martin* (Oxford: Clarendon Press, 1975), 57, 106, 96.

88 *The Comic Poems of William Tennant*, ed. Alexander Scott and Maurice Lindsay (Edinburgh: Association for Scottish Literary Studies, 1989), 171.

89 Ibid., 185, 187.

90 See Harry D. Watson, *A Literary Biography of William Tennant* (Lewiston, NY: Edwin Mellen Press, 2000), 145.

91 William Tennant, 'Hebrew Poetry' (his 'introductory Address to his Students in 1843') in Matthew Forster Conolly, *Memoir of the Life and Writings of William Tennant, LLD* (London: James Blackwood, 1861), 174–5.

92 Hugh Miller, *The Old Red Sandstone*, 217.

93 Moreover, the Hill and Adamson calotype of the fossil *Stagonolepis robertsoni*, found in 1844, was the basis for a lithograph published by Louis Agassiz in 1844–5 in *Poissons Fossiles du Vieux Gres Rouge*. The calotype is published in Stevenson, *David Octavius Hill and Robert Adamson*, 220.

94 *The Poems of Tennyson*, ed. Christopher Ricks (London: Longman, 1969), 1411 ('Parnassus'). These pictures of St Andrews Castle may be formed by the Romantic gaze. Yet in a famous Scottish painting such as John Thomson's 1824 *Fast Castle from Below* (now in the National Gallery of Scotland in Edinburgh) much of the drama comes from waves which fling their spray against the base of a cliff surmounted by a distant fortification. A similar sense of a surging sea beating against the cliffs characterises Sam Bough's mid-nineteenth-century oil painting *St Andrews* where castle and cliffs are seen in the distance from a crowded, rain-lashed pier. Hill and Adamson's photographs of the castle and its rocks from the beach look quite different. The emphasis is not at all on the sea, but on the ancient, eroding rocks below the ruined castle battlements. The poetry is not of storm, but of immobile endurance.

95 Hugh MacDiarmid, *Collected Poems* (New York: Macmillan, 1962), 221.

96 Did these photographs have any direct influence over landscape painters? Just occasionally, there are hints. There was correspondence between Anne Chambers and the painter Joseph Noel Paton whose work in the 1850s has clear Pre-Raphaelite affiliations and whose sister, the remarkable sculptor Amelia, later married D. O. Hill. The Patons were a Fife family, from Dunfermline, a city south-west of St Andrews on the Firth of Forth. On 26 April 1852 Amelia's brother, the young Waller Hugh Paton, who later became a successful self-taught Victorian Scottish landscape artist, painted a watercolour (now in a private collection) of St Andrews Castle seen from the beach. As in the most striking 1840s photographs (which Paton may have seen), it is the geology of the view which is at least as arresting as the human structures

included. At the painting's centre is the cliff-face, a great mound of shadowed rock that rears up from the beach. Above it can be seen a few rooftops and a spire, while to the right the tower of the castle is instantly recognizable. Signs of human civilisation in the picture have been pushed to the margins by the artist's intense focus on rock.

97 D. O. Hill to David Roberts, 12 August 1847, quoted in Stevenson, *David Octavius Hill and Robert Adamson*, 15.

98 D. O. Hill to Joseph Noel Paton, 18 January 1848, National Library of Scotland Accession 11315, quoted from Sara Stevenson's transcription in *The Personal Art of David Octavius Hill*, 18.

CHAPTER 7 *Legacies*

1 Some of Smout's writings such as his 1990 British Academy Raleigh Lecture, 'The Highlands and the Roots of Green Consciousness', show a clear awareness of Scottish traditions of environmental thought. Writing about the late-nineteenth and early-twentieth-century period when the nearby University College, Dundee, was part of the University of St Andrews, Smout points out that,

> There was a special Scottish context for the study of ecology. It was associated particularly with the teaching of zoology and botany as *'Vitalistic science'* at the University College of Dundee, under Patrick Geddes, Professor of Botany, and D'Arcy Thompson, author of *Growth and Form*, marine biologist, classicist and *savant extraordinaire* . . . Another in the same mould was W. R. Collinge, student at St Andrews in the 1880s, founding editor of the *Journal of Economic Biology* by 1906, university assistant lecturer in D'Arcy Thompson's St Andrews by 1917, when he started an organisation called the Wild Bird Investigation Society which sounds like an early forerunner of the British Trust for Ornithology.

(Chris Smout, *The Highlands and the Roots of Green Consciousness, 1750–1990* (Perth: Scottish Natural Heritage [1993]), 14–15).

2 Details of this undergraduate degree are quoted from the University of St Andrews School of Geography and Geosciences website at http://www.st-andrews.ac.uk/gg/courses/ug/sustain_dev.shtml (accessed 2 July 2009).

3 Professor Tim Mulgan, contribution to after-dinner discussion following John Houghton Lecture in the James Gregory Lecture series, 19 February 2009. This and other material quoted from the Gregory Lectures website is available at www.jamesgregory.org (accessed 4 July 2009).

4 Houghton on James Gregory Lectures website.

5 Alastair Reid, 'Scotland', in *Inside Out: Selected Poetry and Translations* (Edinburgh: Polygon, 2008), 35.

6 Les Murray, 'Robert Fergusson Night', in Robert Crawford, ed., *'Heaven-Taught Fergusson': Robert Burns's Favourite Scottish Poet* (Edinburgh: Tuckwell Press, 2003), 19.

7 Ulf Leonhardt and Thomas Philbin, *Geometry and Light: The Science of Invisibility* (New York: Dover, 2010).

8 Dhanraj Vishwanath, interview cited in 'Why it's all a blur', University of St Andrews press release available at http://www.st-andrews.ac.uk/news/archive/2010/. See also Dhanraj Vishwanath and Erik Blaser, 'Retinal blur and the perception of egocentric distance', *Journal of Vision*, 10.10, article 26. http://www.journalofvision.org/content/10/10/26.abstract (both items accessed on 18 October 2010).

9 Richard Ovenden, *John Thomson (1837–1921), Photographer* (Edinburgh: National Library of Scotland/The Stationery Office, 1997), 2–3; for the photograph of Thomson in St Andrews see Stephen White, *John Thomson: A Window to the Orient* (Albuquerque: University of New Mexico Press, 1985), 10.

10 Tom Normand, *Scottish Photography: A History* (Edinburgh: Luath Press, 2007), 64, 71.

11 Biographical information is from Adam's entry on the Archives Hub at http://www.archiveshub.ac.uk/news/0312rma.html (accessed 3 March 2008).

12 From Adam's title to the photograph. See University of St Andrews Library Photographic Archive item, RMA–S137A, available digitally through the website of the University of St Andrews Library.

13 University of St Andrews Library Photographic Archive, RMA–H49.

14 Ibid., RMA–F96, 'Descending a chimney, Harold Raeburn on Salisbury Crags, Edinburgh (February 1920)'; RMA–H5591[X], 'Interior of Hebridean croft house: Harris woman sitting at window, East Tarbert' (2 July 1937).

15 University of St Andrews Library Photographic Archive, RMA–S299, 1 January 1907.

16 Ibid., RMA–F623A, September 1931.

17 R. M. M. Crawford, *Plants at the Margin: Ecological Limits and Climate Change* (Cambridge: Cambridge University Press, 2008), 425.

18 R. M. M. Crawford, email to the present writer, 6 July 2009.

19 John Burnside, 'A Science of Belonging: Poetry as Ecology', in Robert Crawford, ed., *Contemporary Poetry and Contemporary Science* (Oxford: Oxford University Press, 2006), 93, 106.

20 John Burnside, 'Steinar Undir Steinahlithum', and Robert M. M. Crawford, 'Introduction [to "Steinar Undir Steinahlithum"]', in Crawford, ed., *Contemporary Poetry and Contemporary Science*, 109, 107–08.

21 Walter Benjamin, 'Little History of Photography' in *The Work of Art in the Age of Its Technological Reproducibility, and Other Writings on Media*, ed. Matthew W. Jennings, Brigid Doherty, and Thomas Y. Levin, trans. Edmund Jephcott et al. (Cambridge, Mass: Belknap Press, 2008), 276.

22 John Burnside, *Glister* (London: Jonathan Cape, 2008), 8, 10, 11, 51.

23 Ibid., 122, 212, 249–50.

24 Kathleen Jamie, *Findings* (London: Sort Of Books, 2005), 11, 39, 61, 79, 186.

25 Kathleen Jamie, 'Primal Seam', *Scotsman*, 'Critique', 30 July 2005, 14.

26 Kathleen Jamie, 'The Puddle' in Robert Crawford, ed., *The Book of St Andrews* (Edinburgh: Polygon, 2005), 140–41.

27 John Burnside, 'History' in *Selected Poems* (London: Cape, 2006), 90–91.

28 Robert Crawford, 'St Andrews', in *Selected Poems* (London: Cape, 2005), 97.

29 Robert Crawford, 'Rounding', in *Full Volume* (London: Jonathan Cape, 2008), 13.

30 John Felstiner, *Can Poetry Save the Earth?* (New Haven: Yale University Press, 2009), xiii.

31 Don Paterson, *Orpheus* (London: Faber and Faber, 2006), 28.

32 On Paterson's celebrity, see Mark Ford, 'Hide and Be Found', *New York Review of Books*, LVII.13 (19 August–29 September 2010), 65.

33 *The Best Laid Schemes: Selected Poetry and Prose of Robert Burns*, ed. Robert Crawford and Christopher MacLachlan (Edinburgh: Polygon, 2009), 47.

34 Douglas Dunn, 'Land Love' in *Elegies* (London: Faber and Faber, 1985), 47.

35 T. C. Smout, 'Foreword' to Charles Warren, *Managing Scotland's Environment*, (Edinburgh: Edinburgh University Press, 2002), xxi.

36 Andrew S. Brierley and Michael J. Kingsford, 'Impacts of Climate Change on Marine Organisms and Ecosystems', *Current Biology*, 19.14 (2009) [no page numbers] (available online).

37 Douglas Dunn, 'Body Echoes', in *Dante's Drum-kit* (London: Faber and Faber, 1993), 62.

38 Martin Kemp, 'Fresh Formulae for Portraiture', *Nature*, 460 (8 July 2009), 179.

39 Tom Normand, 'Natural Magic: Calum Colvin and the Legacy of Sir David Brewster', in Calum Colvin, *Natural Magic* (Edinburgh: Royal Scottish Academy, 2009) [5].

40 Robert Louis Stevenson, 'The Coast of Fife' in *Further Memories*, vol. XXVI of the Skerryvore Edition of Stevenson's Works (London: Heinemann, 1925), 91.

41 Brierley and Kingsford, 'Impacts of Climate Change'.
42 Andrew Brierley quoted in Tom Peterkin, 'Scientists claim planet is heading for "irreversible" climate change by 2040', *Scotland on Sunday*, 2 August 2009, 6.
43 Don Paterson, *Landing Light* (London: Faber and Faber, 2003), 61.

Index

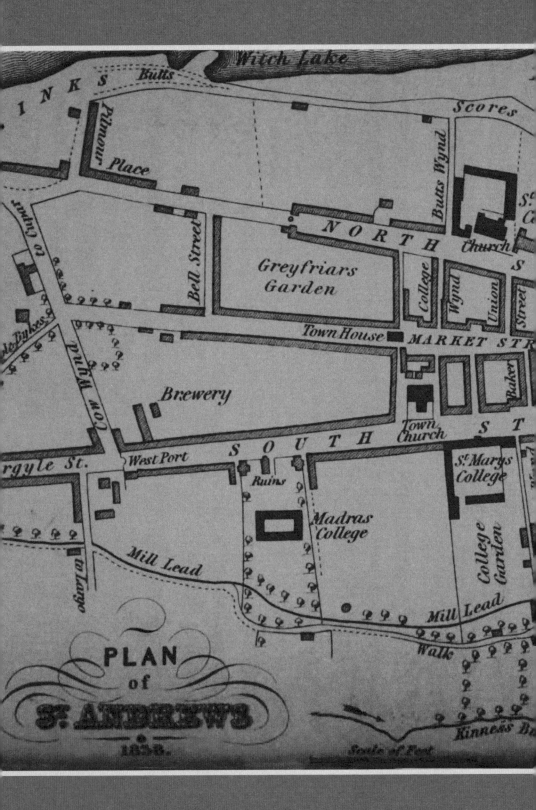

PLAN
of
S^t ANDREWS
1838.